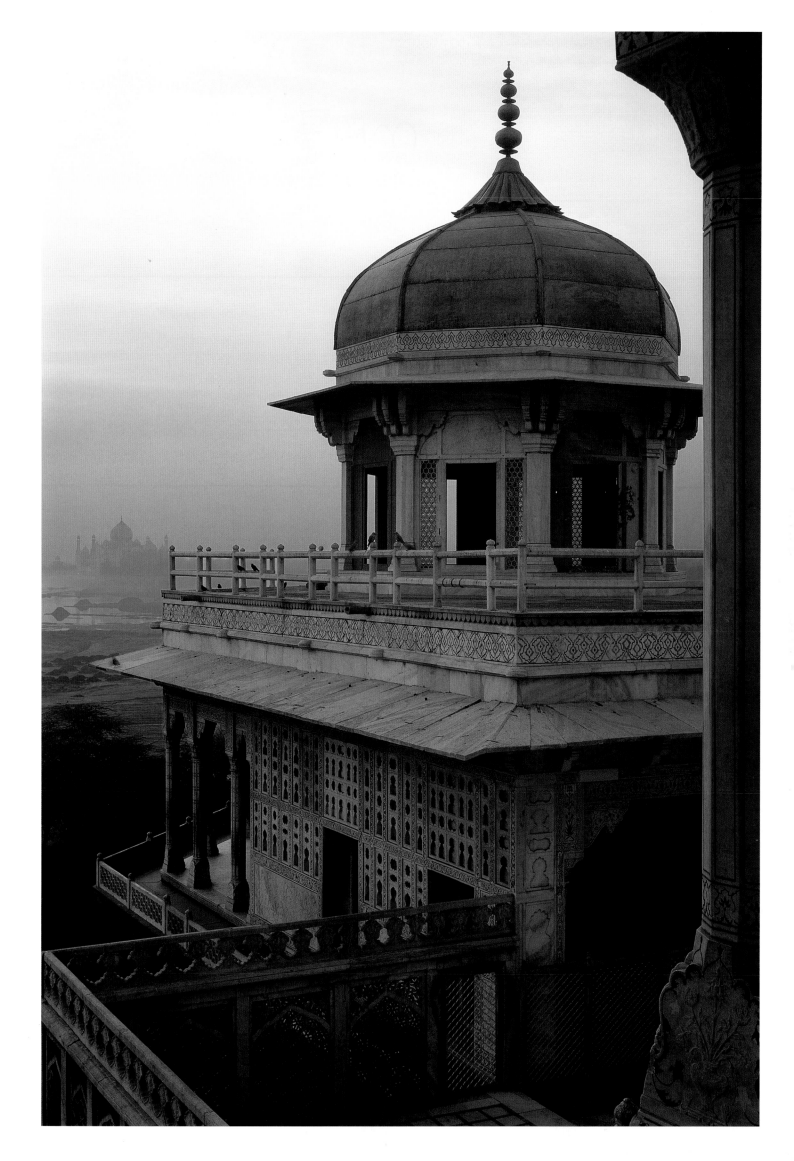

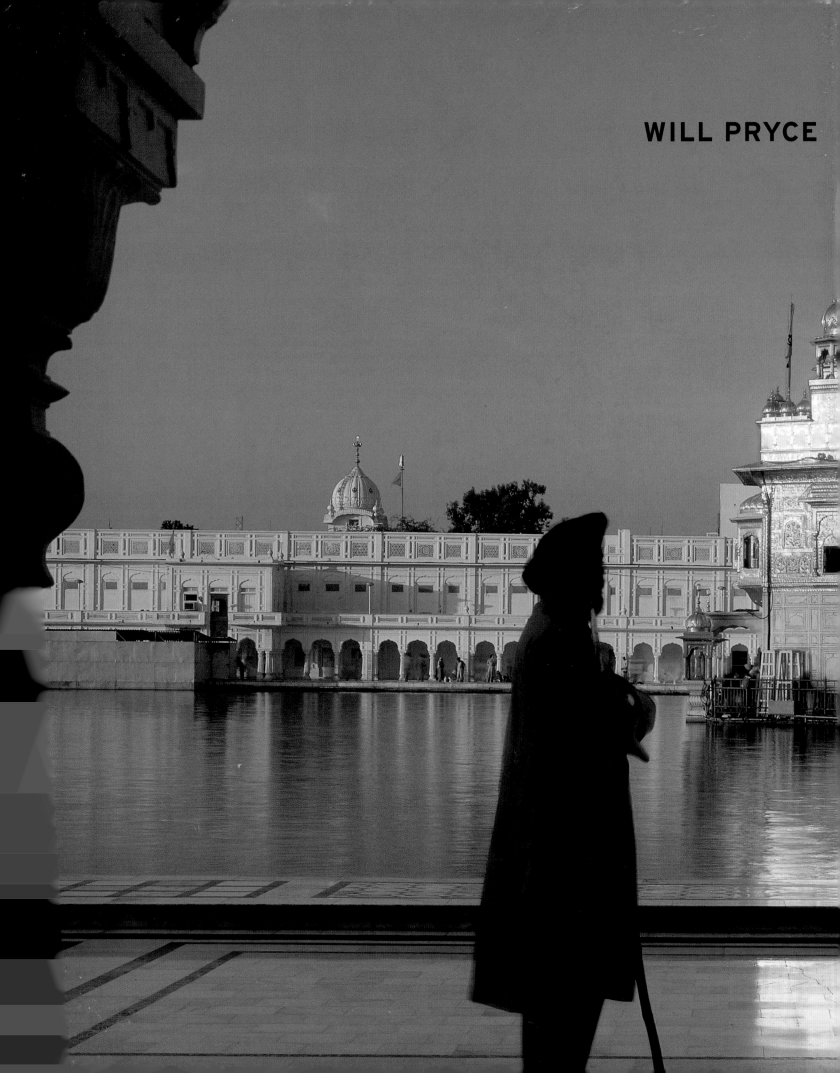

WILL PRYCE

WORLD ARCHITECTURE
THE MASTERWORKS

Thames & Hudson

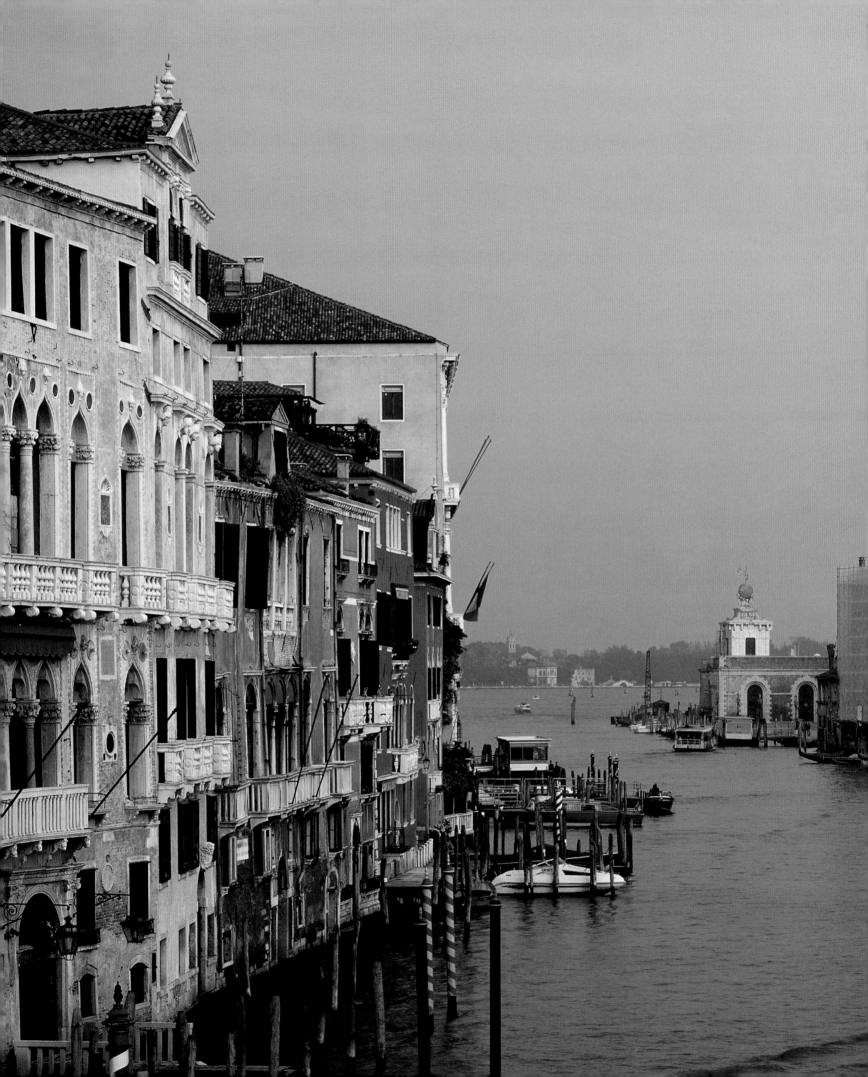

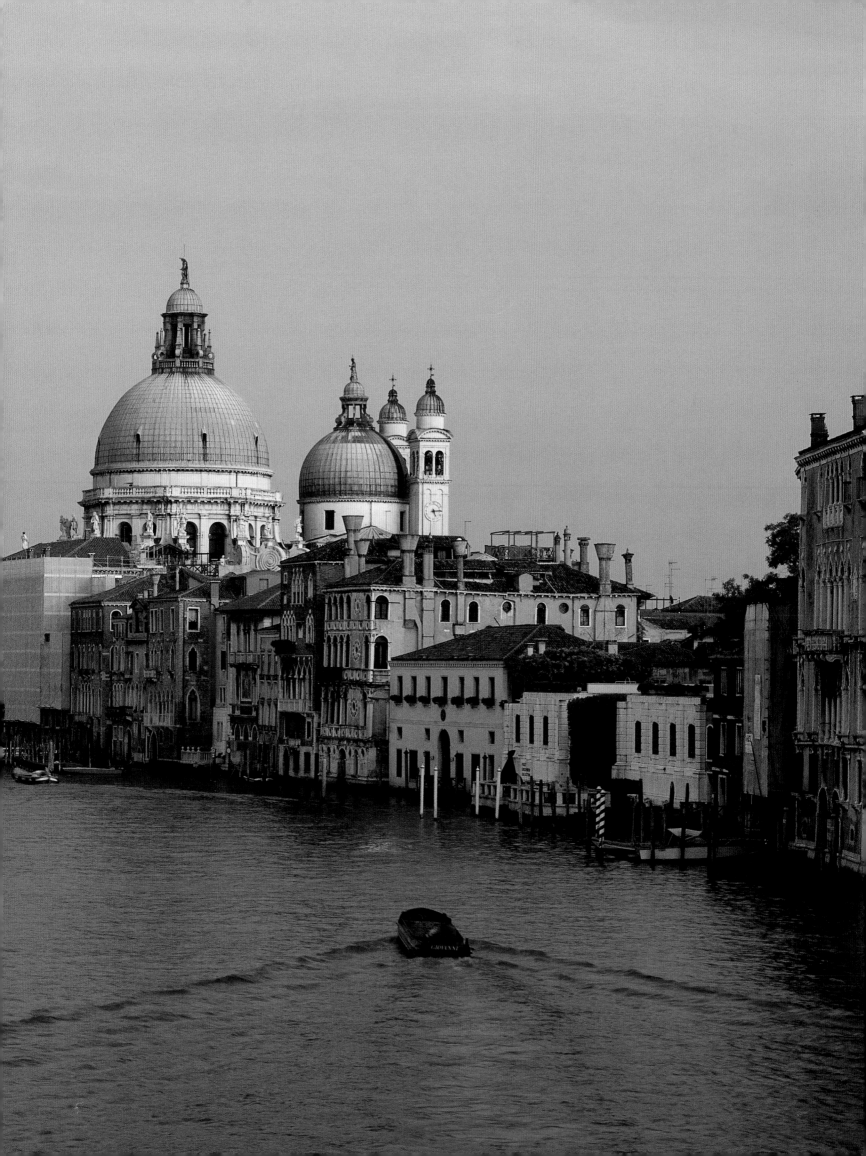

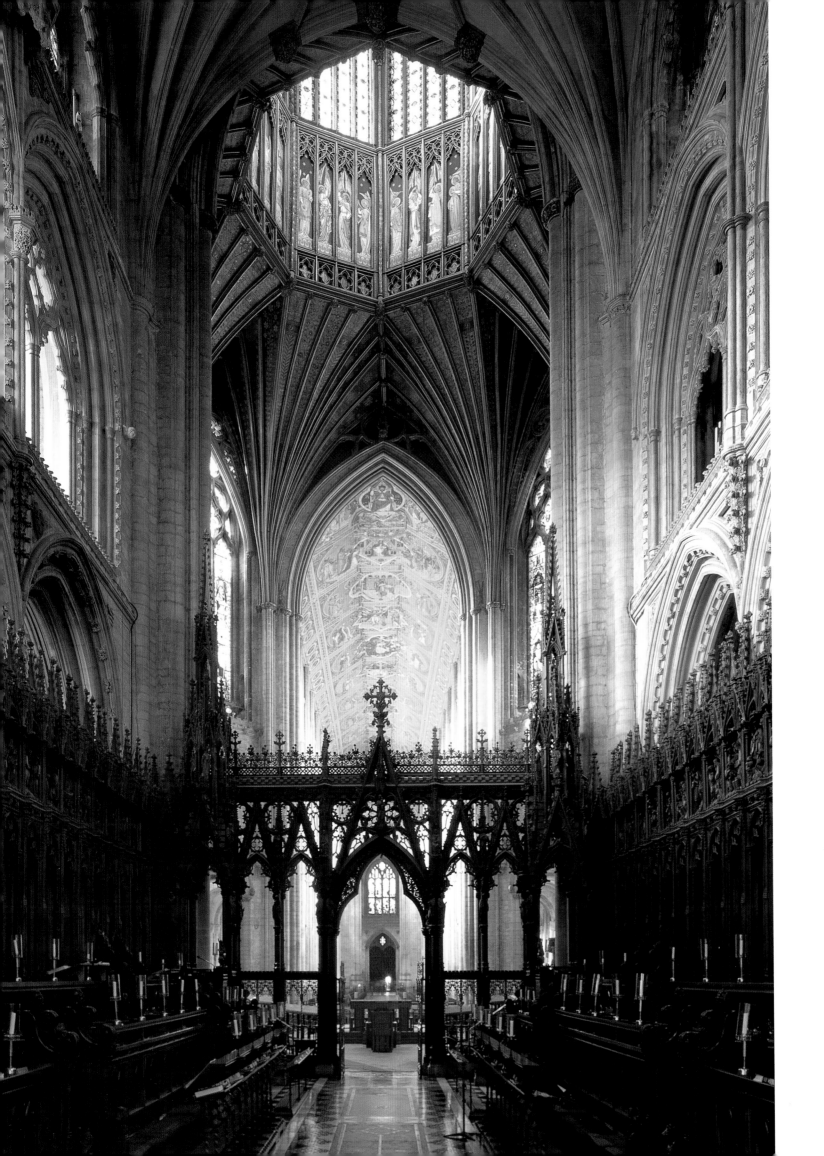

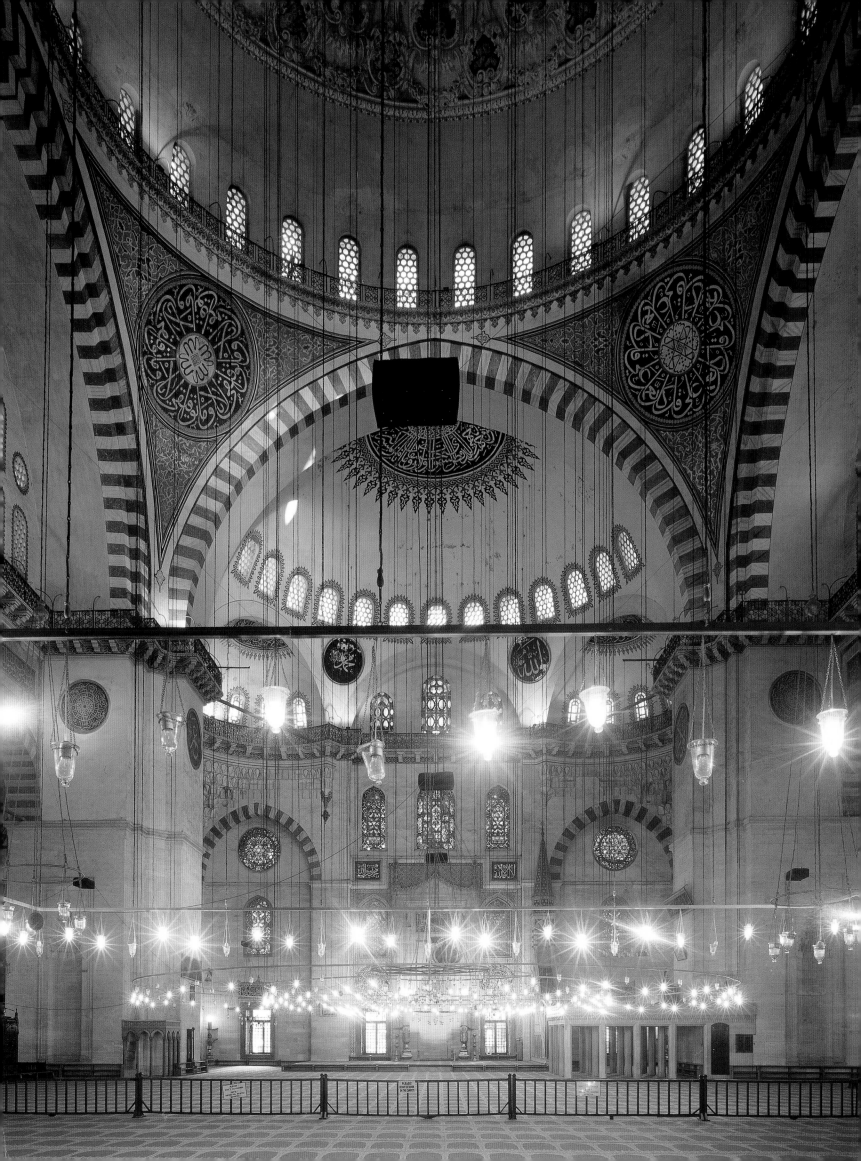

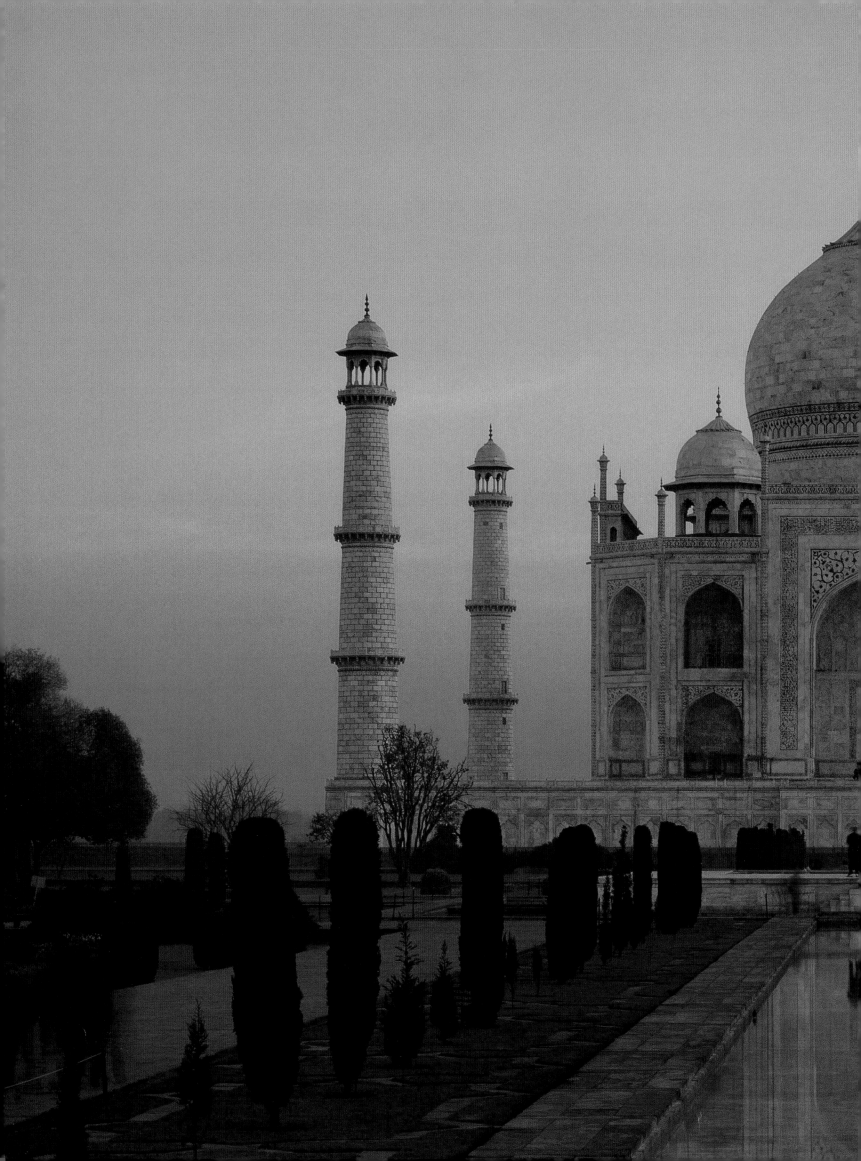

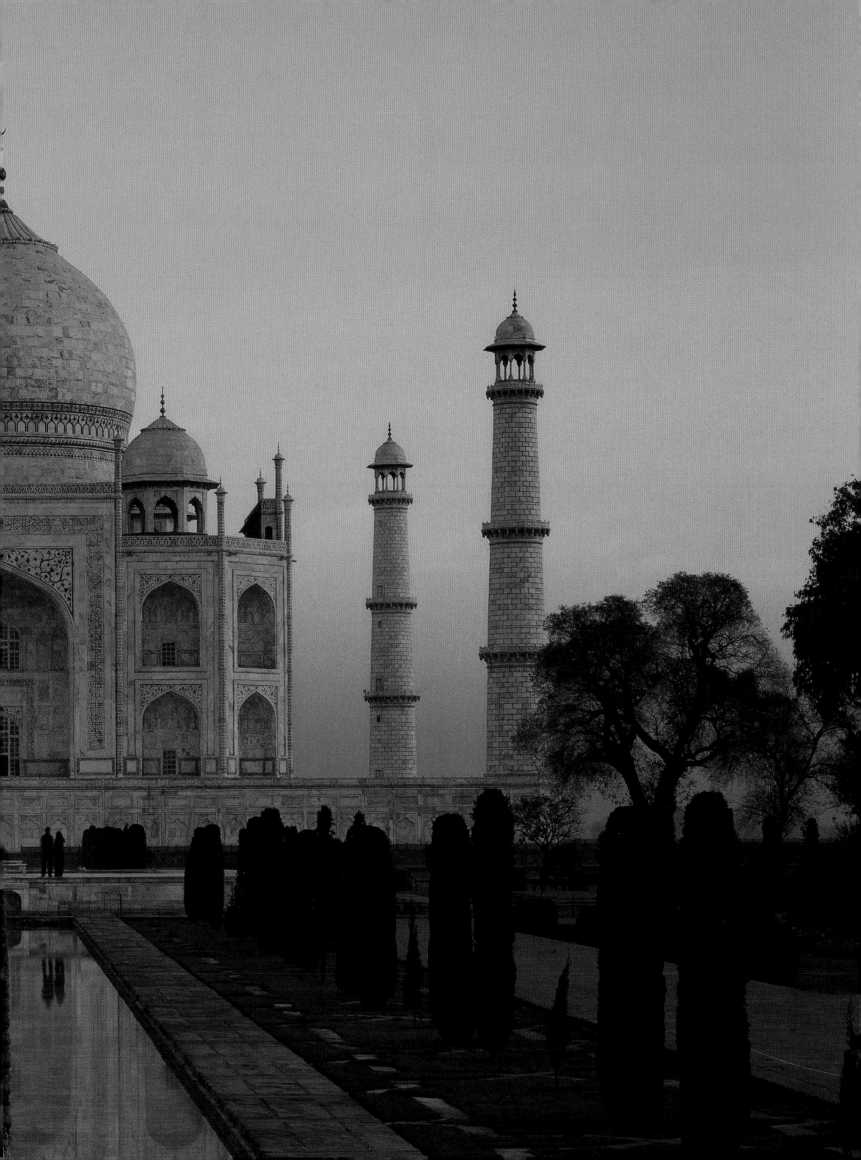

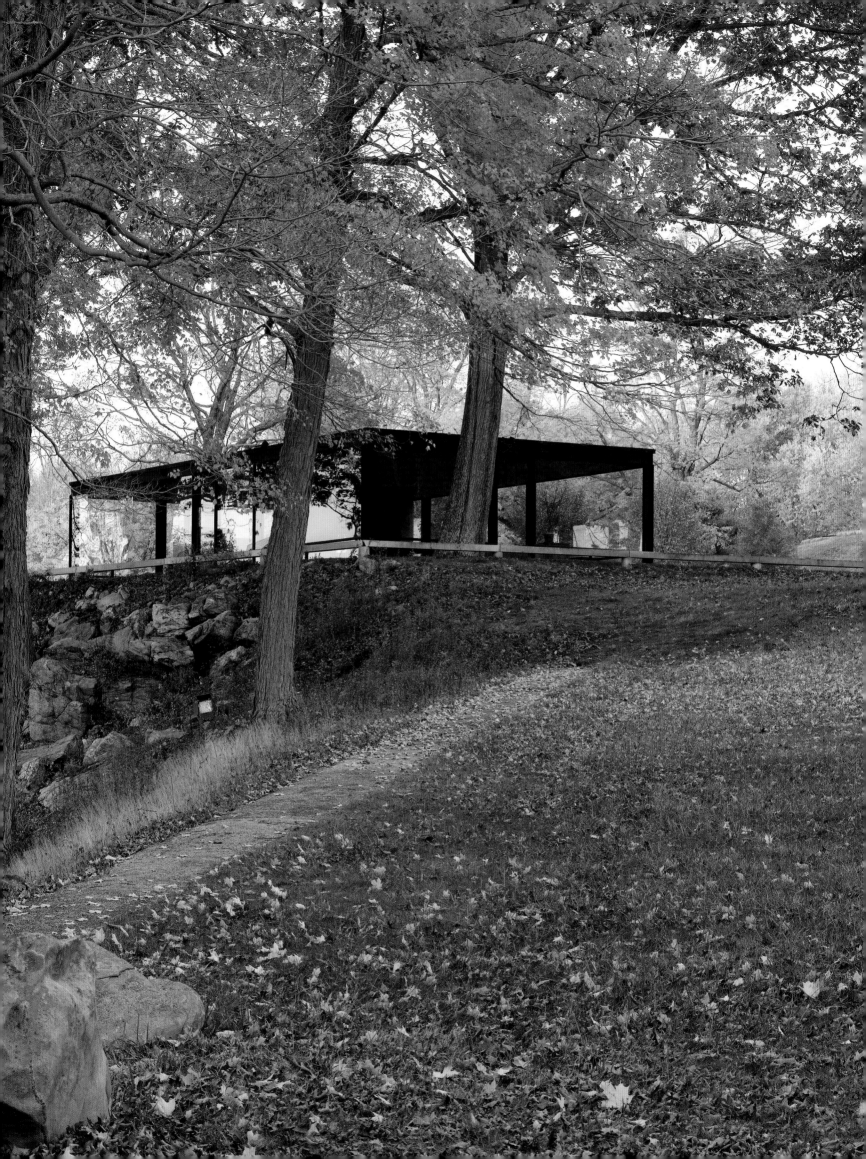

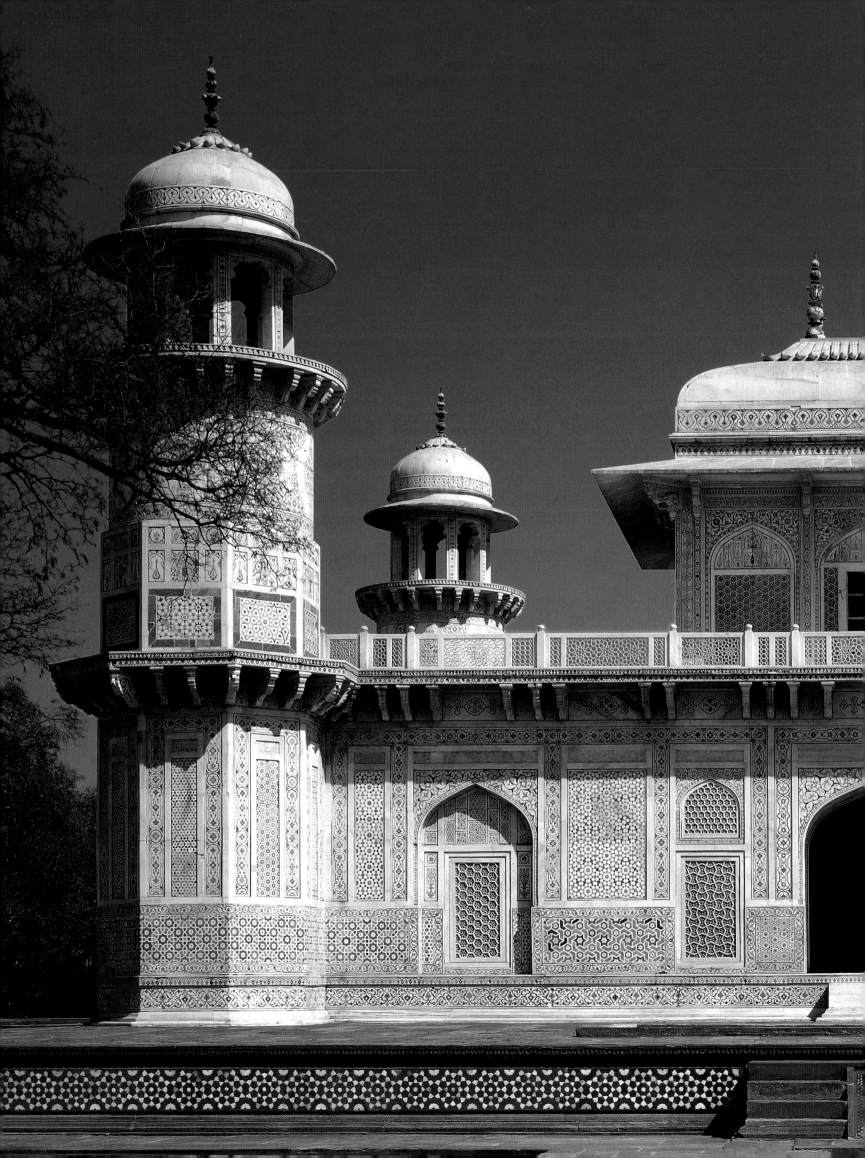

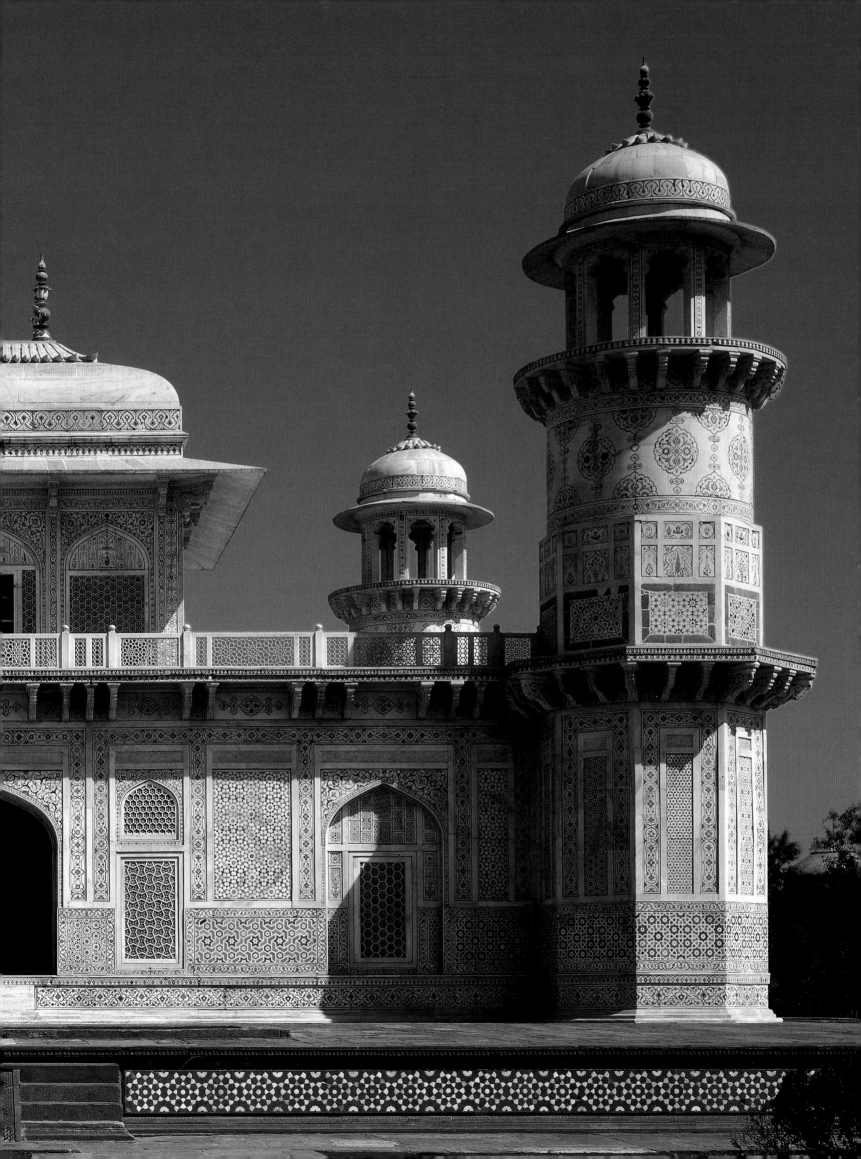

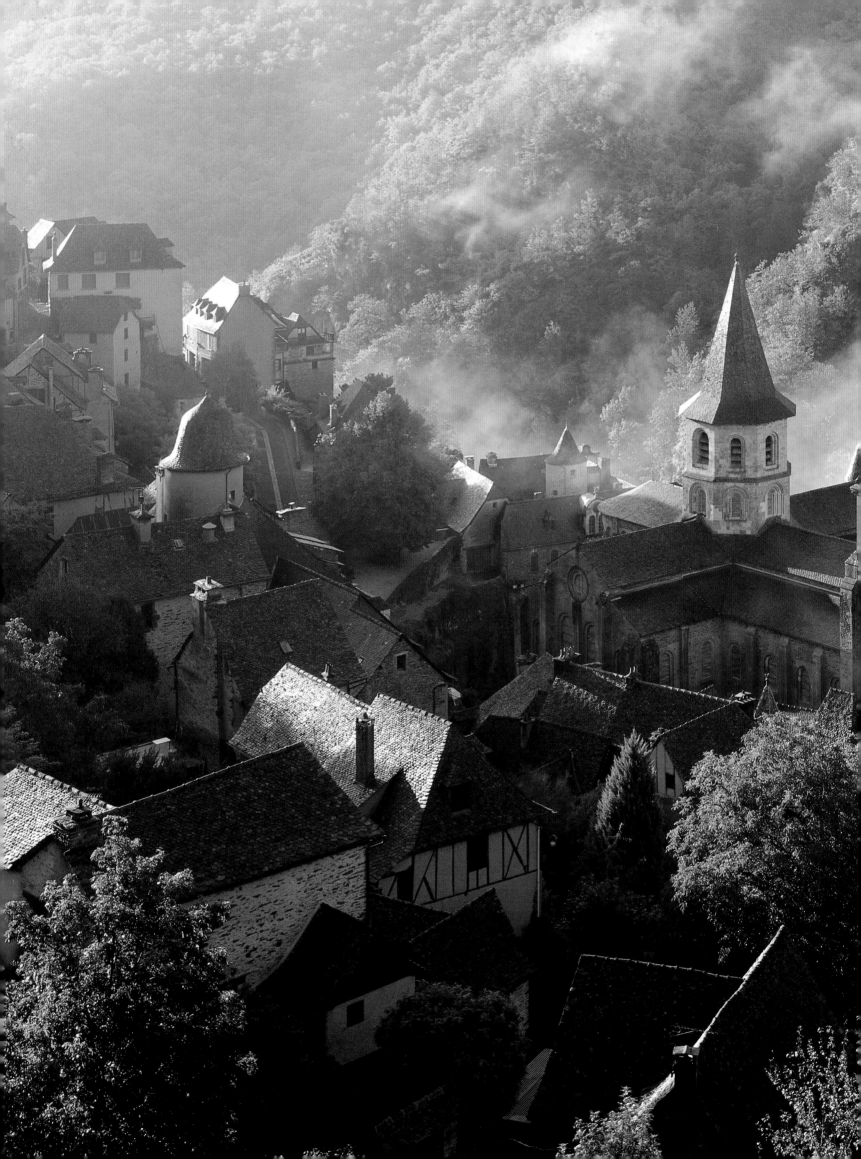

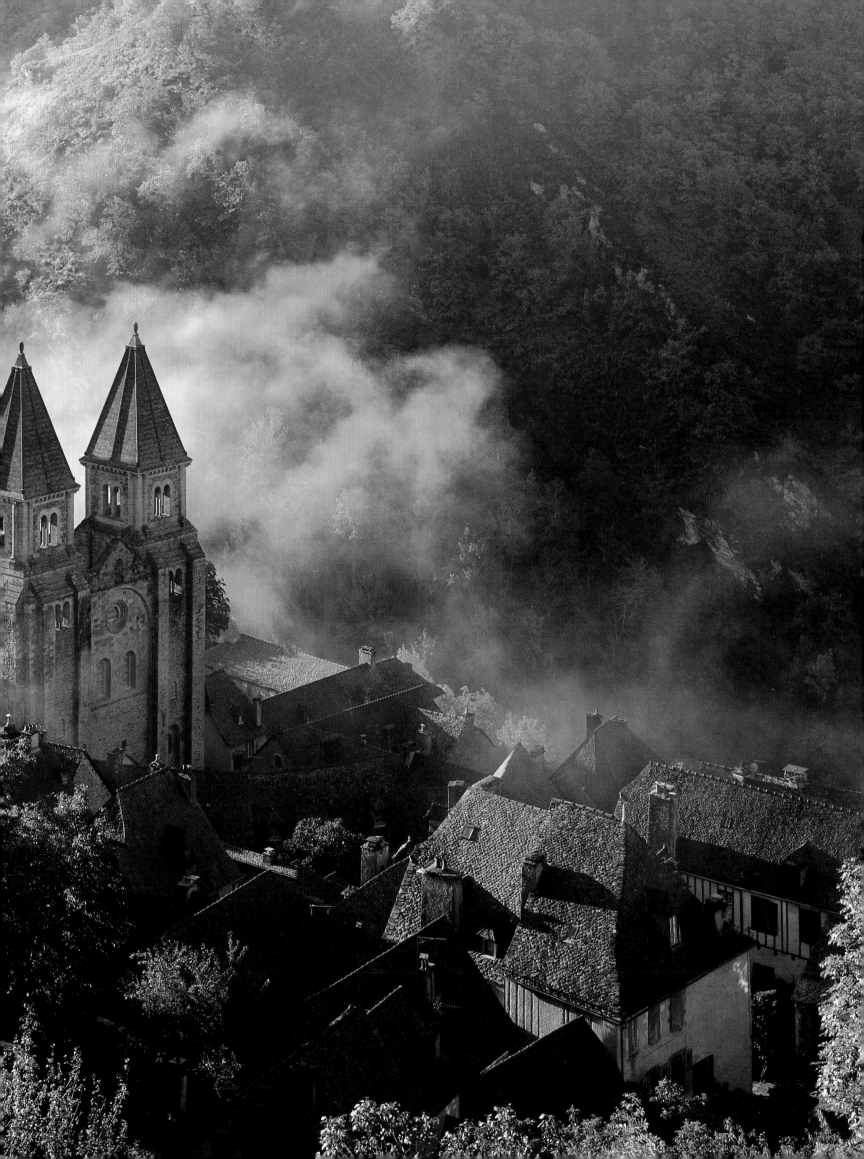

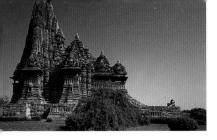

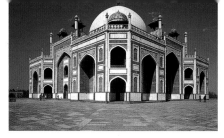

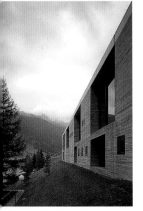

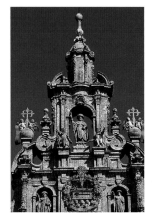
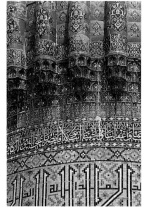
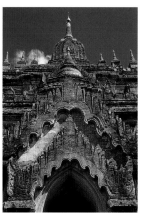
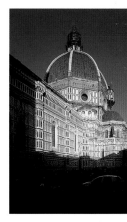

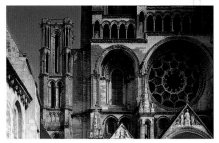
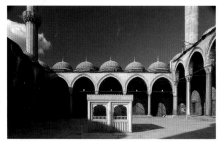
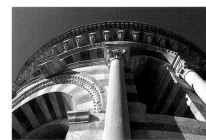

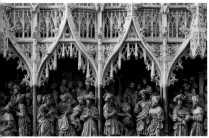
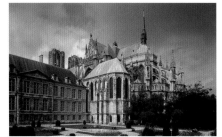
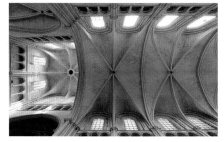
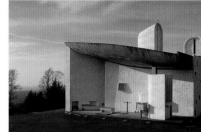

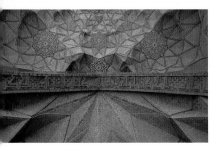

First published in the United Kingdom in 2008
by Thames & Hudson Ltd, 181A High Holborn, London WC1V 7QX

www.thamesandhudson.com

© 2008 Thames & Hudson Ltd, London

British Library Cataloguing-in-Publication Data
A catalogue record for this book is available from the British Library

ISBN 978-0-500-34248-0

Printed and bound in Hong Kong by Paramount

On the previous pages

PAGE 1
Agra Fort, Agra, India

PAGES 2-3
Golden Temple, Amritsar, India

PAGES 4-5
Santa Maria della Salute, Venice, Italy

PAGE 6
Ely Cathedral, Ely, England

PAGE 7
Süleymaniye Mosque, Istanbul, Turkey

PAGES 8-9
Taj Mahal, Agra, India

PAGES 10-11
Glass House, New Canaan, USA

PAGES 12-13
Itmad-Ud-Daulah's Tomb, Agra, India

PAGES 14-15
Abbey Church of Sainte-Foy, Conques, France

CONTENTS

PREFACE

In 1721 the Austrian architect Fischer von Erlach published the first complete survey of the world's greatest architecture. It ignored all Romanesque, Gothic and Renaissance buildings but did include three buildings by…Fischer von Erlach. He did have a point, however. He recognized that if you apply the principle that some buildings are better than others, it will logically follow that some periods will contribute far more than others. If everything is only judged within the confines of its context, then the Taj Mahal can be no better than the best product of the 1960s. My choice of the world's best buildings is a little less dogmatic but ultimately also subjective.

In terms of what to include and what not I had to establish some simple guidelines. I chose to look at buildings rather than ruins. The idea is that a building must be complete enough not to require reconstruction in the imagination. This distinction can be appreciated if we compare, for example, Rome's Colosseum and Pantheon. Despite some changes over time, the Pantheon still provides much the same experience as it did in AD 125. Stand inside the Colosseum and you have to imagine the entire floor of the amphitheatre and ranks of seating to understand how the building worked.

There also had to be a basic definition of what constitutes a building as opposed to a simple monument. The obvious dividing line is that a building must have some form of internal space. If we consider, for example, temples and stupa in the Buddhist architectural tradition, temples may have very limited interiors but stupa have none (for people at least). Hence the only stupa mentioned in this book is Borobudur (and that only briefly) since it is of seminal importance.

What makes a building a masterwork is not so simple. In the context of this book, masterworks are what I have chosen to call the pre-eminent aesthetic achievements of architectural design. Their beauty is not, however, simply that of the two-dimensional variety that makes a façade attractive. Architecture is measured by how well it satisfies practical needs and yet transcends them to provide a concrete form for broader ideas and values appropriate to the culture that created it.

First of all, every building sits on a unique site and its relationship with that site is crucial to its success. Borromini's San Carlo alle Quattro Fontane is jammed into an unpromising scrap of land on an awkward street corner in Rome. But Borromini was undaunted, and the vibrant plasticity of the façade is outshone only by the superb modelling of the oval interior. The skill with which he transcended the limitations of his tiny site is integral to the aesthetic impact it has. The next consideration is the interrelationship of spaces or rooms – volumes – within the building. The entrance court at Sinan's Seliyme Mosque at Edirne is as beautifully modelled a volume as the colossal interior into which it leads. Moreover, the diminutive proportions of the former enhance the dramatic impact of the latter.

As all buildings are designed for human inhabitation (of one form or another) the scale and proportion of each part of the building affects the way we experience them. The perfection of the Mausoleum of the Saminids can only really be perceived when we appreciate how small it is – small enough for every single brick to play a legible part in its composition. By contrast, the impact of Hagia Sophia is dependent upon an appreciation of the engineering prowess of its colossal breadth – the same is true of Bourges Cathedral's enormous height. Moreover, the relationship between the scales of different architectural elements is of crucial concern. Classical buildings are very often carefully proportioned following a canon of accepted codes. This means that their height and breadth are carefully harmonized. The individual semi-domes and cubes that make up Santa Maria della Consolazione are not that remarkable, but placed together, each element balancing the size of its neighbours, the whole forms a powerful sculptural unit.

Of vital importance is the colour and texture of the materials used. The stave church of Borgund is a powerful evocation of Norwegian rural life over a millennium ago, tiny and delicate, crafted out of over a thousand wooden members. By contrast the great Mughal monuments used huge façades of cut stone to epic effect. Humayun's Tomb is a stark design in red sandstone interlaced with white marble, a dramatic combination of colours. Symbolism also plays a part here, for red and white represented the two highest castes in Hindu society – by welding these colours together, the Mughals were appropriating the natural authority of the caste system. The architects of the Taj Mahal, by contrast, chose only white marble for this mausoleum. At first light the building appears quite formless, a series of profiles that emerge out of the humidity. Soon it reflects the pinks and reds of dawn before emerging in full magisterial white in the searing heat of the day, before softly fading into a golden mist at sunset.

The finest buildings in the world are not evenly spread chronologically or geographically. History has been kind to some

countries, while others have placed greater emphasis upon other cultural pursuits such as literature and music; others still simply haven't had the money or materials. Moreover, the history of great architecture is not the same as architectural history. There are many buildings that have been enormously influential in the history of the subject but are not, deliberately taken out of context, that outstanding. Abbot Suger's choir at St Denis in Paris was revolutionary. In 1144 it introduced the essential elements of the architectural language of Gothic that would dominate European architecture until the turn of the 16th century. However, judged purely as a structure, it was quickly overtaken by much more powerful expressions of the same language – at Laon Cathedral and Notre-Dame in Paris. Centuries later Walter Gropius's Bauhaus was one of the first true Modernist structures, and, what was more, it was the school where Modernism was first taught. However this icon to the principles of the new design was almost immediately overtaken by a series of better buildings without the jarring acoustics and inadequate heating of the prototype.

The truth is that if the circumstances are propitious for the creation of one architectural masterpiece, they tend to be propitious for the creation of others as well. As a result masterworks have tended to come in clusters – such as the great Gothic cathedrals of the Île-de-France, the great Mughal monuments in northern India or the great Ottoman mosques in Turkey.

It is also true that while architectural history based upon a narrative favours buildings that are built of a piece by a single author, buildings like St Peter's in Rome are often considered lesser masterworks for being the product of generations of architects. Certainly French High Gothic architecture is tremendously exciting because of the clarity and integrity of a single idea, as many of France's most significant cathedrals were built in a relatively short period of time. The attraction of English Cathedrals is quite the opposite: most have been altered over many years in different styles and it is their heterogeneous appearance that is attractive. The octagon of Ely Cathedral, like the dome of Florence Cathedral, were later solutions to practical problems. Not quite happy accidents, but the harmonious amalgamation of different styles from different periods. No one today seriously looks across the Backs at Cambridge and considers the over-scaled and Gothic King's College Chapel an eyesore, as they did in the 18th century. Historical distance has given us the capacity to appreciate harmonies and juxtapositions that Fischer von Erlach would almost certainly have considered absurd.

ABOVE
**Santa Maria della Consolazione,
Todi, Italy. See pp. 188–91**

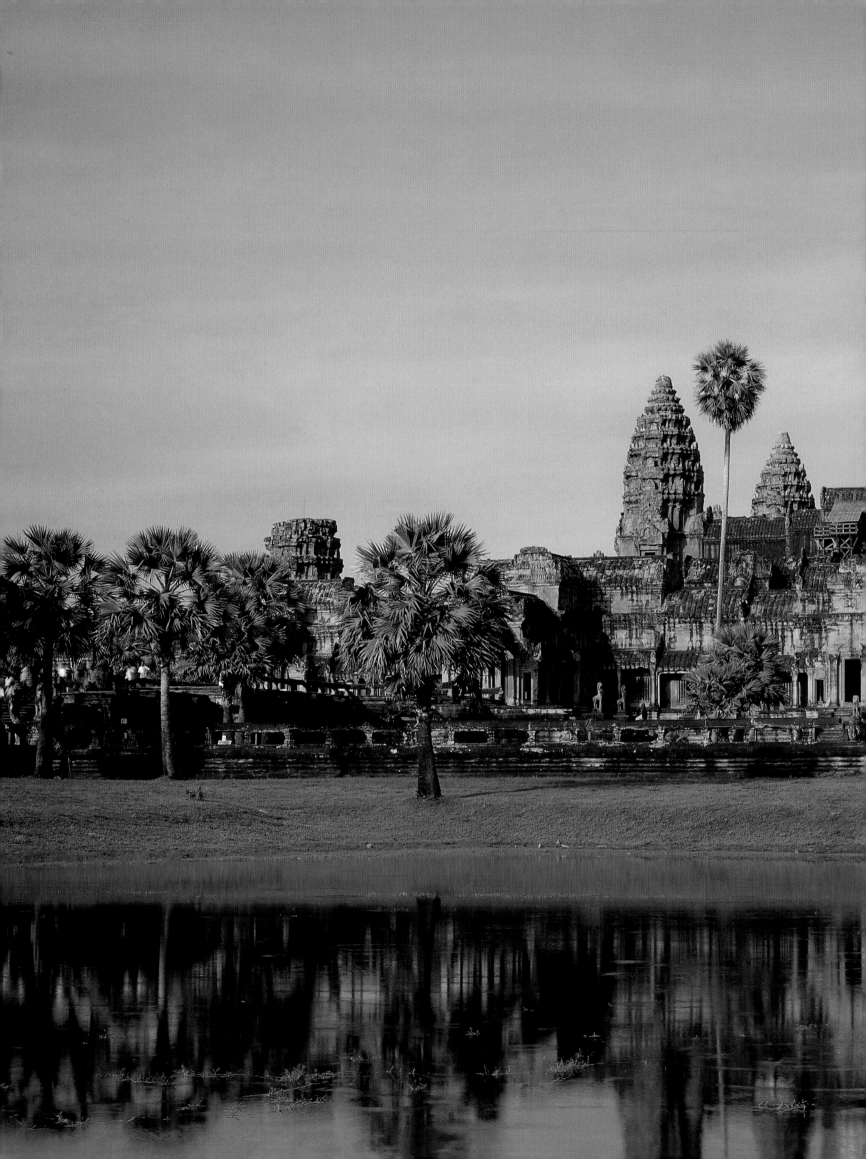

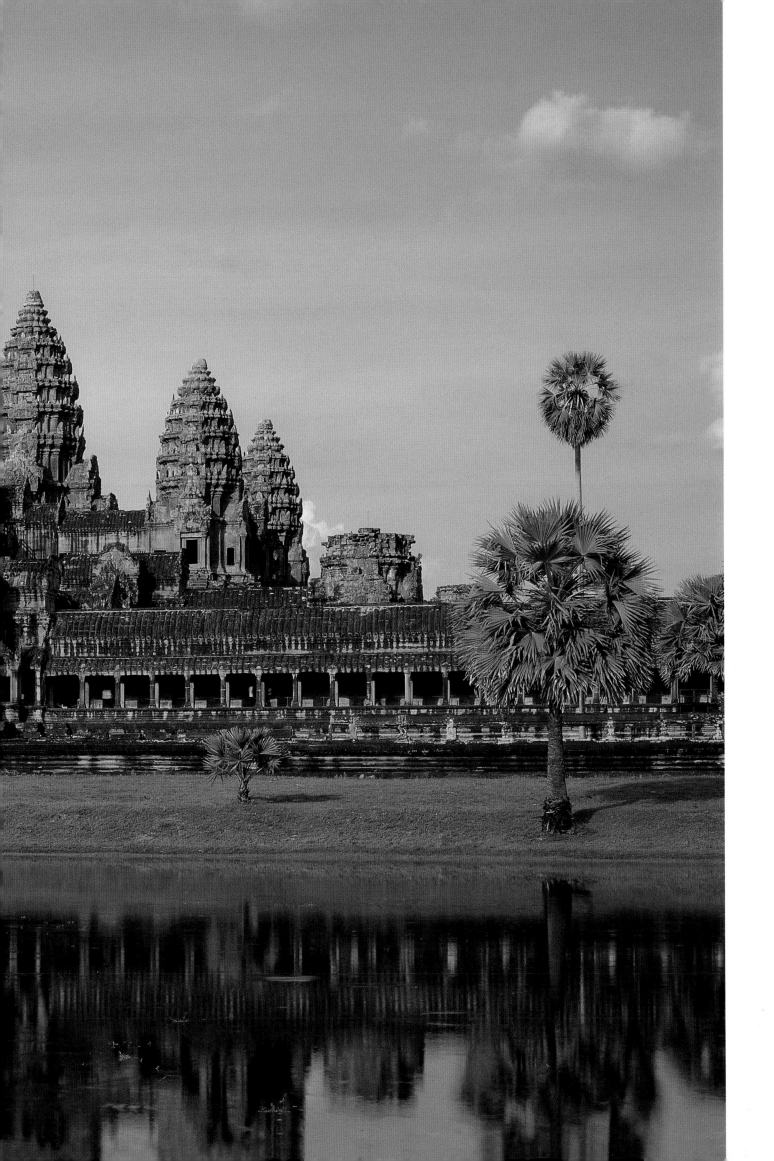

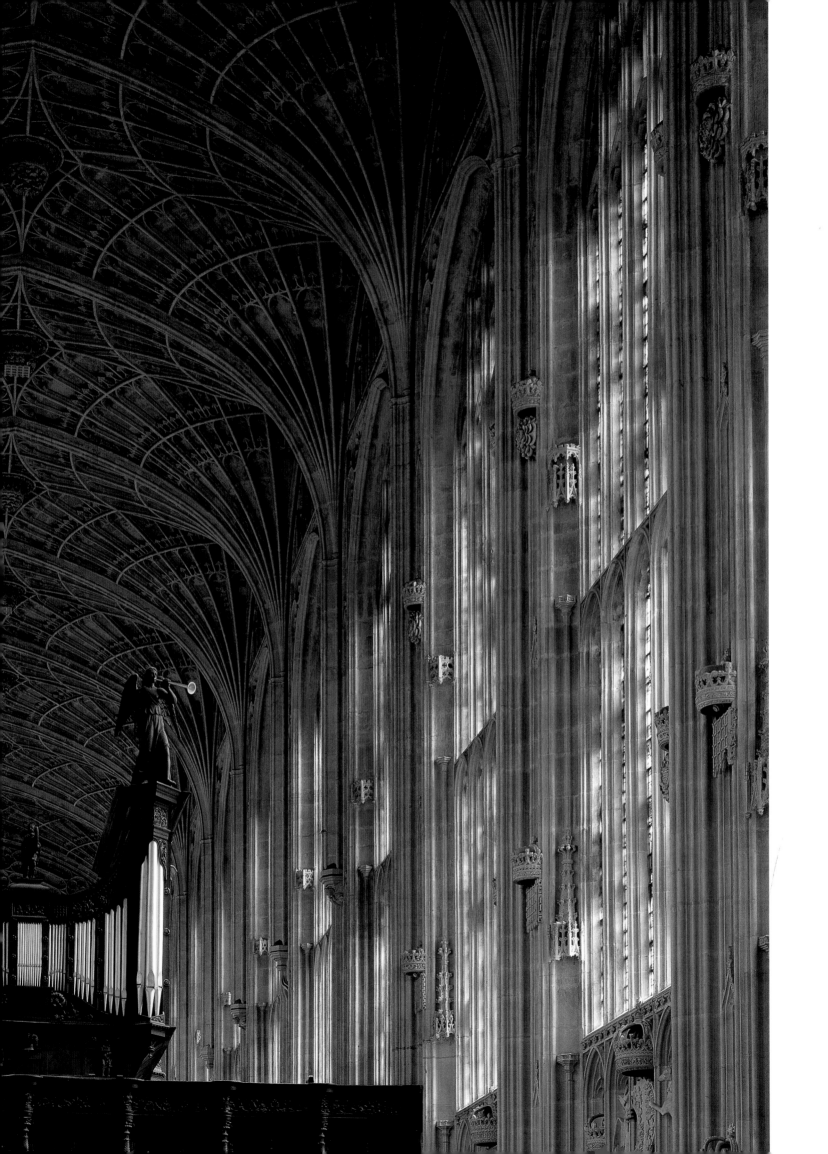

PAGES 20-21

**Angkor Wat seen from inside
the first of three compounds.**

OPPOSITE

**The chapel of King's College,
Cambridge, shows the English
Perpendicular style at its most
expressive.**

INTRODUCTION
PART ONE BEFORE 1500

Nearly all the world's major architectural traditions originally evolved
in response to the needs of religious practice. Buildings not only provided
practical places to worship in groups but also gave symbolic form to
religious values and history. The largest religions – Hinduism, Buddhism,
Islam and Christianity – each founded its own rich architectural
tradition. Periodically these influenced each other, regardless of
whether their teachings were at that time perceived as being compatible
or contradictory. The subsequent development of these traditions was
transformed by an enormous number of other factors, such as the
availability of materials and the secular requirements of the societies
they served, be they military, political or economic. Other secular
building types such as palaces and forts were important but their
architectural characteristics, such as the iwan or Gothic arch, tended
to have been pioneered in churches and mosques. And only religion
consistently justified the colossal investment of time and resources
necessary to the pursuit of aesthetic perfection.

The world's oldest major religion, Hinduism, originated in the
Indus Valley in the 3rd millennium BC. The followers of Siddhartha
Gautama, who became known as the Buddha or 'Awakened One', split
from mainstream Hinduism in the 6th century BC. Both religions spread
across the whole of Asia, and Hindu and Buddhist religious buildings
have many features in common. They involve, for example, rather
literal attempts to represent Mount Meru, the central point in Hindu
cosmology, which is believed to connect Heaven and Earth
and so provide a sacred structure by which the Gods might intervene in
the affairs of men. This representation took the form of vertical stupas
or temples, the former essentially freestanding solid monuments, the
latter providing interior spaces. This defined the temple as a sacred
architectural space, a space that should be decorated and treated in a
particular way and that was suitable for particular types of rite. Indian
Hindu temples describe the innermost space as the *garbhagriha*, or 'womb
chamber', and it is placed on the axis of the entrance, directly under the
highest spire. (This emphasis on the axis, along with an obsession with
symmetry generally, seems to be common to all religious structures.)
The subdivision of most stupas and Hindu or Buddhist temples into
three parts – a base, main body and stepped roof – corresponds to the
three realms of the universe. The base corresponds to the realm of
mortals. The central section – which in both stupas and temples contains
the sacred figure – represents the realm of the purified, a place where
he can meet with his ancestors (hence the common appearance of
statutory). The superstructure – a stepped roof and spire – is the
abode of the Gods.

Judaism formally originated when Moses led his people out of
Egypt in *c.* 1240 BC and from the first gave architecture an emblematic
function. The Old Testament gives descriptions of buildings, on occasion
even going as far as to give measurements. The most important building
in Judaism, the Temple of King Solomon, was built to house the Ark
of the Covenant. The first Temple was destroyed, and of the Second
Temple almost nothing now remains. However, certain aspects of the
Temple passed into architectural mythology – for example, Bernini's
twisted columns on the Baldacchino at St Peter's follow the Biblical
description. Other buildings, such as the Escorial in Spain, even
attempted to recreate the dimensions of the Temple as given in the
Bible, assuming that these dimensions had mystical properties.

The Islamic religion was also born in the Middle East. Established
in early 7th-century Arabia, it spread quickly throughout much of
Europe, Asia and Africa. Officially Islam requires no physical structure for
prayer, and a basic *masjid* ('place of prostration') can be as simple as lines
marked on the ground, laid out to indicate the *qibla* or direction of prayer
(towards Mecca). In practice, however, a specially constructed mosque
is preferred, particularly for congregational prayer at Friday noon, the
principal weekly service. Thus the Jami Masjid, or Friday Mosque, is
often a particularly large and significant building. Other religious building
types such as madrassas (a form of school or university) also contain
freestanding prayer-halls arranged like mosques. Such buildings also
responded, naturally enough, to their environments, and often being in
hot countries the principal place of worship is intended to be outside, with
only the focus of worship, the *qibla*, being located as part of a structure.

Unlike the Jewish and Islamic Middle East or Hindu and Buddhist
Asia, the European architectural tradition began with the polytheistic
cultures of the Ancient world prior to the establishment of monotheistic
Christianity. The architecture of Ancient Egypt, Greece and Rome
together constitute what is known as the Classical tradition, which
had enormous influence upon the architecture of Christian Europe.
The first Christian churches, simple basilicas, drew on the Greek and
Roman traditions, but also introduced new forms and plans to fit the
Christian liturgy. In time many churches also took on the form of a cross,
with transepts, recalling the Cross upon which Christ died. After the split
of the Roman Empire into East and West, a fascinating new architectural
language appeared in Byzantium. Much later on, in the high Middle
Ages, the Christian church also began to be seen as a conscious
evocation of the Heavenly Jerusalem – a place where the saved would
go after the Last Judgment. Up until 1500 all churches laid greatest
emphasis upon the altar – the place where the miracle of the Eucharist
was re-enacted. This was normally set facing east, with the priest
celebrating the Eucharist facing away from the congregation; therefore,
the main entrance, often with a grand façade and portals, was placed
in the west.

Hinduism and Buddhism spread right across Asia and their greatest monuments are scattered throughout that colossal continent. Interestingly, the most significant monuments prior to 1500 date from broadly contemporaneous civilizations. In Madhya Pradesh, in Central India, the Chandela dynasty flourished between the 9th and 12th centuries, leaving behind the temples of Khajaraho. The Khmer civilization in Cambodia was also founded in the 9th century and flourished until the 15th, when it was abandoned in the face of attacks from the neighbouring Thai kingdom of Ayutthaya. In Java dozens of religious monuments, both Hindu and Buddhist, were constructed between the beginning of the early 8th century and the mid-10th, including vast complexes such as Candi Borobudur and Candi Loro Jonggrang at Prambanan. In Burma the Buddhist civilization of Pagan was probably founded in the 9th century AD and fell in the 14th. In China, Korea and Japan during this period Buddhism mixed with indigenous religions to produce wooden temples of colossal size and complexity in a tradition that was unique to the Far East. Thus, all these countries developed their own specific interpretations of the architecture of their religion, while retaining certain key elements in common.

The Buddhist interpretation of Mount Meru is most commonly served by the stupa. Since they do not contain interior spaces they are outside the scope of this volume but the most important stupa in the world, that of Borobudur in Java (c. AD 800) is a monument of such unique value that it deserves to be mentioned. Candi Borobudur is located some 40 kilometres (25 miles) north-west of the city of Yogyakarta. Its shape is unlike a true stupa in that it doesn't have a 'cella' chamber at its centre containing a sacred shrine. Instead, it is a solid man-made hillside with the general profile of a low dome but one defined by a series of stepped walkways that run around it at nine different levels. These are divided into the classic tripartite arrangement of lower, middle and upper parts, reflecting the division of the Buddhist world. The lowest level, which contained relief sculptures that illustrated the laws of karma, is now hidden by a processional walkway. The second section of the structure is made up of five levels that have the same redented square plan but on smaller diameters as they rise. The walls of these gallery levels are covered

BELOW LEFT

The white Ananda temple (1105) seen surrounded by other temples at Pagan. Its extreme scale is tempered by the balance of horizontal and vertical lines.

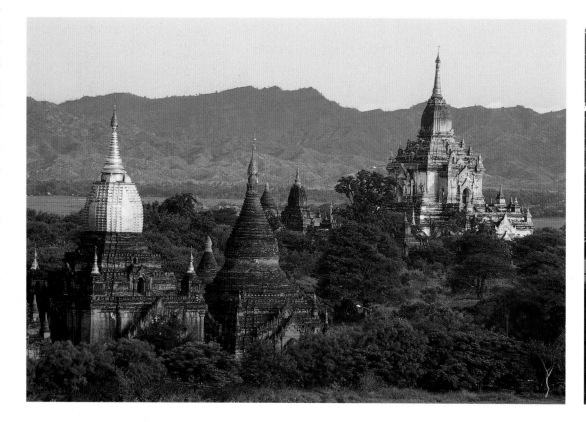

BELOW

**At Borobudur, Java (c. AD 800),
the metaphorical reference to
Mount Meru is turned into a real
hill, to be ritually circumambulated
to the summit.**

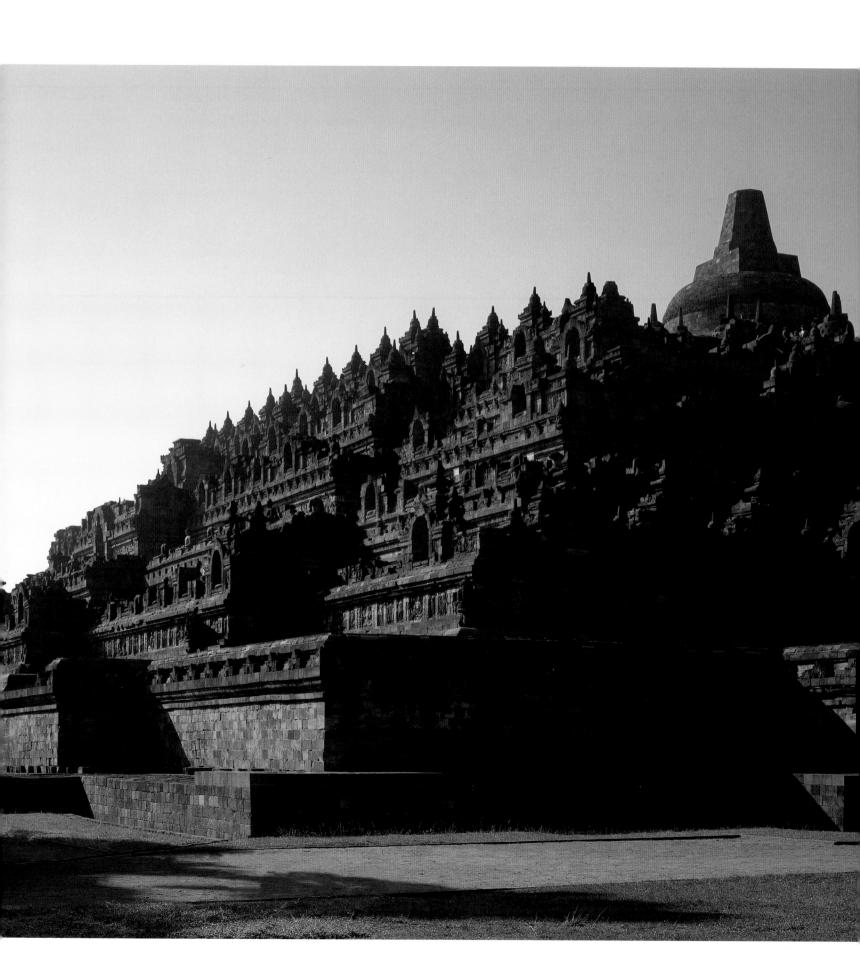

with narrative reliefs, which pilgrims would follow around the terraces to the top of the monument, immersing themselves in the Buddha's teachings. The uppermost levels differ in that they are circular in plan. All the walls are smooth and devoid of decoration and symbolize the formless world where the human spirit has transcended all physical matter. To maintain the idea of nothingness even the images of the Buddha are hidden within latticed stupas – 72 of them, arranged in circles on the terraces surrounding a larger central stupa.

The Buddhist temple is superficially similar to a stupa but functions as a place of communal rather than individual worship. It is sometimes part of a monastic complex, sometimes within the same sacred walled enclosure as other, smaller shrines. The city of Pagan was founded on a bend of the Irrawaddy River in Burma in the arid region known as *tattadessa* (the parched land). The city's official Pali name, meaning 'crusher of foes', appears in contemporary stone inscriptions. While all the residential buildings were built in wood and have today disappeared, 2,230 religious monuments survive, including 524 stupas, 415 monasteries, 31 other structures (ranging from isolated sculptures to image houses, libraries and ordination halls) and 151 unexcavated brick mounds (marking the site of collapsed structures). There are 911 temples, some of which are tiny, others of which are the size of European Gothic cathedrals and rank among the most extraordinary Buddhist temples ever built. One of the largest and most striking is the 52-metre (170-foot) high Ananda Temple, built in 1105 by King Kyanzittha. It has a cross-shaped plan centred upon four shrines that sit back-to-back around the central core of a stupa-shaped tower. It is a storehouse of sculptural information with scenes from the previous life of the Buddha and events from the historic Buddha's life. The Gawdawpalin Temple was begun by Sithu II (1174–1211) and was completed in the reign of his successor Nadaungmya. It was built to commemorate royal ancestors – *gawdawpalin* means 'throne' – and follows the traditional arrangement, with the main shrine on the upper level. Three terraces lie between the lower and

upper storeys with three more between the upper storey and the finial. However, these are so deftly proportioned that the entire edifice forms a single vertical thrust.

The Hindu interpretation of Mount Meru also involves different vertical zones, but the higher levels are less accessible to the pilgrim. Indian temples such as those at Khajuraho, in Madhya Pradesh, involve a high sacred plinth above. The building culminates in a multifaceted tower more reminiscent of a distant mountain range. Similarly the Hindu temples at Angkor in Cambodia have complex multifaceted towers. This form is ancient and while it reaches its apogee in huge complex of Angkor Wat, it was also used centuries earlier in the modest temple complex of Banteay Srei. This was consecrated in 968, the first year of the reign of Jayavarman V. It is approached by a 70-metre (230-foot) long causeway made of laterite, but its central shrine is just under 10 metres (33 feet) high while the door is a mere metre (three-and-a-half feet) tall and extremely narrow. These modest dimensions are accentuated by its beautiful colour – a consequence of the use of pink-brown sandstone in conjunction with brownish brick and laterite. The quality and profusion of the decoration is also outstanding, while the complexity of the decoration on the pediments foreshadows the great pediments decorated with narrative scenes of Angkor Wat and the later classical period of Khmer art. This classic phase was international and many similarities can be found in the work of an entirely different civilization, at Prambanan on Java.

All these surviving stone structures are products of building traditions pioneered not in stone but in wood. As a result, they employ techniques – for example, the use of flat lintels – that in some senses are not so practical in the new material. In Japan, unusually, wooden monuments themselves exist from as early as AD 677, the date of the Golden Hall at Horu-ji Temple, near Nara. In Korea, Japan and China architectural traditions in wood developed divorced from the rest of the world but originally inspired by examples from India. All countries with

The temple of Banteay Srei lies 20 kilometres (12 miles) to the north-east of Angkor and was consecrated in 968. Its pediments are richly carved with scenes from the Hindu epics.

The symmetrical perfection of the Gawdawpalin Temple (1174–1211) is enhanced by rich decoration on its upper storey where ornamented gateways to the shrines, capped by pediments with a *makara* or 'sea-monster' motif, have a wave-like shape.

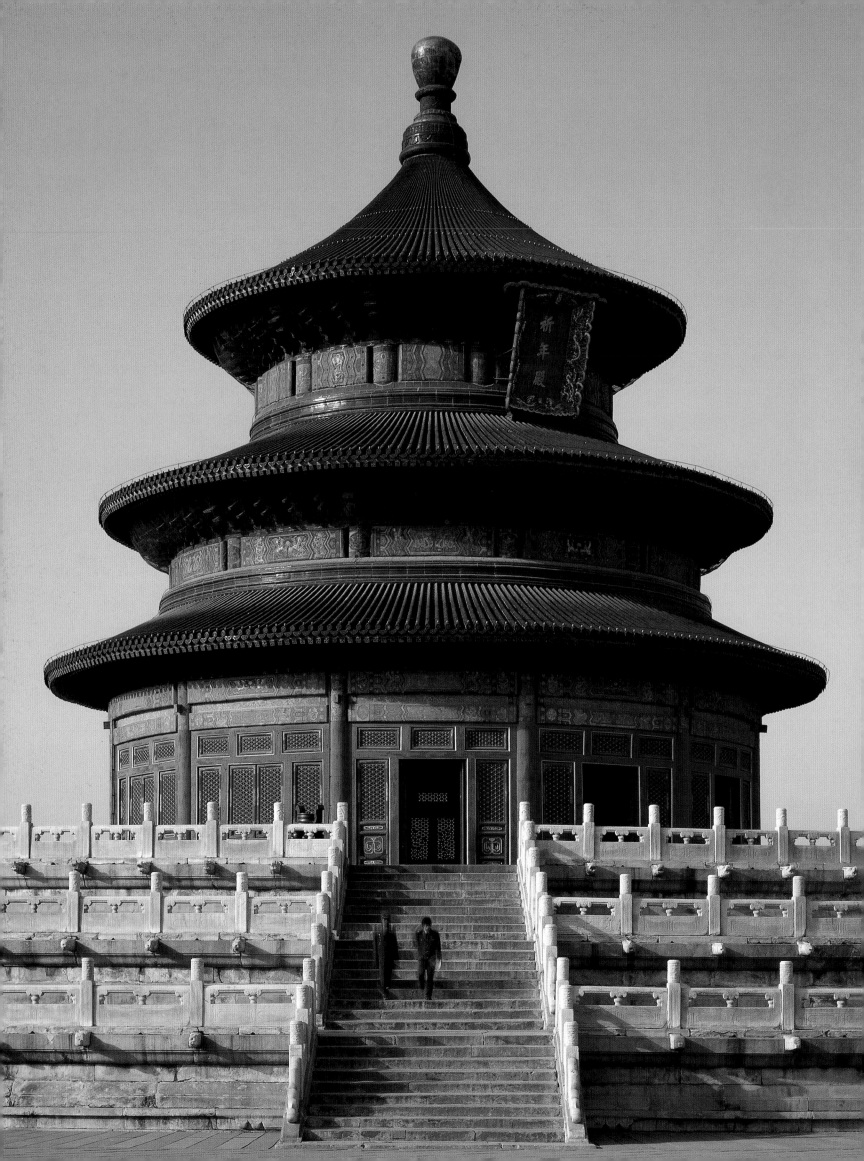

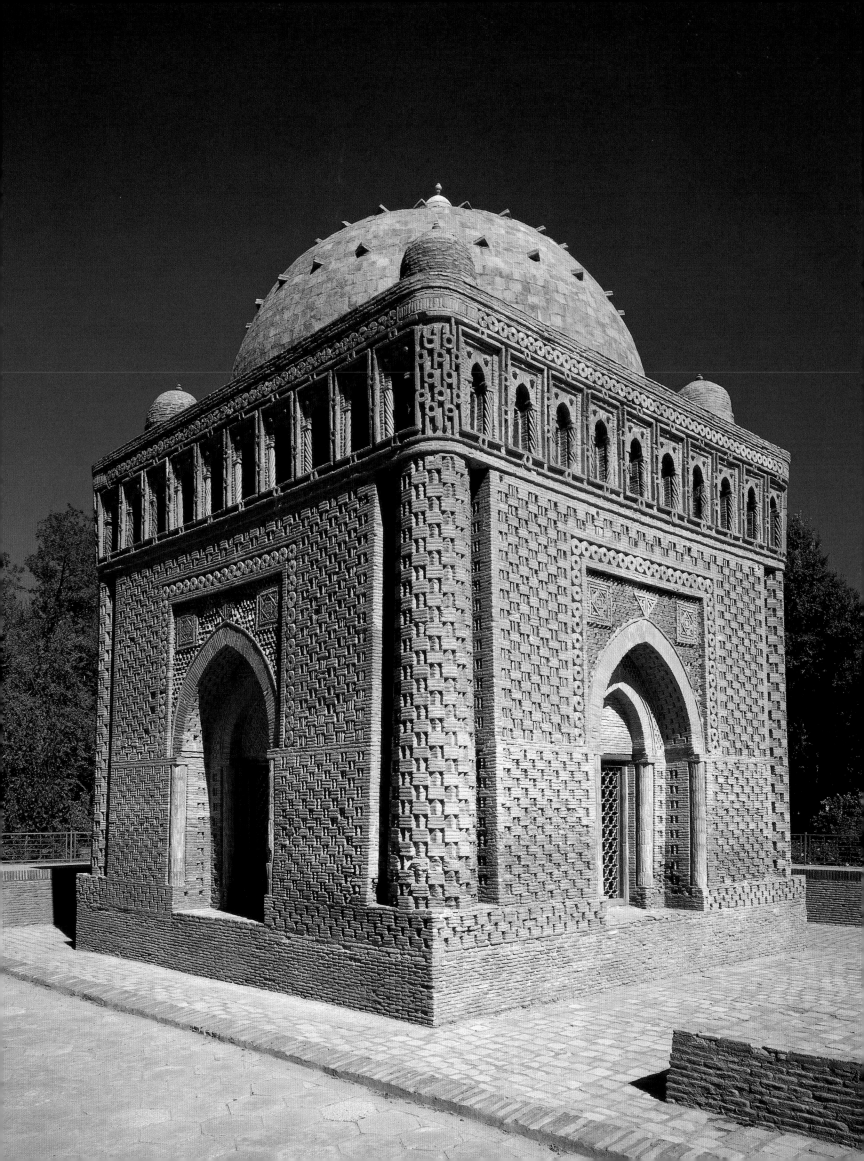

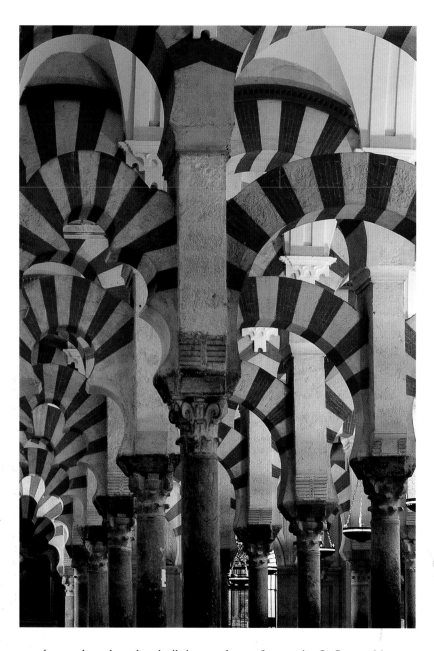

LEFT

The Great Mosque, Córdoba, begun in 785 in the capital of the Umayyad caliphate. Its horseshoe arches have alternating voussoirs of red brick and white stone, carried on antique columns.

BELOW

The Alhambra Palace, Granada, was built mainly in the 13th and 14th centuries.

PAGE 28

The pavilion called Prayer for a Prosperous New Year (Qinian Dian) is the largest structure in the Temple of Heaven (Tian Tan) complex. Originally built in the early 15th century, it has been rebuilt twice, in 1751 and 1889, after being damaged by lightning.

PAGE 29

The Mausoleum of the Samanids in Bukhara, one of the oldest examples of commemorative architecture in the Islamic world, was built by Ismail I (reigned 892–907).

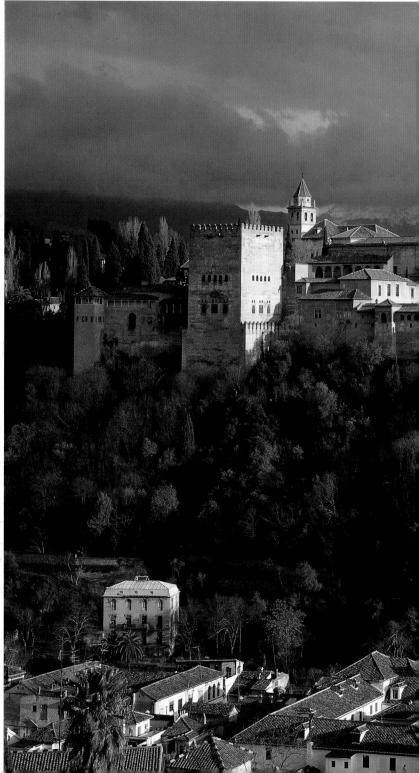

regular earthquakes, they built in wood out of necessity. In Japan this is particularly marked as little attempt was made to adapt an essentially subtropical architectural style to the rigours of the much colder climate. In China, home to a great and powerful early civilization, the vast majority of historic architecture has since been destroyed. Notable exceptions are the Forbidden City and Temple of Heaven in Beijing. Both complexes followed the design precepts dictated by Chinese cosmology to embed the emperor within the natural world. In the Temple of Heaven this function was made explicit as the site was designed as a place for the emperor to intercede on the behalf of his people and make sacrifices to the gods. Originally built in 1420, shortly after the refoundation of Beijing as the imperial capital, its wooden pavilions have been rebuilt subsequently in identical fashion. The largest structure, called the 'Prayer for a Prosperous New Year', remains one of the most perfect of all wooden buildings, and everything from the number of pillars to the shape of the eaves had a specific symbolic purpose.

In AD 622 when the Prophet Muhammad left Mecca to found the first Islamic state in Medina he had only a handful of followers. By 750, Arab Muslim armies had invaded Spain and southern France and reached the Indus River. Islam therefore grew not only as a faith but also as an entire political and cultural system.

While the vast majority of truly great Islamic buildings are located in the Middle East or on the Indian subcontinent, several of

the earliest masterpieces can be found in Spain. Home for hundreds of years to powerful Moorish dynasties, the scale and ambition, as well as learning, of these dynasties can be gauged from a number of significant Islamic buildings that survive, including the Great Mosque (Mezquita) at Córdoba and, later, the Alhambra at Granada. At Córdoba the first phase of the Great Mosque was built in 785 by Abd al-Rahman I and extended in 836 by Abd al-Rahman II. Muhammad I (reigned 852–86) added a *maqsra* and completed the building's exterior. His doorways have a blind horseshoe arch above an arched lintel and are framed with niches and blind arcades that often exhibit complex interlaced or polylobed arches. Each plane of this complex composition is covered with a different texture or relief, making the relationship between parts of the building difficult to read. Abd al-Rahman III went on to add a new, larger minaret to the mosque and rebuilt its courtyard, and in 961–6 al-Hakam II extended the prayer-hall by 12 bays and added an

elaborately domed *maqsra*. This delicate process of development of was wrecked in the 16th century by the clumsy imposition of a Christian cathedral in the middle of the building. It is hard not to agree with Charles V who commented upon seeing the new cathedral that, 'You have built what you or others might have built anywhere, but you have destroyed something that was unique in the world.'

The most important Islamic buildings to survive in Spain from the Middle Ages are the palaces of the Alhambra and Generalife built during the Nasrid period (1232–1492). In 1238 the first Nasrid sultan, Muhammad I, organized the supply of water by canal to the existing fortification thus making possible the establishment of an entire royal city. This was expanded into the walled Alhambra City by his descendents, comprising the Alcazaba fortress, palaces, mansions, mosques, baths, an industrial zone with tanneries, a mint, kilns, workshops, and royal gardens – the Generalife.

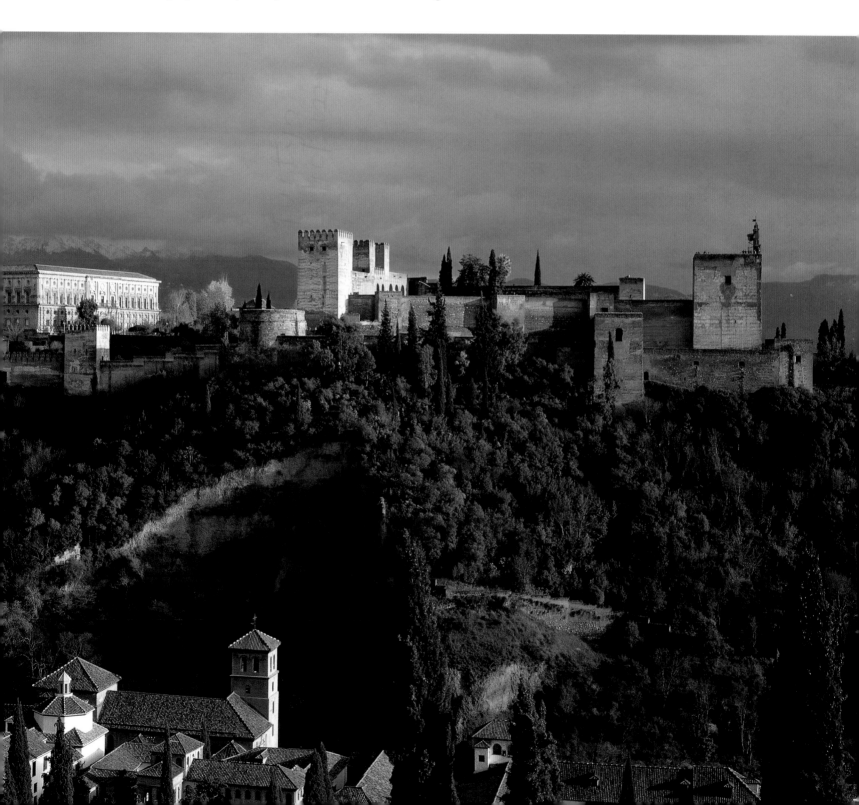

In Iran and Central Asia the precise history of the early Islamic dynasties is more difficult to determine. The native Iranian Samanids (819–1005), Arab Tahirids (821–73) and Saffarids (867–963) exercised control over large areas without clearly defined borders. Of these the Samanid dynasty, founded by a converted Zoroastrian noble from Balkh, left the finest buildings. The founder's four grandsons served the Abbasid Caliph al-Ma'mun (reigned 813–33) and were rewarded with governorships in Transoxiana. By 875 they controlled the entire province.

The most successful and astute of these rulers was Ismail I (reigned 892–907), and by the time of his death the empire extended from the borders of India to not far from Baghdad. He left behind one of the great surviving early Islamic buildings and one of the earliest examples of commemorative architecture in the Islamic world, the Mausoleum of the Samanids (see p. 29). It lies to the west of medieval Bukhara and is thought to have been built to commemorate his father Nasr I, who had been governor of Samarkand. It is one of the finest brick buildings in the world. The mass is very simple, its proportions unique but harmonious. It is a small cube, almost 11 metres (36 feet) in each direction with thick walls pierced by four arches. The building is roofed by a dome with smaller domes at the corners. Its four façades are identical. However, this simple form is offset with decoration of enormous subtlety and consummate mastery. All the walls and corner columns are made up of a lattice of bricks in a chequerboard pattern. Every brick is both an element in the structure and a part of the decorative design.

The Saminids re-established Iranian political autonomy and its cultural identity. At the same time they transformed the Central Asian cities of Bukhara and Samarkand into major centres of learning and civilization where Persian culture flourished. However, right across Central Asia the devastations of the Mongol conquests in the mid-13th century brought major building to a virtual halt, and Bukhara and Samarkand were both sacked in 1220. Ironically it was Timur (known in the West as Tamerlane), a nomadic chieftan who sought the authority of the Mongols by marrying a direct descendent of Chingiz Khan, who started the rebuilding process. He transformed his tribal organization into a world empire and used architecture as a powerful tool to bolster his authority. He made the cities of Samarkand and Bukhara the centre of his empire, and embellished them with splendid buildings. These buildings, reflecting the scale of his ambition, were deliberately mighty, and provided inspiration to Islamic rulers from Turkey to India via either direct knowledge of the buildings themselves, or else via the dissemination of drawings of the buildings and the emigration of the architects and craftsmen who worked on them. The centres of excellence that the Timurid cities formed made it possible to systematize a dynastic style of architecture. Subsequent Islamic dynasties such as the Safavids, Ottomans and Mughals all emulated Timurid architectural forms, but also sought to find within them an imperial ideal, even if their interpretations of that ideal ranged widely.

European architecture had as its forerunners the ancient cultures of Mesopotamia and Egypt, but it was in Ancient Greece that the

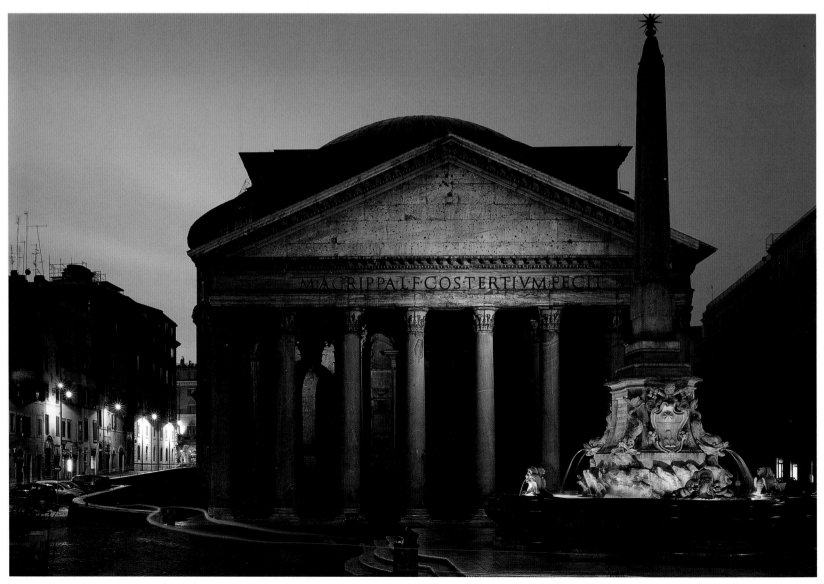

Classical orders – Doric, Ionic, Corinthian – were born and subsequently integrated into a tightly rational geometric system. The supreme example of the application of these orders is the Parthenon in Athens, but it is not the only one – indeed, it takes a skilled eye to distinguish it from a dozen other Doric temples. For the Greeks, it was the formula that mattered.

When the Romans conquered Greece they inherited the same vocabulary of forms, but used them in a variety of new ways. In the Pantheon in Rome they utilized concrete as a building material; they experimented with the arch and the stone vault and they invented the dome as a boldly innovative motif. The roof of the Pantheon is one of the most revolutionary structures in the history of architecture. It extended the possibilities of engineering in ways that had no precedent and for several centuries no successors. Built in the early 2nd century AD under the emperors Trajan and Hadrian, it was dedicated to 'all the gods', or the seven planetary deities, and took the form of a rotunda representing the cosmos. The main material was brick, but the domical vault was of concrete and light was admitted through a central oculus.

The Christian faith grew up in the shadow of the Roman Empire and by AD 391 had become its official religion. However, after the empire's fall in the 5th century AD the Christian architectural tradition diverged from Classical precedent. After the division of the Roman Empire by Constantine there had been two developing architectural traditions. Constantine founded Constantinople (324–330) on the site of the small town of Byzantion. The inhabitants would have thought of themselves as Romans but the eastern provinces of the Roman Empire took on an independent character with a distinct architecture. This new style, today called Byzantine, absorbed influences from Asia and reached its apogee under Justinian in the 6th century in the construction of the Hagia Sophia. It also left a few solitary offspring in the West, such as St Mark's, Venice. St Mark's was always a unique building in western Europe, partly because of its architectural form and partly because of the extraordinary richness of its mosaic decoration. Both are due to the fact that Venice, a commercial empire founded on sea power, looked east, towards Constantinople, rather than west. The design, and perhaps also the architect, came from Constantinople – the model on which it was based, specifically, was Justinian's much older Church of the Holy Apostles in Constantinople, which was destroyed after the Turkish conquest. Begun in 1063 and consecrated in 1094, St Mark's has a Greek-cross plan: four equal arms form the nave, transepts and chancel, with domes over the arms and the crossing. The chancel ends in an apse and around the nave and transepts, outside the domes, run aisles. Originally there were galleries over the aisles but these were later removed, making the aisles two-storeyed (although there are narrow balustraded walkways at the upper level above the arcades). From the main west door, the visitor enters an atrium or narthex, where the subjects of the dome mosaics are drawn from the Old Testament: the Creation, Adam and Eve, the Fall, Cain and Abel, Noah and the Flood, the Tower of Babel, the stories of Abraham and Joseph, and finally the story of Moses and the Exodus.

In the western Roman Empire, major building works ceased altogether until the reign of Charlemagne (768–814), a Frankish king who expanded his kingdom from Rome to the English Channel and northwards beyond the River Elbe. Charlemagne consciously conceived of his empire as not only a political entity but also as the cultural recreation of the Roman Empire. He sought to do this by reviving

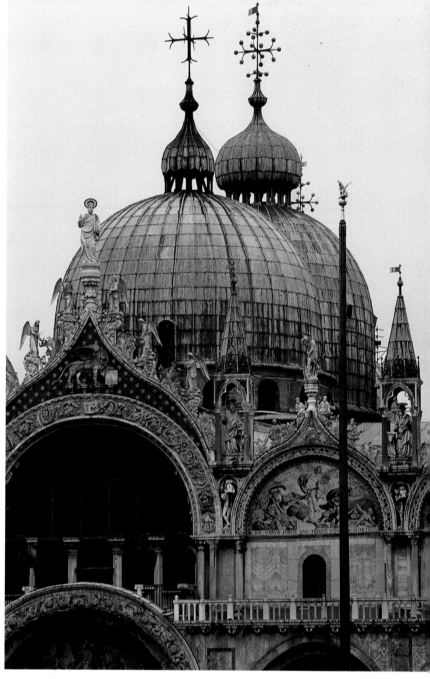

ABOVE

The inspiration for the predominantly 11th-century basilica of St Mark in Venice was Byzantium, specifically Justinian's Church of the Holy Apostles in Constantinople.

OPPOSITE

The Pantheon is a remarkable survivor. Erected on the Campus Martius between c. AD 118 and 125, it was converted into a church in AD 609. The dome is made from concrete.

the culture of Ancient Rome – specifically that of Constantine the Great, the first Christian emperor. Crowned emperor in Rome by Pope Leo III in 800, Charlemagne drew Christian scholars to his court, establishing high standards of Classical and Biblical studies for the first time since Constantine. His imposition of the Roman liturgy across his German territories generated the need for new buildings, including imperial residences, cathedrals and monasteries. A few extraordinary buildings from this period survive, the most significant being the chapel of Charlemagne's own palace at Aachen. The Palatine Chapel would prove to be the most commonly imitated building of the early Middle Ages and inspired a new building type, the centralized two-storey chapel known as the Doppelkapelle.

Charlemagne provided Europe with political stability and the rule of law after centuries of unrest. His descendents would augment this hegemony to establish the Holy Roman Empire and during the 11th century it would play a major part in the development of the first major pan-European building programme since the Roman Empire. It also occasioned the creation of a new architectural style whose name suggests the intention, if not the practice, of following Ancient Roman architecture as its model: the Romanesque. The buildings of this style are a product of various factors. The creation of the Holy Roman Empire and the empire of the Norman kings created cross-European political entities. The Norman kings controlled not only Normandy, but also England, Sicily and, to a lesser extent, the Holy Land. They embraced the use of the new style, particularly in England after the Conquest in 1066 (today the Romanesque in England is frequently referred to as the 'Norman' style). The Romanesque also reflected the popularity of the pilgrimage, where Christians travelled across Christendom taking ideas (as well as drawings and experiences) with them, and the importance of the papacy. In the case of the papacy, bureaucratic requirements ensured a continuous flow of emissaries across western Christendom to resolve even trivial matters and this ensured the transportation of ideas about architecture.

Romanesque architecture has no single definitive characteristic, though the round-headed arch is commonly found. It is most easily understood as involving a distinct emphasis on the articulation of a building into separate architectural elements. Everything from the most important structural elements to the smallest decorative detail are easy to identify separately and can also be seen to be subordinate to the broader idea of the building.

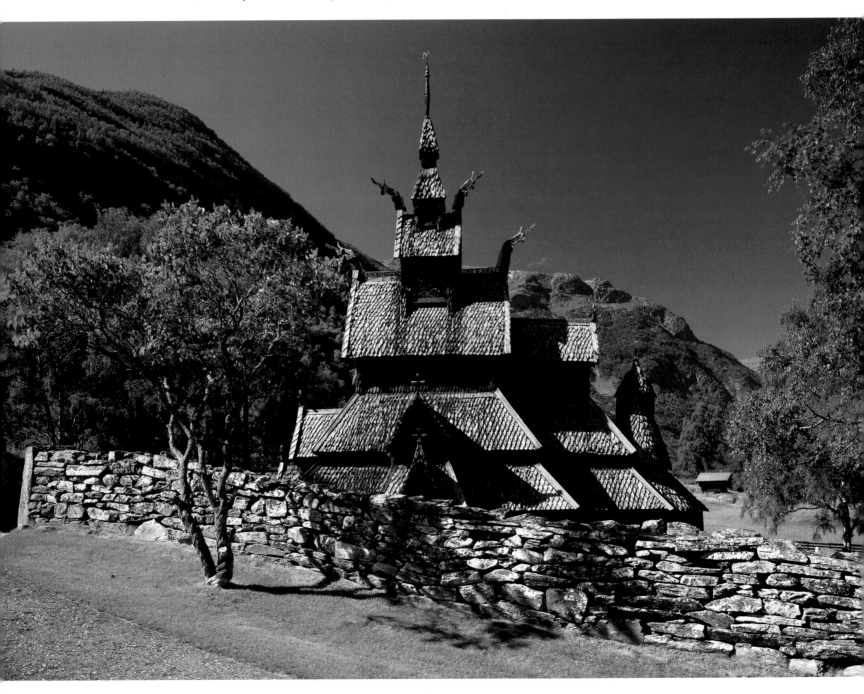

OPPOSITE

Borgund in Norway is
the only stave church to
retain its original exterior
completely unaltered. Built
c. 1150 the form of the nave
is a development of the
Romanesque basilica, though
its carved dragon-head
finials suggest the influence
of earlier pre-Christian
traditions.

RIGHT

The Romanesque nave of
Speyer Cathedral had a
pioneering groin vault, the
first in Germany and, with
a height of 33 metres (108
feet) and span of 14 metres
(46 feet), one of the largest
in Europe. Each bay of the
vault topped two aisle bays.
Every second pier was given
additional support by a
stepped projection fronted
by a massive three-quarter
column.

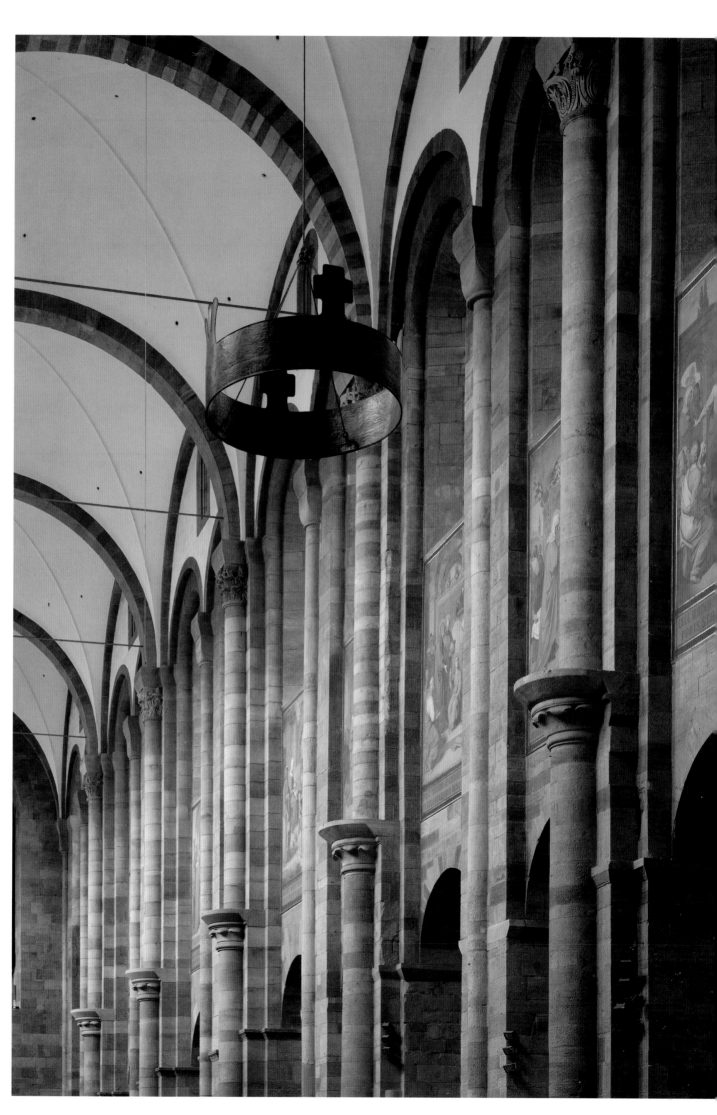

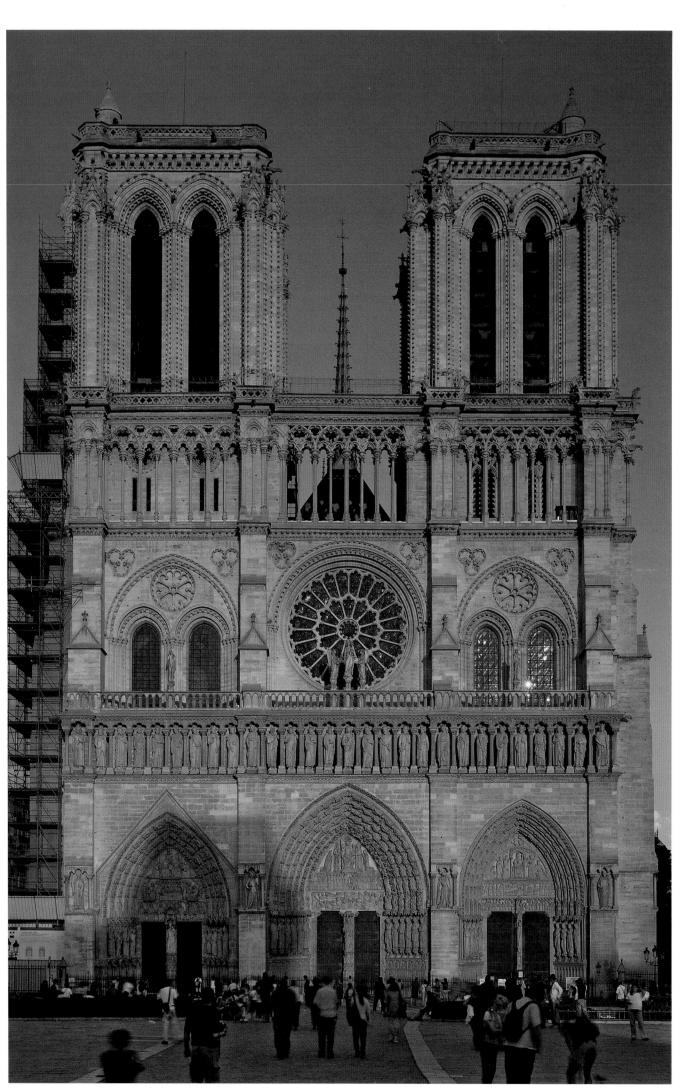

The influence of the Romanesque was to be felt right across Europe from Sicily to Scandinavia. In each case the new style mixed with native features. Speyer Cathedral, in the heart of the Holy Roman Empire, was built in the 11th century by the Salian dynasty. They employed the Romanesque style as a conscious reference to the imperial tradition of Ancient Rome, but the building remains in many ways very un-Classical. The arcade is supported on piers rather than columns, which rise the complete height of the building to carry arches over clearstorey windows. This creates a giant order that gives vertical rhythm to the length of the nave. At the other end of the scale, the remote wooden stave churches of Norway mix Romanesque features with pagan references. Borgund, built *c.* 1150, is the finest of a handful of survivors from many hundreds. It rests upon a rectangle of horizontal beams. The vertical posts (staves) stand on these beams, linked by cross-braces. In plan it consists of a tall central space – the nave – and an extra room for the chancel. On the outside, however, the dragon finials that adorn its gable ends evoke pre-Christian traditions.

Unlike Romanesque architecture, where varied regional types appeared at a similar time, the finest Gothic buildings have a clear genealogy derived from an innovative series of structures built in the Île-de-France during the 12th century. The phrase 'Gothic' was originally coined during the Renaissance by Classical architects as

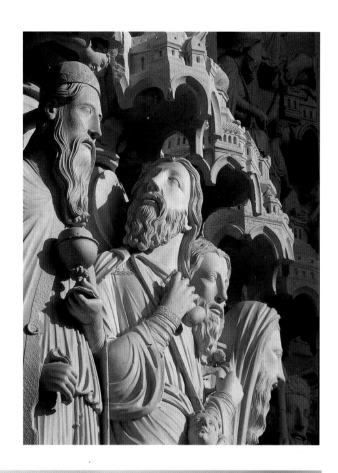

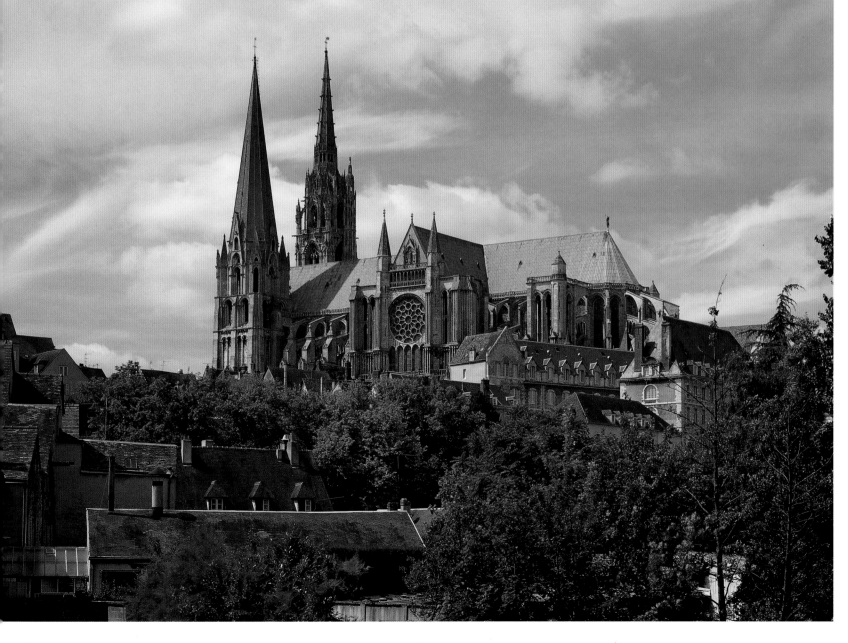

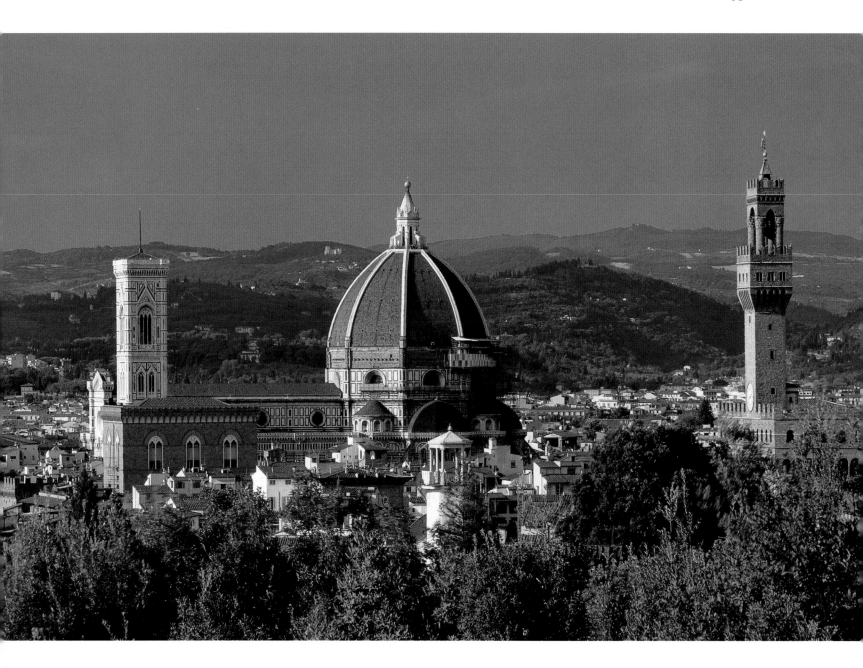

a pejorative description of these northern European buildings
– a reference to the Goths who sacked Rome in the 5th century AD. Today,
more specifically, it refers to those structures that employed the pointed
arch, the rib-vault and the flying buttress to create a wholly original and
impressive series of churches and cathedrals. They are
all (except Bourges) cruciform in plan, with a nave and aisles, transepts
meeting at the crossing and an eastern choir. Most of them have façades
with two towers. The earliest examples had a four-storey internal
elevation (that is, an arcade, gallery, triforium and clearstorey)
and sexpartite vaulting; later this gave way to three storeys and
a quadripartite vault. The two outstanding cathedrals from the first phase
are those of Laon and Notre-Dame in Paris. Begun in 1163, the 33-metre
(108-foot) high nave of Notre-Dame suited the aspirations of what was
then the most important city in Christendom. The walls are in most places
only a metre thick, indicating the scale of the technical achievement the
building represents.

Traditionally the great French churches of around 1190–1230
– Chartres, Reims, Amiens and Bourges – are considered the highpoint
of Gothic architecture. This view regards the greater homogeneity of
the later Rayonnant phase as a symptom of decline. Perhaps this is due
as much as anything else to the Modernist preference for the products
of 'primitive' as opposed to 'classic' periods of art. Also it cannot be

ABOVE

**The Italian Gothic cathedral of
Florence was begun about 1300
by the master-mason Arnolfo di
Cambio who had conceived of an
octagonal crossing like that of Ely.
However only Filippo Brunelleschi
in 1419 worked out exactly how to
roof it.**

OPPOSITE

**Sitting on a limestone ridge,
Lincoln Cathedral is visible from far
away. The lower parts of the west
towers are Romanesque, but the
rest of the cathedral is a product
of the 13th-century, with some
14th-century additions. The central
tower, some 83 metres (271 feet)
tall, once carried an enormous
timber spire, but it came down
in a storm in 1548.**

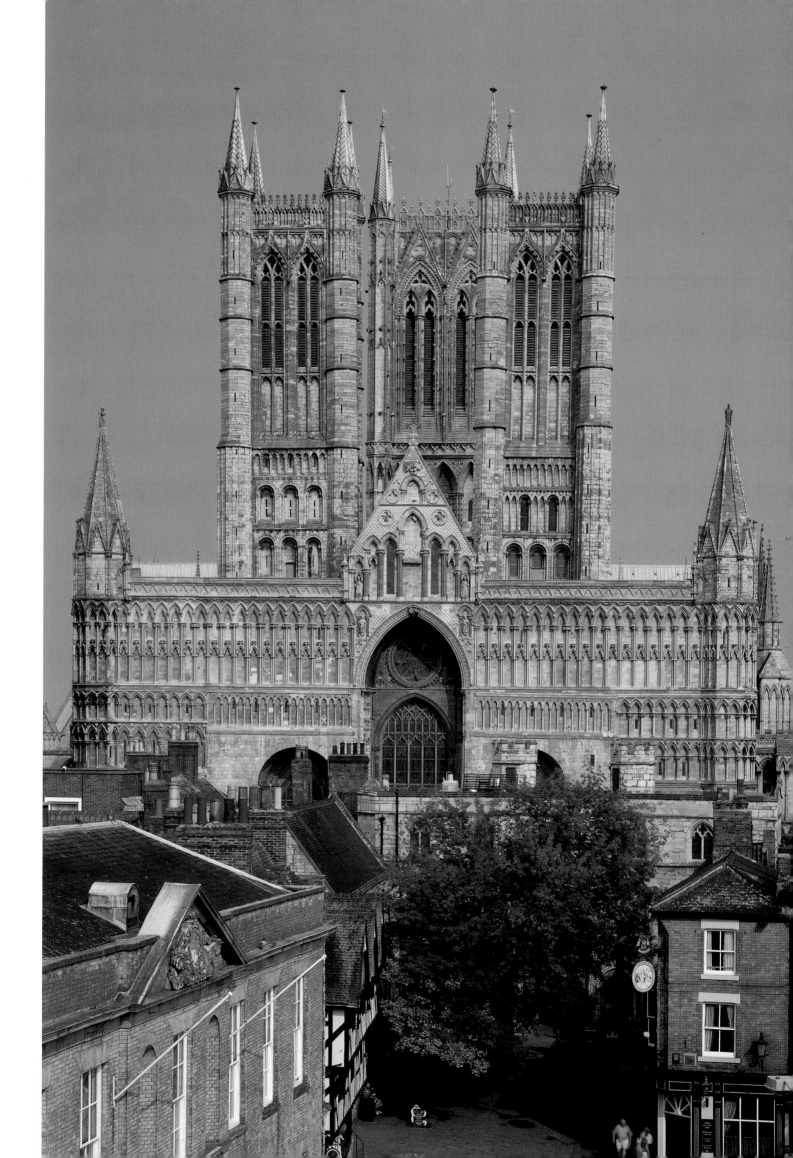

accidental that the finest Rayonnant building of all – Cologne Cathedral – was built outside France altogether. However, there are many genuinely extraordinary features common to buildings of this generation.

The cathedral at Chartres is conceived as a pure container for sculpture and stained glass. Begun in 1194, it reduces the elevation to three storeys, allowing the maximum space for the rich glass, most of which it still retains. For the first time the flying buttress was used consistently to raise the heights of the nave to unprecedented levels. These changes were facilitated by the increased standardization of elements in the workshops. The building of the majority of the cathedral in 25 years is testimony to their success. Not only did the result allow for a profusion of glass but also a huge array of sculpture. The figures at Chartres were sculpted in a taut academic style in which the characters show no emotion (unlike those at Reims) but instead form part of a complex didactic display. Those of the transepts in particular rank among the finest of all Gothic sculpture.

The three-storey internal elevation of Chartres was copied at Reims and Amiens and would form the basis of the later Rayonnant style. This style, which appeared in the mid-13th century, placed ever greater emphasis on the display of glass and sculpture, and in this window tracery was key. Cologne Cathedral was begun by French architects in 1248 but only the choir was completed during the Middle Ages. The building was not entirely finished until the 19th century but thanks to the survival of the original drawings the whole structure displays the same artistic intention.

As Gothic architecture spread beyond France it developed in different ways. The German architect, Peter Parler, took his experience of Rayonnant architecture in the Rhineland to Bohemia, where he oversaw the construction of St Vitus's Cathedral in Prague. This work was continued by his sons, Wenzel and Johann, who were the Masters of Works in 1397 and 1398, respectively. Johann is also credited with having a major hand in the design of St Barbara, Kutná Hora.

The first English cathedral to embrace the Gothic style was Canterbury, where French architect William of Sens rebuilt the choir. However, it seems that during the 13th century a new generation of native architects took over the design of cathedrals, in the process taking the Gothic architectural language in a different direction. English cathedrals place much greater emphasis on longitudinal development and have naves that are much lower, but often longer, than their French counterparts. They also tend to employ thick-wall, rather than thin-wall, construction and are less concerned to have a great western portal. The best English Gothic cathedrals – Canterbury, Lincoln and Wells – are each highly individual and while the French cathedrals are today often as their original architects intended them, the English Gothic cathedrals have all been much altered. Lincoln, begun in 1192, is the most peculiar of all, and in many respects found no imitators. The patron (St Hugh) and the architect (Geoffrey de Noiers) initiated a series of innovations that make the building a highly exciting experiment. In particular, the choir was vaulted in a bizarre asymmetrical way (known to architectural historians as the 'crazy vault'). In the next century the idea was brought

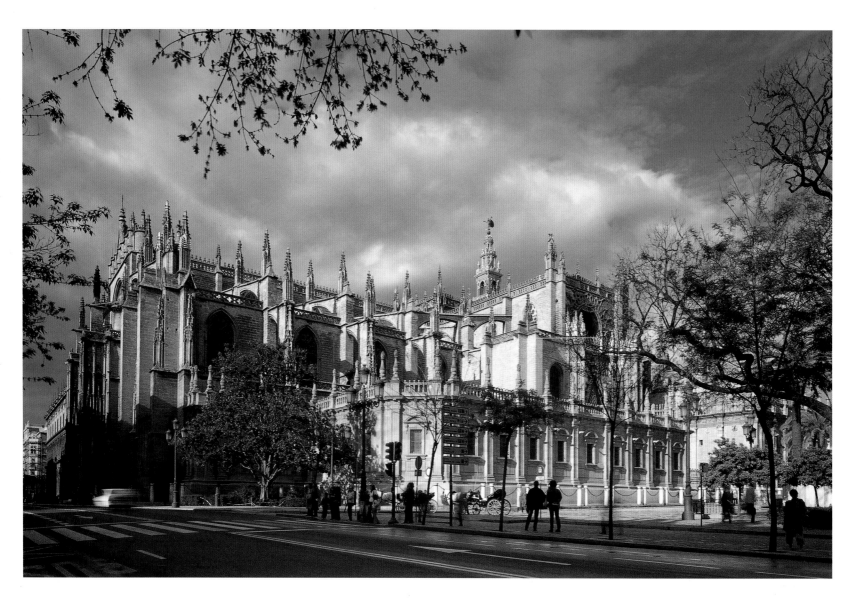

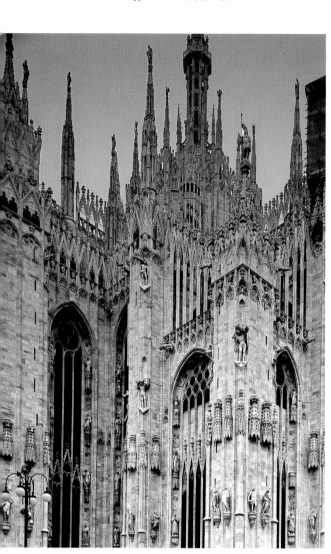

ABOVE

**Milan Cathedral is quite unlike any
other Italian cathedral since it was
built in the northern European
Gothic style. It was designed in
the 1390s but completed centuries
afterwards.**

RIGHT

**Cologne Cathedral is the finest
example of the Rayonnant style
of Gothic normally associated
with France. Its west front was
completed in the 19th century
according to a design from *c.* 1300.**

OPPOSITE

**Started in 1402 but only finished
in 1518, Seville Cathedral is the
largest medieval church anywhere.
Double side aisles give it a low-
slung appearance.**

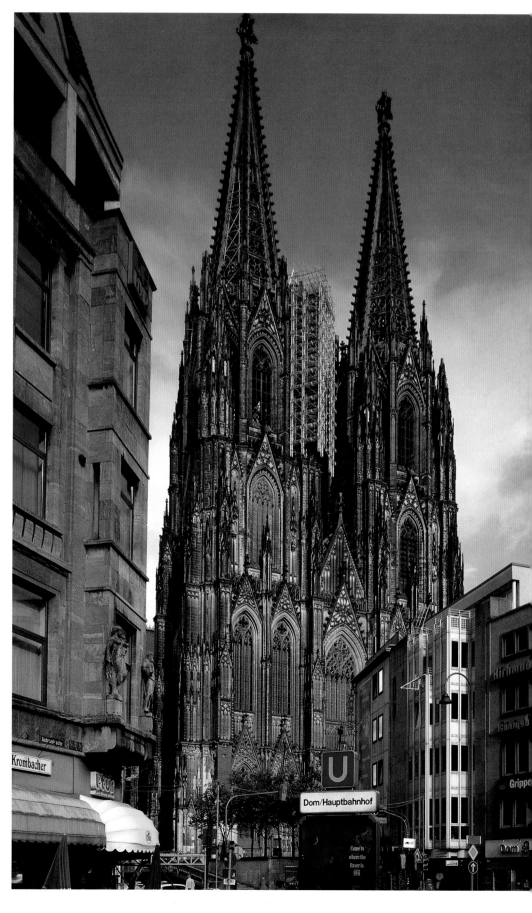

BELOW

The nave of Ulm Minster is perhaps the greatest example of the German device of a single western tower. The original drawings, by Mathäus Böblinger of about 1480, were discovered in the 19th century and used to complete the tower.

RIGHT

St Vitus Cathedral, Prague, was started by a Frenchman, Matthew of Arras, but in 1356 was transformed by the 23-year-old German architect Peter Parler.

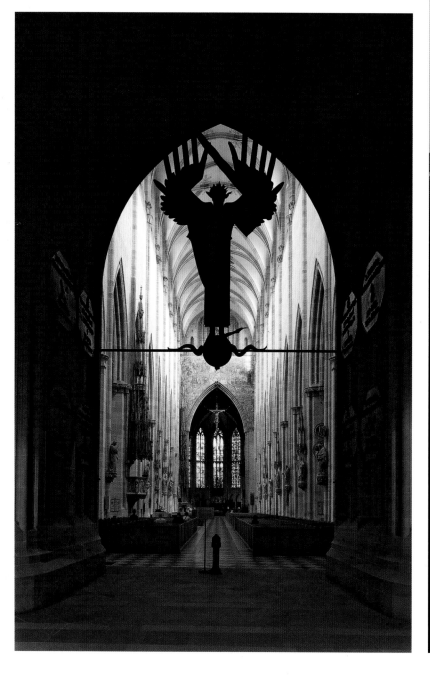

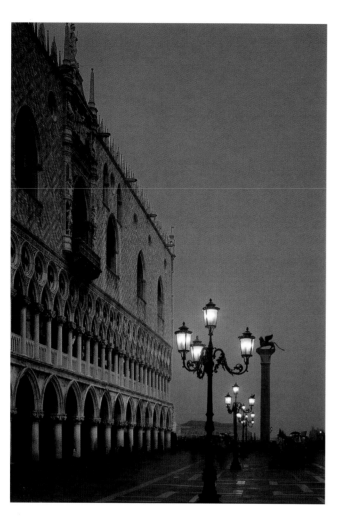

LEFT AND BELOW

Some of the finest examples of medieval secular architecture can be found in the mercantile city of Venice. The Doge's Palace (left, begun in 1343) forms a centrepiece of the state beside St Mark's and the Ca' d'Oro (below, 1423), a private palace on the Grand Canal.

OPPOSITE

St Barbara at Kutná Hora. Begun by Johann Parler in 1388, work was interrupted by the Hussite Wars and it was not completed until the 16th century when the three distinctive tent-like roofs were added by the outstanding late Gothic architect Benedikt Reid.

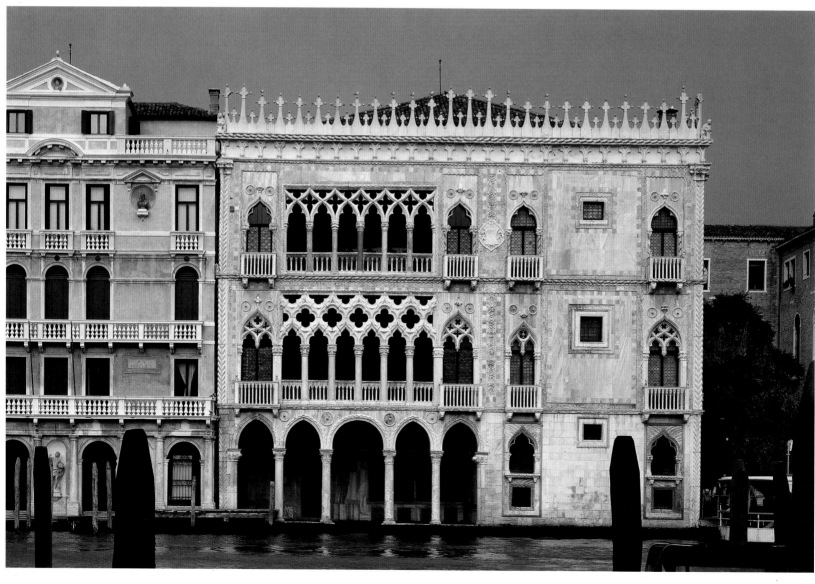

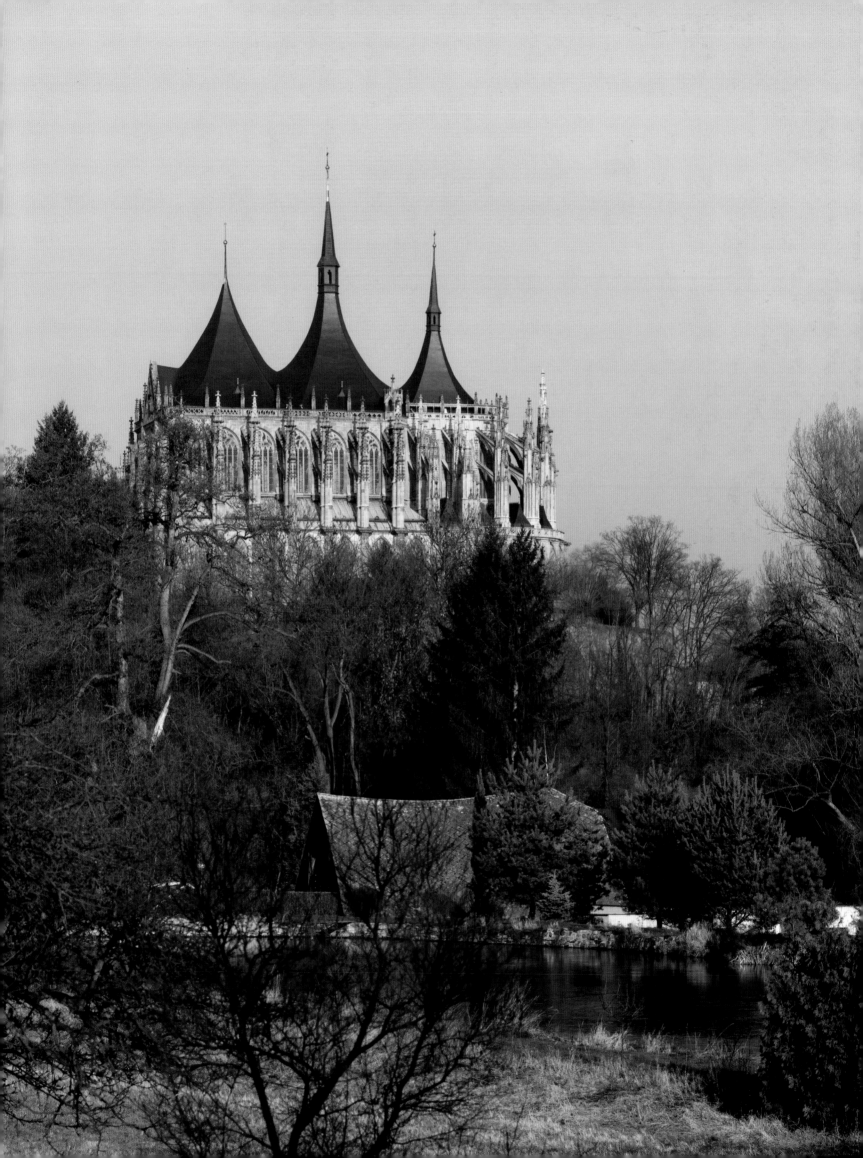

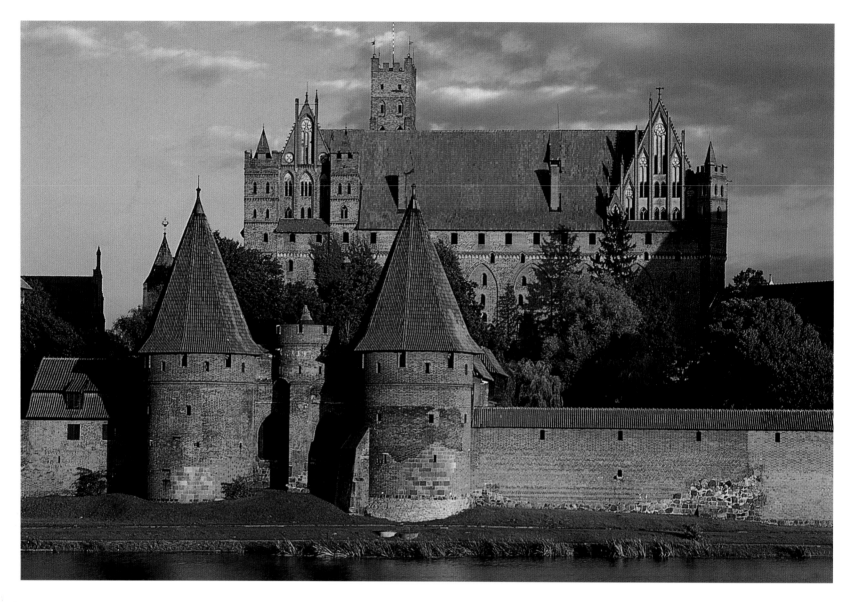

under control in the nave, leading to a new development (tierceron vaulting) and including the first ridge-rib – a rib running the whole length of the building.

Italian Gothic is quite unlike that north of the Alps, and to those who find a northern Gothic cathedral a moving and sublime experience, it is a disappointment. A few exceptions apart, there are no soaring vertical shafts ending in intricate rib-vaults, no mysterious vistas or daring evocations of infinity. Space is rational and measured. The nave of Florence Cathedral is divided into just four bays, and instead of flying buttresses, which are normally used to conceal the way the vault is supported, it has tie-beams holding it together, a mundane solution that would have been anathema to a French master mason. Even so, the space under the dome, an open octagon on a vast scale (made to seem more vast by apsidal transept-ends and chancel) is something that no northern architect would have dreamed of. The cathedral was begun about 1300 by the master mason Arnolfo di Cambio who conceived an octagonal dome but did not know how to build it. That was eventually solved by Filippo Brunelleschi in 1419. Like many Italian medieval churches, the west front was left unfinished for over 400 years and only built between 1875 and 1887. But the campanile to its right is from the 14th century and is attributed to the painter Giotto, who was then in charge of the cathedral.

Milan Cathedral is completely unique. It is truly Gothic in the Northern European sense, and yet quite unlike any church beyond the Alps. Begun about 1385, its proportions stress width rather than height,

while its white marble gives it an exceptional lavishness of ornament. Internally, too, the giant arcade, with very small clearstorey windows and over-life-size statues in the place of capitals, place it in a category of its own.

Spain was the last European country to relinquish the Gothic style in favour of the architecture of the Renaissance. Seville Cathedral, begun in 1402 but not finished until 1518, is like Milan in emphasizing width rather than height. This gives the impression from outside that its proportions were low, but that is an illusion. Internally it is sublime. In fact, one of the building committee expressed the exaggerated hope that 'those who see it finished will think that we were mad'.

Secular buildings – castles, palaces and noble dwellings – have survived from the Middle Ages in far fewer numbers than churches, but among them are some which are by any standards masterworks. Among castles, none surpassed those of the military orders. Malbork (or Marienburg), in Poland, was the headquarters of the Teutonic Knights, who transferred their energies from the Holy Land to the Baltic as part of the crusade against unbelievers. Its earliest building dates from 1280, but during the 14th century it was rebuilt and enlarged as palatial quarters for the Grand Master.

Palaces in the Middle Ages tended to be loose collections of buildings unrelated to one another, like the Kremlin in Moscow. The Doge's Palace in Venice, however, which was begun in 1343, is a unified composition taking full advantage of its position overlooking the waterfront. It is strikingly designed in pink and white with a delightful

form of tracery, uniquely confined to secular buildings, known as 'Venetian Gothic'. The same style was used for the Ca' d'Oro, a private palace on the Grand Canal, a century later in 1423.

The date 1500 serves as a break in both Western and Eastern European traditions. The coming of the Renaissance (in Italy around 1420, in the rest of Europe later in the century) signified the end of the Middle Ages and a return to the architectural language of Greece and Rome, though this language was inevitably used to convey meanings quite alien to the Romans. An early Renaissance church like Alberti's Sant'Andrea at Mantua, for instance, combines diverse elements from Roman architecture. Apart from the use of the Corinthian order throughout, the dominant motif is the triumphal arch, upon which Alberti bases both the façade and the internal elevation, while the coffered vault is copied from Roman baths. While the western Christian tradition was about to undergo complete revision, the eastern tradition came abruptly to an end. After the fall of Constantinople in 1453 to the Ottoman Turks, it was Islam not Christianity that would be inspired by the architectural heritage of Byzantium.

OPPOSITE

The Castle of Marienburg (now Malbork, Poland) was the headquarters of the Teutonic Knights, a military order who protected Christendom from the pagan Slavs.

BELOW

Sant'Andrea in Mantua was begun by Alberti in 1472. The inspiration of the baths of Ancient Rome can clearly be seen in the coffered barrel vaults that support the side aisles and nave.

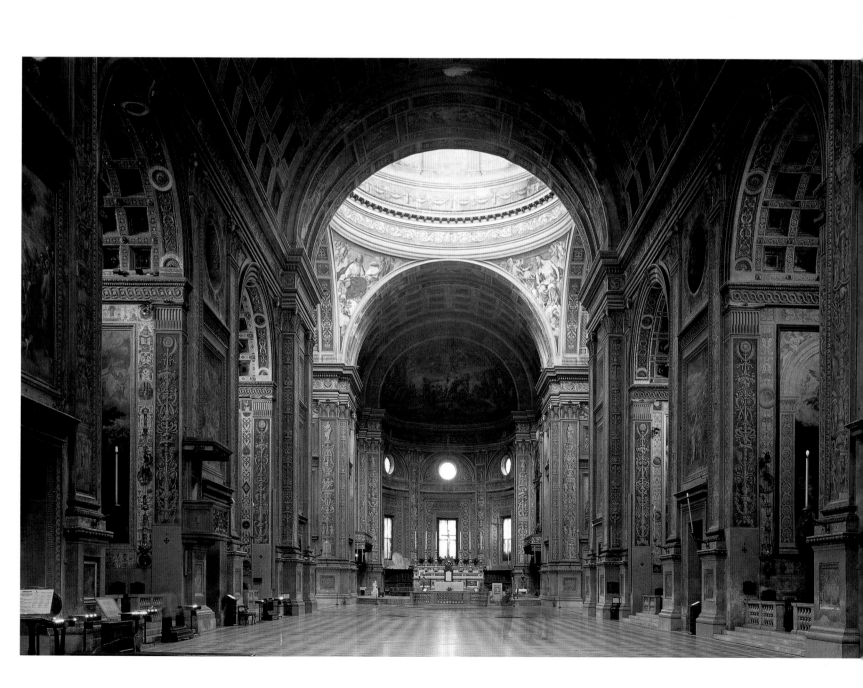

Hagia Sophia

ISTANBUL TURKEY

The building of the Hagia Sophia (Church of Holy Wisdom) was a feat of architectural daring that went unmatched for a thousand years. The main church in the Byzantine capital of Constantinople (today Istanbul), it was built to replace an earlier incarnation that had been burnt down in the Nika riots of 532. Despite earthquake damage in 557, the structure has remained in its 6th-century form ever since.

The Emperor Justinian I commissioned the court writer Procopios to write a text to celebrate its construction. In this Procopios attributes more credit for the design to the Emperor than to the two documented architects, Anthemios of Tralles and Isidore of Miletus. While these men may have been acquainted with the geometrical theories of Heron of Alexandria, and may have worked on some innovative buildings in Armenia, the origins of the sensational structure of the Hagia Sophia are unknown. Its design essentially places a shallow circular dome onto a square foundation. The weight of this dome is concentrated along forty ribs, between which are windows. The forces channelled by these ribs, both downwards and sideways, could only be supported at the four corners of the square plan, and the transition from square to circle was made by pendentives – triangular areas of masonry between the four arches springing from the corners. These pendentives were in turn supported to the east and west by half-domes that lean against the arches and conduct the forces to the ground. Seen from inside, the structure still seems miraculous – a space uninterrupted by columns, 76 metres (250 feet) long and over 30 metres (100 feet) wide. The dome hangs above the central space, as an early observer put it, 'as if suspended by a golden chain from heaven'. 'Solomon, I have outdone thee!' cried Justinian when he first saw it.

Much of the Hagia Sophia's original decoration – the glowing ranks of saints along the walls, the giant cherubim with their multicoloured wings in the pendentives and the rich marble columns with their exquisitely carved and gilded capitals – has long since been lost during periods of iconoclasm and the church's conversion to a mosque in 1453. For chroniclers in the 6th century, there was nothing like it. 'Whoever sets foot in this sacred place', wrote the court official Paul the Silentiary, 'wants to live there for ever, and his eyes fill with tears of joy.'

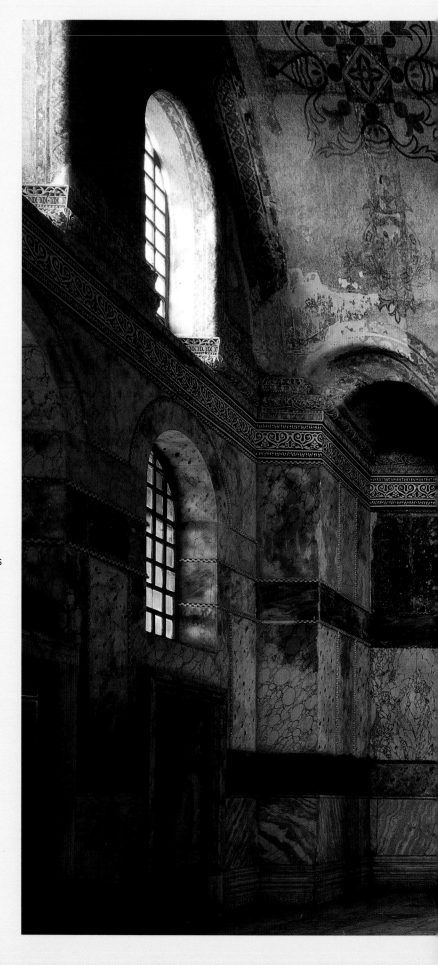

These galleries provided space
for church councils and for women
to overlook ceremonies on the
church floor.

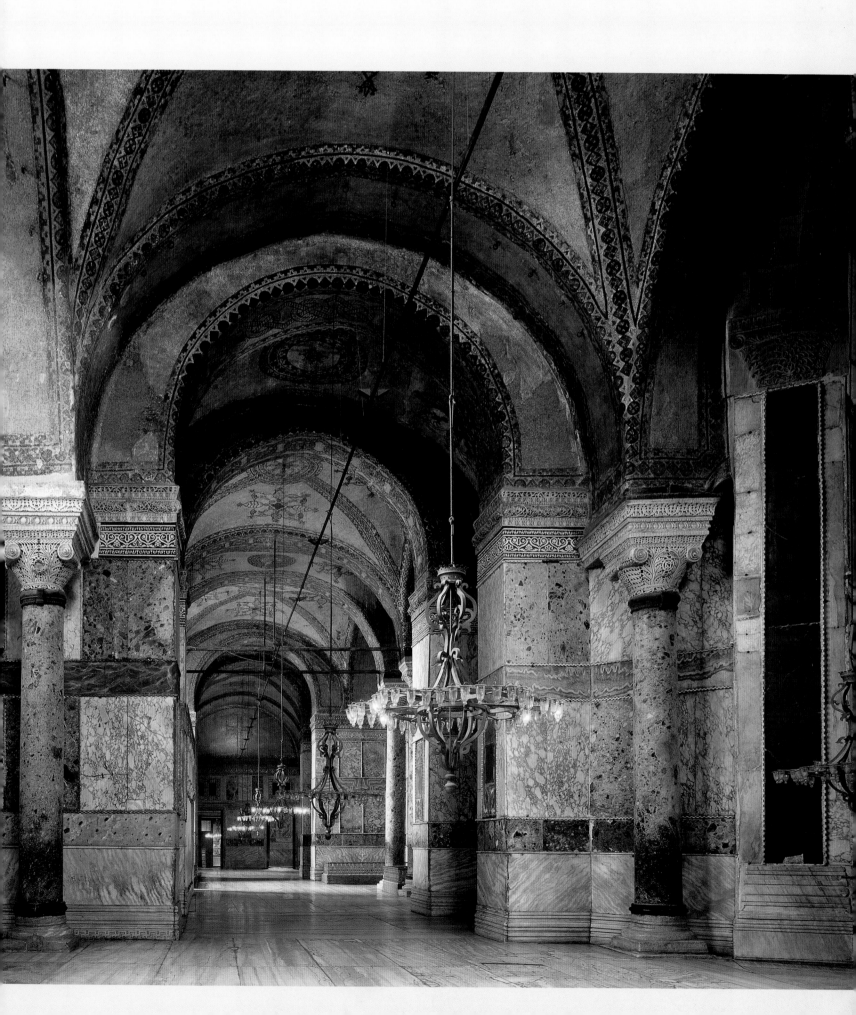

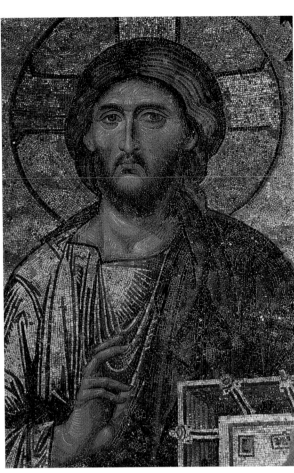

LEFT
Surviving fragments of mosaics, such as the famous Deësis Mosaic of Christ seen here, date from after the iconoclasm of the 7th and 8th centuries.

BELOW
The Hagia Sophia continues to dominate the Golden Horn on the Bosphorus, as it has done since the 6th century.

OPPOSITE
A view of the main space from the women's gallery. The Byzantine tradition of women's galleries on an upper storey was often copied by the Ottomans.

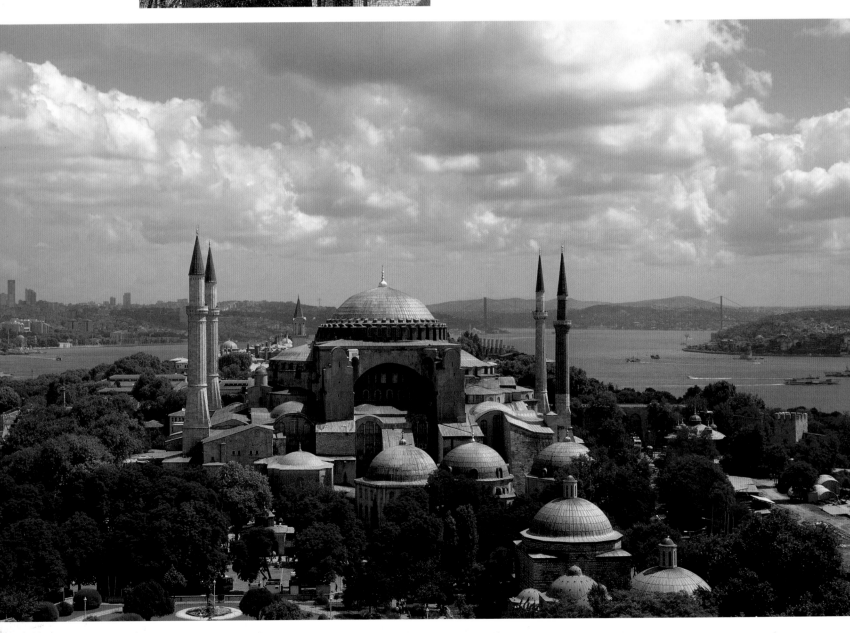

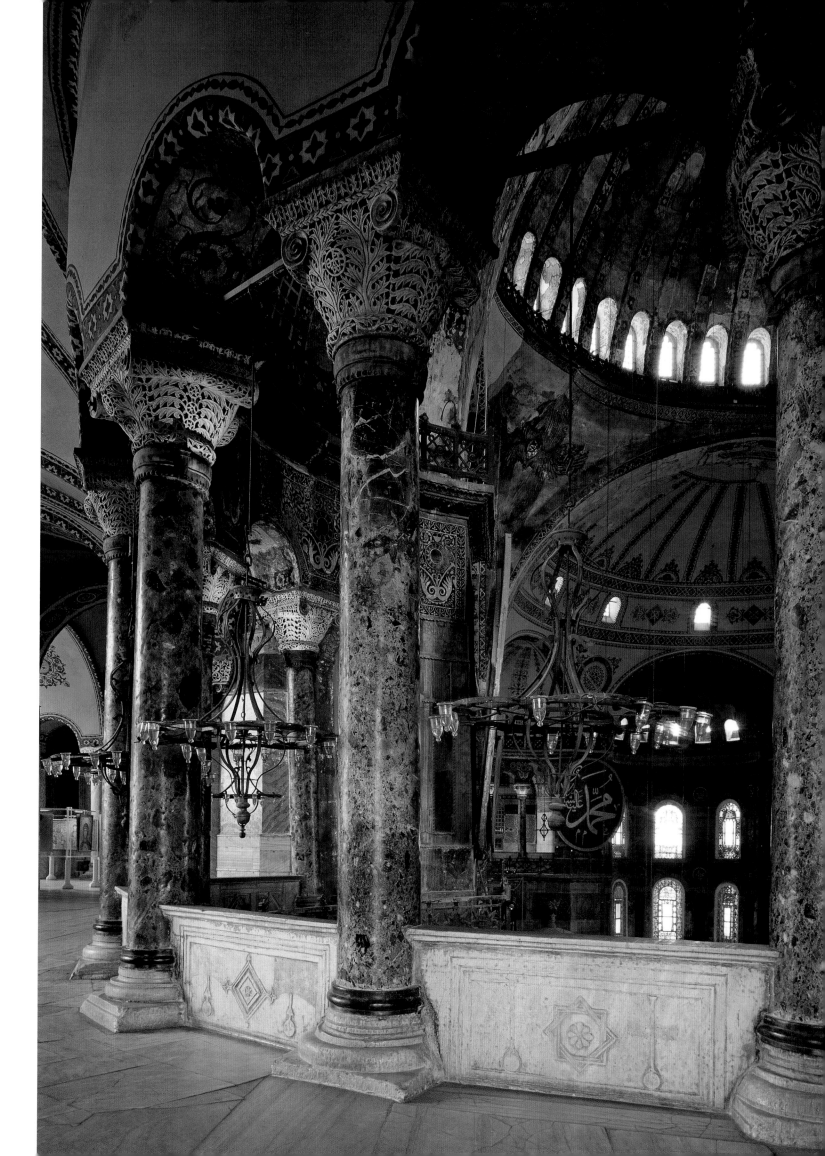

Palatine Chapel

AACHEN GERMANY

Aachen was the birthplace and residence of Charlemagne, King of the Franks and later Holy Roman Emperor. The Palatine Chapel – 'palatine' meaning belonging to a palace – is the best-preserved portion of his original complex and today it still dominates the city. Probably begun around 792, a letter by Alcuin, an English scholar at Charlemagne's court, states that it was near completion in 798.

It has a complex, double-shell design heavily influenced by the 6th-century Byzantine basilica of San Vitale at Ravenna, which was built in the reign of the Emperor Justinian. This choice of prototype was deliberate – by referencing San Vitale, Charlemagne was laying claim to imperial authority. The form of the building also assisted in the practical running of grand ceremonies, with the domed octagonal core allowing subjects to crowd into the imposing building that functioned as both royal court and church. The ceiling of this central space was covered with mosaic work, while around it run a series of dark ambulatories roofed with groin vaults. Above the ambulatories are much lighter galleries roofed with transverse barrel vaults; these galleries run right around the octagonal vessel, divided into rectangular and triangular bays by diaphragm arches. The overall effect is one of great vertical emphasis, drawing the gaze up from the ground to the gallery storey. The abode of the emperor was at the same level as the gallery, and it connected directly to his private palace quarters. Charlemagne's imperial throne still sits in the centre of the gallery, placing him on the same axis as the main altar and the image of Christ depicted in the dome. This axis was further emphasized in the late 14th century when the eastern end was replaced by a light, two-bay Gothic choir with tall traceried windows and a quadripartite rib vault.

Charlemagne was buried in the chapel in 814 and after the intervention of Frederick Barbarossa in the 12th century he was canonized by Antipope Paschal III (though today this is not recognized). The Palatine Chapel consequently became a symbol of German kingship and inspired several copies. Since at the time of its construction there were few other buildings of similar architectural ambition in Europe, it has come to be seen as the key example of Carolingian architecture, and its solid elements and clear geometry prefigure the great Romanesque cathedrals. The chapel became the cathedral of a new diocese in 1802.

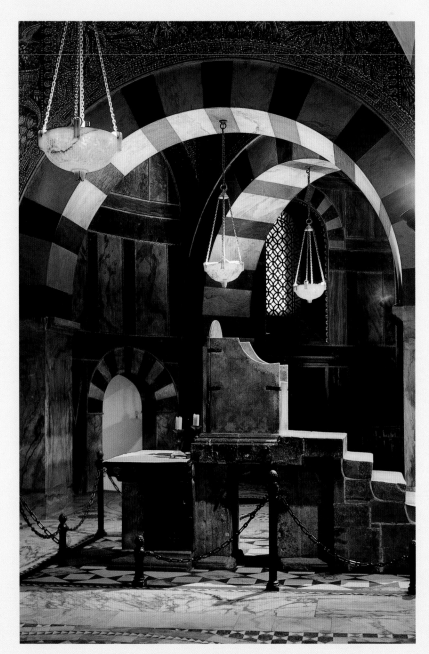

ABOVE AND OPPOSITE

The throne of Charlemagne. The Palatine Chapel functioned as both a court and a church, and was intended by Charlemagne to be an evocation of the imperial idea that he sought to revive.

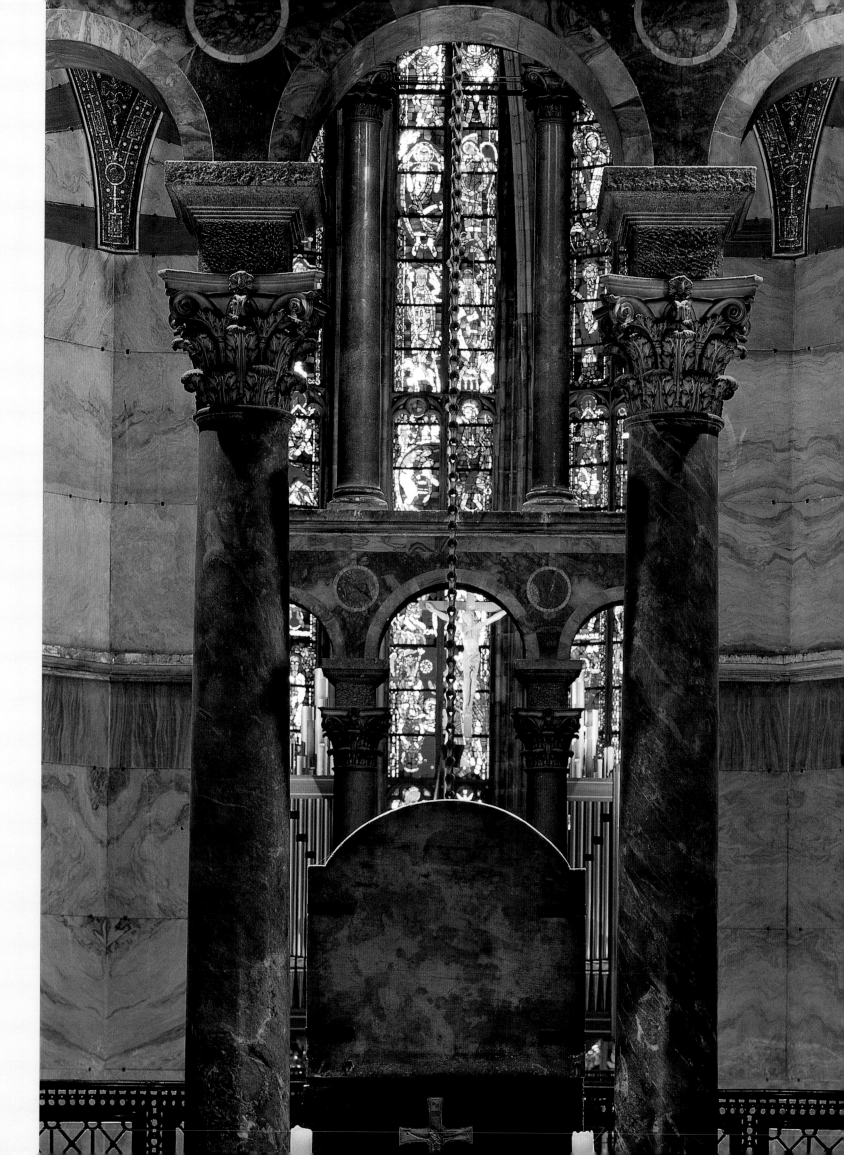

LEFT

The Gothic choir, added between 1355 and 1414, was built to accommodate the influx of pilgrims who came after Charlemagne's canonization by Antipope Paschal III in 1165.

BELOW

Much of the mosaic is the result of a restoration of 1900, though in the style of the original quasi-Antique mosaic work. The candelabrum was given by Frederick Barbarossa in 1165.

OPPOSITE

The entrance to the chapel is under the seat of Charlemagne on the gallery above and today looks into the Gothic choir beyond.

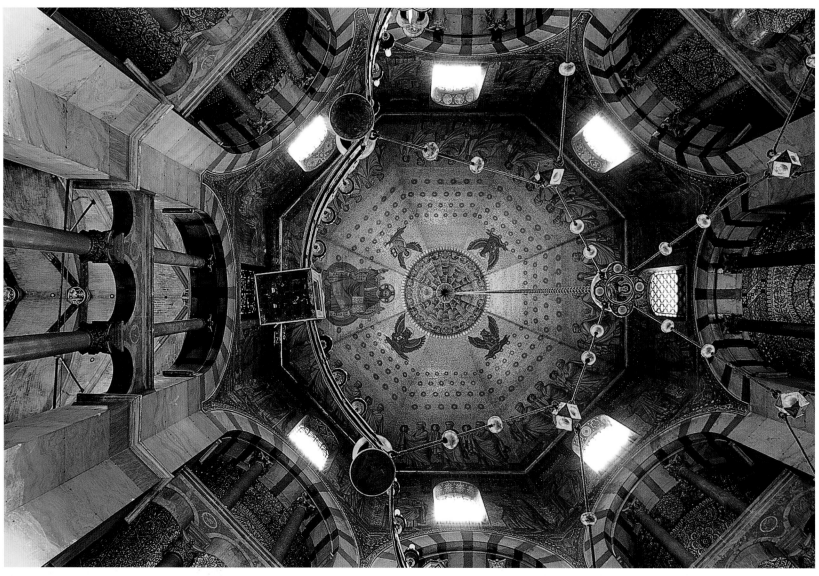

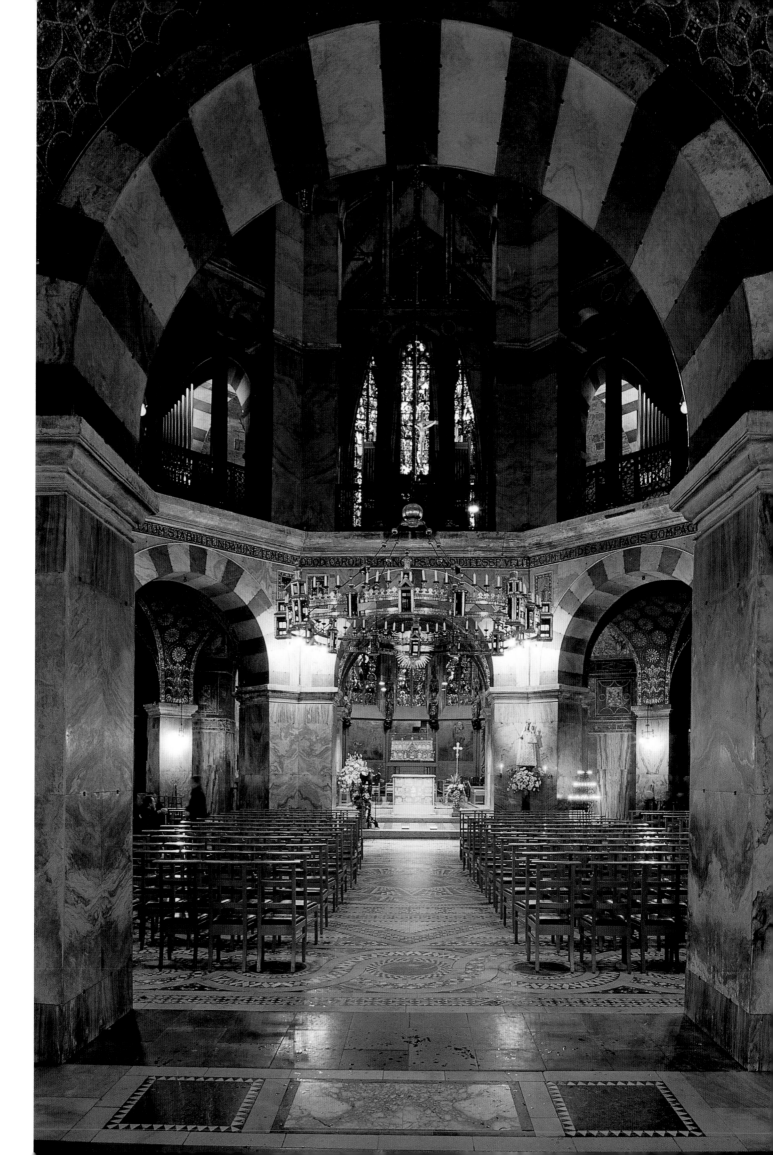

Loro Jonggrang

PRAMBANAN JAVA

Loro Jonggrang, situated in the south of Central Java, is the largest and most important Hindu temple complex in Indonesia. An inscription suggests it was begun in 856. The complex consists of 250 structures of various sizes, distributed over two square courtyards, one inside the other, separated by enclosing walls. The inner courtyard contains the six primary temples; the outer contains subsidiary temples built on four tiered platforms. These temples are called *candi perwara* – *perwara* meaning 'lady-in-waiting' in Indonesian.

Like all Hindu temples, the form of those at Prambanan is at least in part a representation of Mount Meru, the mountain at the centre of the Hindu universe. It has even been suggested that originally the central compound was flooded, with the pool representing the Ocean of Milk through which Mount Meru was rotated in Hindu legend.

The largest temple, dedicated to Shiva, rises 47 metres (154 feet) from a 34-metre (112-foot) square base. It is flanked by smaller structures that are dedicated to Brahma and Vishnu. Another three smaller temples stand opposite these first three; the central one, opposite the Shiva temple, contains a statue of Shiva's bull mount, Nandi. On each façade of the Shiva temple there is a stairway leading to a chamber or *cella* cut out of the mass of stone. Three of these chambers contain statues of Shiva's attendants, Agastya, Ganesha and Durga, while the eastern staircase leads to the main chamber, located deep in the centre of the structure, which contains the figure of Shiva himself.

Each of the major temples is encircled by bell-like ornaments or mounds reminiscent of stupas. They are probably supposed to be miniature temple replicas. Every element at the top of each temple points upwards to the heavens. The inner corners of each successive storey recede more swiftly than the parts supporting the bells. Consequently the profile becomes more incised, forming a sharper cross in plan, as it climbs up until a final massive bell-like finial surmounts the summit.

ABOVE

A platform allows the penitent to ritually circumambulate the Shiva temple before entering it. The animal heads overlooking the pathway act as gargoyles with drainage spouts.

OPPOSITE

The eastern entrance to Shiva temple. Next to the stairs is a small turret containing stones that mark the geometrical centre of the innermost temple enclosure. Beyond this is the smaller Vishnu temple.

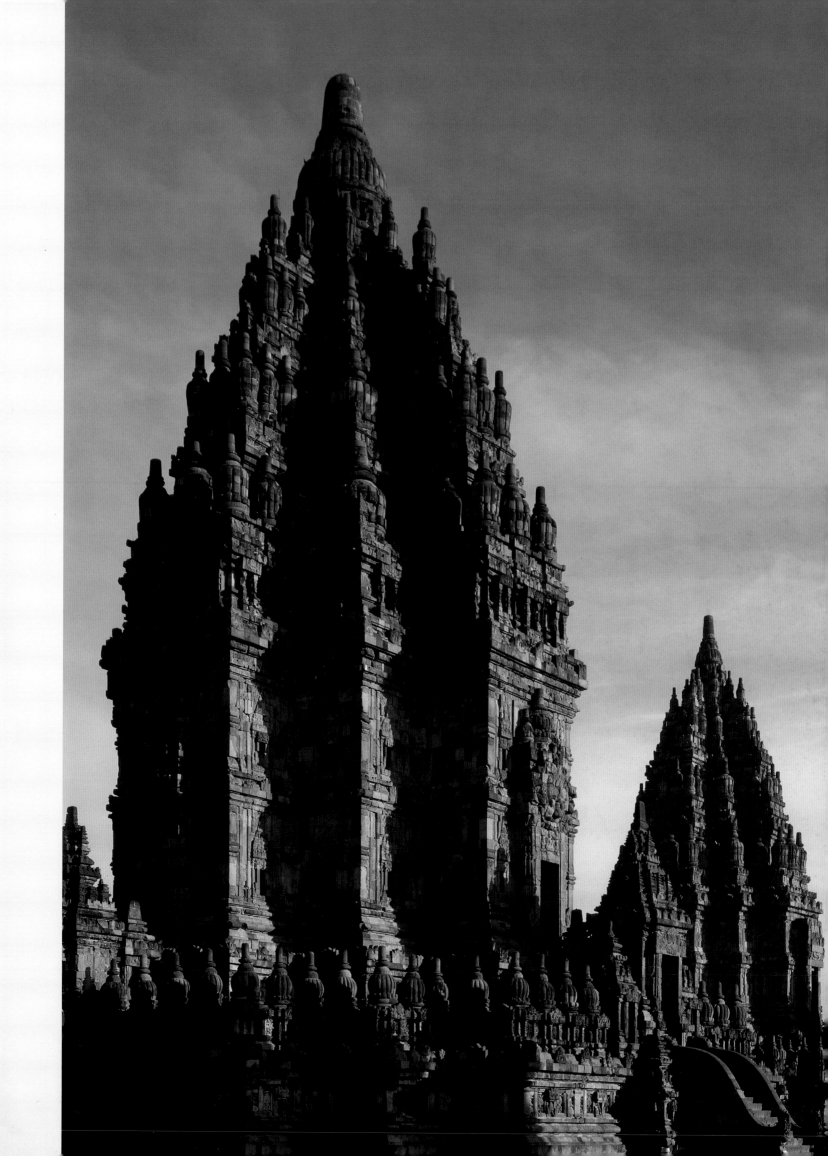

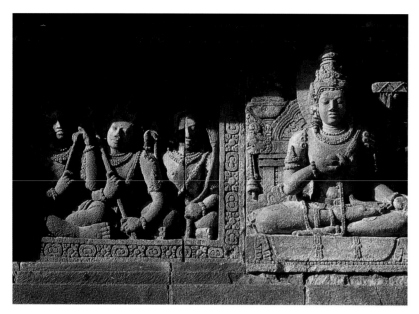

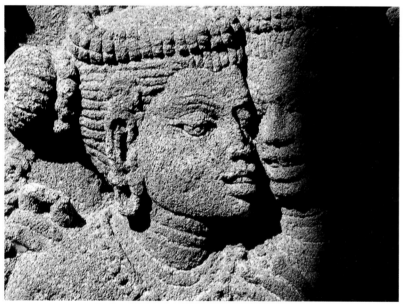

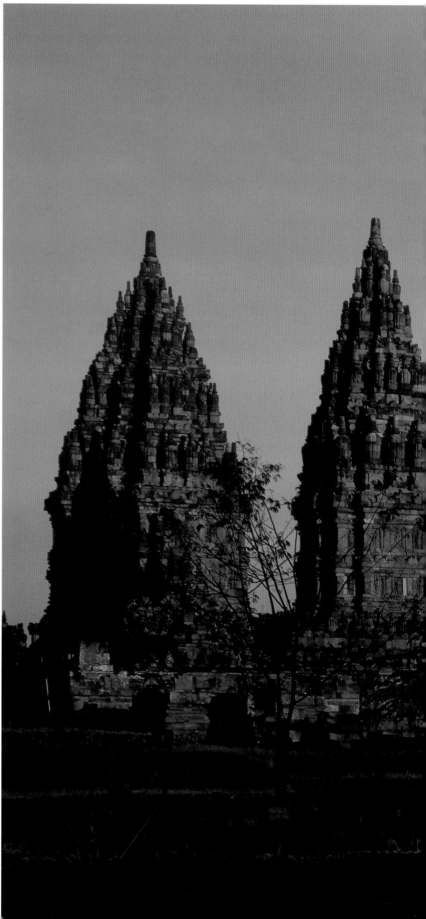

**Statues from the balustrade
of the platform surrounding
the Shiva temple.**

**The Shiva temple is flanked by
other temples dedicated to Brahma
and Vishnu. In front of each
stands a smaller temple (only two
of the three are visible in this
photograph). The central one
in front of the Shiva temple was
built for his bull mount, Nandi.**

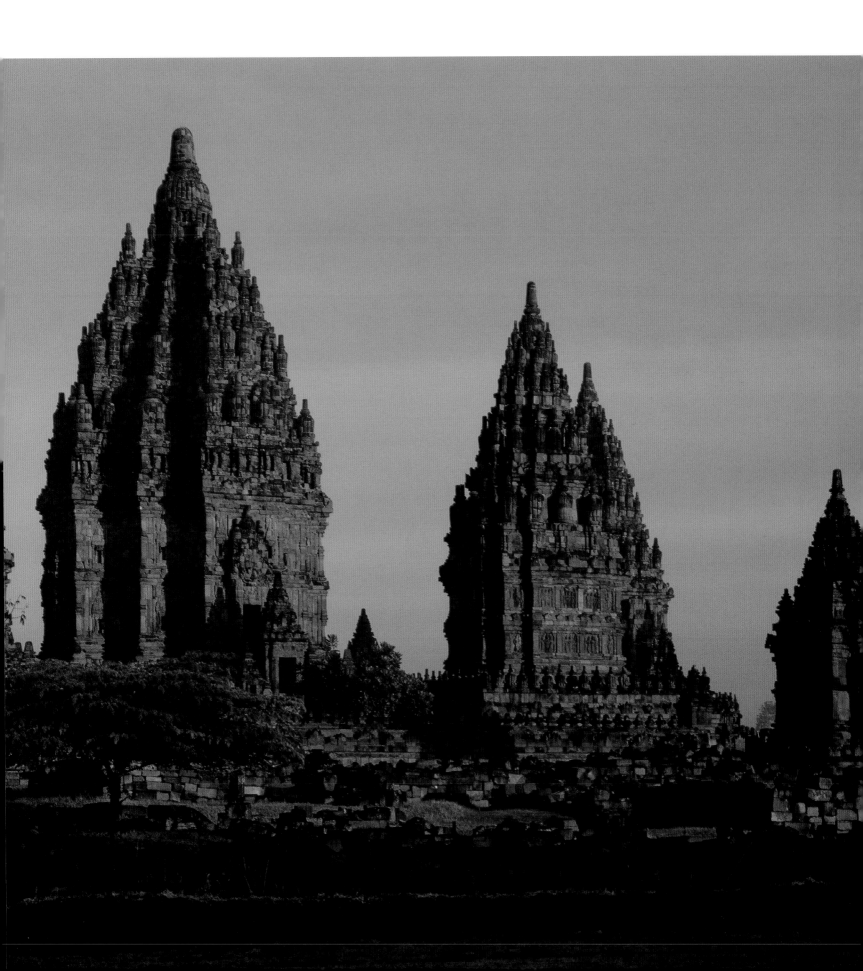

At about 30.5 metres (100 feet)
long and 20 metres (66 feet) tall,
the central tower rises 30 metres
(99 feet) from the terrace (*jagati*).

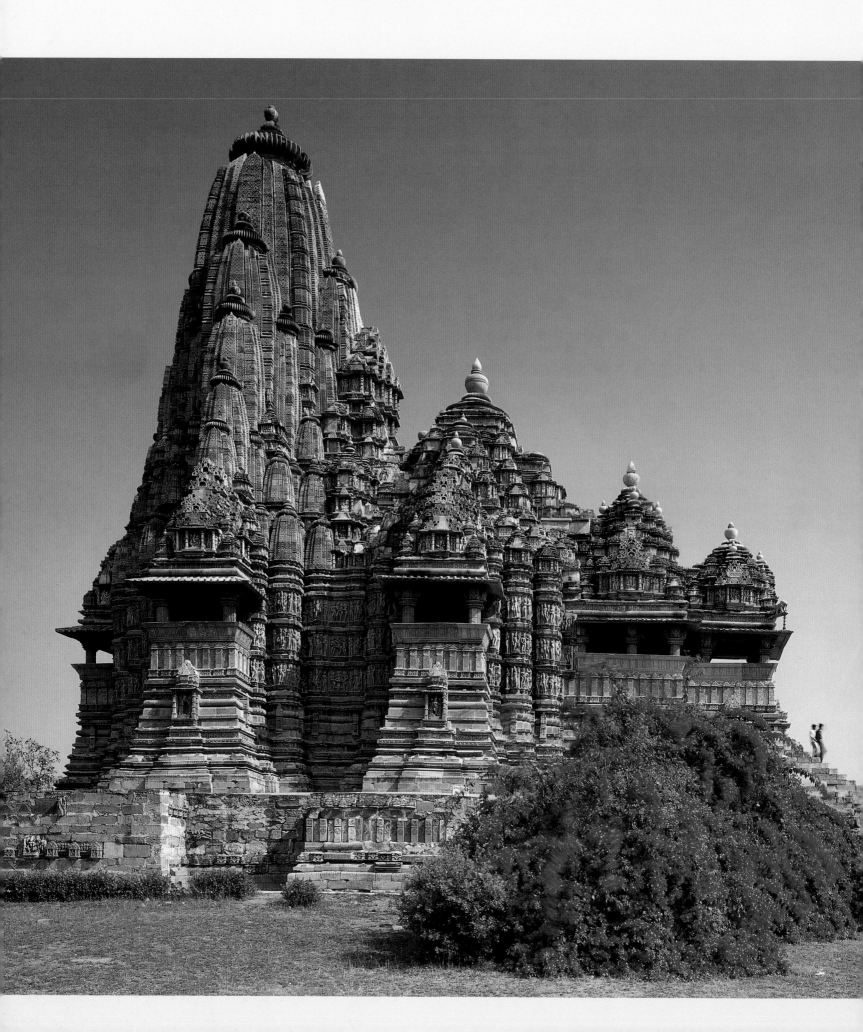

Kandariya Mahadeva Temple

KHAJURAHO INDIA

The Hindu temples at Khajuraho, Madhya Pradesh, represent the finest achievements of Indian architecture of the medieval period. They were built by the Chandela dynasty, which came to power during the early 10th century and reigned until the 14th century, when it was overthrown by Muslim invaders. The largest, most technically ambitious and richly decorated is Kandariya Mahadeva. Started in about 1025, during the reign of Vidyadhara (c. 1004–1035), it was completed in about 1050.

The Hindu religion sees the universe as being governed by harmonic relationships, and temples are designed using strict proportional systems that mirror these harmonies; in the words of the Hindu architectural treatise the *Mayamata*, 'if the measurement of the temple is in every way perfect, there will be perfection in the universe as well'. A badly proportioned temple, conversely, would have a detrimental effect upon those who worship there. Kandariya Mahadeva's elevation is divided into three horizontal zones: the platform upon which it stands (*jagati*), the wall (*jangha*), and the roof or spire (*sikhara*). Across the façade, balconied windows alternate with carved walls, allowing great variation in depth of relief. This dramatic effect is intensified by the indentations and projections that begin on the ground level and are then carried upwards to the superstructure of the temple.

Subordinate structures such as the porch and halls have pyramidal roofs, while the main tower is surrounded by layers of graded peaks. The ascending and descending superstructures are designed to resemble a mountain range – inscriptions on the building compare it both to Mount Kailasa, the abode of Shiva, and to Mount Meru, the centre of the universe.

The temple's sculptures are rendered in a smooth but high-relief style; the poses harmonize to create rhythmical patterns across the façade, and these sculptures seen together form horizontal bands that balance the verticality of the structure. A huge range of subjects is depicted: elephants, soldiers, hunters, acrobats, dancers, royalty and, most famously, copulating figures. At the heart of the temple lies the *garbhagriha* or 'womb chamber', designed to resemble the sacred cave-residence of Shiva and placed on the same axis as the entrance. It is surrounded by an ambulatory that opens into transepts in the north, south and east. A devotee approaching the temple would process clockwise around the platform, contemplating the sculptures, before climbing the stairs, processing around the ambulatory, and finally praying to the figure of Shiva within the *garbhagriha*.

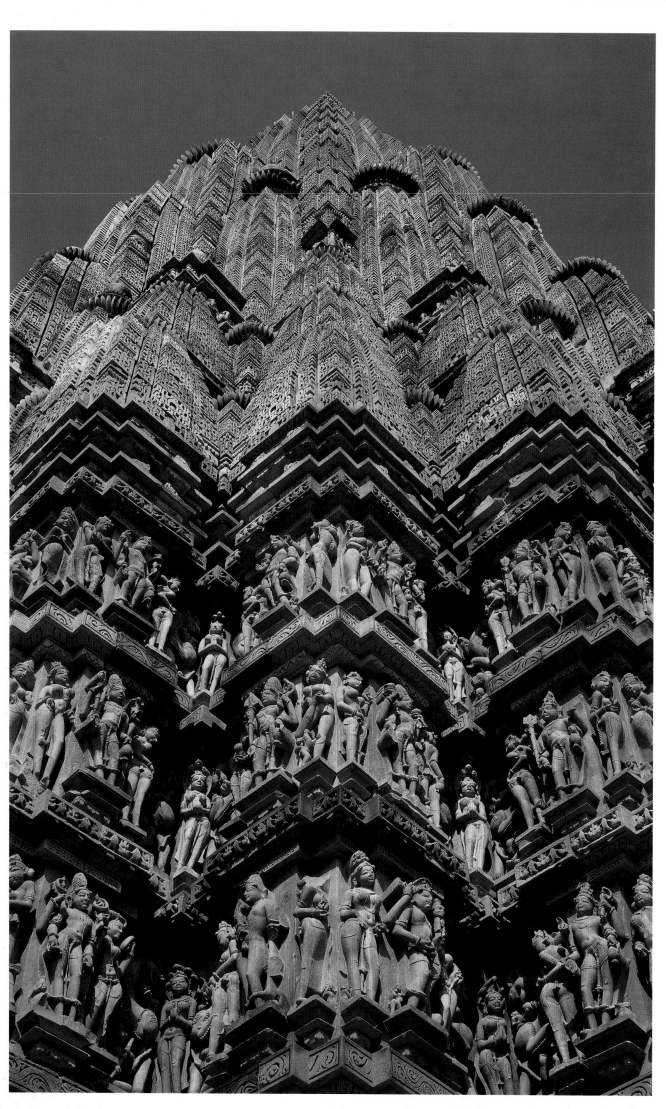

LEFT

Sculpture is brilliantly integrated into the architecture forming rhythmical patterns across the façade and countering the extreme verticality of the building.

OPPOSITE

The ambulatory around the *garbhagriha* or 'womb chamber'. 'Womb chambers' were designed to evoke a cave space, reminding worshippers of the natural grottoes where deities were believed to appear in person. Several deities are located within the wall niches inside the temple.

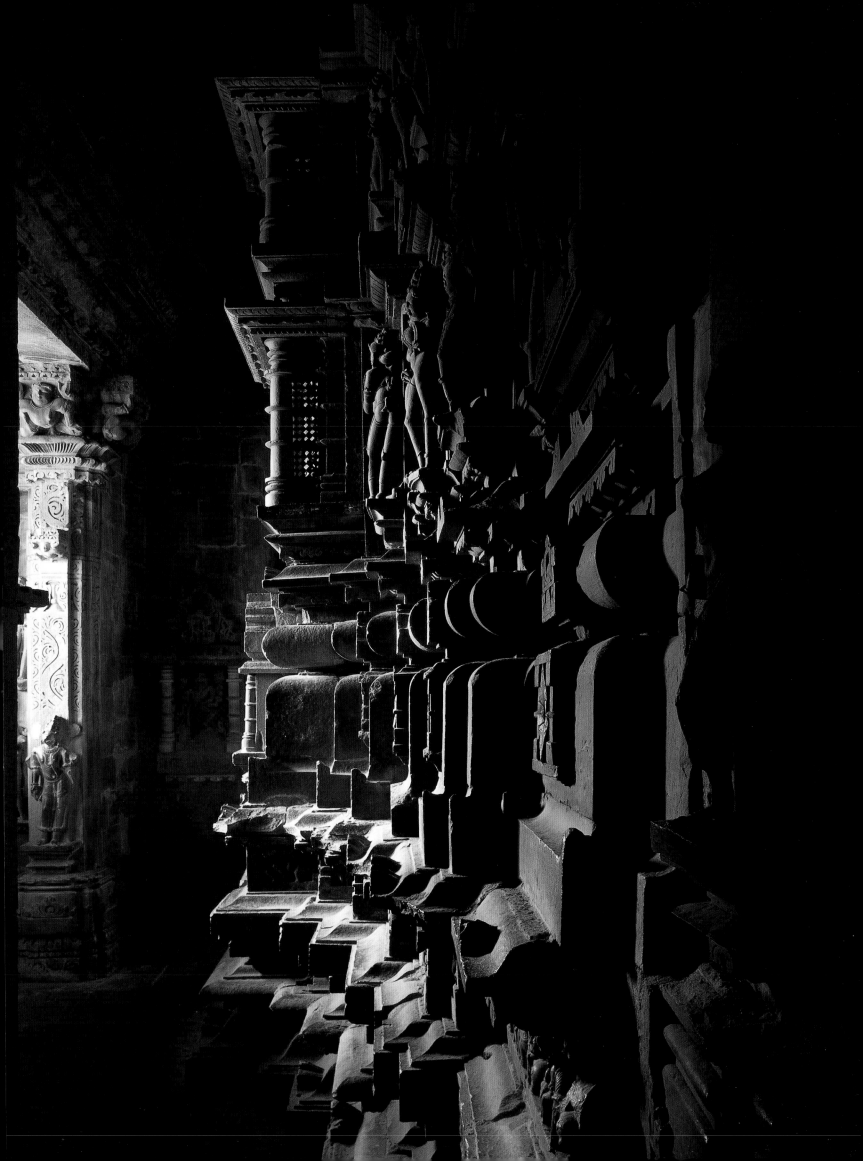

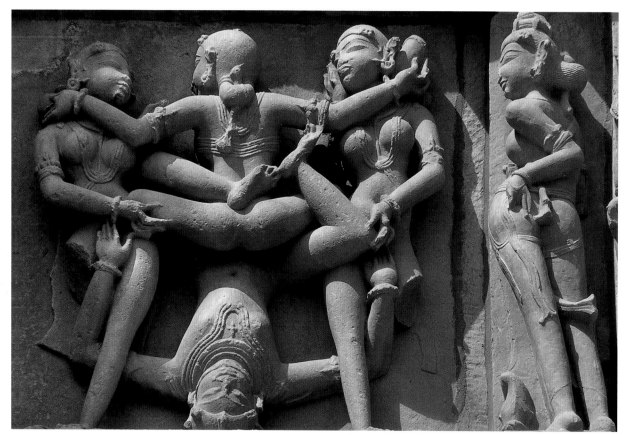

LEFT ABOVE AND BELOW
Erotic figures from the south-east façade. Such motifs occur in Hindu, Buddhist and Jain sculpture in India, and originate in a common set of beliefs and practices associated with fertility cults. Fertility was not only associated with procreation but also with the avoidance of evil, death and misfortune, and the promotion of life, happiness, prosperity and good luck.

OPPOSITE
The Kandariya Mahadeva temple shares its terrace (*jagati*) with the Devi Jagadamba temple to the right.

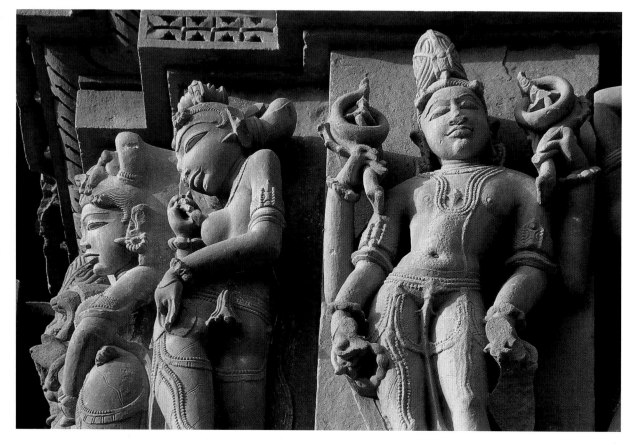

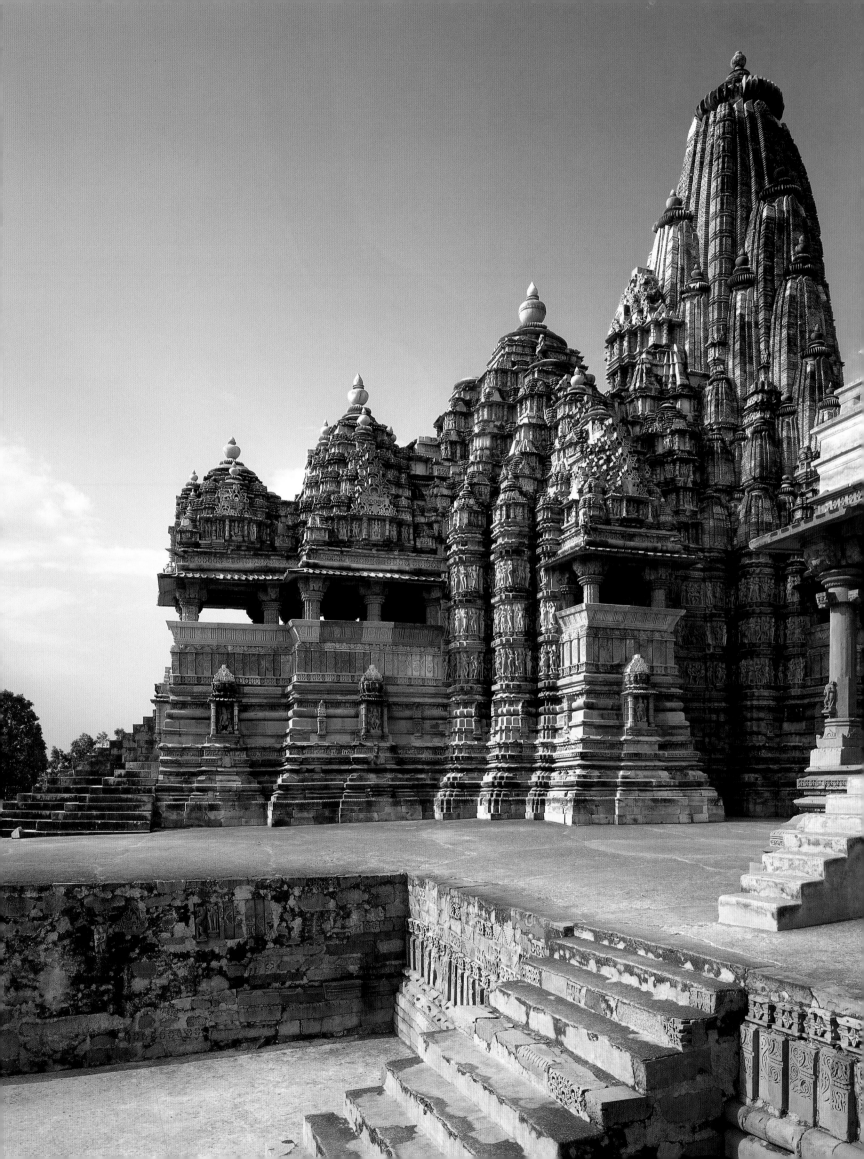

The tall nave of Sainte-Foy could
be seen by travelling pilgrims from
miles away.

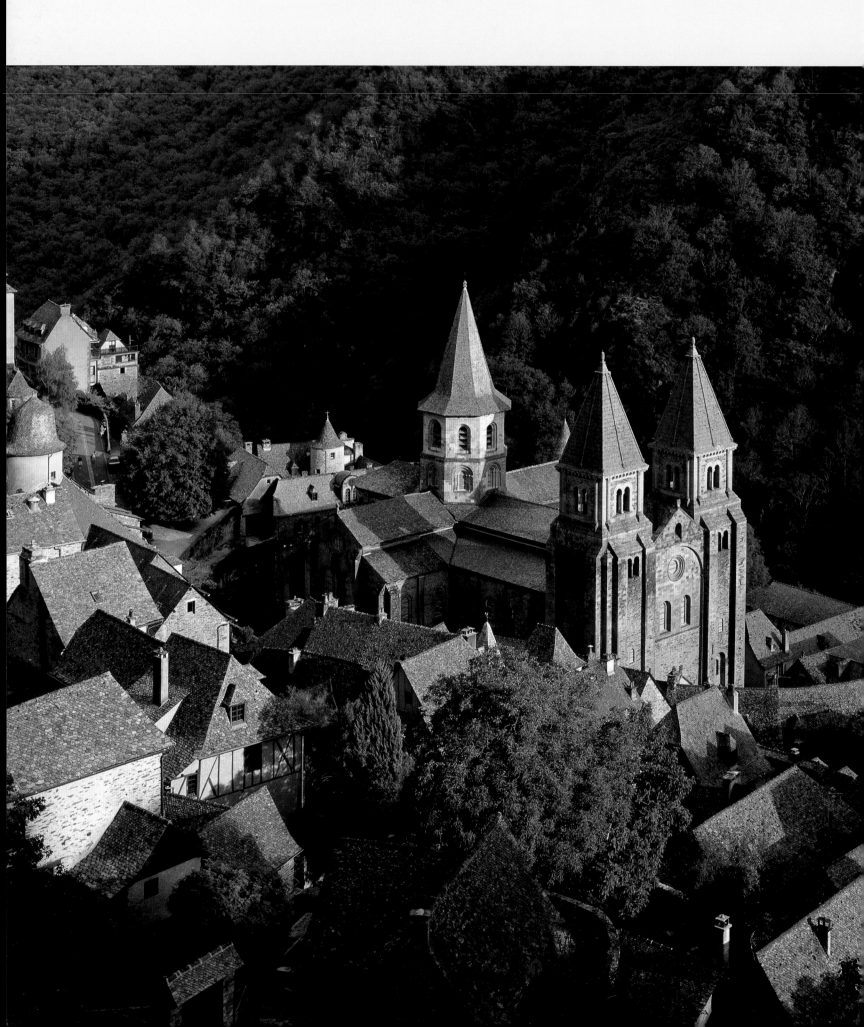

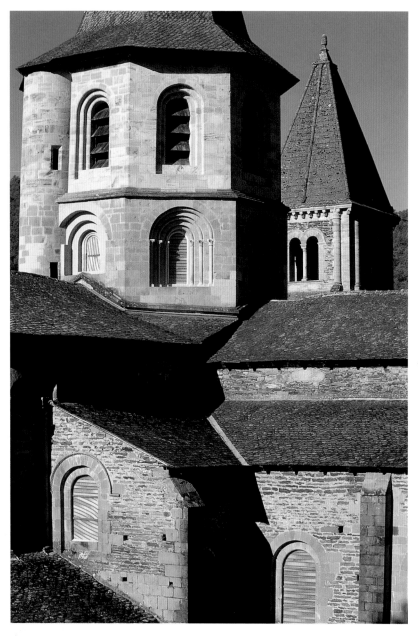

The central octagonal tower, and
behind it one of the western towers
added in the 19th century.

The town of Conques with its
church seen from the south-west.

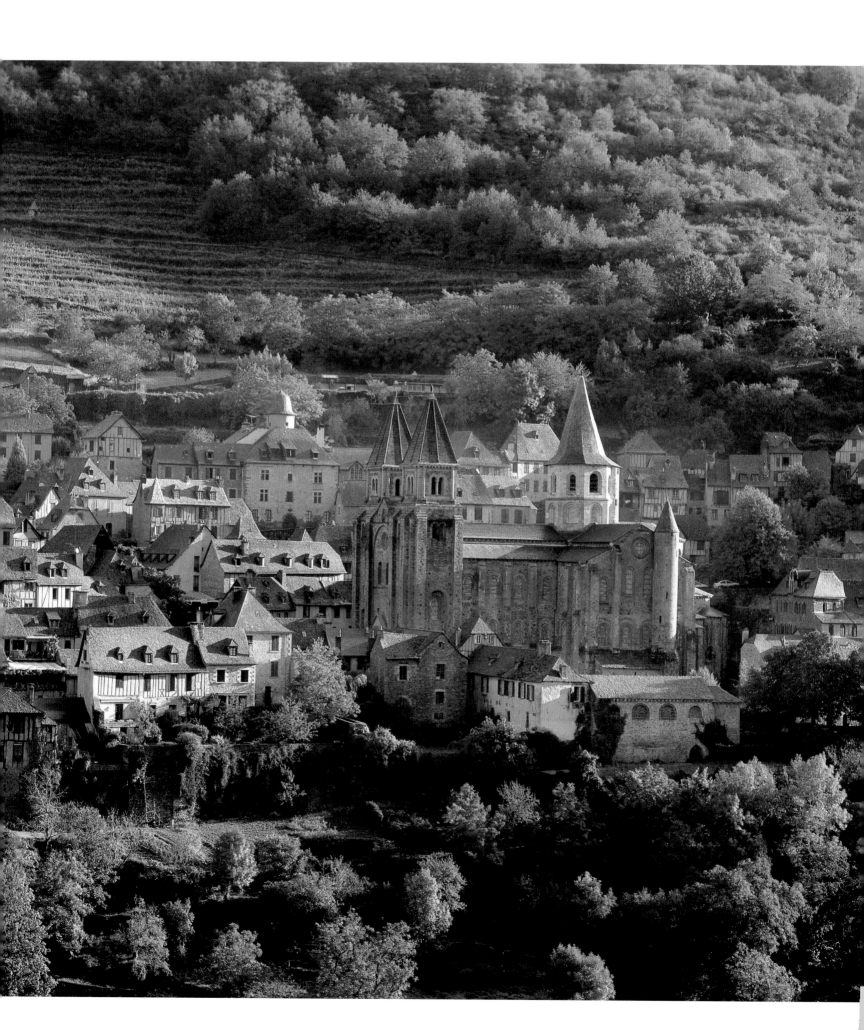

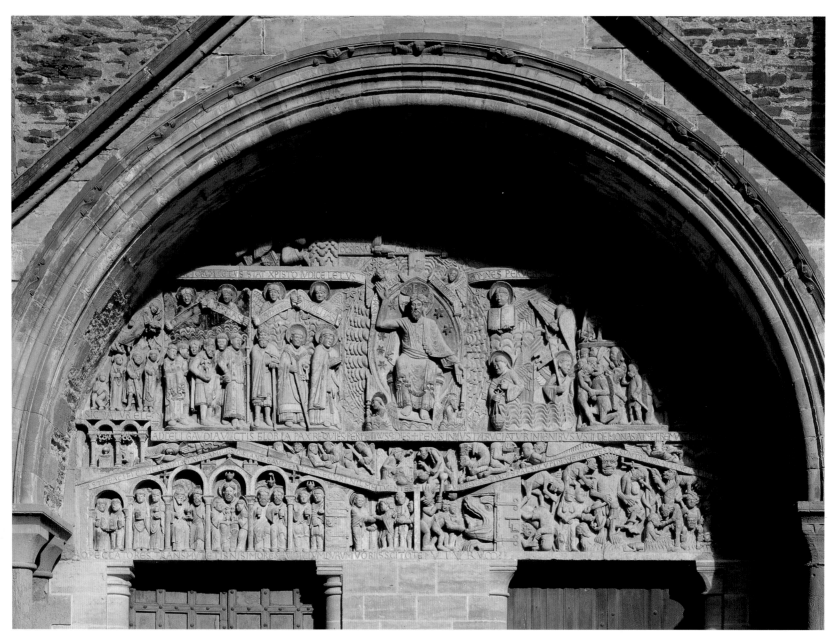

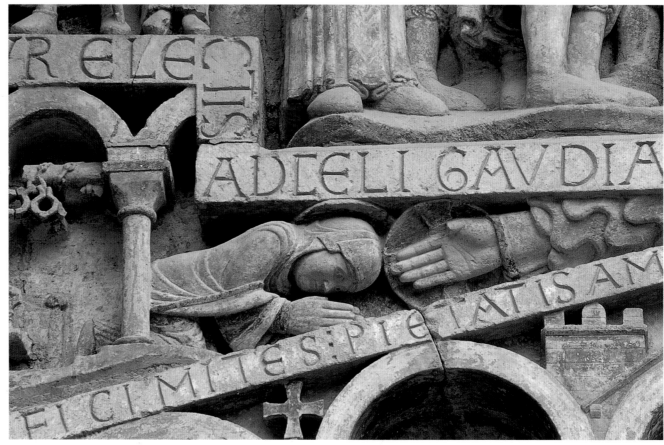

ABOVE

Scenes of the Last Judgment are often found above the west portal in Romanesque churches. That at Conques contains 124 figures, and is one of the richest ensembles of Romanesque sculpture anywhere. Nobody is spared: a king has his crown grabbed by the teeth of a demon while a knight in chain mail dies falling; even an abbot and three monks appear among the damned.

RIGHT

The figure of Ste Foy herself appears leading the prayers of the saved at the right hand of Christ.

OPPOSITE

The nave looking east. The holy relics of Ste Foy – St Faith – were kept inside the choir, where they could be contemplated by pilgrims processing around the ambulatory. The 12th-century latticework screens that protected the relics are still in place.

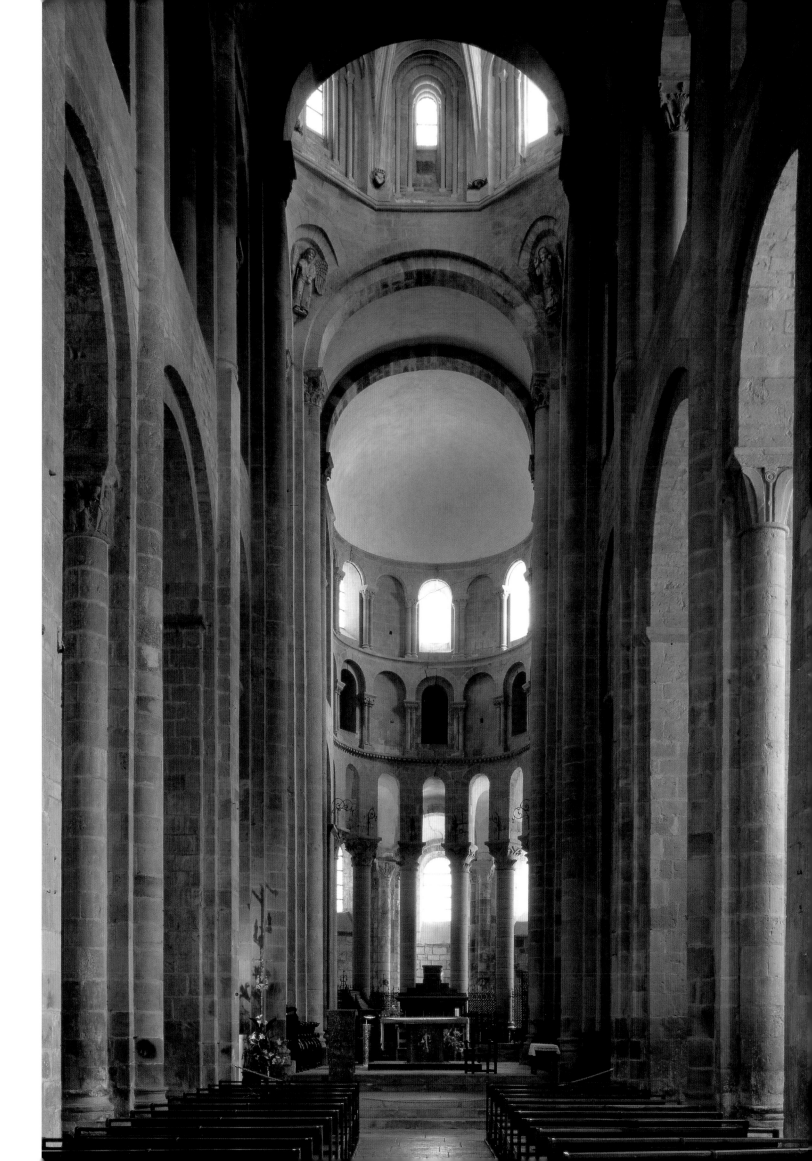

The baptistery is a mixture of Romanesque base (by Diotisalvi, from 1152) and Gothic upper part by Nicola and Giovanni Pisano (13th century). It was based on the rotunda of the Holy Sepulchre in Jerusalem.

Pisa Cathedral, Baptistery and Tower

PISA ITALY

On the edge of the city of Pisa is a large, immaculate lawn known as the Piazza dei Miracoli. The 'miracles' in question are three buildings of shining white marble: the cathedral, the campanile (the famous 'Leaning Tower') and the baptistery. Pre-eminent examples of the Pisan Romanesque style, all three buildings are characterized by repeated rows of miniature arcades, to which the local white marble is naturally suited. These arcades run in straight lines across the cathedral's façade and round its sides; another ring of them runs around the baptistery and they cover six levels of the campanile.

The cathedral was started in 1063 during a period in which the Pisan state was becoming a major political and military power. That same year Pisans sacked the then Muslim city of Palermo and used the spoils to begin the new cathedral. A series of inscriptions carved into the façade provides information about the project, including the original architect's name: Buscheto. The inscription also makes it clear that the cathedral was intended to be comparable with the largest and greatest Christian buildings in Europe. Certainly it was conceived on a grand scale: 96 metres (315 feet) long from façade to apse, 21 metres (69 feet) wide and 28 metres (92 feet) high. The early Christian basilicas of Rome inspired the plan, particularly its wide nave and aisles. However, the elliptical dome surmounting the crossing, a pointed arch in cross-section, also suggests some Islamic architectural influence.

The foundations of the campanile were laid in 1173 – and, in hindsight, not very well laid. When the tower had reached only its third level it began to lean. Work was halted for an entire century, until 1275 when attempts were made to correct the angle of inclination. Only in the last twenty years has it been stabilized, but the citizens of Pisa, conscious of its fame, have resisted proposals from modern engineers to straighten it altogether. The baptistery harmonizes with cathedral and campanile, but is less consistent in style. The lower half was built from 1152 by Diotisalvi in the Romanesque style, but the upper part, including the dome, is mid-13th-century Gothic, the work of sculptor Nicola Pisano and his son Giovanni.

To the north of the cathedral lies the wall of the Camposanto, the old monumental cemetery of Pisa. Begun in 1278, it presents a face of blind arcades to the outside world. Inside, it is an elongated rectangle of four covered walks lit by traceried windows. The centre, filled with earth said to be from the Holy Land and sewn with grass, contains graves and the cloister walks are full of monuments including some Ancient Roman sarcophagi.

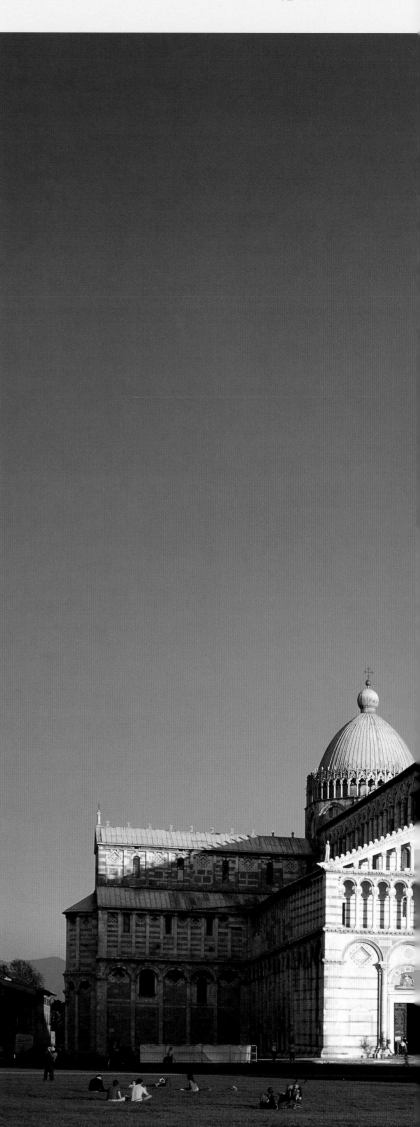

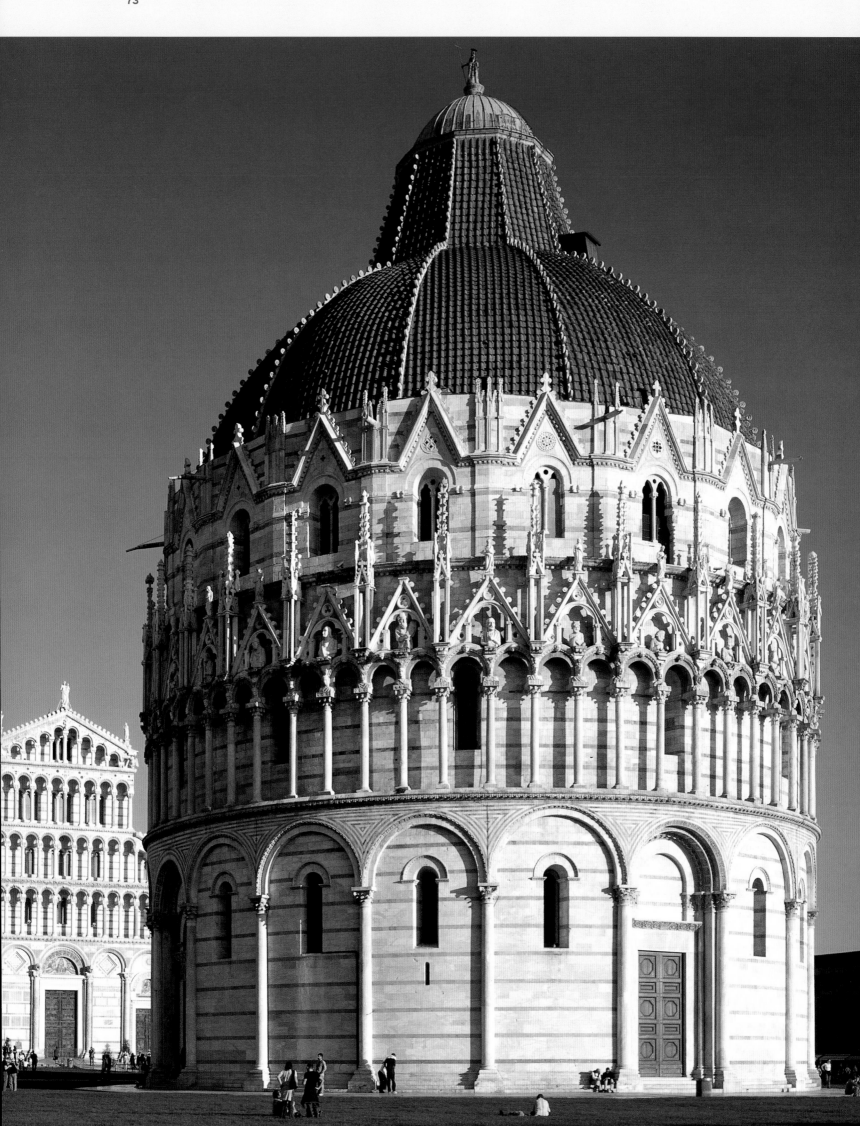

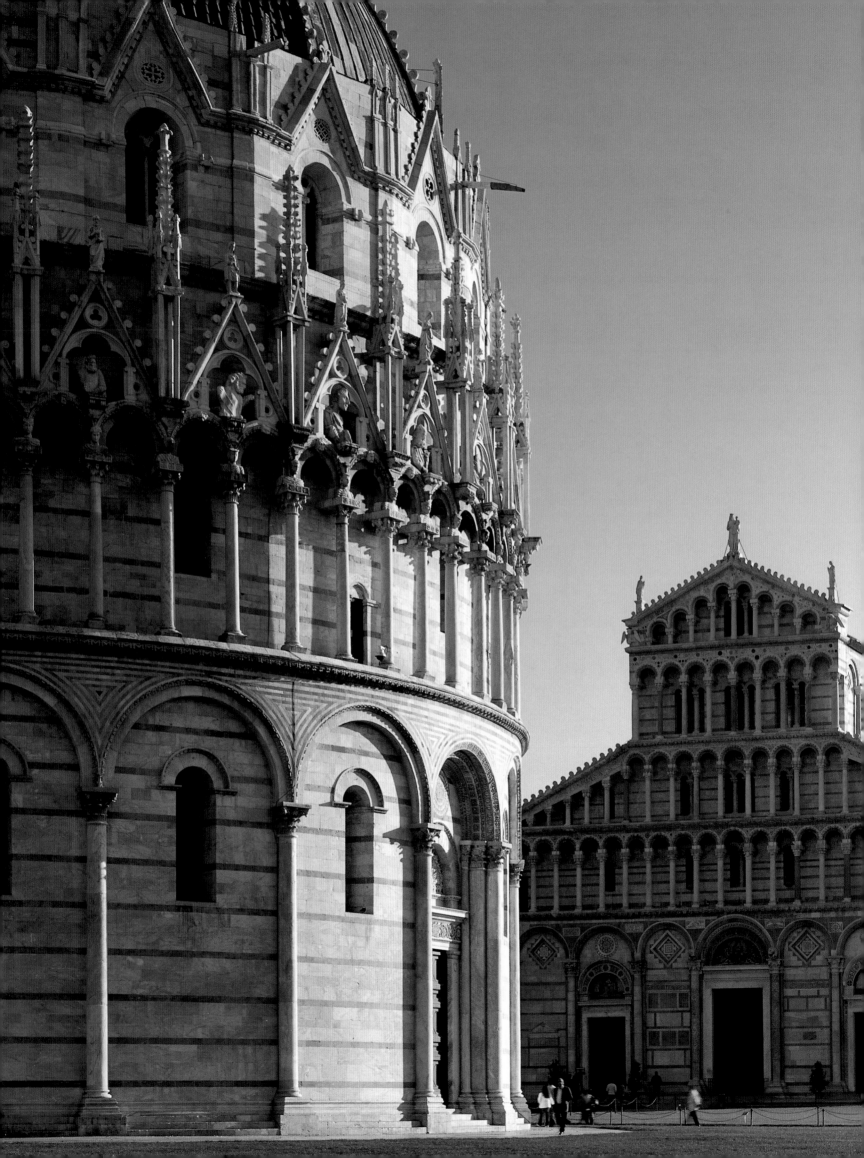

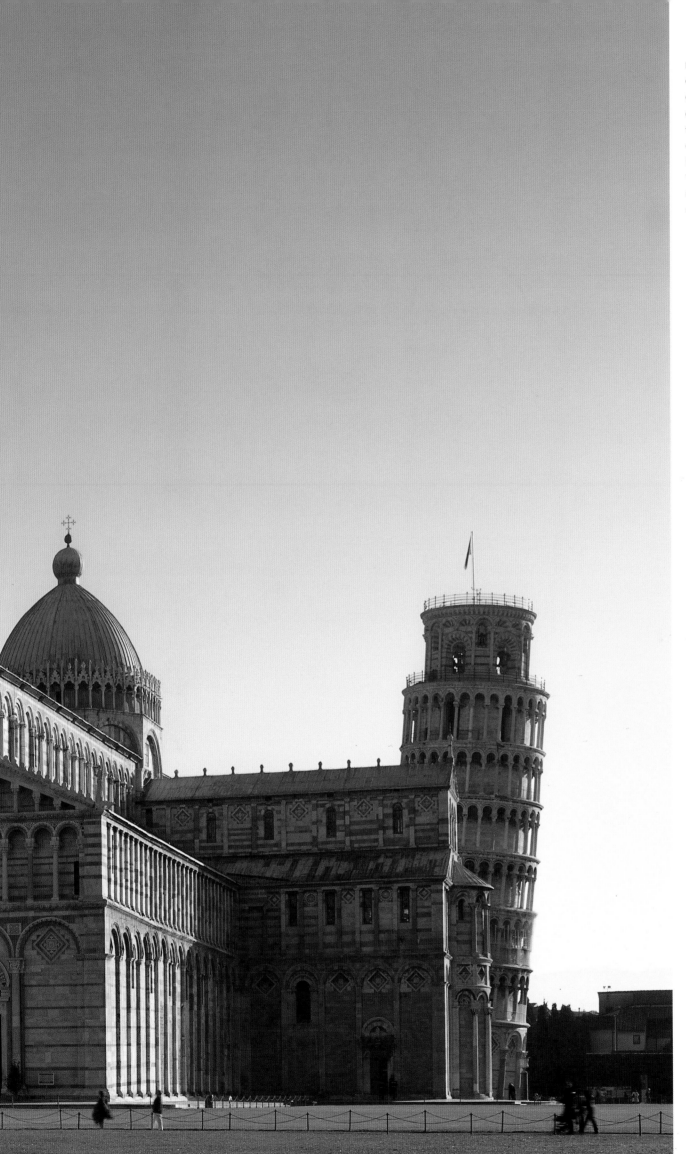

Limestone from San Giuliano, Carrara marble and reused Greek marble give subtle differentiation to the white façades of the baptistry, cathedral and campanile. Details are highlighted in grey Vecchiano limestone and yellow marble limestone from the Pisan mountains.

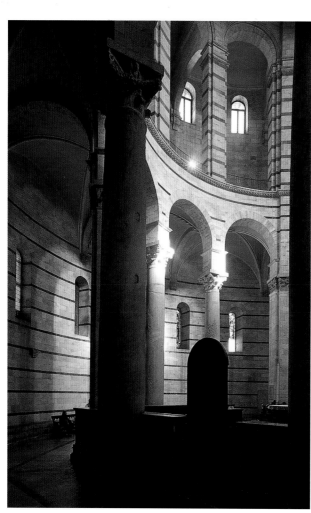

LEFT

**The interior of the baptistery shows
the marble banding characteristic
of the Pisan Romanesque style.**

BELOW

**The Camposanto was designed by
Giovanni di Simone. Its cloisters
are said to contain soil brought
from the Holy Land.**

OPPOSITE

**The west front of the cathedral,
begun by the architect Buscheto
and finished by Rainaldo, is one
of the largest of any church from
this period.**

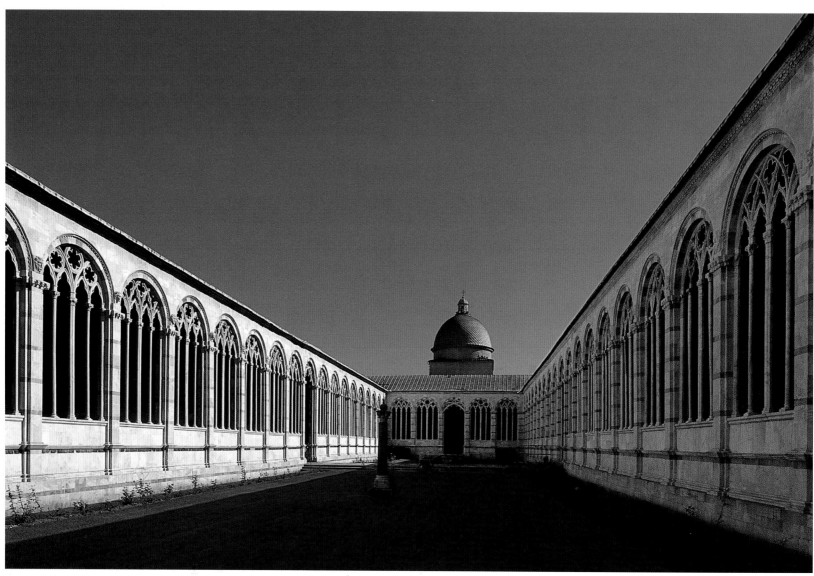

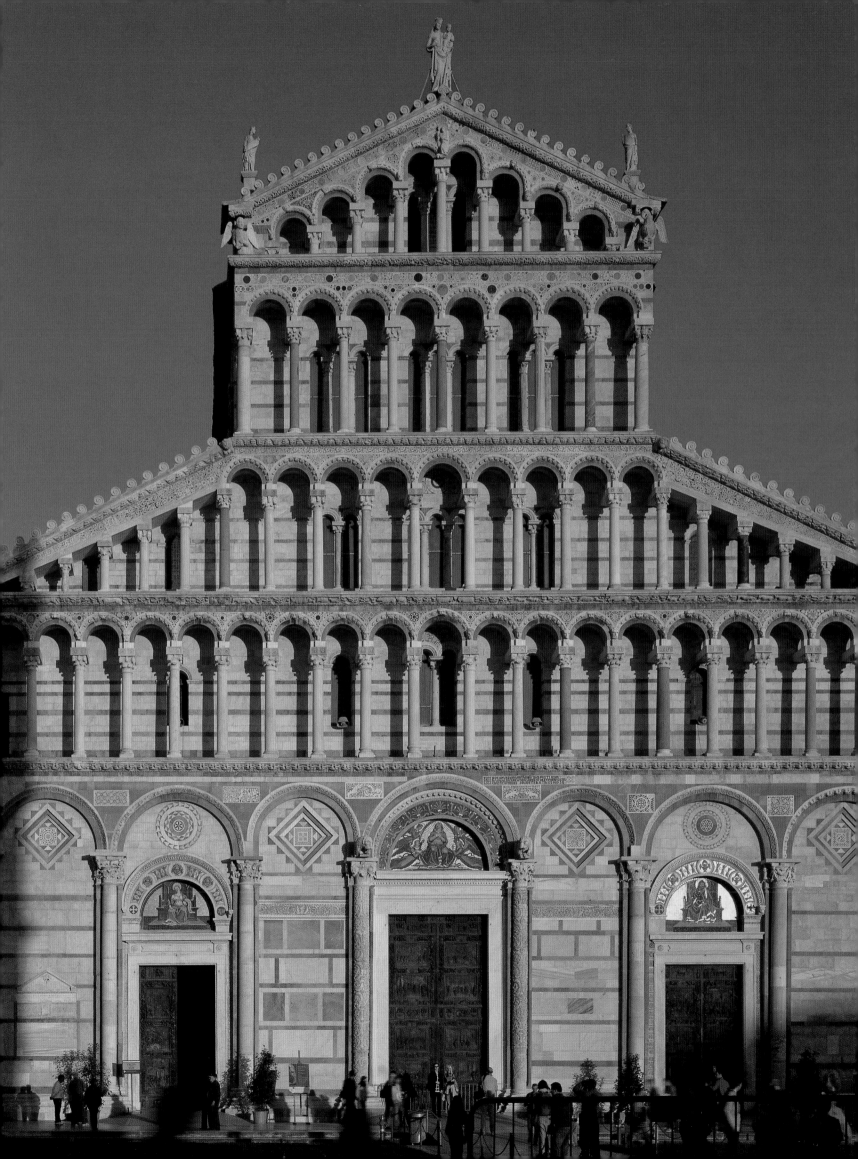

Friday Mosque

ISFAHAN IRAN

Unlike most of the great monuments of Isfahan, which were conceived
and erected by the Safavid dynasty, the great congregational mosque
was slowly constructed over centuries by successive ruling families.
The original 8th-century adobe mosque was replaced in the 9th by
a brick structure built on a different plan. However, it was not until the
11th century that the Seljuq dynasty gave the mosque a permanent form,
adding two domes to either side of the central courtyard. The south dome
was built in 1086 by the sultan Malik Shah, and his chief vizier Nizam al-
Mulk. Nizam al-Mulk's great rival, Taj al-Mulk, sponsored the construction
of a northern dome on an even grander scale, which at that time was not
part of the mosque but just connected to it. During the 12th century the
iwans (vaulted spaces open on one side) were added to the sides of the
court, thus completing the standard Iranian mosque layout of four iwans
and a dome.

The Ilkhanid dynasty made further additions. The sultan Uljaytu
(who ruled 1304–17) added a stucco mihrab (a niche that indicates the
direction of Mecca) in 1310 that backs onto the west iwan; at the same
time the courtyard arcade was reconstructed on two levels. Later in the
14th century, under the Muzaffarid sultans, a madrasa (school) was added
to the east and a prayer hall to the west. Almost all the Safavid sultans
added decoration to the iwans and minarets.

The result is a wide range of Iranian architectural features that
blend very successfully. Particularly striking is the superb quality of
workmanship both in brick and terracotta. The domes and iwan contain
some of the finest examples of *muqarnas* – a honeycomb-shaped vault
created from tiers of curved and faceted elements. These were covered
with tile mosaic, creating a magical shimmering effect.

The courtyard and western iwan,
seen from within the southern iwan.

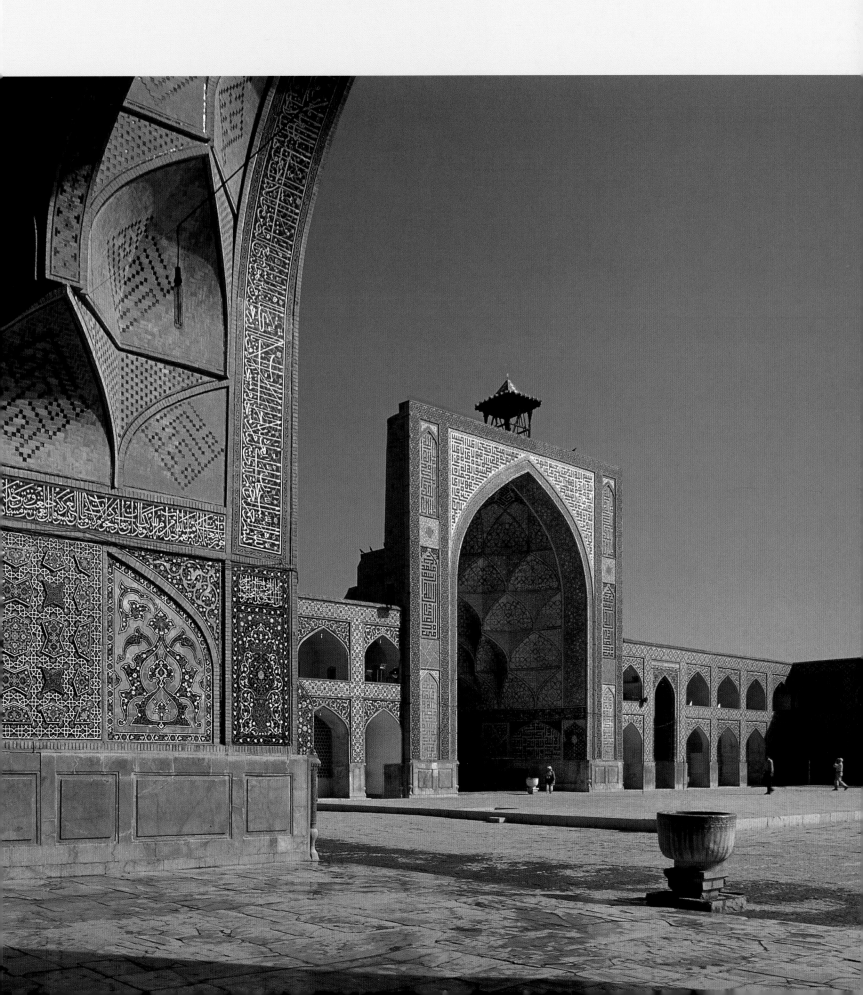

RIGHT

A detail of the mihrab of Uljaytu, dated 1310. Its floral decorations resemble an undulating bed of waterlilies, overlaid with inscriptions from the Qur'an.

BELOW

A detail of the intersection of two separate geometrical patterns of *muqarnas* ceiling, in the southern iwan.

OPPOSITE

Men sleep off the heat of the midday sun under the superb brick vault of the northern iwan.

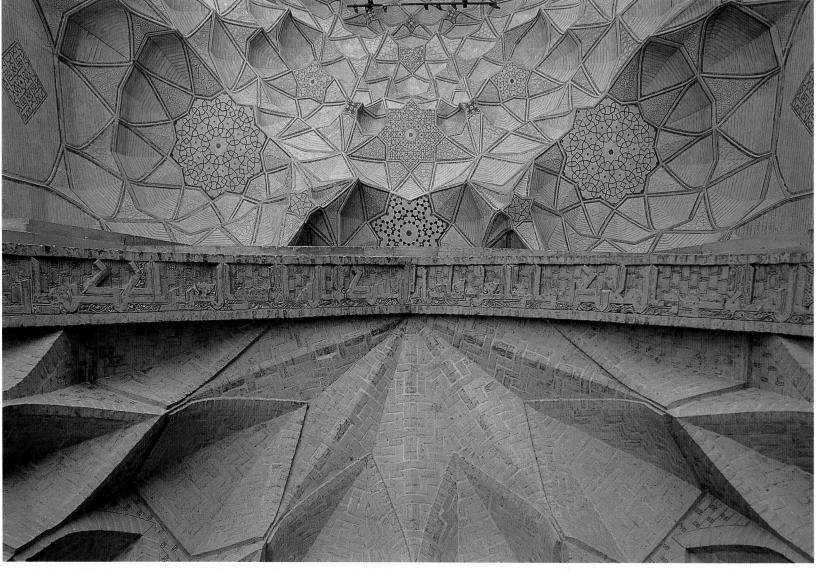

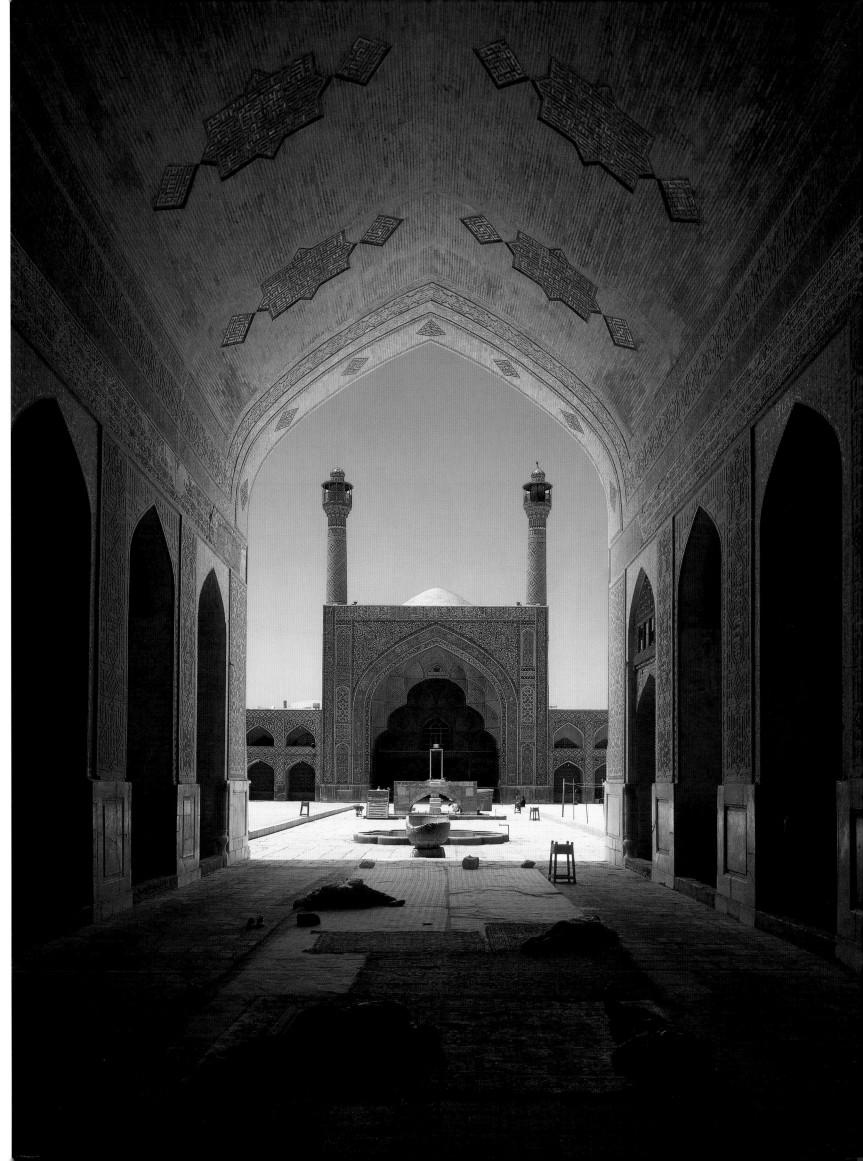

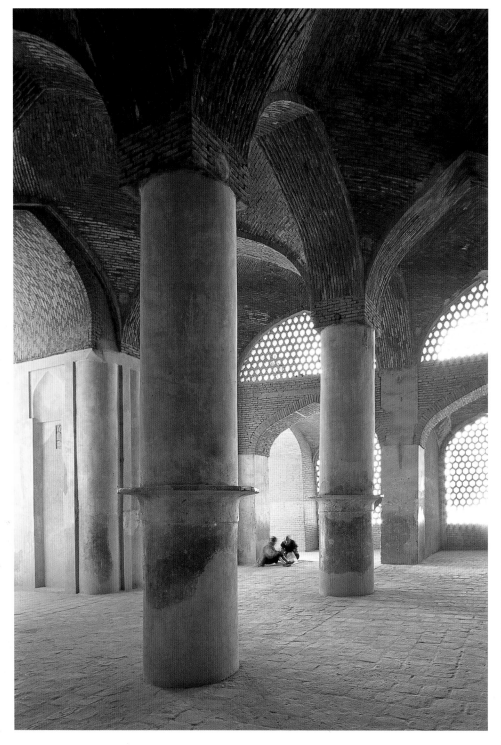

ABOVE

**The vaulting behind the northern
arcade is supported by brick piers.**

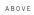

RIGHT

**The central pool in the court.
Beyond is the southern iwan.**

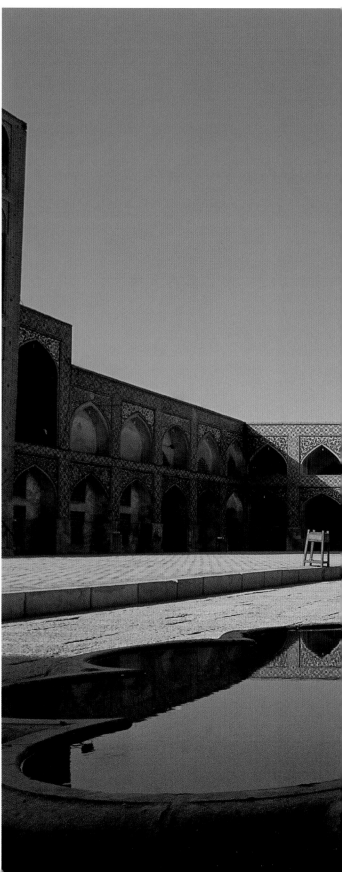

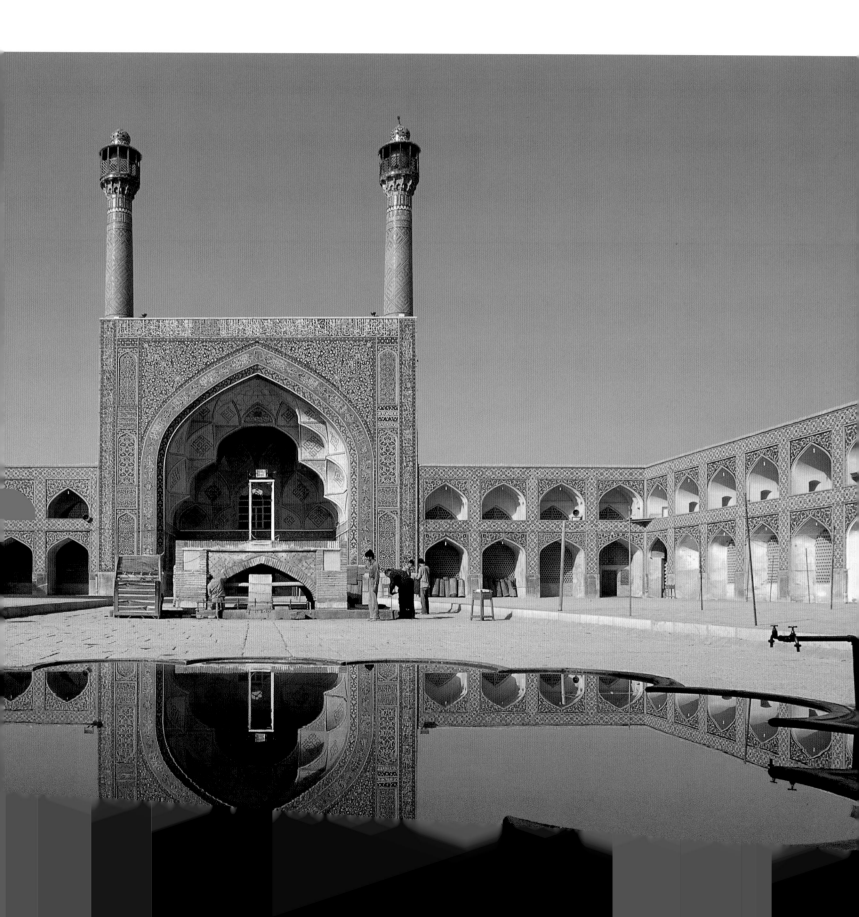

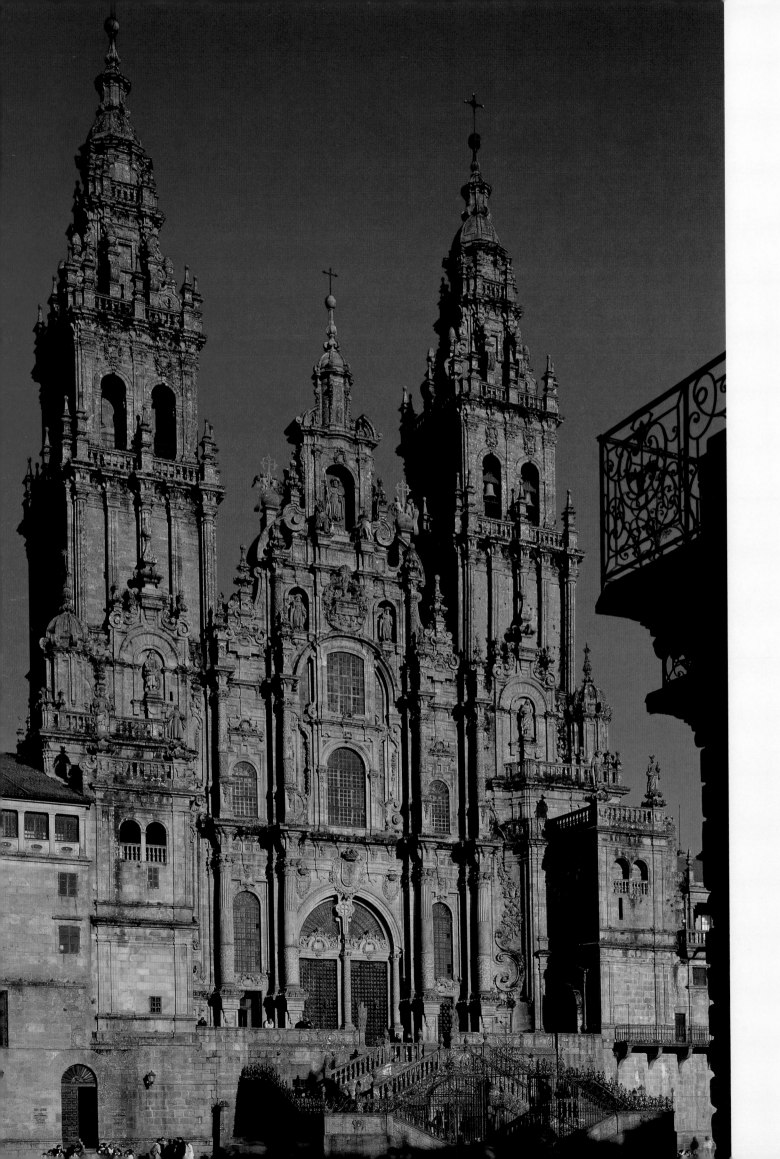

ABOVE
A detail of the south façade overlooking the small Praza das Praterias – Silversmiths' Square.

LEFT
One of the great sights of Christendom, the west façade in the 'Churrigueresque' style.

PAGE 86
The figure of St James flanked by two of his followers overlooks the Praza da Quintana on the eastern façade of the cathedral.

PAGE 87
A detail of the original Romanesque façade, the Pórtico da Gloria, begun c. 1188, that sits behind the Baroque façade. The vivid naturalism of the figures brings an almost theatrical energy to the architecture.

Cathedral of Santiago

SANTIAGO DE COMPOSTELA SPAIN

Early in the 9th century the body of the martyred apostle St James (Santiago) was discovered near Compostela in the north-west corner of Spain. According to different legends he had come after Christ's death, or possibly had been brought there following his own death. It was an opportune discovery. At war with the Moors, the Christian inhabitants found in the saint a supernatural ally, earning him the name *Matamoros* ('Slayer of Moors'). Soon his burial place became the most popular shrine in Europe, attracting vast crowds of pilgrims.

A contemporary document, the *Liber Sancti Iacobi*, recorded that work began on a new cathedral in 1075 under the architect 'Bernard the elder, a wonderful master', who was accompanied by his assistant Rotbertus and fifty masons. The building was finished by 1128. While there are other pilgrimage churches of a similar design in France, including Sainte-Foy at Conques (see pp. 66–71), Santiago is the most developed example of this type. It has an aisled nave of eleven bays that intersects with transepts of six bays each. To the east extends a choir of three bays, ending in an ambulatory and five radiating chapels.

Between 1168 and 1211 a superb western façade was added, incorporating the 'Pórtico da Gloria', which was sculpted by Master Mateo between 1168 and 1188. Inspired by contemporary examples in France (which in turn show Byzantine influence), there are three doorways, each flanked by near life-size statues of prophets and apostles and with tympana above. In the central tympanum sits Christ, displaying his wounds; around him are the Evangelists with their symbols, and beside them angels carrying the instruments of the Passion. In the semicircular archivolts above are the twenty-four Elders of the Apocalypse.

Approaching the cathedral today, however, none of this is even hinted at. In the mid-18th century a whole new façade, the Obradoiro, was added by Fernando Casas y Novoa, concealing the Pórtico da Gloria behind it. This new façade is a masterpiece of the Spanish Baroque style called Churrigueresque and shows an extreme decorative detailing involving layers of half-columns and pilasters surrounding an enormous central window. The façade ignores the Romanesque church behind it (though the two earlier towers of 1675 remain beneath it), yet it serves as a striking visual exclamation that the pilgrim has reached his goal.

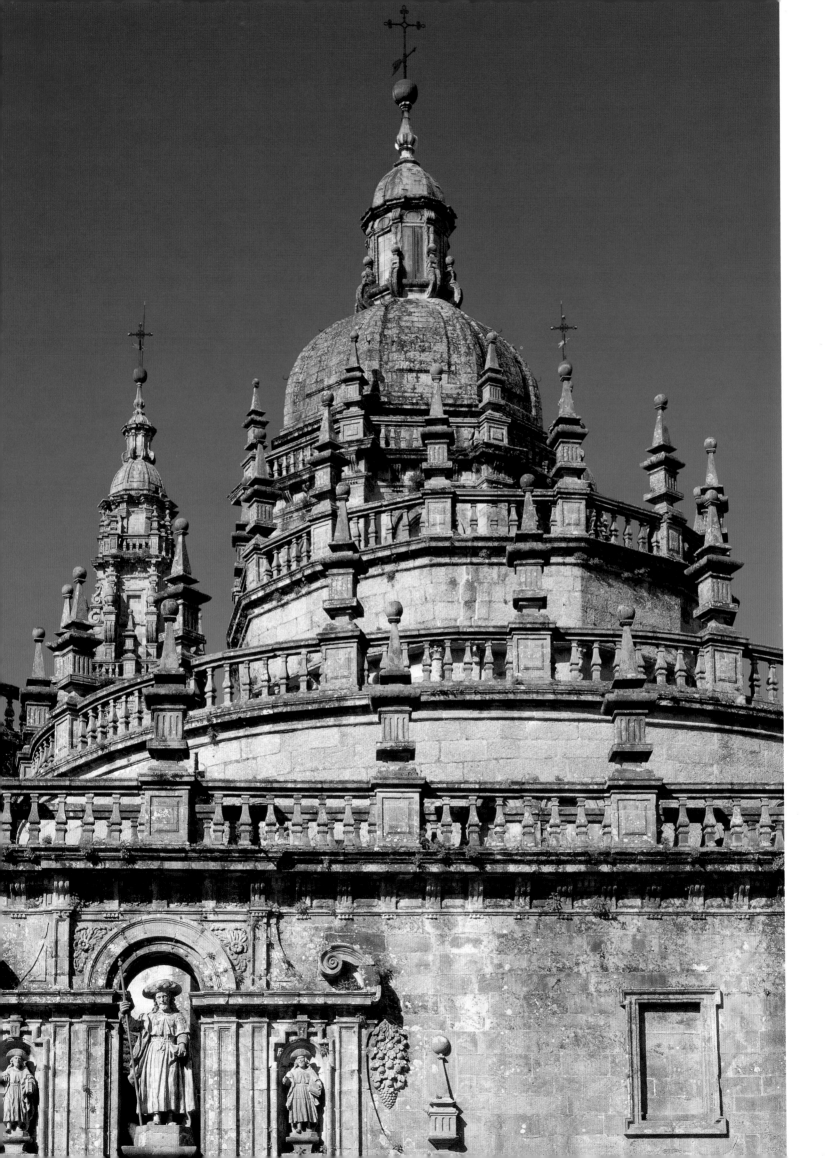

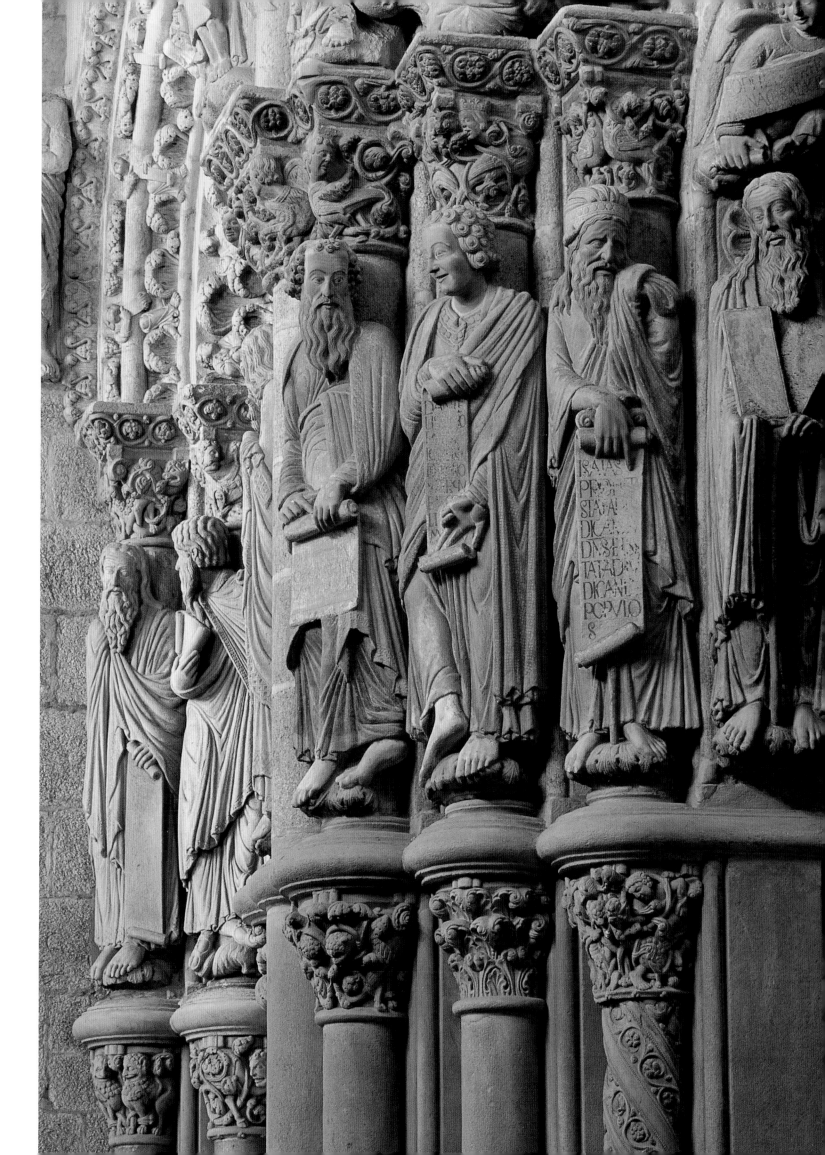

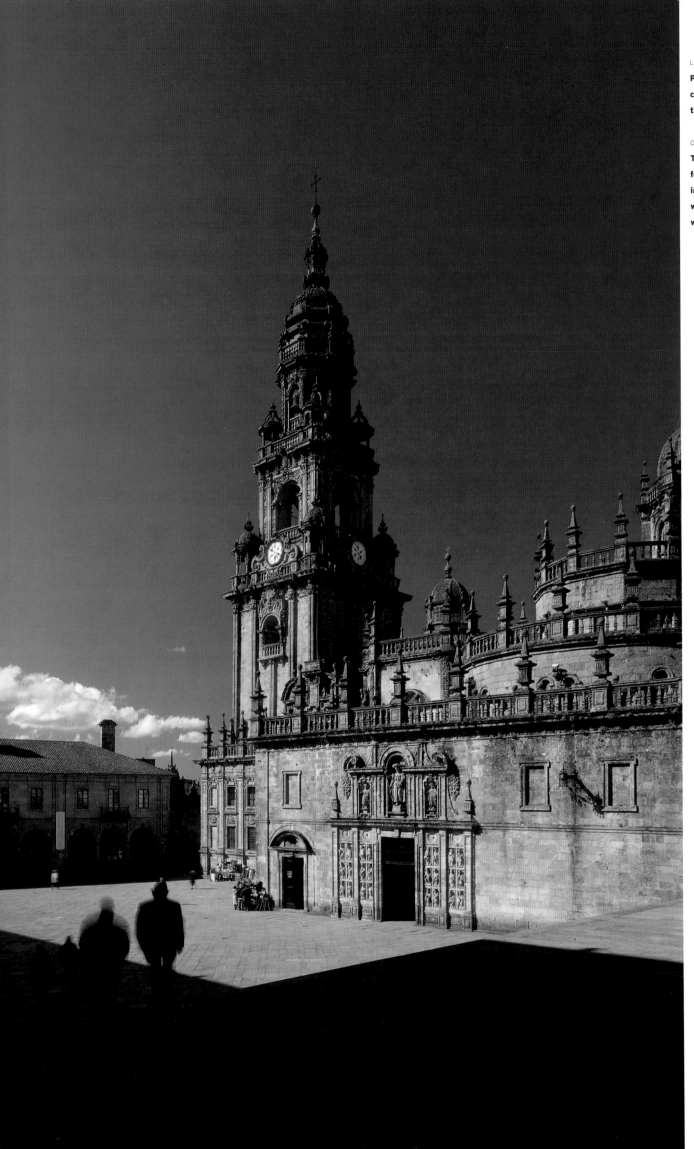

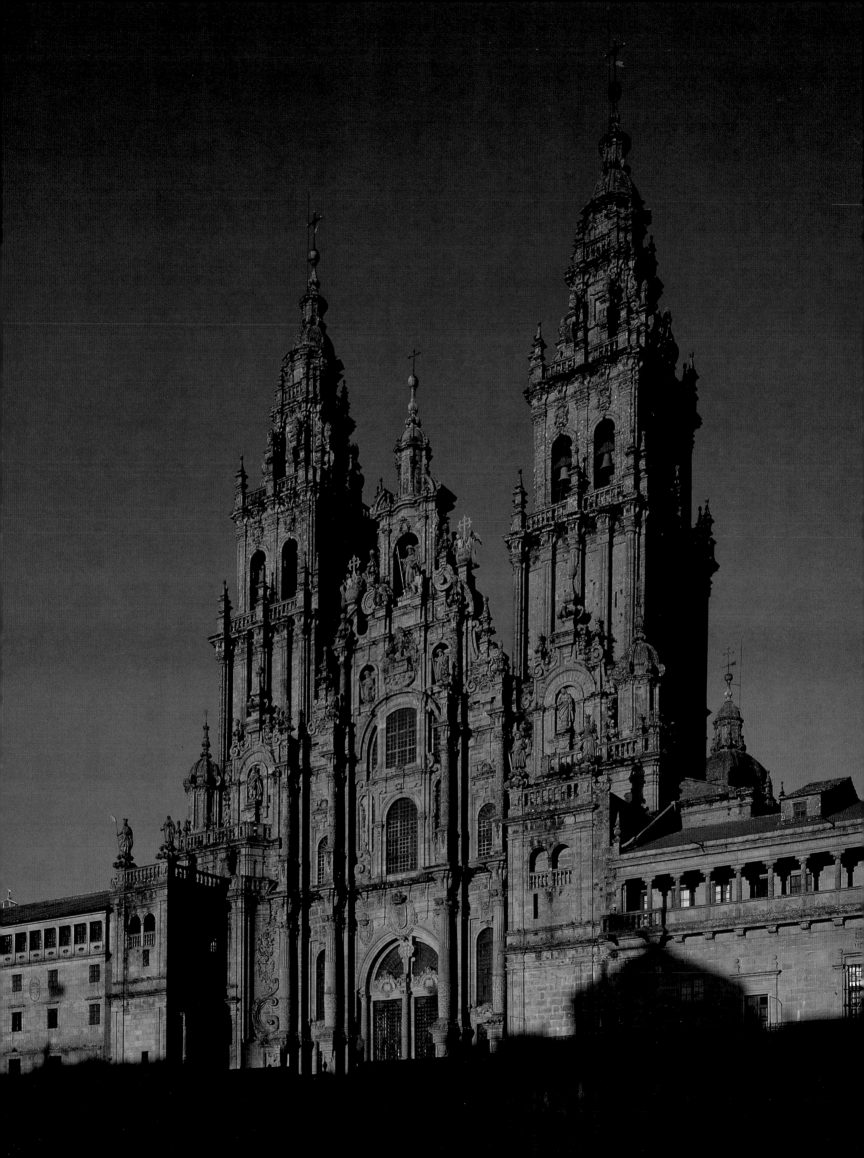

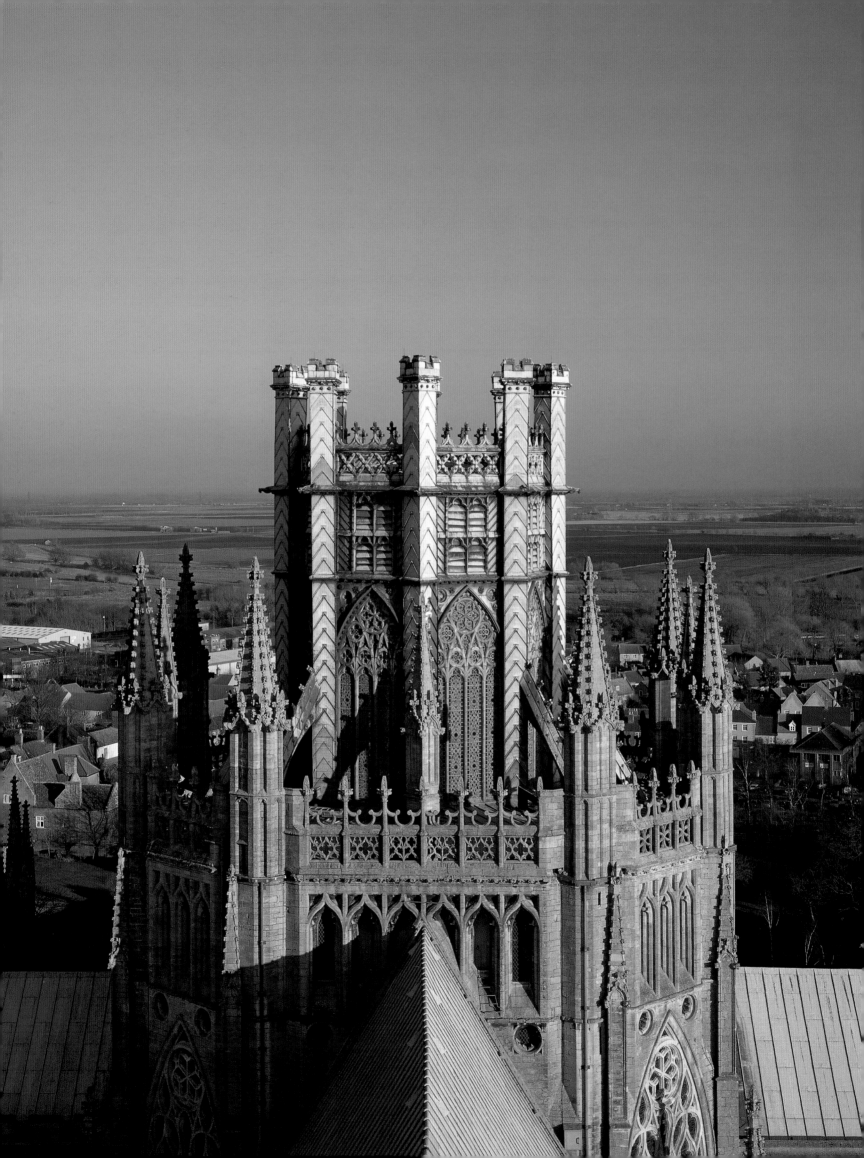

A view into the Decorated choir (which was completed by 1349), past one of the diagonal walls erected by 1328 to support the lantern.

A masterpiece of English carpentry, the octagonal lantern was completed in 1340 and the exterior covered with lead in 1352-3. It was restored in the 19th century.

Ely Cathedral

ELY ENGLAND

Ely Cathedral is a superb amalgamation of English architectural styles: its nave is Romanesque, its presbytery illustrates Early English (early Gothic) at its best, and its crossing is a unique example of Decorated (advanced Gothic).

Until the draining of the surrounding Fenlands in the 18th century, the city of Ely was an island. After the Norman conquest of England in 1066 it became the stronghold for the Anglo-Saxon outlaw Hereward the Wake (who was eventually captured in 1071). In a symbolic act of conquest, the existing Anglo-Saxon monastery was replaced with a huge Norman (Romanesque) cathedral, which was begun in 1082. The west end of this new Norman structure terminated in a short transept (the northern arm of which collapsed in the 15th century); and above the transept was built the single, axial tower that we can still see today.

The twelve-bay nave also dates from the Romanesque period but as with nearly every medieval great church, over time the chancel was found to be too small and in the mid-13th century a presbytery was added to the east end. Inspired by work at Salisbury and Worcester Cathedrals, this extension surpassed both of these churches in the range and quality of its decoration. The tribune, clearstorey and arcade of the presbytery are all richly detailed and shafts of Purbeck marble divide the bays, each topped with a stiff-leaf capital and supported by a luxuriant foliate bracket.

On 22 February 1322, the Norman crossing tower collapsed. To replace it, the Chapter (the governing body of the cathedral) commissioned one of the boldest structures in medieval architecture. Instead of building another tower, they decided to demolish the last aisle bay of the nave, main transepts and choir, transforming the square crossing into an octagon. Above this they constructed a lantern that floods the space with light. This lantern is apparently made of stone and supported on stone corbels that consist of eight sections of tierceron vault (tierceron ribs are ribs without structural function). In fact the ensemble is made of wood, and is the work of master-carpenter William Hurley (or Hurle), and it does not rest on the vault-sections, but instead on eight massive, unseen, timber beams. Since there was no liturgical reason for this form, the entire enterprise seems to have been motivated purely by a desire to manipulate space in a new way, a desire typical of English architecture in the mid-14th century. Nevertheless, it is hard to grasp how revolutionary it must have been at the time of construction, and even today Ely Cathedral is an architectural experience unlike any other.

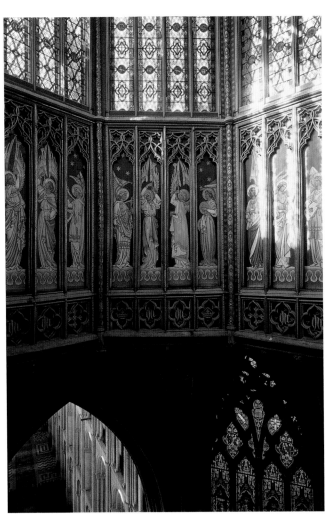

The interior of the wooden lantern sits almost magically above the crossing. Though the vaults look as through they are made of stone, they are in fact painted wood.

Originally Ely was an island, and the cathedral is still known as the 'Ship of the Fens'. The Romanesque west tower contrasts with the Gothic lantern and east end.

Ely Cathedral is 157.6 metres (517 feet) long; here, looking from east to west, we see the presbytery, the chancel, the choir, the octagonal crossing and finally the nave.

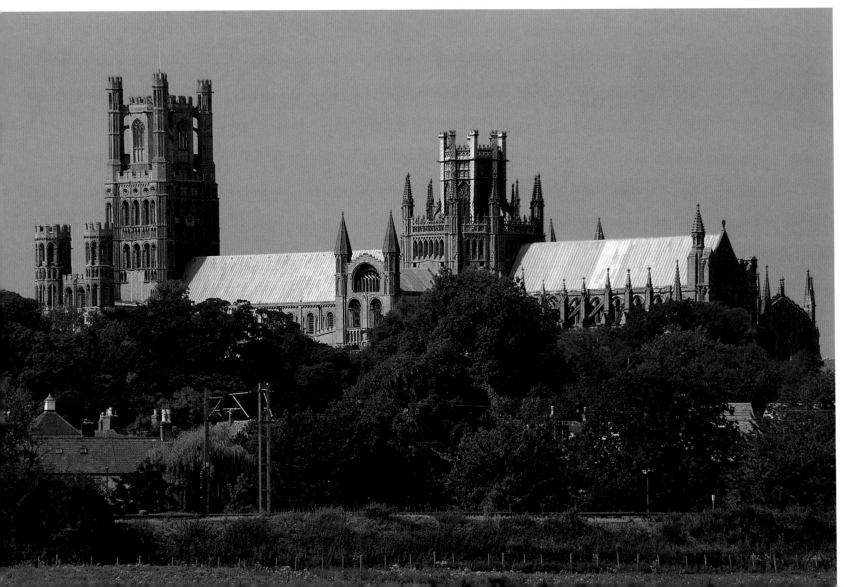

Durham Cathedral

DURHAM ENGLAND

In about 995 Bishop Aldhun of Chester-le-Street and his clergy brought the remains of their patron saint, Cuthbert, to this isolated place in the north of England, thus effectively founding the city of Durham. However, the layout of the city, as well as its castle and cathedral, are all products of the Norman Conquest of 1066. The Normans immediately recognized the strategic importance of this craggy rock surrounded by the River Wear as the first line of defence against the Scots. They fortified the peninsula in 1072 and began a new cathedral and monastery in 1093. As a consequence the Bishop of Durham acquired an additional role as a military leader and secular lord.

The new cathedral had a conventional Romanesque plan, though the three-storey internal elevation has unusual proportions for the period. The arcade of piers is very tall, almost as tall as the gallery and clearstorey above it combined. This great size gives Durham a powerful monumental appearance, with minor cylindrical piers alternating with major compound piers whose shafts rise to the clearstorey and support the transverse arches and ribs. It is these ribs, in particular, that put Durham at the vanguard of architecture at the time (similar ribs can be found at the near-contemporary church of Sant'Ambrogio in Milan, though its vault is much lower than that of Durham).

Durham's internal surfaces are covered with brilliantly distributed geometrical patterns. Zigzags, spirals and lozenge-shaped incisions cover the round piers, while mouldings, shafts and chevrons juxtapose delicate details against the extreme mass. In the 12th century a single-storey structure, known as the Galilee Chapel, was built in front of the west end of the cathedral. This five-aisled hall was intended to serve as a Lady Chapel (that is, dedicated to the Virgin Mary), but was not placed where it might normally be found, at the east end, so as not to offend the remains of the notoriously female-fearing St Cuthbert. The style is late Romanesque with slender, elegant arcades and lavish use of zigzag ornament.

Today, Durham survives more or less intact. While it has some later Gothic elements - the flying buttresses concealed by the sloping roofs of the tribunes, and some pointed arches - its massive monolithic character, solemn rhythms and distinctive decoration remain as the most complete example of the Romanesque in Britain and arguably the greatest Romanesque building in the world.

ABOVE

The simple design of the Galilee Chapel is offset by heavily incised zigzag patterns and the use of Purbeck marble for half the shafts of the quatrefoil section piers.

OPPOSITE

Durham Cathedral seen across the River Wear. The low Galilee Chapel sits below the west front. In spite of alterations to the western towers during the Middle Ages, Durham remains the most complete Romanesque building in Britain.

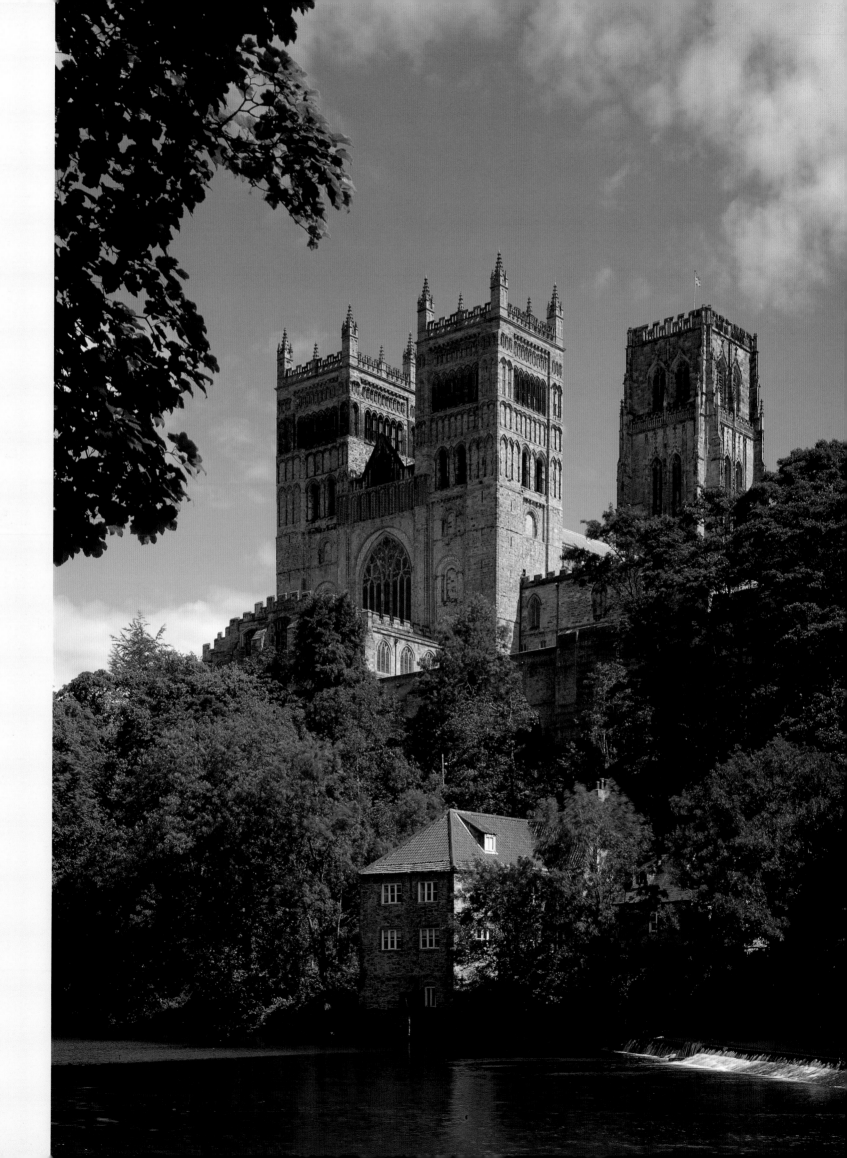

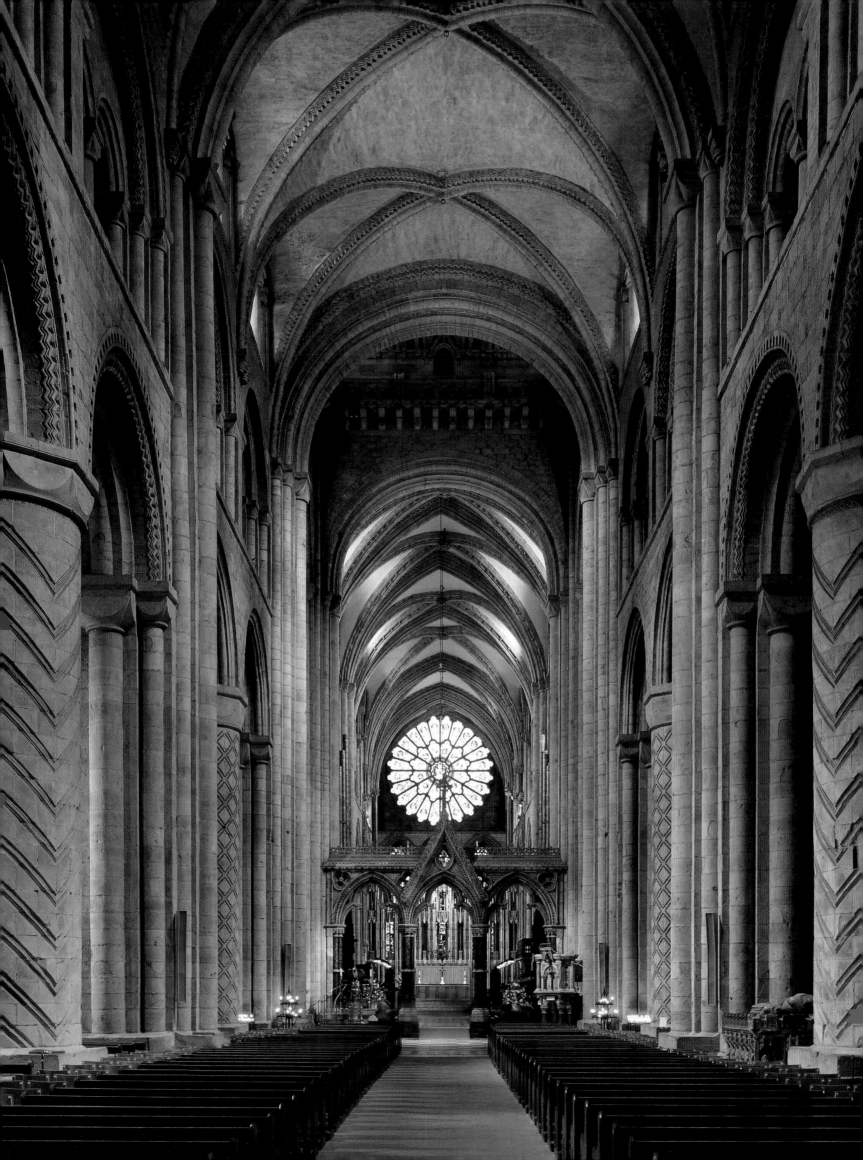

OPPOSITE

**The nave contains the
earliest rib vaulting found
anywhere, preparing the
way for the Gothic style.
The decoration of the piers
was audaciously incised
after their erection.**

RIGHT

**The present choir vault
dates from the mid-13th
century and has Gothic
pointed arches. Behind
the high altar stands
the Neville Screen, an
elaborate structure in
the Perpendicular style
consecrated in 1380.
The canopies once
protected statues,
but these went missing
during the Reformation.**

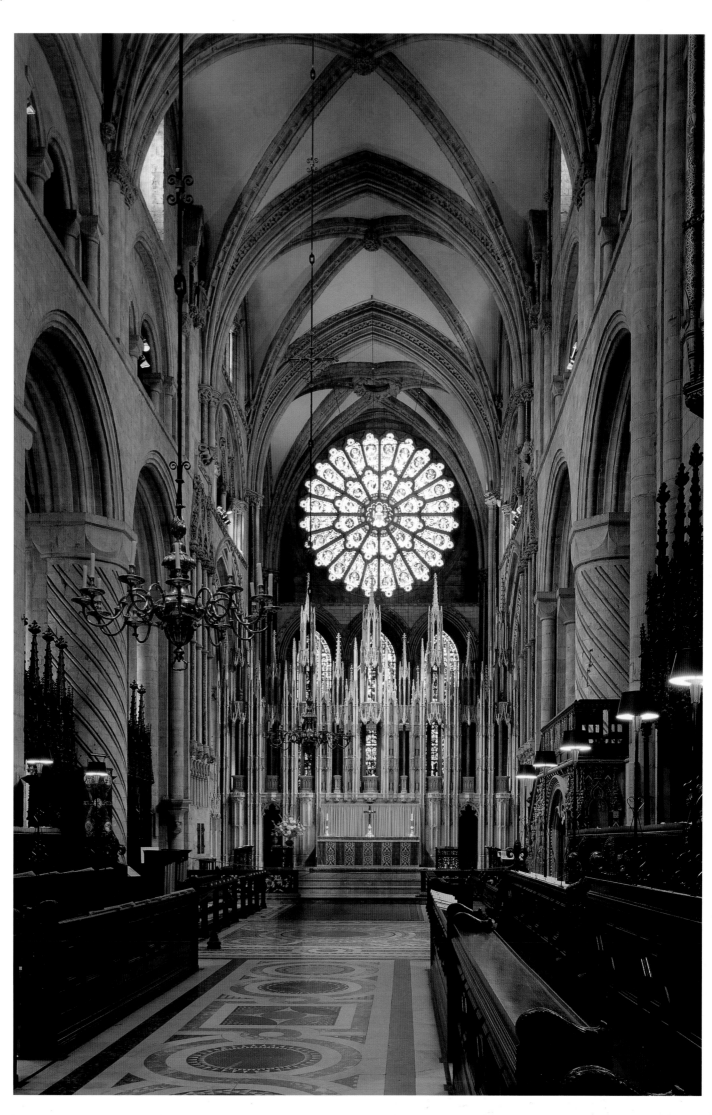

Modena Cathedral

MODENA ITALY

The town of Modena had existed since Roman times, but it was only at the end of the 11th century that it established a leading position in the Po Valley. Under the powerful Matilda, Countess of Canossa, a new cathedral was begun in 1099, and the relics of the local saint Germinianus were translated to the crypt in 1106. Building went on for almost one hundred years, and the cathedral was eventually consecrated in 1184. Later in the 12th century a wheel or rose window was added to the west front and the tall bell tower - known as the Ghirlandina - was added next to the apse. In the 15th century the wooden ceiling was replaced with a stone vault.

Unusually, we know the name of the architect responsible for the design: Lanfranco. Apart from the later additions mentioned above, the cathedral has retained most of its 11th-century appearance, and is widely regarded as the finest Romanesque building of its type. Its civic importance is underlined by the fact that it is unabutted by other buildings on three sides, and the overall feel of the building and its arrangement with the city is reminiscent of Roman planning.

While the structure is brick, the façades are covered with superb ashlar. The west, main façade is divided vertically by buttresses on either side of the central vessel and horizontally by a course of galleries. These sit within semicircular openings supported by half-columns. Above this level lies the large wheel or rose window. These simple shapes are countered by a wealth of sculptural embellishment added by Wiligelmo (whose name is recorded in an inscription on the façade) around the three portals. Around the central portal we find scenes from Genesis (from the Creation to Noah), figures of Enoch and Elijah, and prophets. Around the south portal, meanwhile, are legends of St Geminianus (the 4th-century bishop to whom the cathedral is dedicated), together with the Twelve Apostles. And around the north portal the scenes seem to allude to the story of King Arthur, curiously predating any of the literary sources. Wiligelmo's style, which was highly influential in the north of Italy, is formalized but also capable of a surprising degree of naturalism and a great feeling for narrative.

The north façade contains three apses, the two smaller ones ending the aisles flanking the taller apse of the nave. The south façade is plain but contains two elaborate portals - the Porta dei Principi and the Porta Regia - the latter a masterpiece of the Romanesque style.

Uniting these façades are the ubiquitous galleries, a Lombard theme here developed by Lanfranco into groups of small tripartite arches entirely of his own creation. They emphasize the modularity of the heavy Romanesque elements and impart a sense of rhythm to the whole.

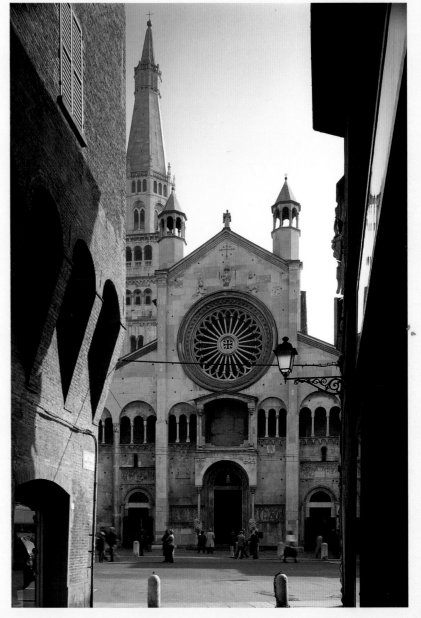

ABOVE
The west façade with its remarkable wheel window, and beyond it the freestanding campanile known as the Ghirlandina.

OPPOSITE
The three apses of the east end, which correspond to the central vessel and two side aisles.

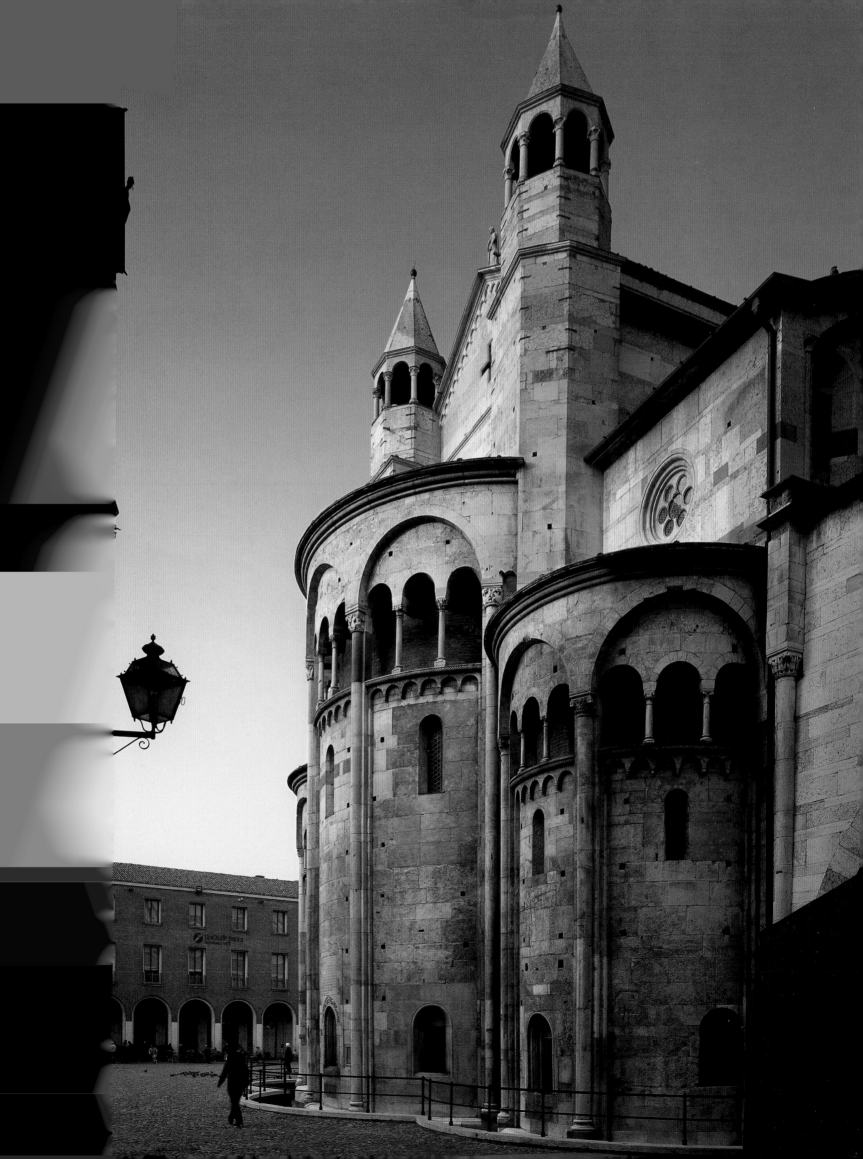

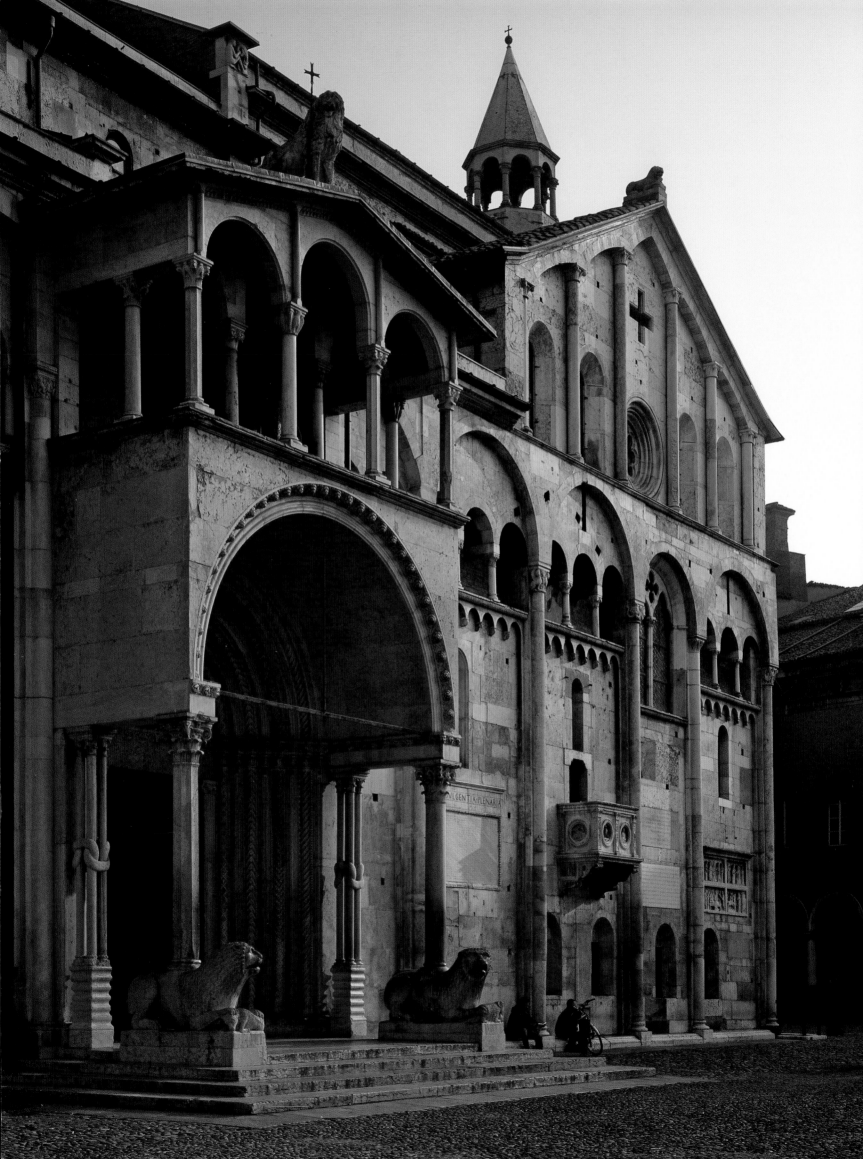

The Porta Regia of the south façade. The lions supporting the columns are of Ancient Roman origin and may have been dug up when building the cathedral's foundations.

The galleries set under a larger arch unite the various façades of the building.

The atmospheric crypt has contained the relics of St Germinianus since 1106.

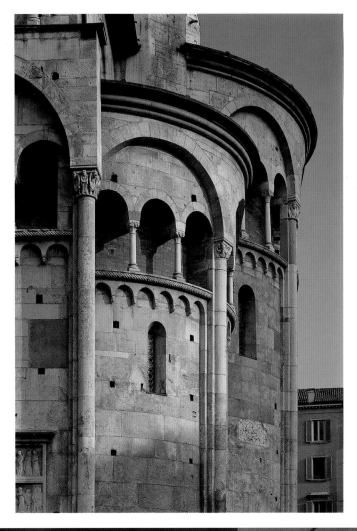

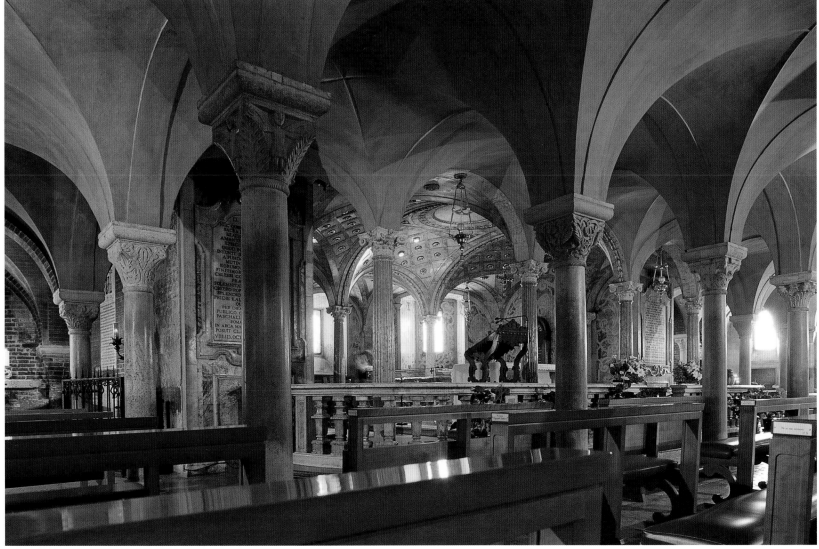

Angkor Wat

ANGKOR CAMBODIA

Angkor, in the north-west of modern-day Cambodia, was the site of the Khmer civilization from the end of the 9th century until the middle of the 15th. During this period each ruler of Angkor built a state temple in the form of a stepped pyramid representing Mount Meru, surrounded by concentric walls, ditches, embankments and moats laid out in accordance with Hindu cosmology. Angkor Wat, the largest and most important of all the temples at Angkor, was started by King Suryavarman II (1113–50), but not completed until after his death. Unusually, it is dedicated not to Shiva but to Vishnu and accordingly it is oriented towards the west.

The temple is arguably the largest religious monument in the world. Its surrounding moat is 1,500 metres (4,922 feet) from west to east, 1,300 metres (4,265 feet) from north to south, and 200 metres (656 feet) wide. The island created, which covers about 21 hectares (52 acres), is entered by a pavilion containing three *gopuras* (entrances surmounted by towers). The central *gopura* opens onto a causeway 350 metres (1,148 feet) long that crosses an outer courtyard. This courtyard is enclosed by a gallery measuring 187 by 215 metres (614 by 705 feet), open only to the outside. The inner wall displays low-relief sculptures of scenes from Hindu epics, sacred texts and a series showing Suryavarman II reviewing his armies and marching towards the kingdom of the dead.

Inside this first enclosure, though 11 metres (36 feet) higher, sits a second enclosure, 100 metres (328 feet) wide and 115 metres (377 feet) long. This, too, is surrounded by a gallery, though this time the solid wall is on the outside, while on the inside openwork doors and windows allow views across the courtyard to the central mass. Within this second enclosure is another enclosure, the gallery of which is open on both sides. Further open galleries, resting on pillars, link four cruciform *gopuras* to the central monument, upon which rests the tallest *gopura*.

The composition of Angkor Wat is a specific attempt to provide a complete rendition of the Hindu universe. Surrounded by the primordial ocean, represented by its moat, the temple unravels in a series of horizontal layers representing the concentric continents that in Hindu cosmology surround the sacred mountain. The penitent had to climb the series of levels, processing around the galleries and from time to time getting a glimpse of the central tower. The general horizontality of the complex emphasizes the verticality of this tower. This highest point was built above the principal sanctuary; below the sanctuary was placed the temple's foundation deposit. This vertical axis linked the three Hindu worlds of Gods, of men and of darkness: the tower's summit was the place where Gods dwelt on earth, the outer moat was chaos, and the layers of Angkor Wat connected the two. Completing the journey to enlightenment was not only profound but also deliberately arduous.

ABOVE
Angkor Wat is today an active focus of devotion for Cambodian Buddhists.

OPPOSITE
The entrance pavilion is flanked by long galleries open to the outside but with solid internal walls. They mark the first point of devotion.

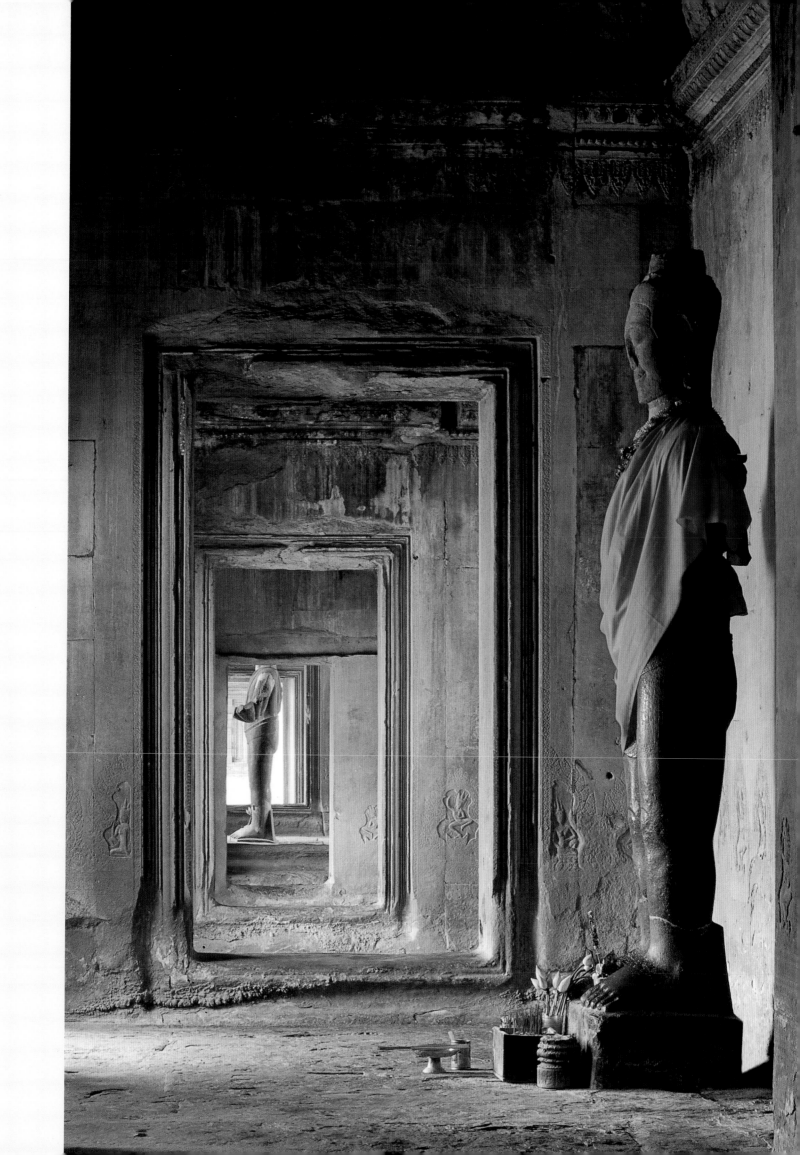

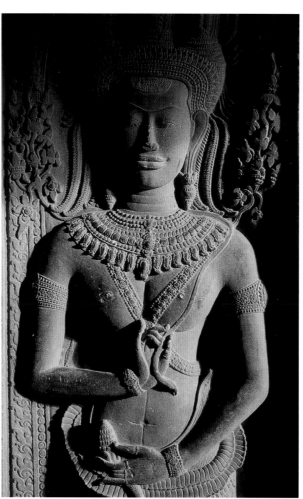

LEFT
There are over two thousand *apsara* figures on the walls of Angkor Wat. These celestial nymphs, whose name means 'water that moves', according to legend were created during the Churning of the Ocean of Milk.

BELOW
An unidentified *asura* king assists the Churning of the Ocean of Milk, part of a 48-metre (157-foot) relief sculpture on the east wall. Organized by Vishnu, the gods (*devas*) and demons (*asuras*) cooperated to churn the Ocean in order to release the elixir of life (*amrita*).

OPPOSITE
The central tower in the first enclosure. This was one of five towers, a specifically Khmer feature intended to invoke the five summits of Mount Meru. It contained the shrine of Vishnu.

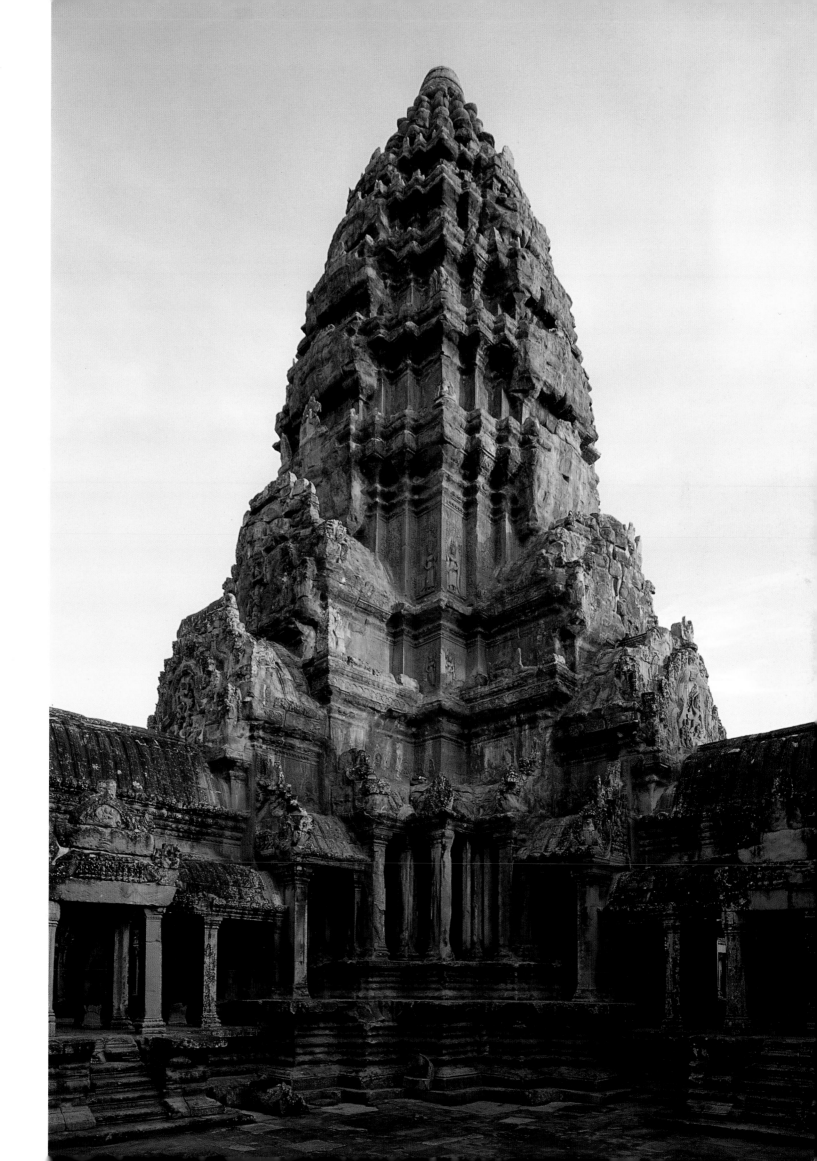

Canterbury Cathedral

CANTERBURY ENGLAND

When St Augustine arrived in England in 597 to convert the Anglo-Saxons to Christianity, he established a monastic cathedral at the court of King Aethelbert, in Canterbury. After the Norman Conquest of 1066 this original cathedral was replaced by a much larger building under Archbishop Lanfranc (c. 1070), which was further enlarged by Lanfranc's successor, Anselm. It was in this building that the Archbishop of Canterbury Thomas Becket was murdered in 1170 and four years later the entire east end, including the choir, was destroyed by fire. After much deliberation, the monks appointed a French architect, William of Sens, to rebuild it – this choice of architect suggests that they consciously intended it to be built in the latest French Gothic style. The new wing would serve both as a choir and as a martyrium to the murdered Thomas. Since his canonization in 1173, Canterbury Cathedral had become one of the most popular pilgrimage sites in England and the new building would have to provide access for the constant stream of penitents.

During the twelve years of the new wing's construction William of Sens was injured in an accident, and had to replaced by another architect, William the Englishman. The work of both men shows all the hallmarks of Gothic architecture: pointed arches, rib-vaults and flying buttresses (even if the latter are concealed under the aisle roof). The architectural style is essentially that of the contemporary Île-de-France, but with certain individual features. For example, the piers are alternately round and octagonal, with the subsidiary shafts in quintessentially English black Purbeck marble. The vaulting is sexpartite with each unit of three crossing ribs spanning two bays.

William the Englishman extended the new choir eastwards by adding the Trinity Chapel to house Becket's shrine. Here the architectural system changes, with coupled columns replacing single ones. Finally, at the extreme east end he built a tall circular chapel known as 'Becket's Crown'. The ensemble is a masterful synthesis of Gothic architecture, further enhanced by the stained glass windows that tell the stories of Becket's miracles.

Throughout this period the old Romanesque nave of Lanfranc was still standing, and it was not until the late 14th century that it was decided to rebuild it on a scale worthy of the country's premier cathedral. Assumed to have been the work of the king's master mason, Henry Yevele, it was constructed in the Perpendicular style, the last phase of English Gothic. Twice the height of the choir, its huge arcade creates a vast unified space filled with a mass of rising shafts.

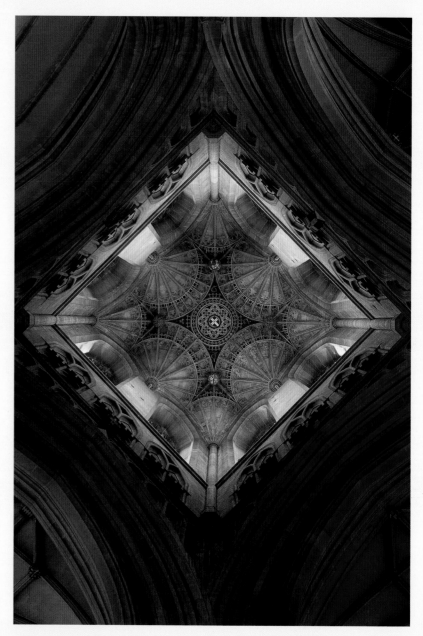

ABOVE

The crossing tower, known as 'Bell Harry', seen from below. Begun in 1496 by John Wastell, the spray of supporting fan vaults anticipates Wastell's later vaults at King's College, Cambridge.

OPPOSITE

A new plan for the west front was drawn up in the mid-15th century, but for some reason only the south tower was built. The strange discrepancy of one early Norman and one Perpendicular tower lasted until 1832, when the north tower was replaced by a copy of the south tower.

PAGES 108-109

The Perpendicular nave (right), contrasts with the early Gothic of Trinity Chapel (left), the site of Becket's shrine until it was destroyed in the Reformation. A candle marks the spot where it once stood.

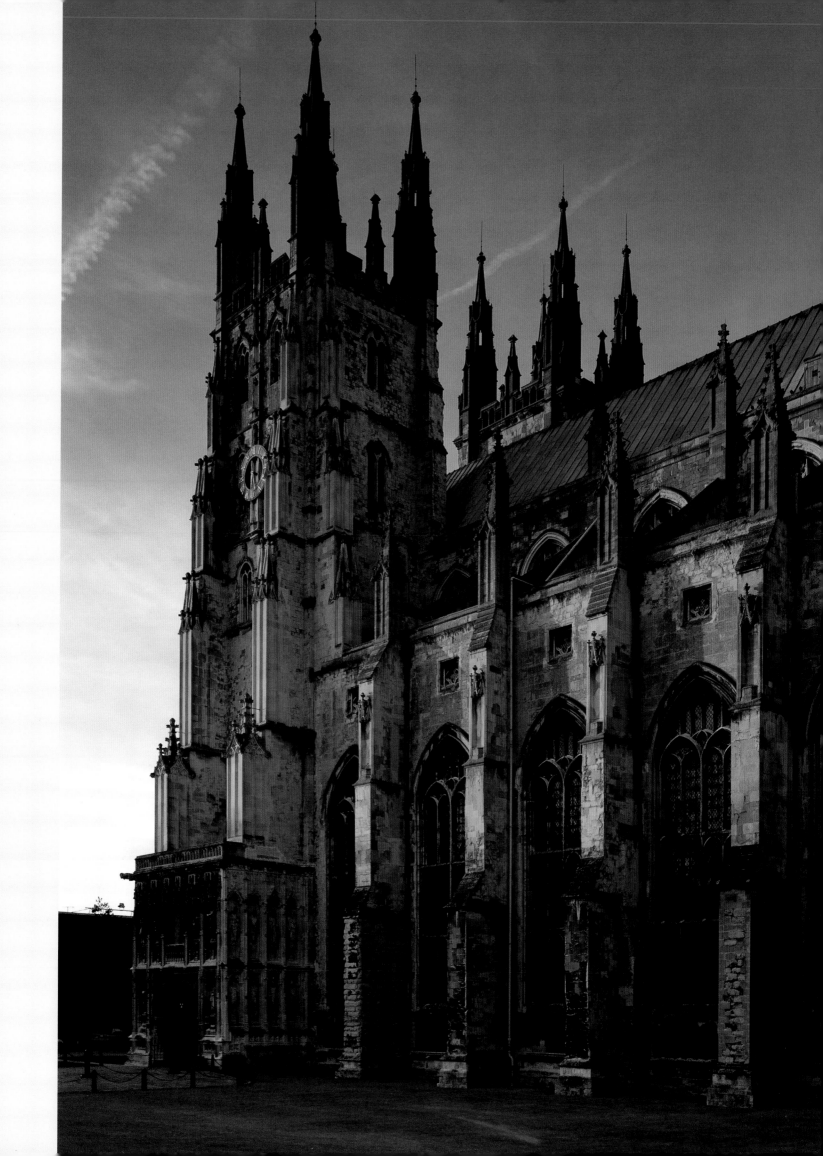

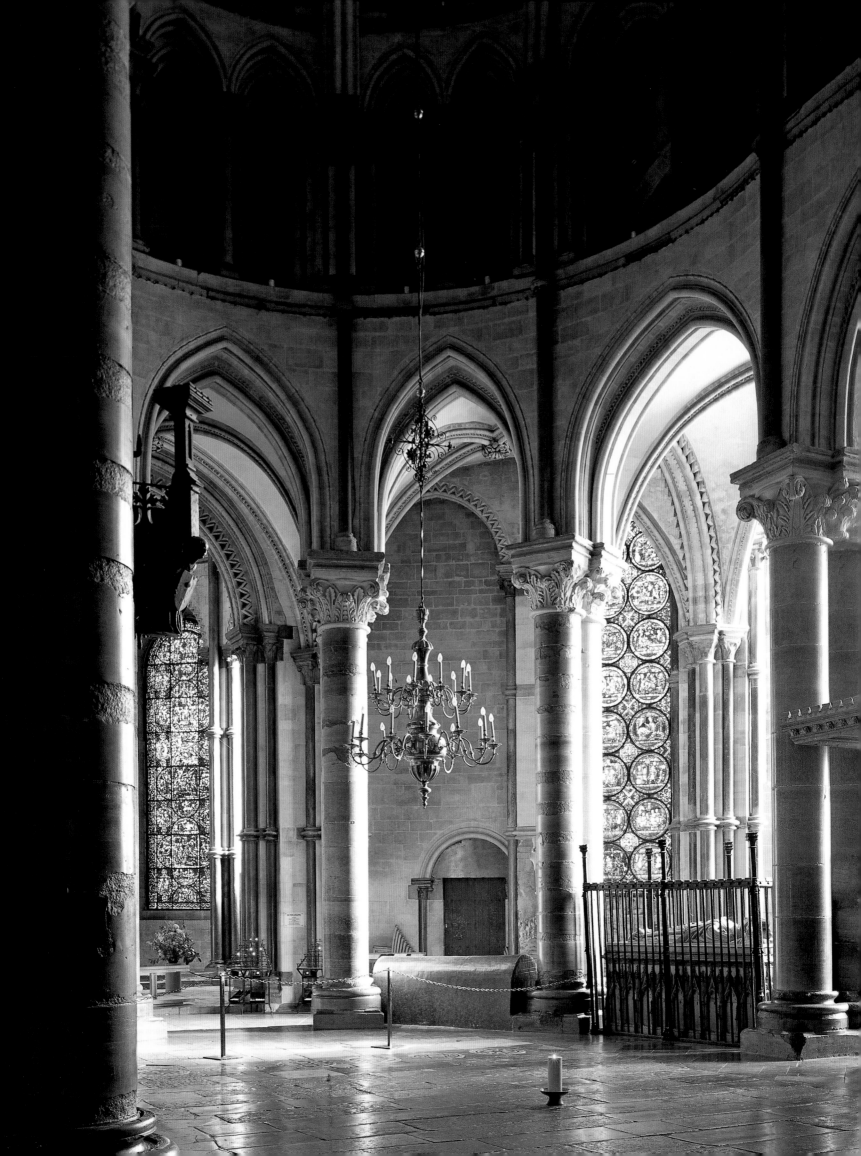

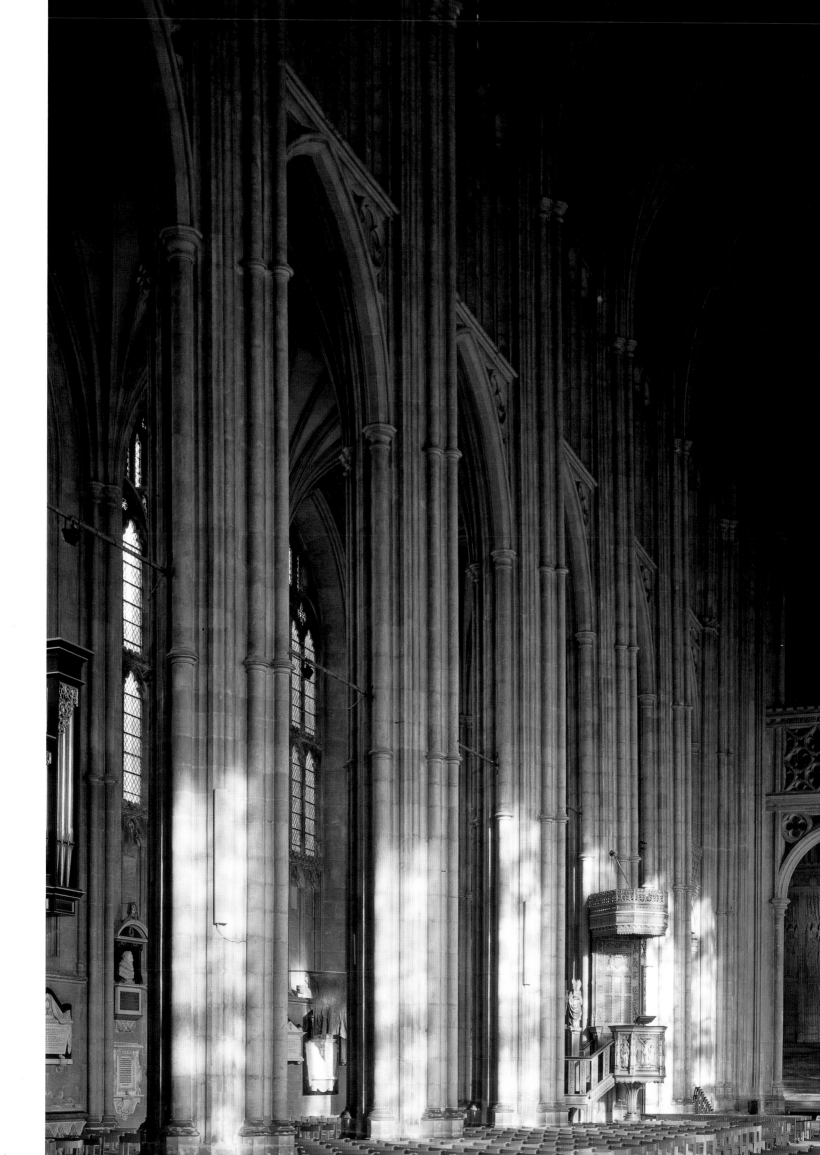

Seen from the east, the solid
bulk of the crossing tower
contrasts with the other more
transparent towers.

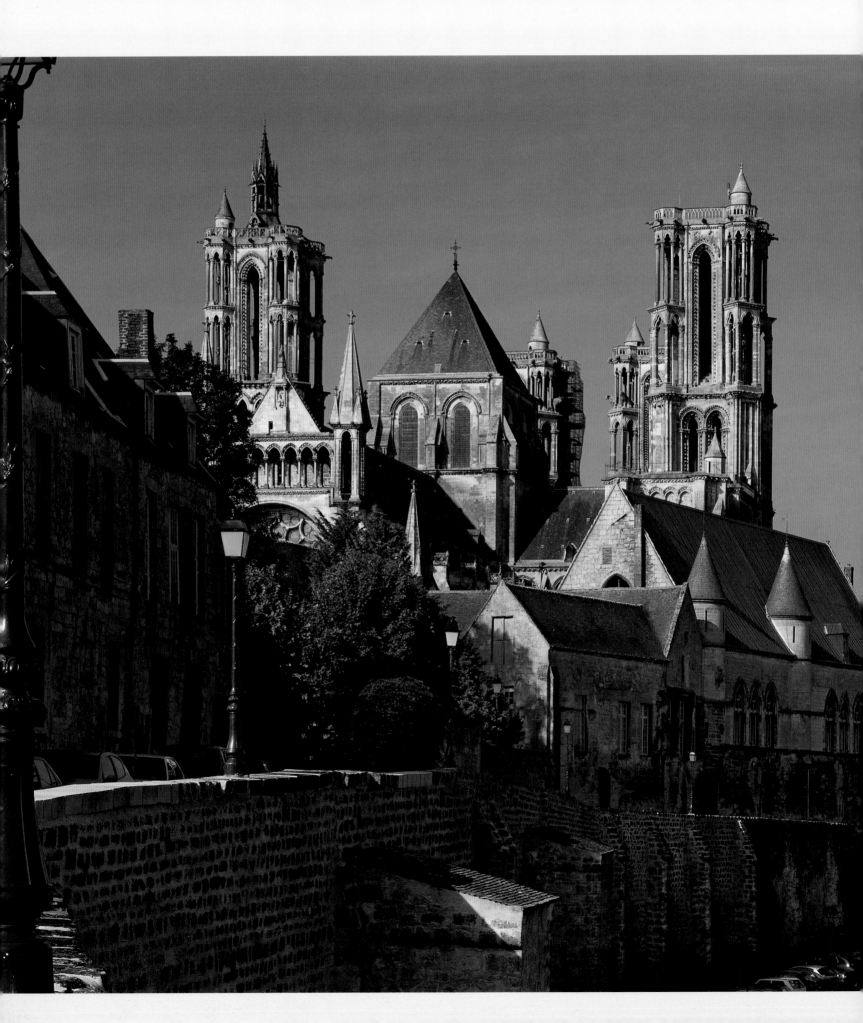

PAGE 112

The view from the nave towards the choir. The east end was originally built with a curved apse, but after a change of heart it was demolished. Now, very unusually, Laon Cathedral has a flat east end.

PAGE 113

View from the choir into the south transept. While the vault is Gothic, the four-storey elevation (arcade, gallery, triforium, clearstorey) and the punched holes for windows show Romanesque influence.

Laon Cathedral

L A O N F R A N C E

The city of Laon is perched high upon a stone plateau, 200 metres (650 feet) above the plains of Champagne and Picardy. Its cathedral is an outstanding member of the first generation of Gothic churches in the Île-de-France, while still containing elements that are recognizably Romanesque. The previous cathedral had been destroyed in 1112 by a fire that began during a violent uprising of the population against the excessive power of the bishop, a man of ducal status with the prestigious title of second peer of France. Its successor was begun in about 1166 and probably not finished until 1220.

Inside the cathedral the sense of solid mass characteristic of Romanesque architecture has yet to give way to one of dynamic line characteristic of mature Gothic. There are still no elements that rise uninterrupted from floor to vault – the cluster of shafts that support the sexpartite vault still spring from capitals at arcade level. The vertical rhythm is instead generated by the traditional columns that support these capitals. However, the four eastern bays of the nave differ in that the columns are given attached shafts, increasing the density of vertical elements as they approach the crossing. The pattern so created draws the eye to the light of the crossing – the focus of the interior. The later choir is an unusual example of what used to be called 'archaism', since the architect exactly replicated the system of the nave, even including the by then unfashionable sexpartite vaulting, and basing the design of the east rose window on the older west one. In fact, this concern for consistency appears to have been valued by all four architects who worked at Laon over almost sixty years.

The exterior, especially the west front, resembles a hollowed-out wall of stone rather than a matrix of separate load-bearing elements. The porches are like dark caves, much deeper than the portals of later cathedrals such as Reims or Amiens (see pp. 132, 134). The towers are heavy constructions in which square and octagon maintain separate identities through multi-shafted turrets at the corners, rather than merging into a complex unity. As the cathedral is both perched on the plateau and hemmed in, the diagonal emphasis of these towers allows them to make a powerful impression when glimpsed from any angle.

Laon was intended to have seven towers but even with five it suggests a conscious intention to evoke Mount Sion, in whose towers Psalm 47 (48 in some translations) reminded the faithful to seek God. The citizens of Laon, however, may well have seen the new cathedral as the determined reassertion of the temporal power of the Church.

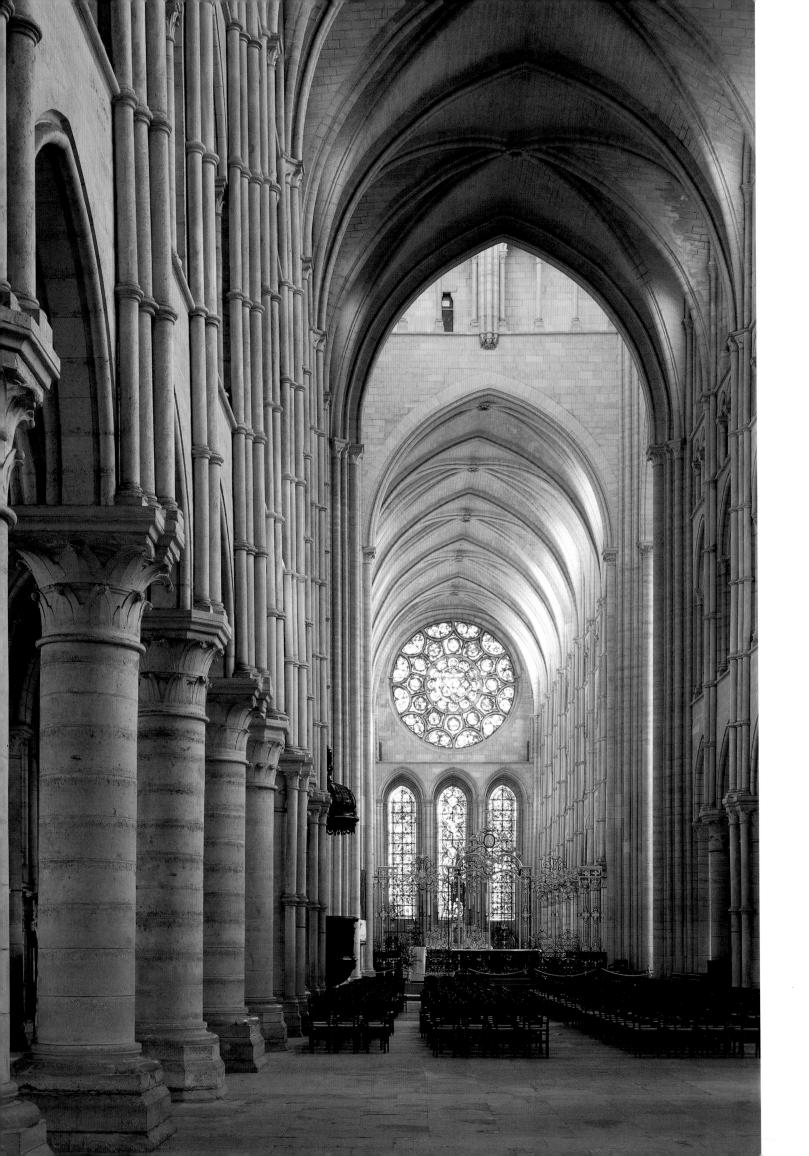

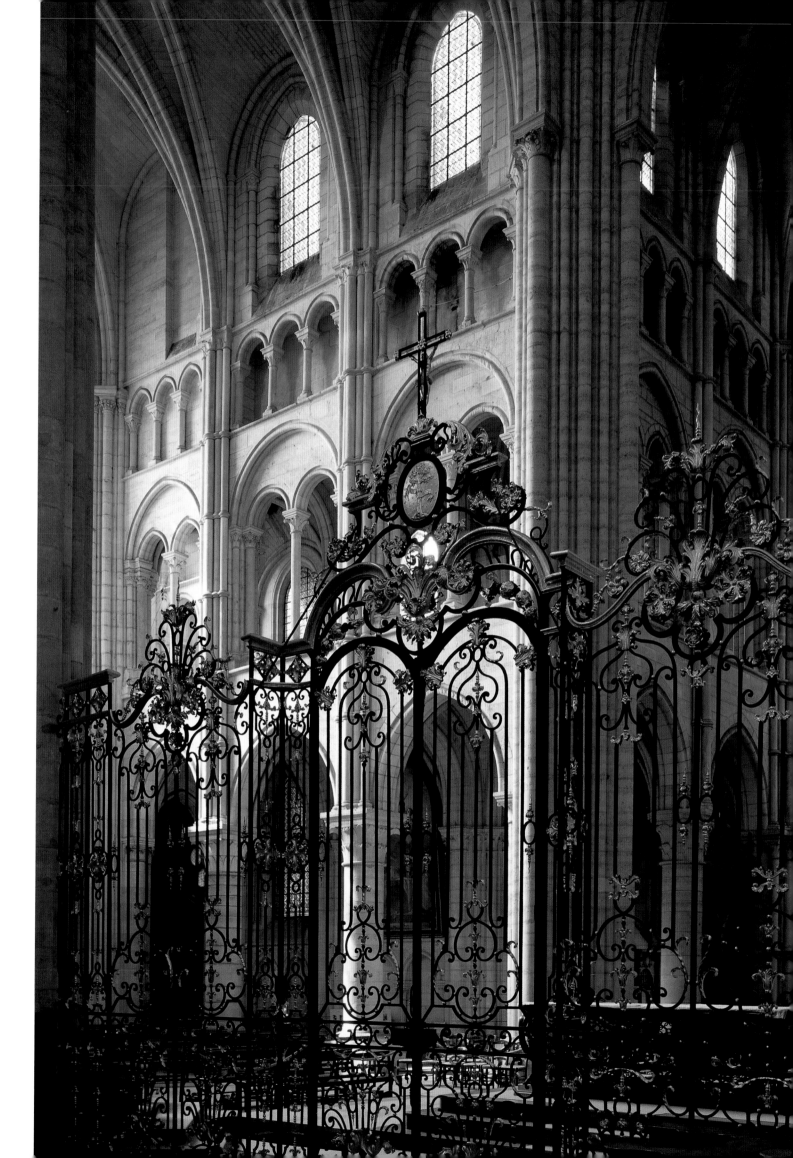

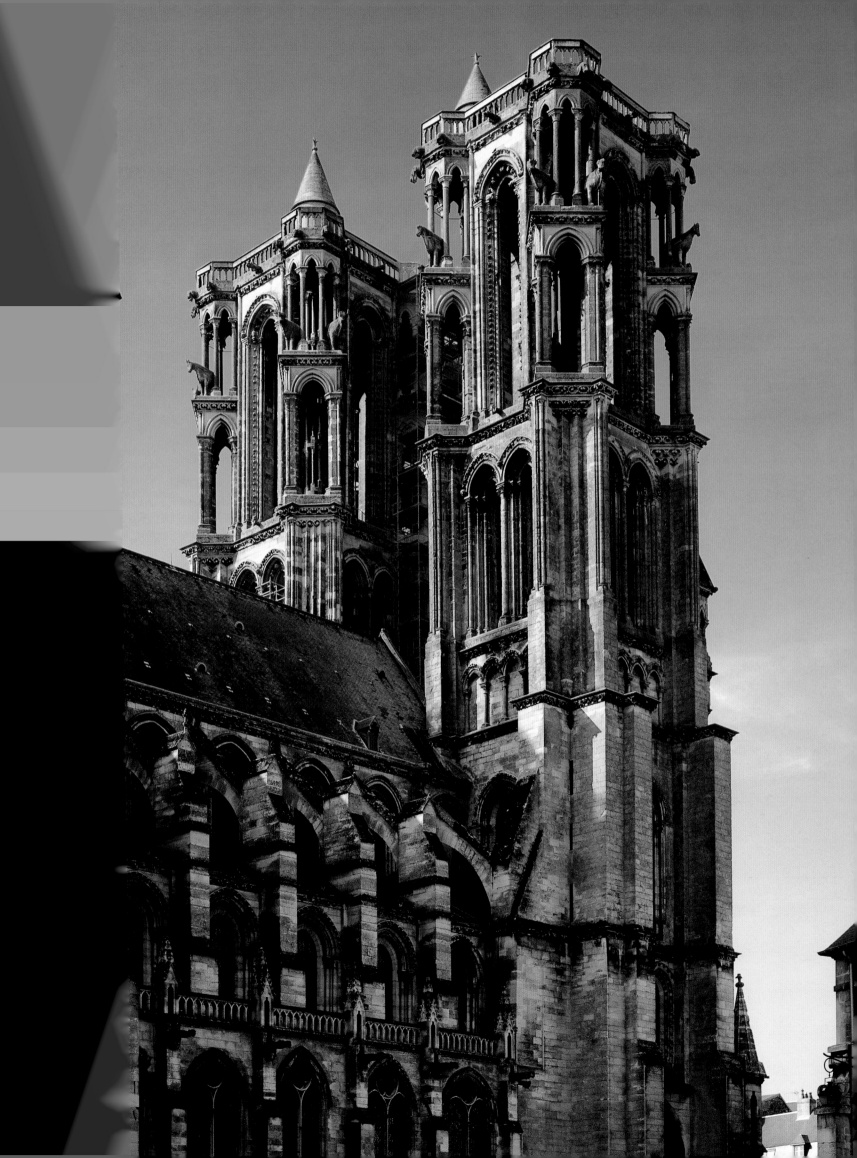

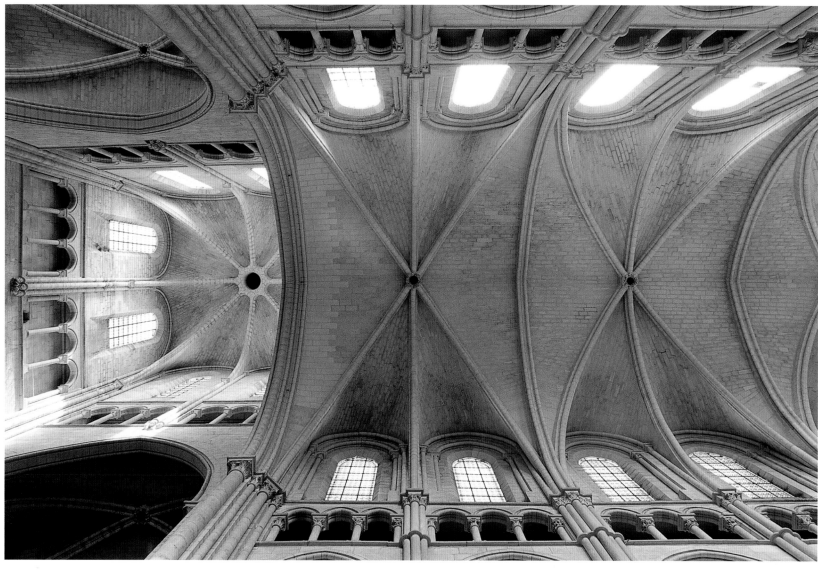

ABOVE

The sexpartite vault of the choir.
To the left is the lantern of
the crossing.

RIGHT

Figures fill the archivolts of the
porches in the west front.

FAR RIGHT

Two jamb figures from the central
portal on the west façade.

OPPOSITE

Sixteen oxen peer out from the
openings of the topmost stage of
the west towers, a commemoration
of the miraculous appearance of
oxen who helped haul the stone
used to build the cathedral
up the steep hill.

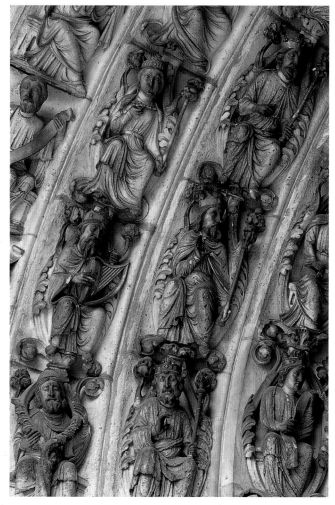

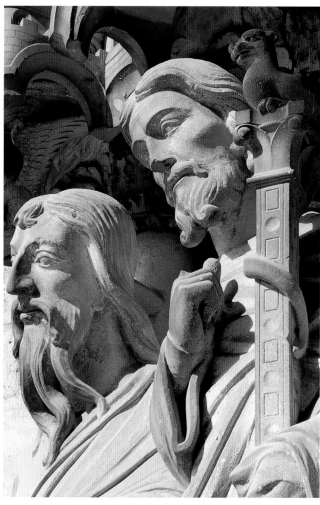

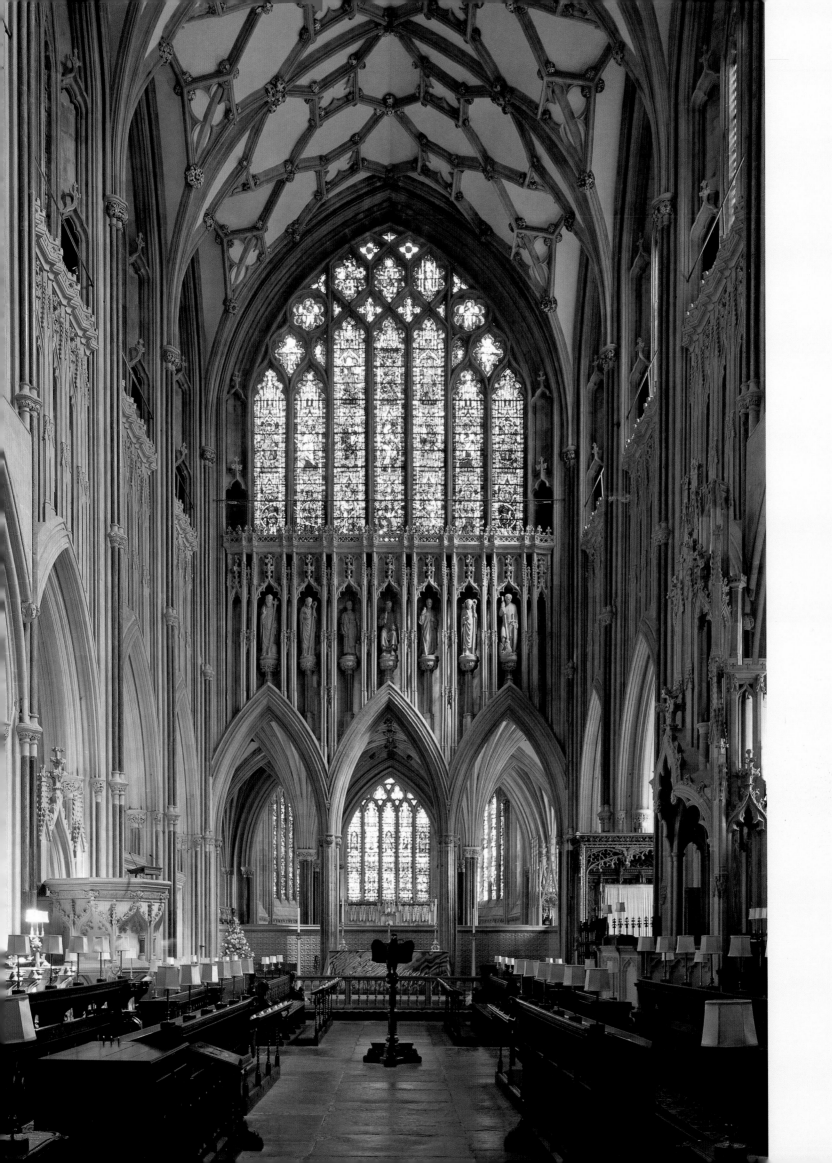

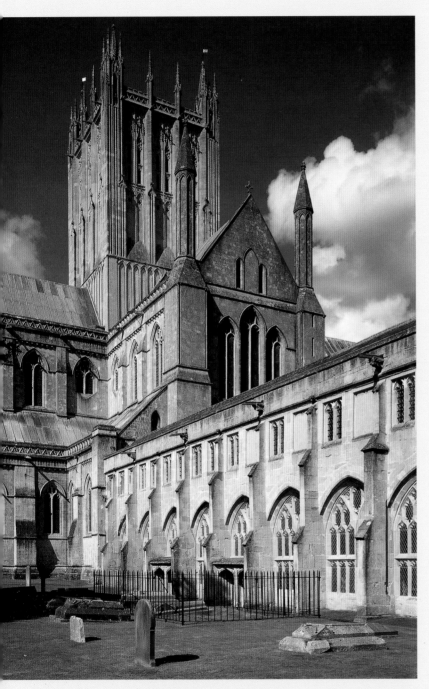

ABOVE

The crossing tower seen from the cloister.

OPPOSITE

The view from the choir (completed c. 1340) looking east to the dissonant vaults of the retrochoir and Lady Chapel beyond.

PAGES 118-119

The west façade is a harmonious and logical composition. Its great breadth is emphasized by the two horizontal string courses, but six buttresses counter this horizontality and give depth of relief to the façade.

Wells Cathedral

WELLS ENGLAND

Wells Cathedral, more or less contemporary to those at Laon and Bourges (c. 1180-1230), is as English as they are French. Where the mighty French Gothic cathedrals strain towards the heavens, their tall piers and linear mouldings all emphasizing verticality, Wells is long and low, resolutely horizontal, with no elements rising from floor to vault. Where the French churches are clearly divided into units, bay by bay, Wells is deliberately continuous, its triforium an unbroken sequence of identical openings. Where the French façades have three cavernous porches with sculpture densely crammed into them, Wells has a single modest doorway and its sculpture is spread across the entire west front like a giant screen. And where French cathedrals are invariably found in the middle of towns or cities, hemmed in by surrounding buildings, Wells stands serenely amid immaculate lawns, its ancillary buildings grouped picturesquely around it.

The cathedral did not remain long in its original Early English state, and between about 1285 and 1345 three important additions were made, all pointing to the Decorated style that was to come. The first was the chapter house, attached to the north side of the church by an enclosed bridge. It is probably the most perfect example of a form only found in England: octagonal, and covered by a rib vault supported by a central column. The second alteration came shortly after this when the east end was extended with a new choir, retrochoir (an area behind the choir) and Lady Chapel. These merge into one another in ways that posed problems for the architect, though he clearly took great delight in solving them. The vaulting, in particular, is full of novelties and surprises: at one point a rib begins to rise and has nowhere to go, so a stone lion appears and bites it off.

Then, in about 1320, the low crossing tower was raised by a storey, adding dangerously to the weight on the crossing piers, which began to show signs of strain (described as 'enormiter deformata' by 1338). To strengthen them, four massive 'X'-shaped arches with circular openings were inserted in the main directions. The effect when seen from a distance is dramatic, completely shattering the tranquil elegance of the original master mason.

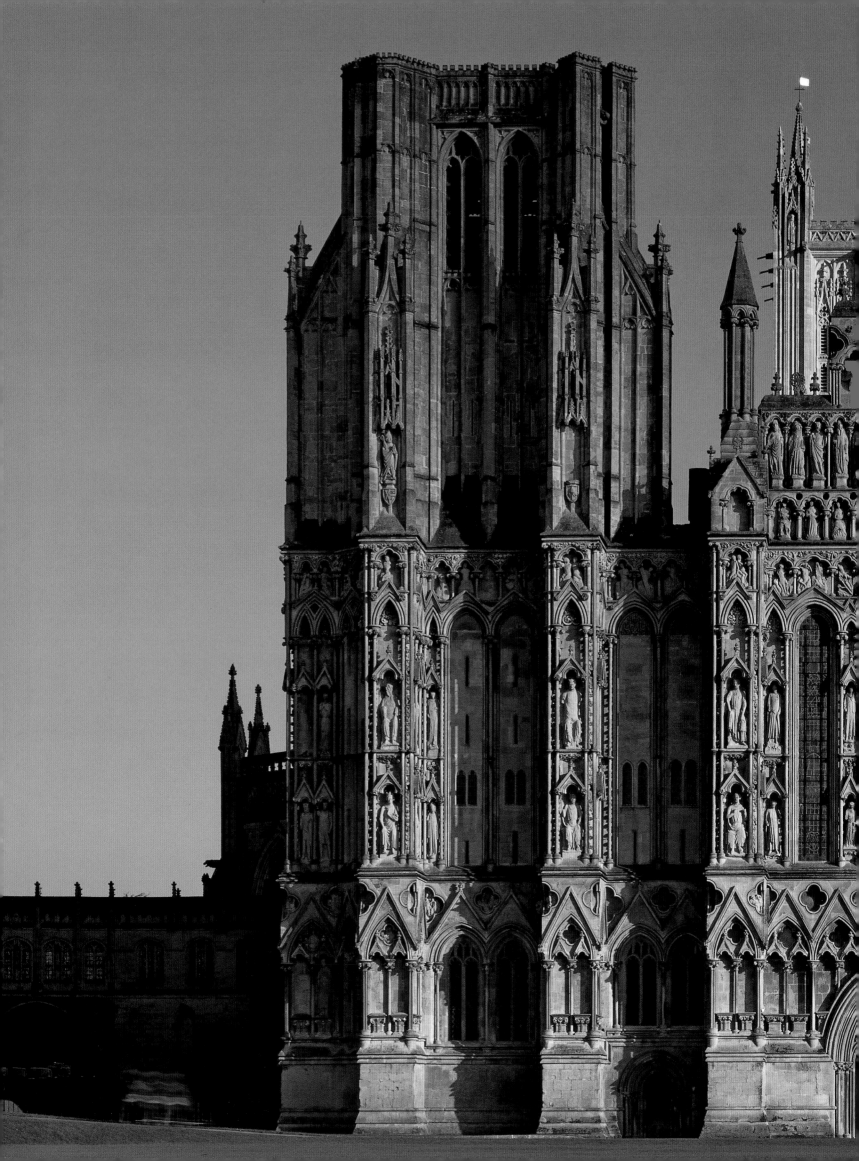

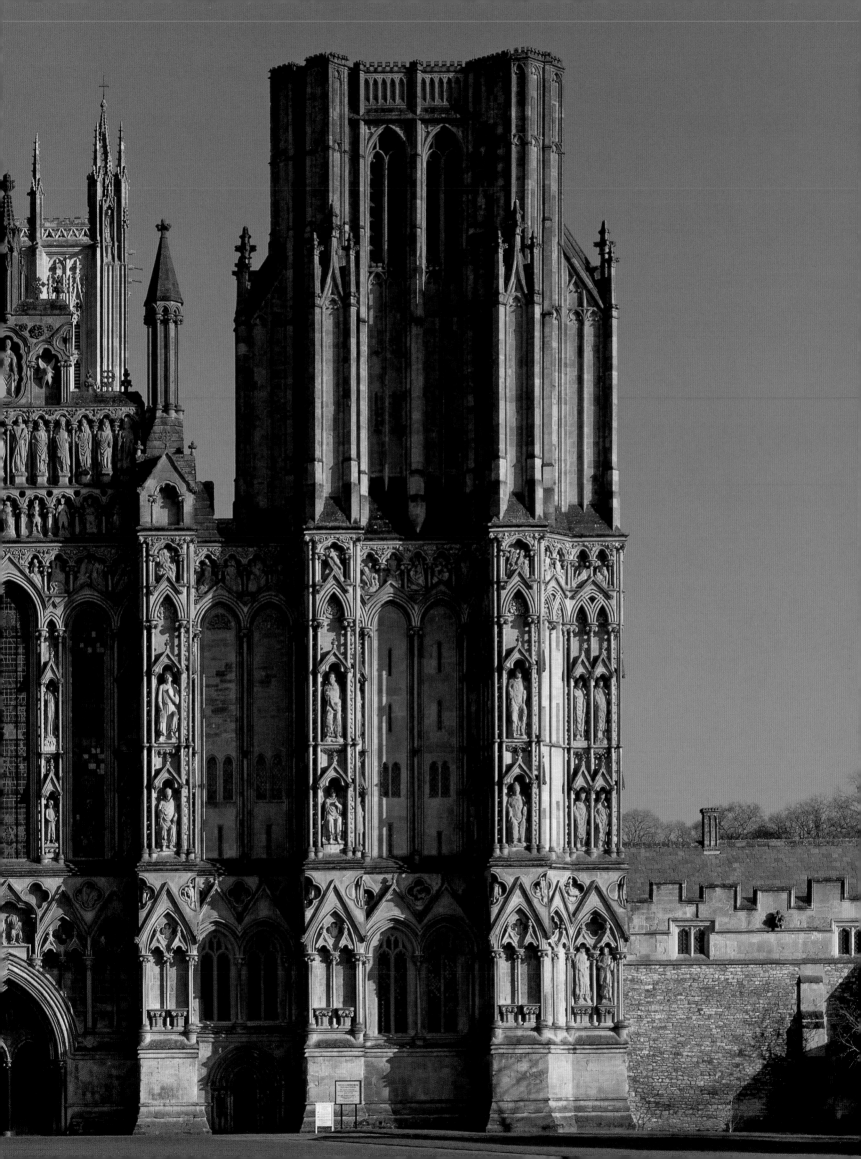

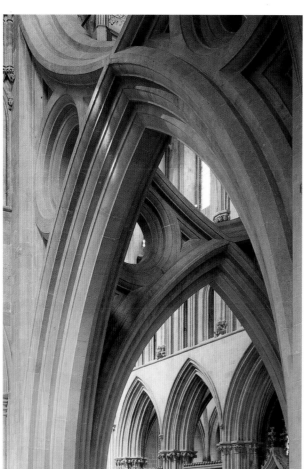

LEFT

The strainer arches were inserted in around 1350 to prop up the tower. While enormously theatrical and technically sound, they clash visually with the delicacy of the nave.

BELOW

The view from the retrochoir looking towards the nave. Retrochoirs were primarily used to house the bones of saints; however, the Chapter of Wells could not find a suitable incumbent, so it remains unoccupied.

OPPOSITE

The Lady Chapel forms an elongated octagon at the east end. Its lovely lierne vault was the first such decorative vault in England.

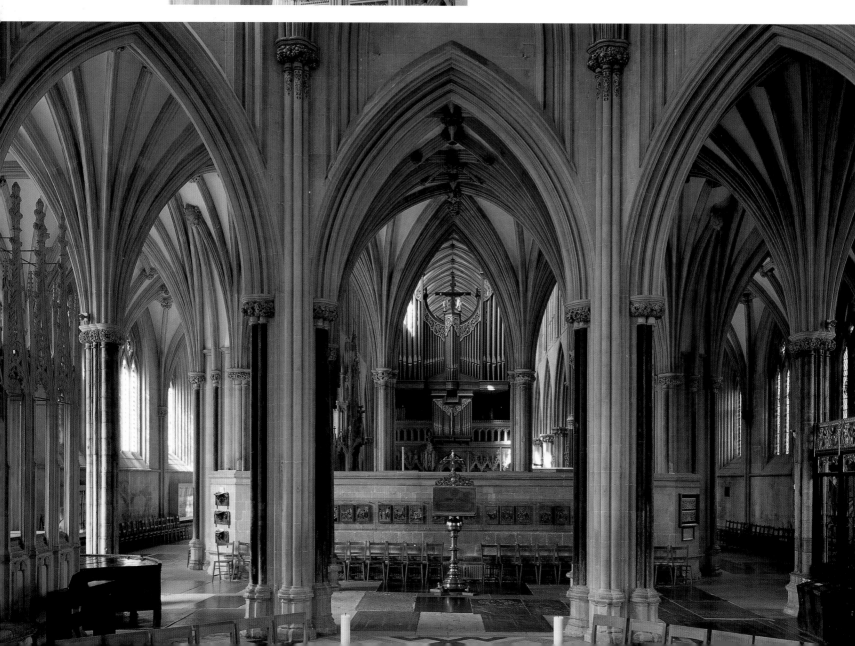

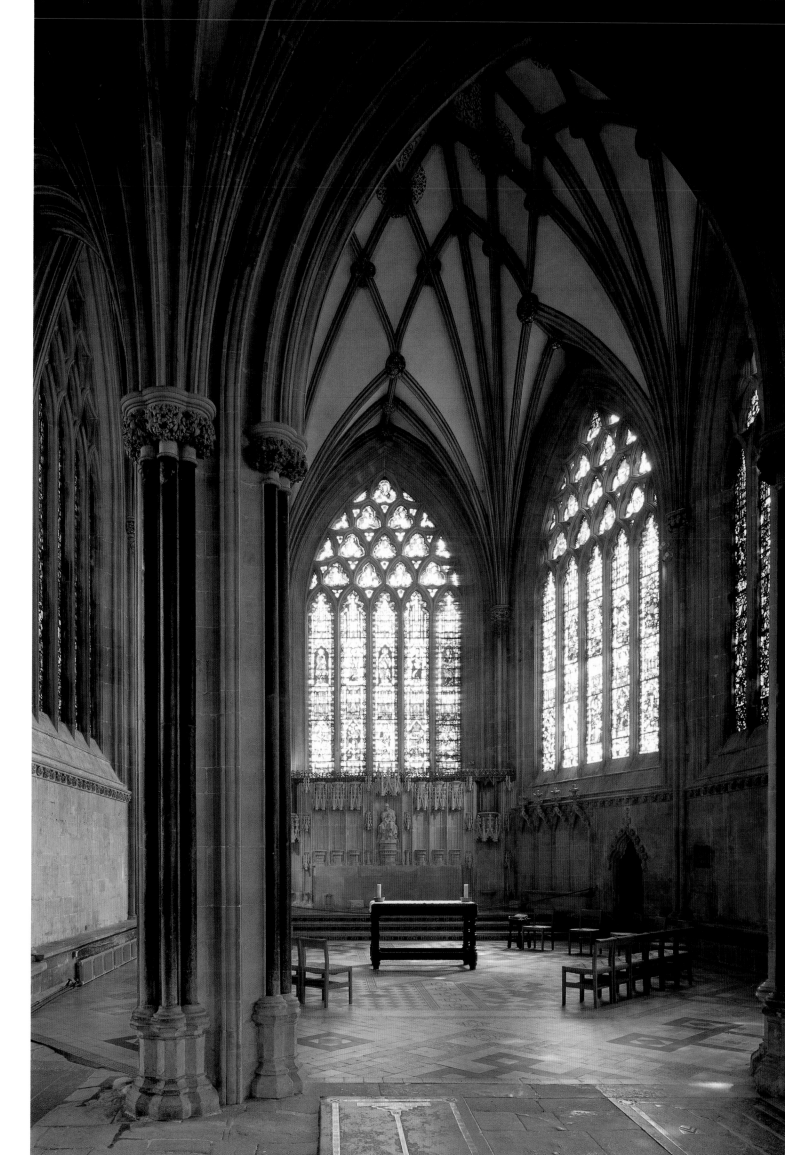

Bourges Cathedral

BOURGES FRANCE

The construction of the cathedral at Bourges, in the very centre of France, is normally dated as starting in 1195. However, since the document that provides this date refers to the work being underway, it may well have begun earlier, and it has been speculated that this is the first of the French High Gothic cathedrals (a group that includes Chartres, Reims, Amiens and Notre-Dame). Yet it is quite unlike any other French cathedral of this period in two important ways: first, it has no transepts, so that the nave extends from the west front to the eastern apse without interruption; and second, it has double aisles, of which the inner ones are three times as high as the outer. This results in a curious cross-section with very squat outer aisles and tall inner aisles that appear narrower than they actually are. As a five-aisled church it necessarily references the original St Peter's in Rome, but also the important Romanesque abbey church at Cluny, France.

Considering its complex formal structure, the interior of Bourges Cathedral is essentially simple and rhythmical. The sixty piers of the five parallel aisles create a unified visual effect appreciable the moment one enters the building. The piers of the nave are immensely tall, rising uninterrupted 17 metres (nearly 56 feet) from their bases to the springing of the arches of the arcade. The main vault is sexpartite, so these piers alternate between major (with five attached shafts) and minor (with three). The tripartite elevation of the nave is echoed on the outer walls of the inner aisle, so that through the arcade of the nave can be seen another elevation of arcade, triforium and clearstorey. The piers of the main arcades are echoed on the other side of the aisles in the form of bulges in the wall. This dramatic device provides a sense of spatial continuity across the cathedral.

The building of Bourges Cathedral was finished in about 1266. After that date the main alterations were to the colossal west front. At different times both towers collapsed and had to be rebuilt, and the rose window between them is dated to about 1390. The chapels between the buttresses were added as late as the 15th century (one of the miniatures in the Limbourg brothers' *Très Riches Heures* shows the cathedral as it appeared in 1485). During the French Wars of Religion of the mid-16th century it suffered damage at the hands of the Protestants, and there was even a serious proposal to demolish it completely. The Revolution of 1789 brought further vandalism, and the cathedral was rededicated to the Goddess Reason. Yet in spite of this, today the cathedral remains both majestic and awe-inspiring.

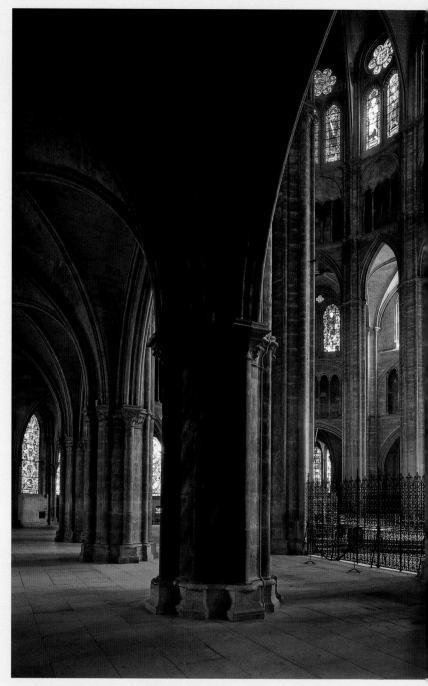

ABOVE

The view from the north aisle looking through the nave. Beyond, the separate elevation of the south inner aisle can be seen mirroring the arcade, triforium and clearstorey of the nave.

OPPOSITE

The nave is given greater vertical emphasis by the extreme uninterrupted height of the piers.

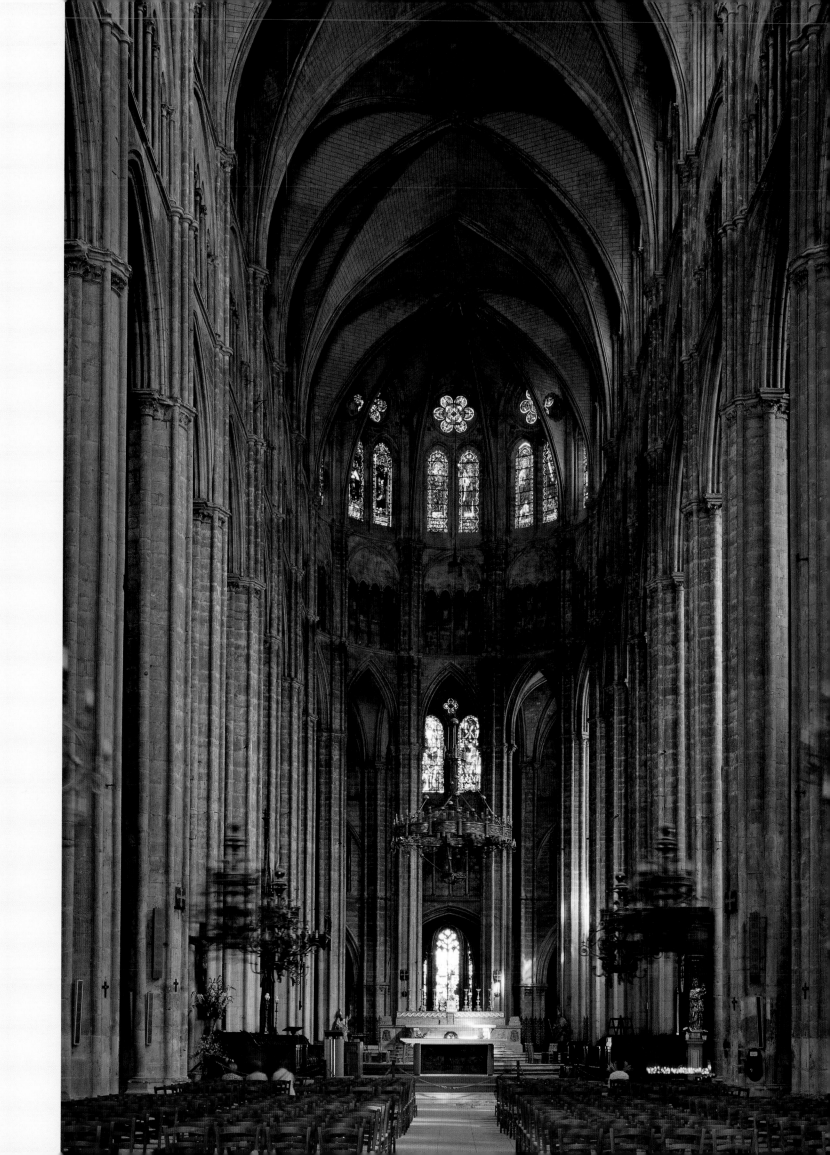

BELOW

**View from the southern arcade
near the apse at the east end.**

RIGHT

**The cathedral seen from the south-
east, where the apse is surrounded
by five small radiating chapels.**

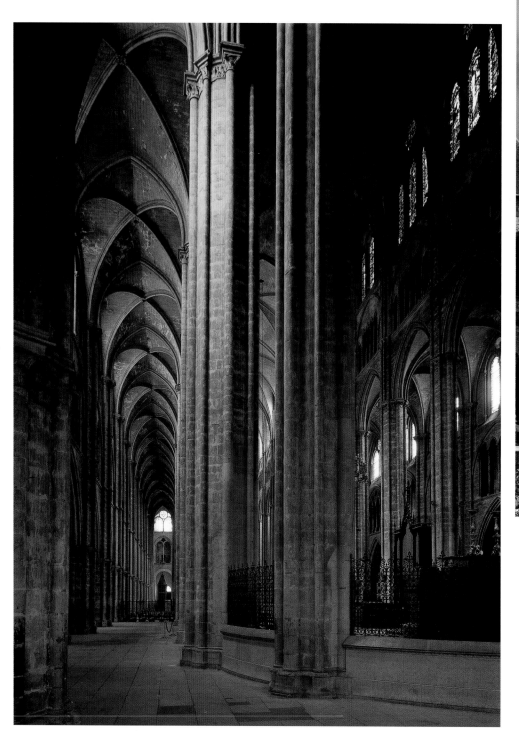

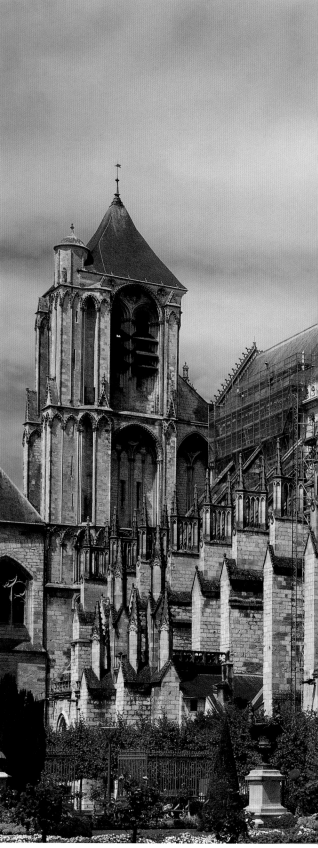

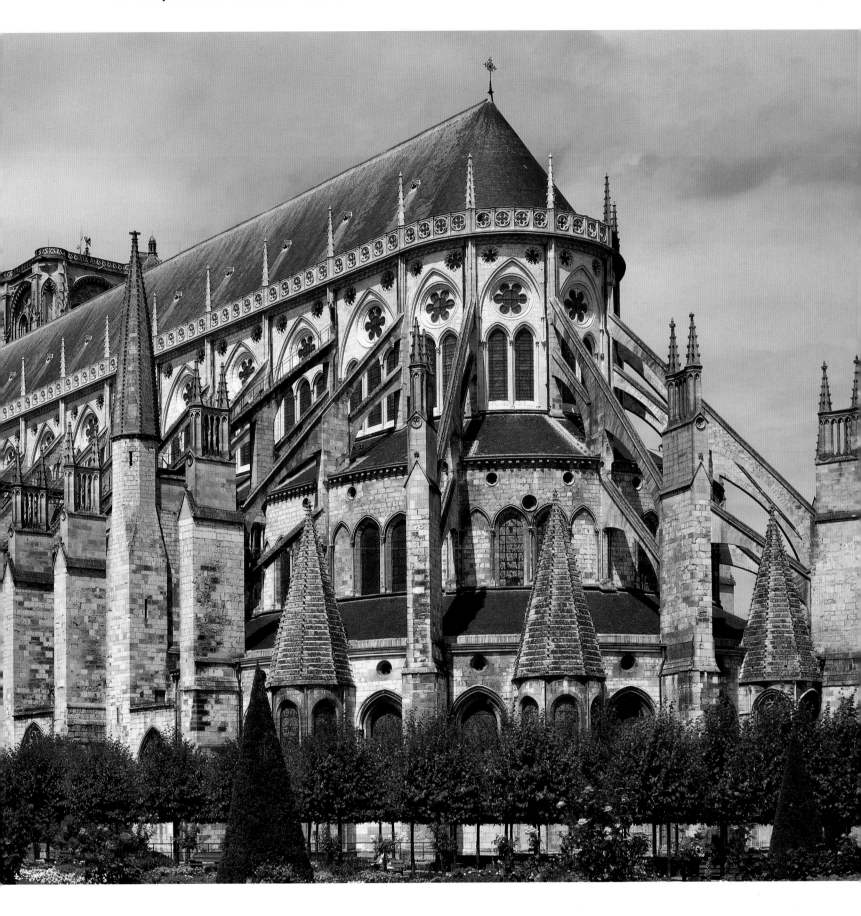

Htilominlo Temple

Htilominlo Temple was begun in 1211 by King Nadaungmya, supposedly as a memorial to a decisive moment in his life. At this point on the road between the village of Pagan and the town of Nyaung-U, the story goes, his father, King Narapatisithu, arranged his four sons around a white umbrella saying: 'May the umbrella bend towards the one who is worthy to be king.'

The temples of Pagan are of a type known as *gu* (literally 'cave'), which ultimately take their inspiration from the earliest Buddhist caves of northern India. The immediate prototypes of the Pagan temples, however, date from the 7th century (or possibly earlier) and can be found at the old Pyu capital of Sri Ksetra near the modern town of Prome. There, the Bebe and Leimyethna *gu* temples have a similar structure to that of the temples at Pagan, with an open ambulatory surrounding a solid core. Each side of the solid core has a niche containing a Buddha image, with one of these Buddhas, the primary devotional image, being much larger than the others.

King Nadaungmya's great temple at Pagan differs from these earlier prototypes in scale, repeating the fundamental *gu* structure over three storeys. The core is 29 by 31 metres (95 by 101 feet), and the major devotional figure of the Buddha is located in the eastern ambulatory, a hall 7 metres (23 feet) wide by 14 metres (46 feet) long. Secondary porches are placed opposite the minor Buddha figures. The same configuration is repeated on a smaller scale on the floor above.

Lighting is carefully controlled. The ritual circumambulation is made in almost total darkness before each Buddha is perceived from the side bathed in light; the very tall ambulatory corridors serve to enhance the majesty of this central figure. Within the ambulatory two tiny narrow staircases on either side of the eastern hall lead up to a terrace above the hall. On this terrace a large formal staircase leads up the outside of the building affording views across the other temples of Pagan, before reaching a doorway into the upper ambulatory.

The temple's exterior shows a judicious balance of central mass and vertical elements. The elevation may be read as a series of horizontal bands: the monumentality of the plain base is offset by a terraced level, covered in pinnacles, that leads up to the second plain band of the upper storey. Above this wide base a multi-tiered *sikhara* finial shoots up into the sky. It is this balance of mass and decoration, horizontal and vertical, that gives Htilominlo its unique grace. It remains today a statement of the confidence and sophistication of the rule of King Nadaungmya.

ABOVE

Originally the entire exterior would have been covered with stucco. Today instead we see the imaginative brickwork underneath.

OPPOSITE

The temple is surrounded by a walled enclosure with four gateways.

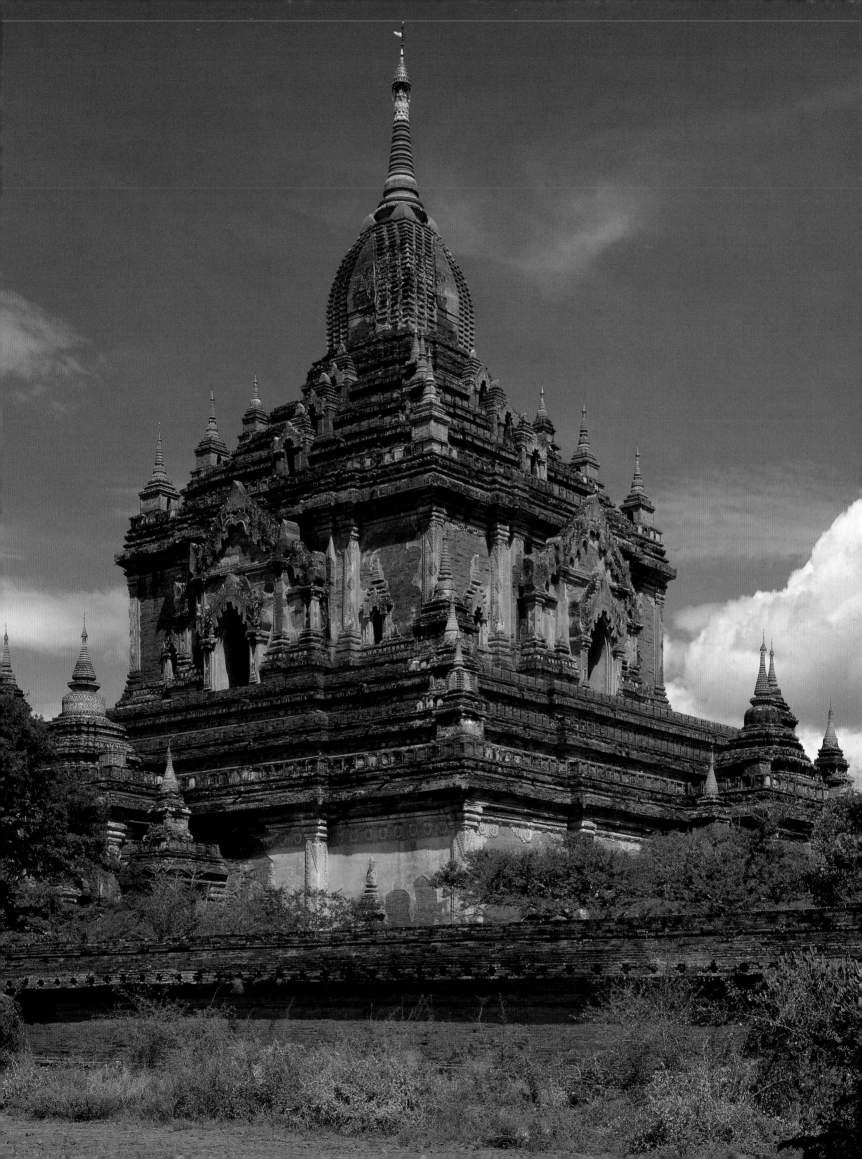

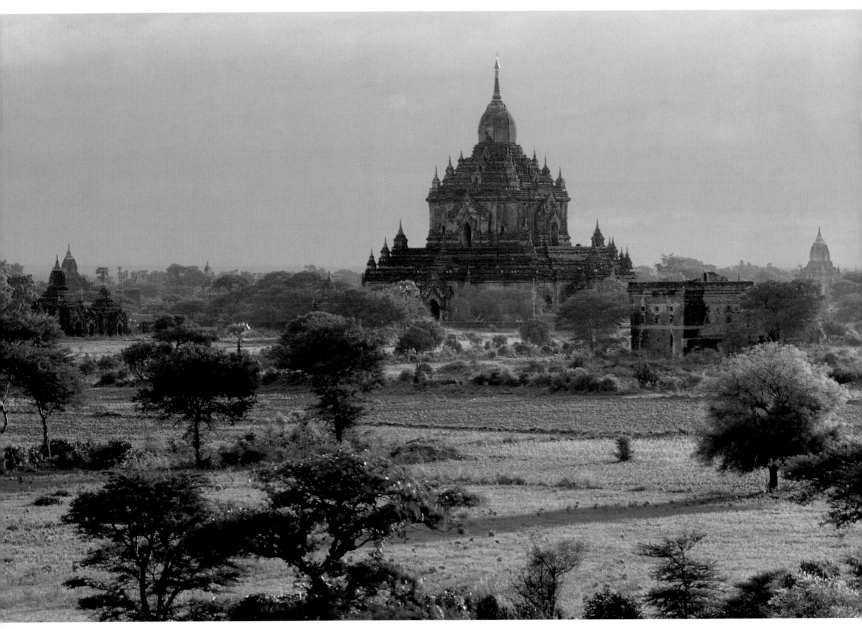

ABOVE

In silhouette the temple can be seen to be made up of contrasting bands: a monumental plain base, then an elaborate terrace, a plain upper storey and finally a multi-tiered *sikhara* finial reaching up into the sky.

RIGHT

The richly detailed south portal.

OPPOSITE

The interior is largely very dark, though occasional pools of light are allowed to fall onto the Buddha figures.

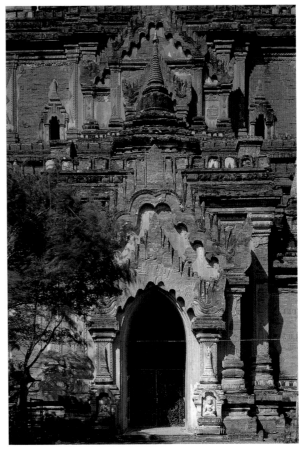

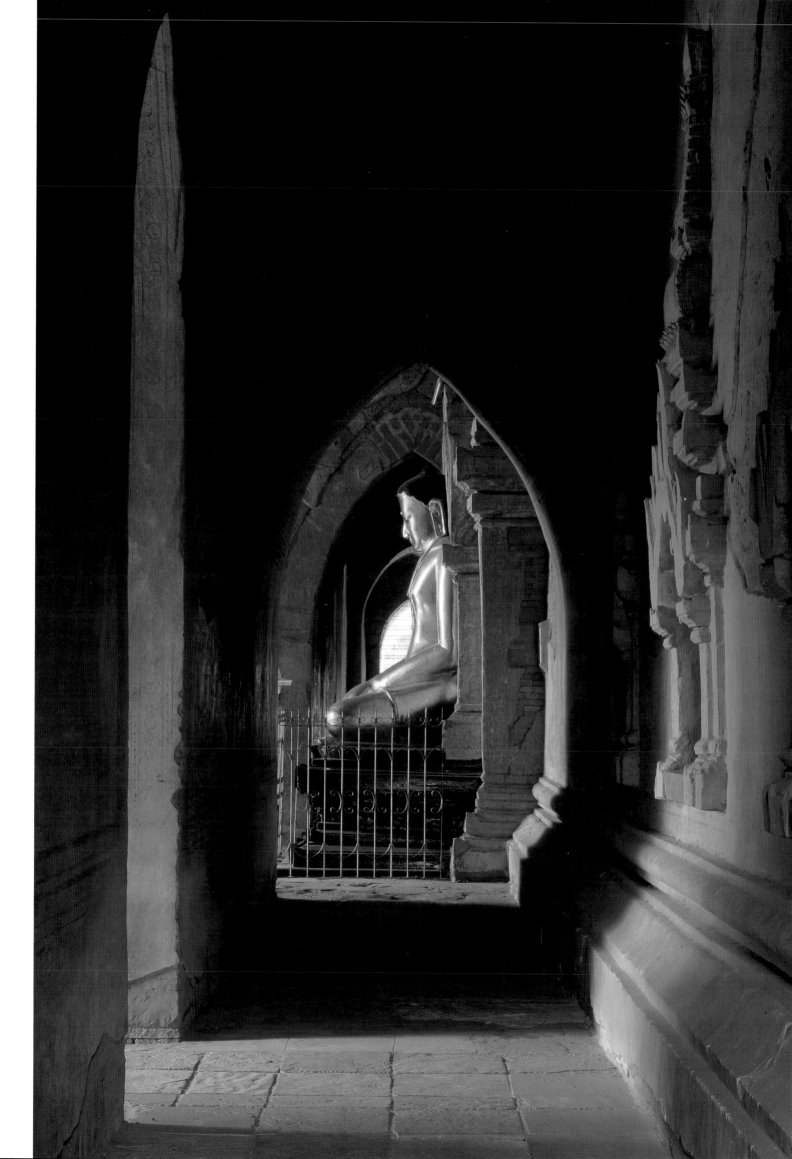

Reims Cathedral

REIMS FRANCE

The cathedral at Reims, in the heart of the Champagne region, belongs to that remarkable set of monumental French churches, including Chartres, Laon and Bourges, which together are known as the High Gothic. Built a little later than the others – it was planned after a devastating fire in 1212, and finished shortly before 1300 – the original architect, Jean d'Orbais, was clearly able to absorb and reuse recent developments in other buildings in the Île-de-France. The plan of the choir derives from the nearby Basilica of St Rémi, while the flying buttresses come from Soissons Cathedral and the wall passages in the south transept resemble those at Laon. The choir and nave are given strong vertical emphasis by the shafts that cluster round the traditional cylindrical columns, though this verticality is balanced by the equally strong horizontal emphasis of the triforium – the narrow colonnaded passage that by this point had all but replaced the open gallery of earlier churches.

The west front is perhaps the most impressive of any Gothic cathedral. Its power derives from the contrasting bands of each level, alternately compressive and expansive. Three superb portals have entirely glazed tympana, meaning that sculpture is pushed into the gables, which together create a taught, jagged line, pointing upwards. The west rose window is delicately distinguished from surrounding glazing by a wider, pointed arch. On either side of it rise the towers. These have lost all trace of Romanesque solidity, and openings above the gables of the portals allow views through to the flying buttresses beyond. The result is an empty layer full of expansive verticality and little horizontal restraint. Above this runs a level of sculpture, the 'Gallery of the Kings', which completes the rectangle of the façade. Again it is a horizontal device, but the jagged edge of its gables frames the towers as they rise much higher still, thin and elongated.

Perhaps the most influential contribution of Reims to the future development of Gothic architecture was the invention of bar tracery. Until then the framework of large windows had consisted of openings that appeared to be punched through stone surfaces (plate tracery). However, as windows got larger and larger, the surfaces between the areas of glass gradually diminished until at Reims these areas no longer belonged to the wall but were instead separate elements, quintessentially Gothic lines or 'bars'. It was soon realized that these bars could be used to form intricate and elegant patterns, and later styles came to be known by the forms conceived in this way: 'Rayonnant', which relied on thin, straight tracery, and 'Flamboyant', which twisted these bars into extraordinary, sometimes flame-like, shapes.

Reims Cathedral, seen here
from the south-east, has a
distinguished history. With just
two exceptions, all the kings of
France from Henri I (1027) to
Charles X (1824) were crowned
here, including Charles VII,
whose coronation took place in
the presence of Joan of Arc.

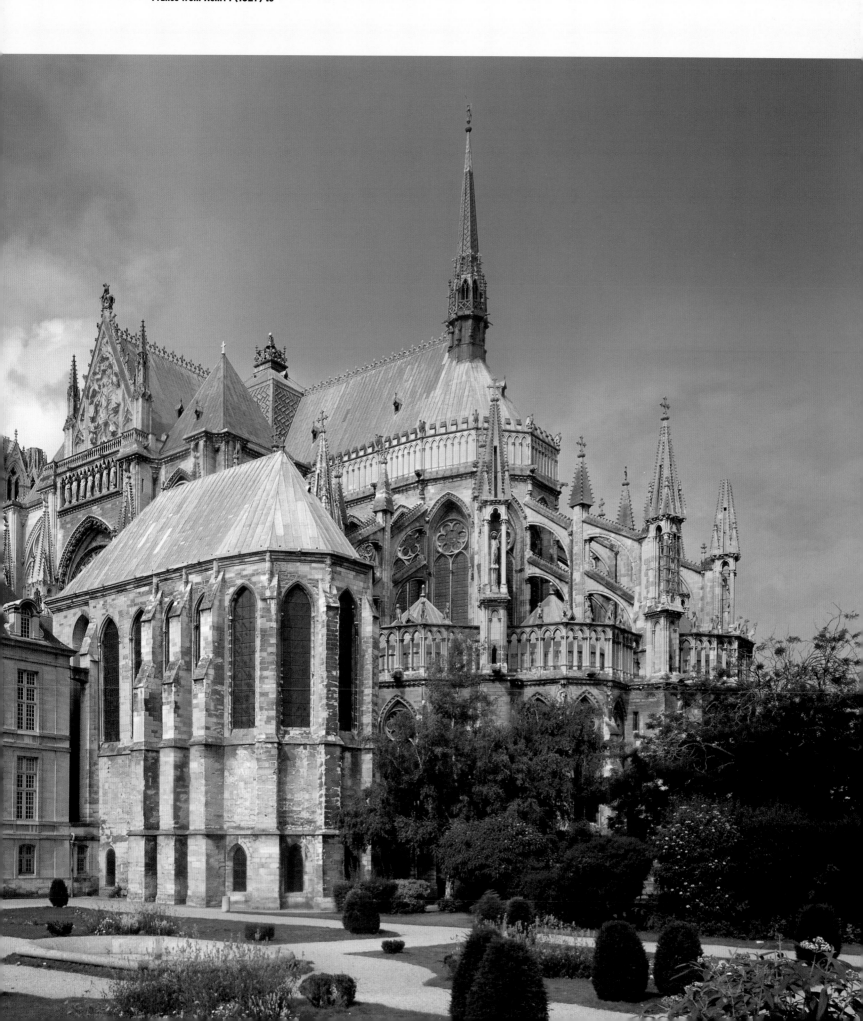

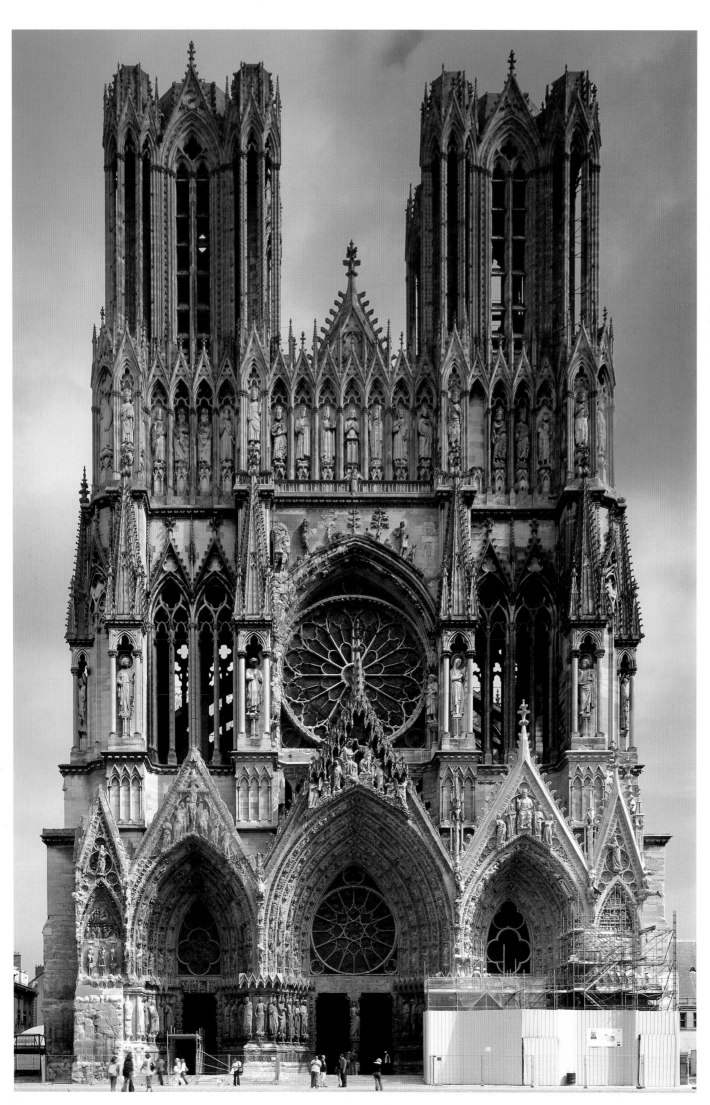

The west façade. Reims vies with Chartres and Amiens in terms of the quantity and the quality of its sculpture. In the central gable Christ crowns his mother Mary as Queen of Heaven.

Looking into the nave we can see the characteristic three-storey elevation, with lower arcade, triforium and clearstorey. Shafts run from ground level to the springings of the vaults, though they are broken by ornate capitals as the arcade level.

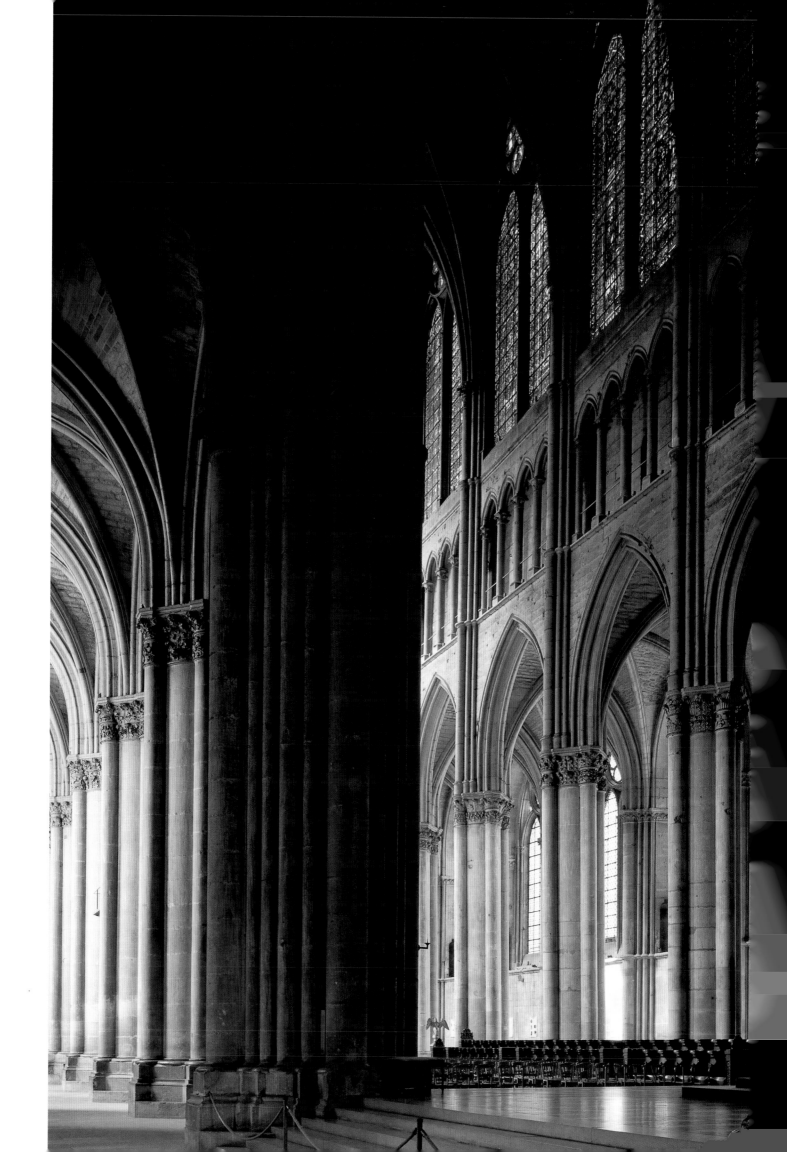

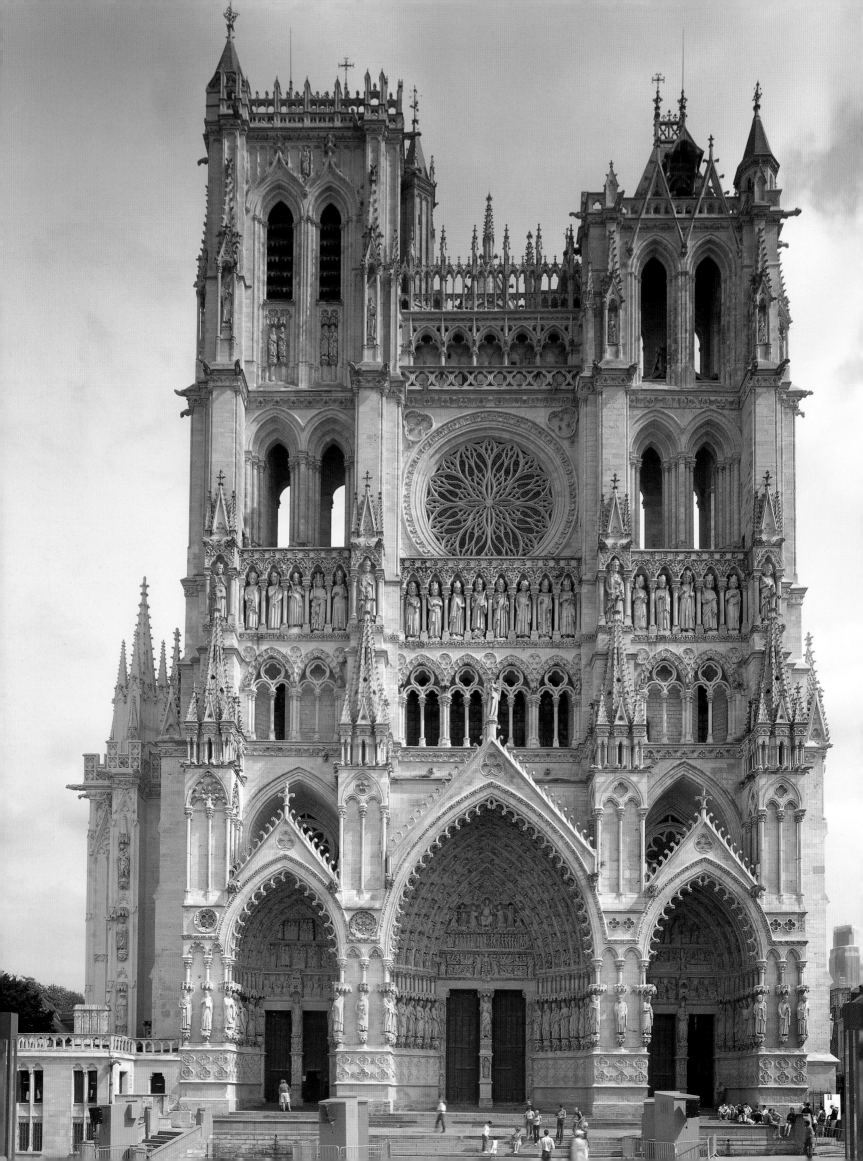

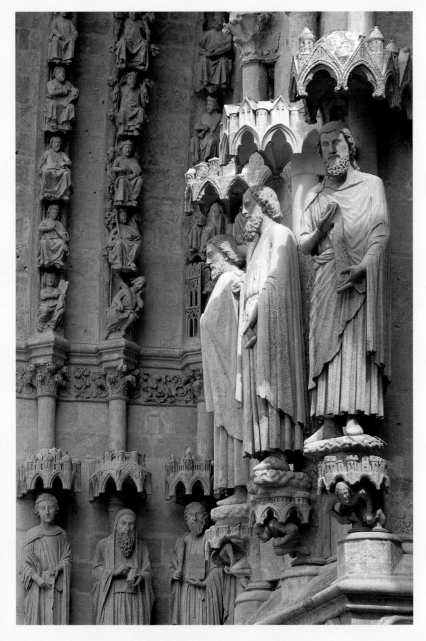

A detail of some of the near life-size jamb figures and archivolts from the north portal.

The west façade. Amiens differs from Reims in having the Gallery of Kings underneath the rose window. The rose is much later, and shows Flamboyant tracery.

Amiens Cathedral

AMIENS FRANCE

At Amiens Cathedral a unique archeological account of the building's development was left in the form of an inscription in the centre of a labyrinth pattern in the floor of the nave. Though the original has since been destroyed, it was recorded and from this we know that the building was begun in 1220 under an architect called Robert de Luzarches. He was succeeded by Thomas de Cormont and then by the latter's son Regnault, who finished it in 1288. Between them they created one of the most dizzying and light Gothic structures to be found anywhere.

The interior elevation of Amiens is a classic three-storey configuration, with a tall arcade, a triforium and a clearstorey, all capped with a quadripartite rib vault. The vault of the nave is an astonishing 43 metres (141 feet) above the floor, making it the highest yet attempted (though it was later eclipsed by that of Beauvais Cathedral). This vertical effect is emphasized by the seemingly delicate piers, which, though of a similar thickness to those at Chartres and Reims, are much more widely spaced and almost twice as high relative to their girth.

Amiens was the first cathedral to make window tracery the focus of the interior. Robert de Luzarches used bar tracery to create an unprecedented four lights (plus a rosette) in each clearstorey window. In order to make the windows visible throughout the cathedral he chose much shallower vaults than the steep low-springing ones of Chartres and Reims. The result is a much lighter looking vault that, married to the elongated proportions, gives the building a visionary quality. To this was added another innovation, the glazing of the triforium around the ambulatory, a daring yet logical next step in the gradual eradication of the wall.

During the Middle Ages Amiens became a popular site of pilgrimage thanks to its famous relic, the head of St John the Baptist. The complex sculptural display on the west front gave pilgrims a powerful didactic message. Each of the three portals of the façade is flanked by near life-size standing figures of Old and New Testament characters. The tympana, dedicated to St Firmin (the first bishop of Amiens), Christ and the Virgin, respectively, are filled with scenes in relief, arranged in horizontal bands. At the lowest level a dado contains small scenes within quatrefoil medallions representing the Signs of the Zodiac, the Labours of the Months, Adam and Eve, the Childhood of Christ and other subjects. The doorway to the south transept is treated like one façade bay with rows of statues and narrative reliefs above. The figure on the trumeau is the famous Vierge Dorée, one of the masterpieces of Gothic sculpture.

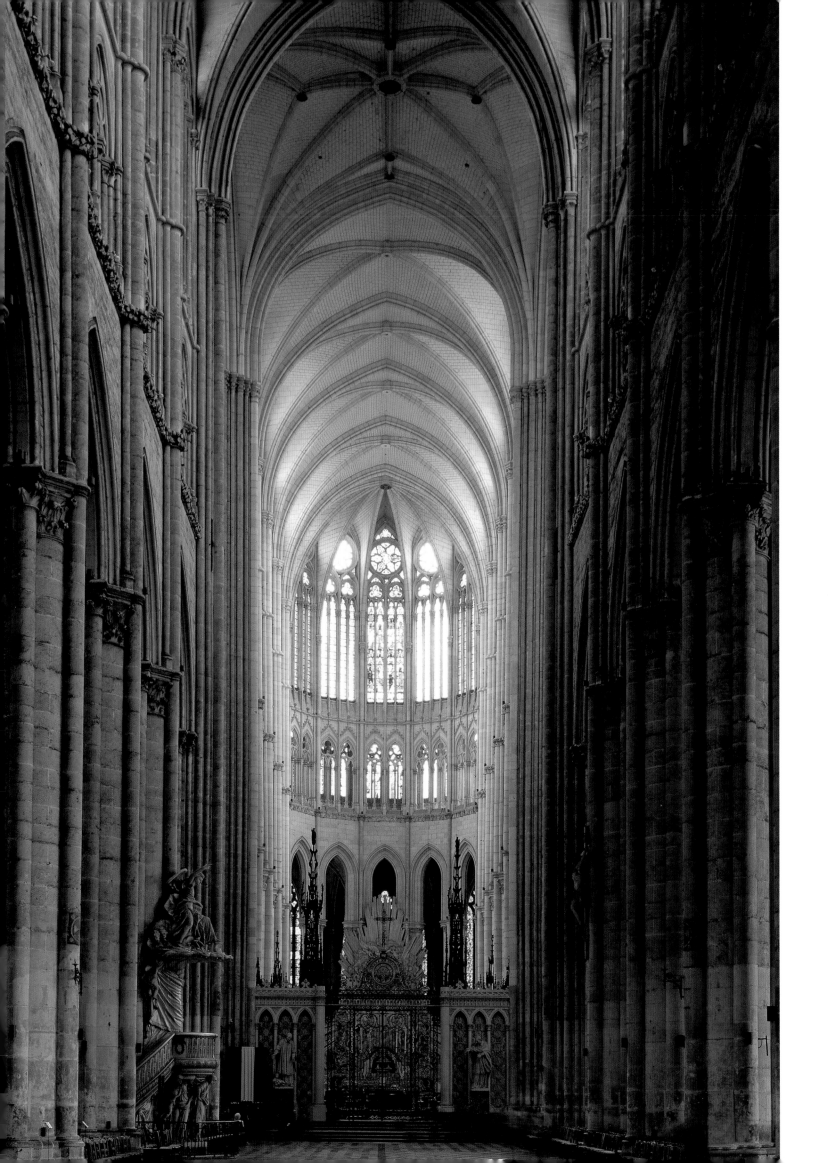

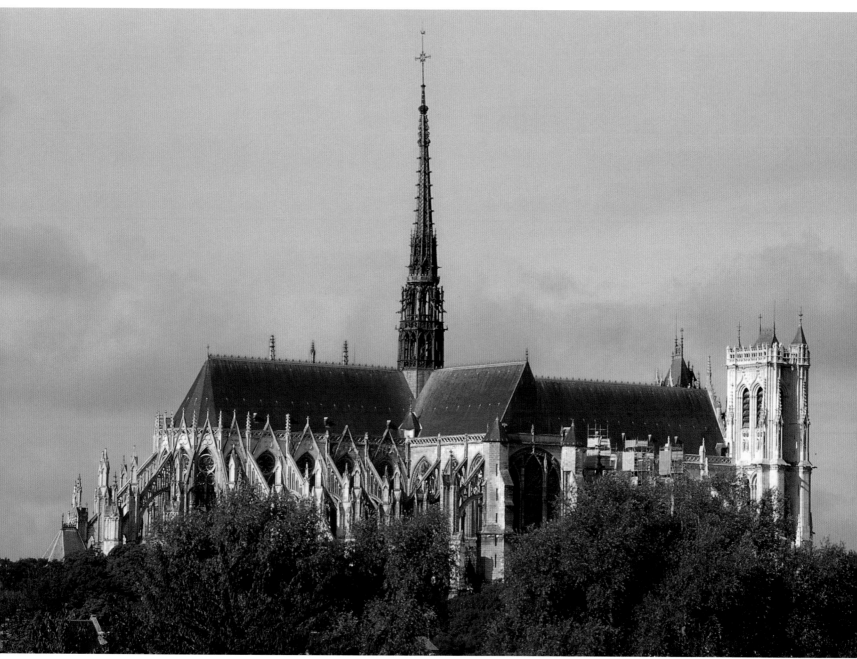

OPPOSITE

The weightless interior of Amiens, looking towards the ambulatory in the east end. While it has the same three-storey elevation seen at Reims, at Amiens parts of the triforium level are also glazed, making the entire structure seem much lighter.

ABOVE

A view of the cathedral from the north-east. Note the gables sticking up in between the flying buttresses.

RIGHT

Among the cathedral's furnishings the wooden choir stalls stand out. Made between 1508 and 1521, every surface of them is covered with superbly depicted scenes. There are 3,650 separate sculpted figures.

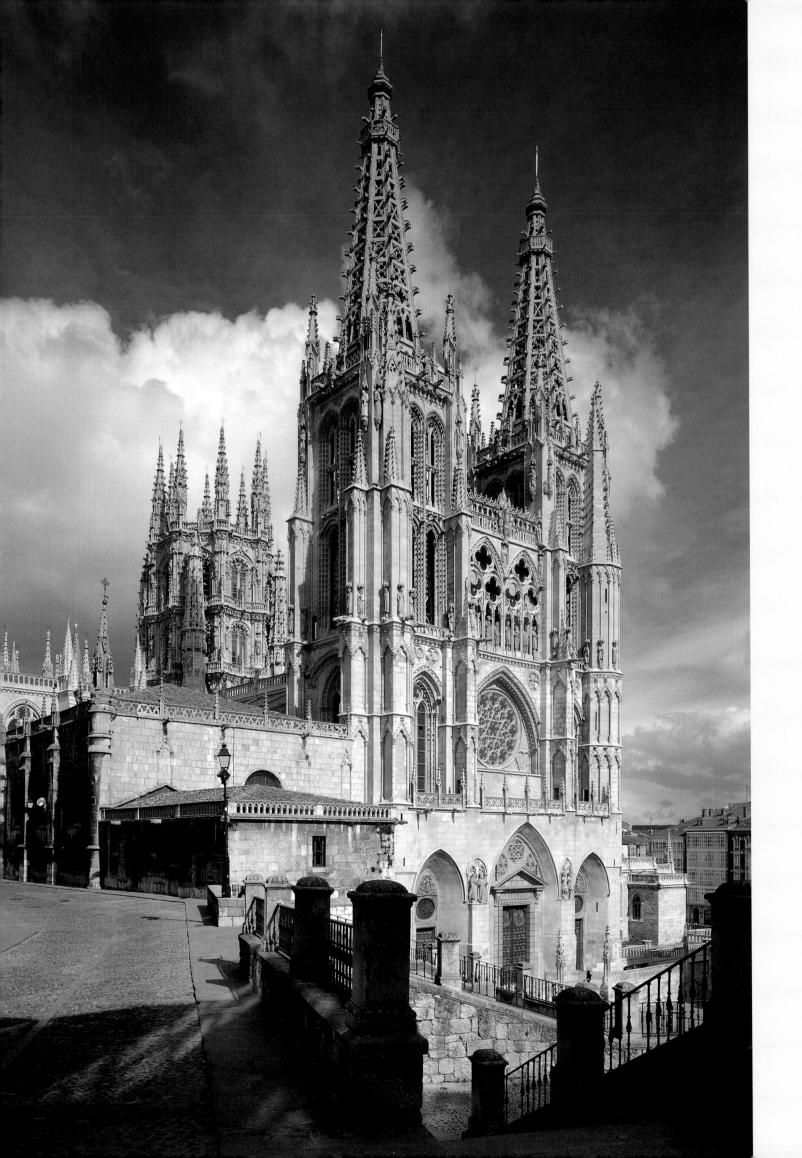

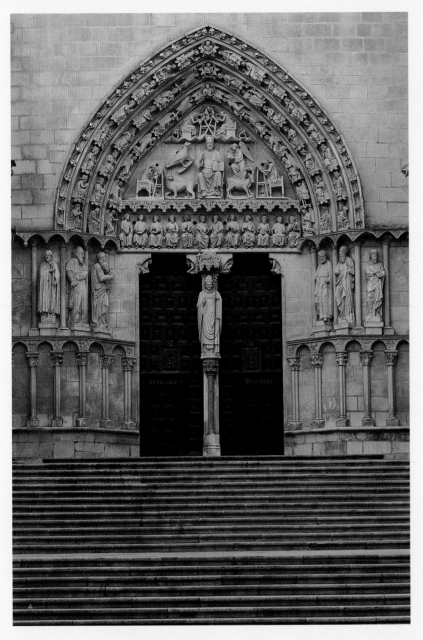

**The south door of the cathedral
leading into the transept, c. 1250,
shows clear French influence.
In the tympanum sits Christ
surrounded by the symbols
of the Four Evangelists; below,
the Twelve Apostles.**

**The west front combines French,
Flemish and German features with
a characteristically Spanish wealth
of ornament. Behind it rises the
octagonal crossing tower.**

Burgos Cathedral

BURGOS SPAIN

When Burgos Cathedral was conceived, Castile and León, who were later
to form the backbone of the Kingdom of Spain, were still rivals. Since
Castile had recently defeated the Moors at Las Navas de Tolosa (1212) it
is likely that the building was intended not only as a statement of pride in
the kingdom, but also as a building to rival the cathedral of Santiago de
Compostela in the Kingdom of León (see pp. 84-9).

As with many 13th-century Gothic buildings throughout Europe, the
architects looked to, or possibly came from, France. The broad massing of
the building shows the influence of Bourges Cathedral, and the elevations
of both buildings share the same essential components with piers rising
from cylindrical cores before opening into eight colonnettes. The flying
buttresses that support the choir show the influence of Notre-Dame in
Paris, while the sculpture galleries of the west façade are similar to those
of the transept façades at Reims.

Over time, however, a distinctly Castilian Gothic style emerged,
one primarily concerned with widespread sculptural and ornamental
decoration. At Burgos these characteristics were considerably enhanced
during the remodelling of the cathedral in the 15th and 16th centuries.
First, between 1442 and 1458, ornate spires were added to the towers
of the western façade by the architect Juan de Colonia; these follow the
latticework spires of Juan's native Germany such as those at Freiburg-im-
Breisgau Minster. Then, during the second half of the 15th century highly
ornate chapels were added around the edges of the cathedral, the most
influential being the Chapel of the Condestable, which was added from
1482 onwards to the axial bay of the ambulatory. Finally, in the mid-16th
century a two-storey octagonal lantern, known in Spain as a *cimborio*, was
placed above the crossing. Its decoration features an array of Gothic and
Renaissance motifs, including gargoyles, escutcheons and figures from
the Old Testament, and it is topped by a vault covered with tracery.

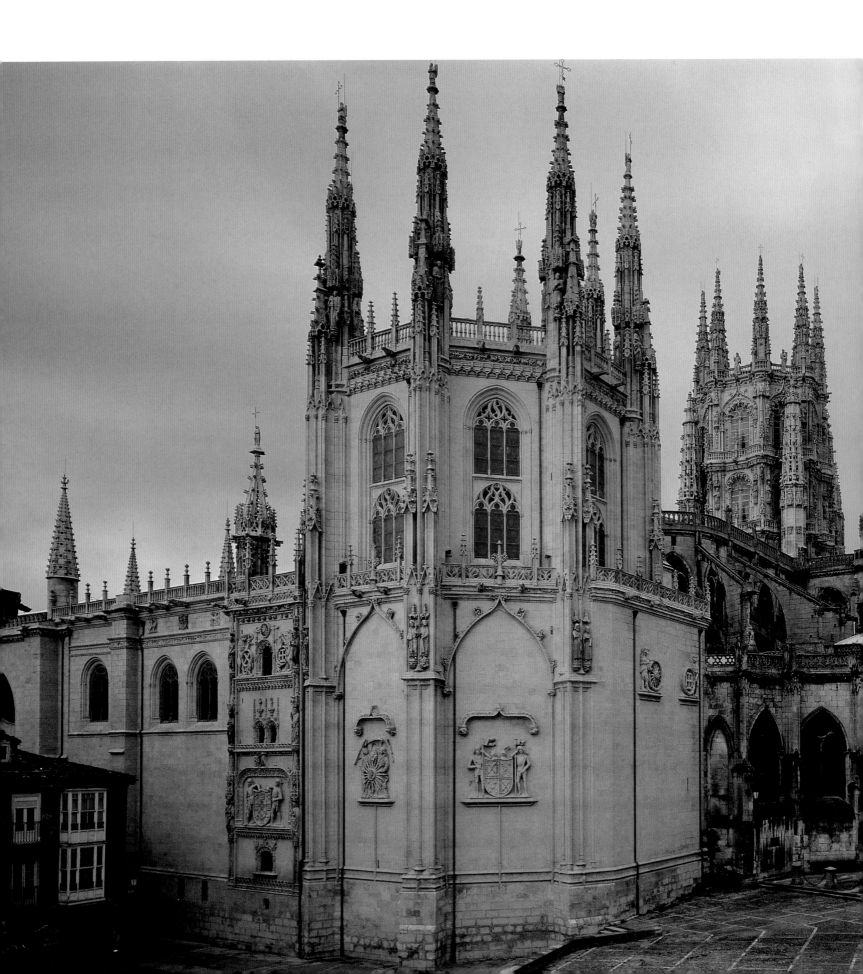

ABOVE

The *cimborio* was finished in 1568 and its design is attributed to Juan de Langres. Its vault imitates that of the Chapel of the Condestable but is here covered with tracery.

LEFT

The cathedral seen from the east, with the octagonal Chapel of the Condestable in the foreground. Beyond that is the crossing tower (*cimborio*), and then one of the west spires. The Chapel of the Condestable was built by the Constable of Castile, Pedro Fernández de Velasco and designed by Simón de Colonia (the son of Juan de Colonia).

PAGES 144-145

BELOW

The Registan: three separate buildings
built across three centuries but
conceived as a harmonious group. From
left to right we see Ulugh Beg's original
madrasa, the Tillya-Kori madrasa and
mosque, and the Shir Dor madrasa.

The Shir Dor madrasa derives its
name from the mosaics on the façade,
which show lions pursuing deer.

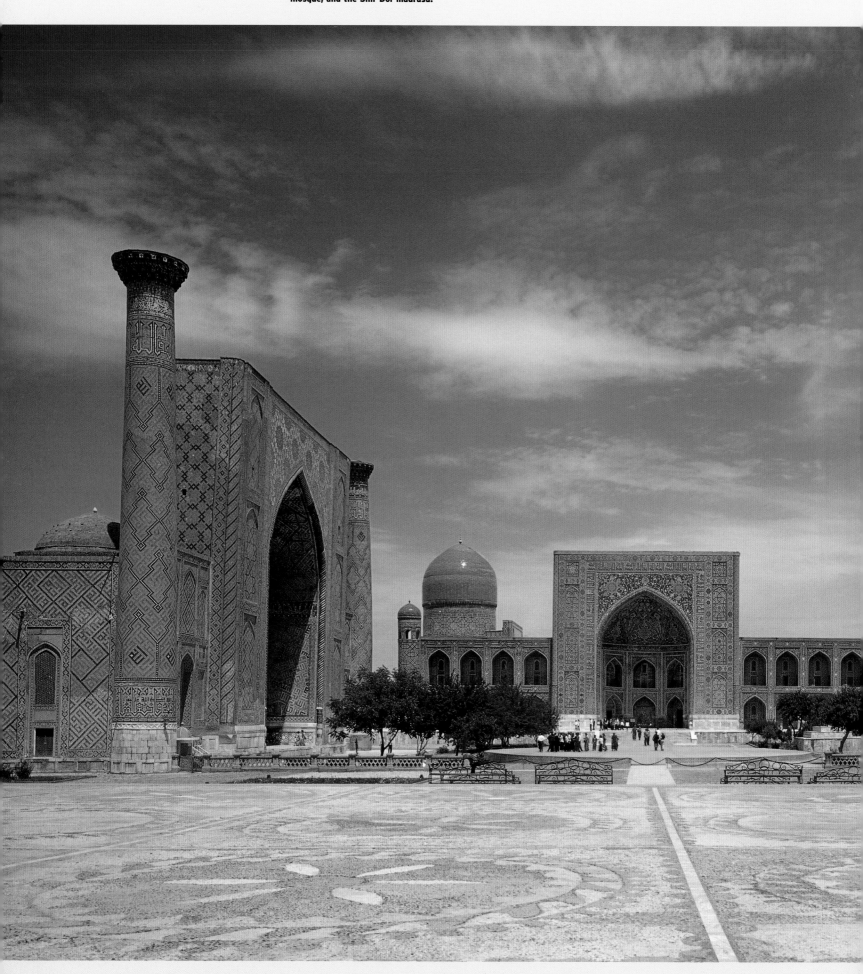

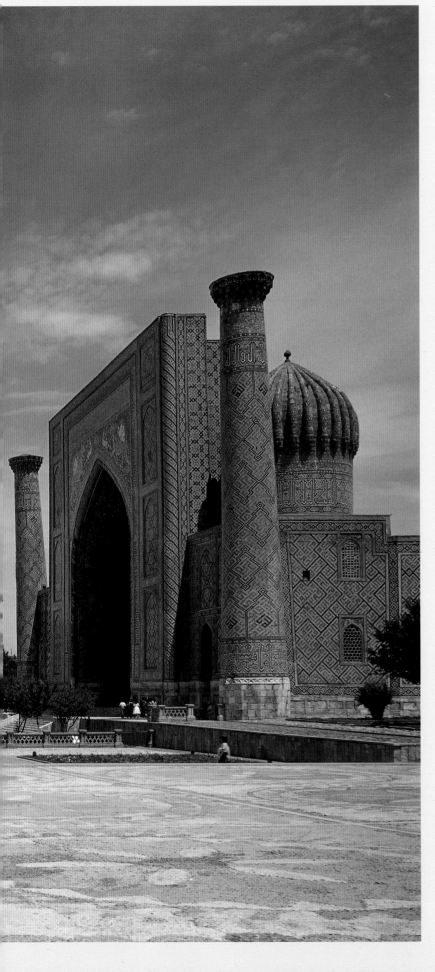

Registan

The Registan in Samarkand is one of the most moving sights in Central Asia. Originally a square that formed the heart of the medieval city, it first took on its present monumental form in the 15th century when Ulugh Beg, the Timurid governor of Samarkand, first conceived of the complex as a powerful unified space surrounded on all sides by buildings. Around the square he built a *khanaqah* (hostel for Muslim mystics), two mosques, public baths and a madrasa. Only the madrasa, built between 1417 and 1420, survives. This rectangular building, measuring 81 by 56 metres (266 by 184 feet) contains a square court measuring 35 metres (115 feet) on each side. Here 50 rooms would have housed 100 students. Opposite the entrance a large vaulted hall was used as a mosque. The main façade onto the Registan contains a huge *pishtaq* (portal) that spans 16.5 metres (54 feet) and reaches a height of 35 metres (115 feet). Minarets stand at the four corners. The entire building is richly decorated with terracotta and brick mosaic above marble panels, depicting a huge variety of geometric, epigraphic and vegetal subjects.

In the early 17th century the governor of Samarkand, Yalangtush Bi Alchin, remodelled the Registan. He had Ulugh Beg's *khanaqah* demolished and, between 1616 and 1636 built a new madrasa known as the Shir Dor ('possessing lions'). It takes its name from the lions that decorate the spandrel panels of the entry portal. It is designed to match the original Timurid madrasa, opposite, with its huge iwan flanked by ribbed domes set upon high drums, themselves flanked by tall freestanding minarets. It also mirrored Ulugh Beg's remaining madrasa in plan. It is decorated in predominately green and yellow mosaic in brick and ceramic tiles. On the third side of the Registan is the Tillya-Kori (literally 'gold-work') madrasa, which was built between 1646 and 1660. This is the largest structure in the Registan and combines the functions of madrasa and congregational mosque. Its walls contain two storeys of arched recesses. The congregational mosque is located under a ribbed dome to the west.

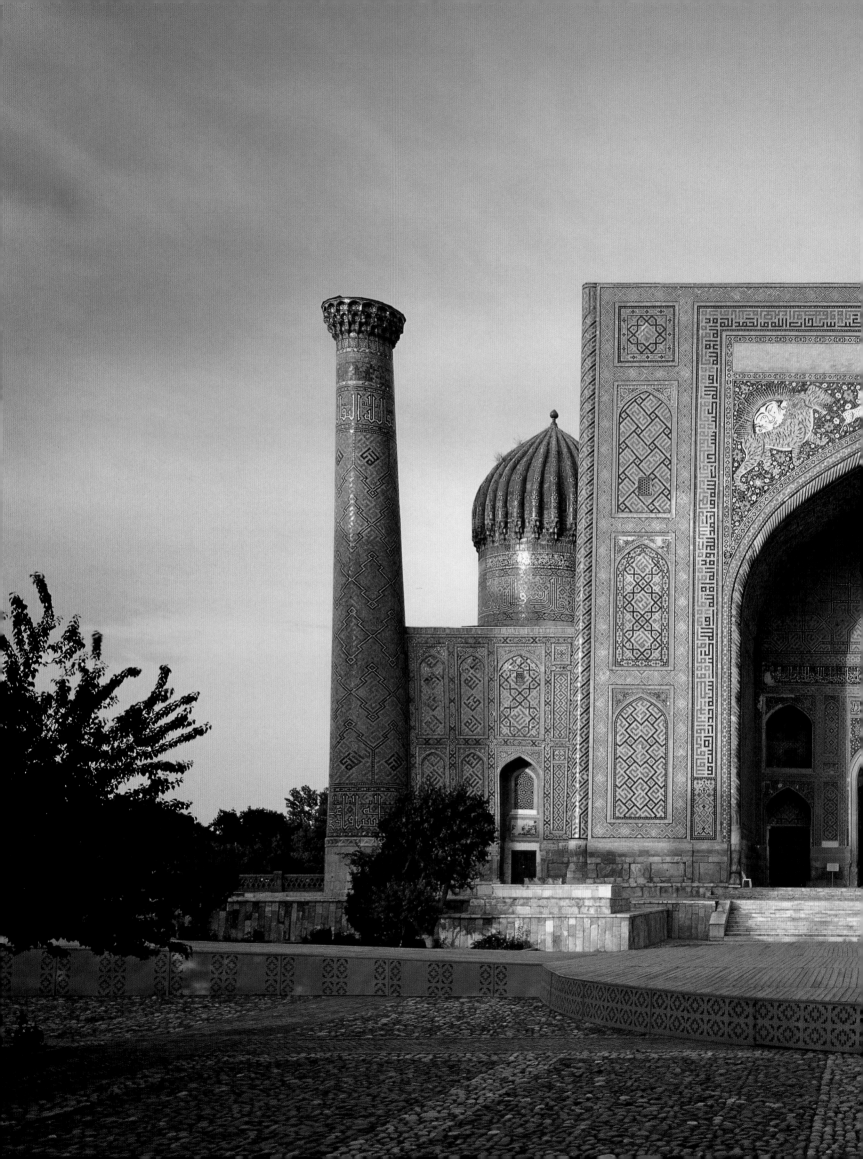

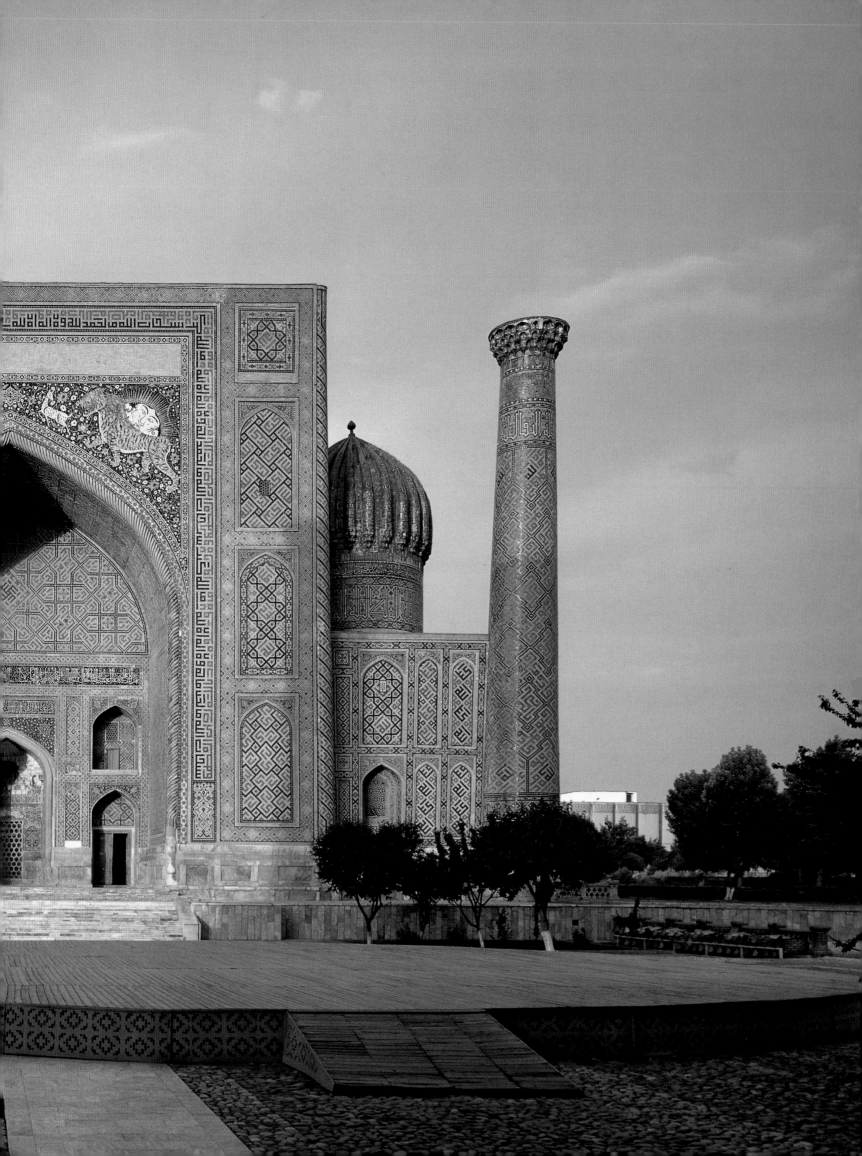

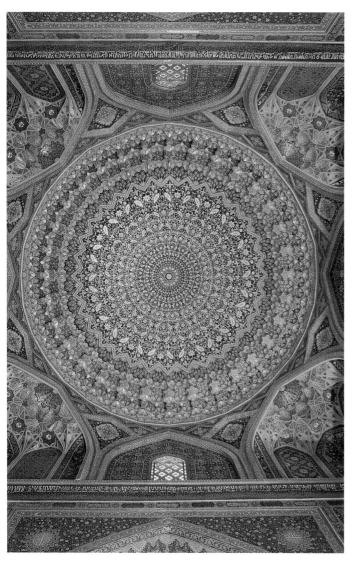

ABOVE

The ceiling of the congregational mosque within the Tillya-Kori building illustrates the continuing decorative richness of the Timurid tradition.

RIGHT

The Shir Dor madrasa seen from the entrance to the Tillya-Kori building.

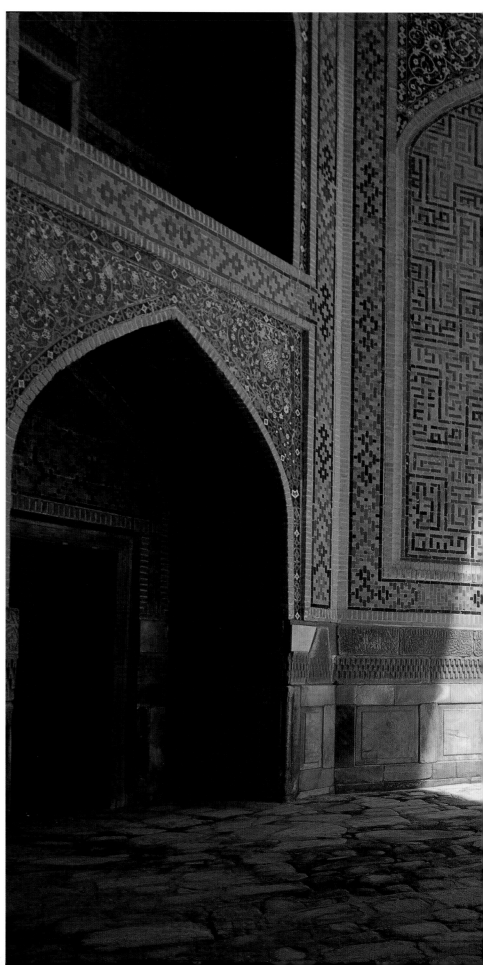

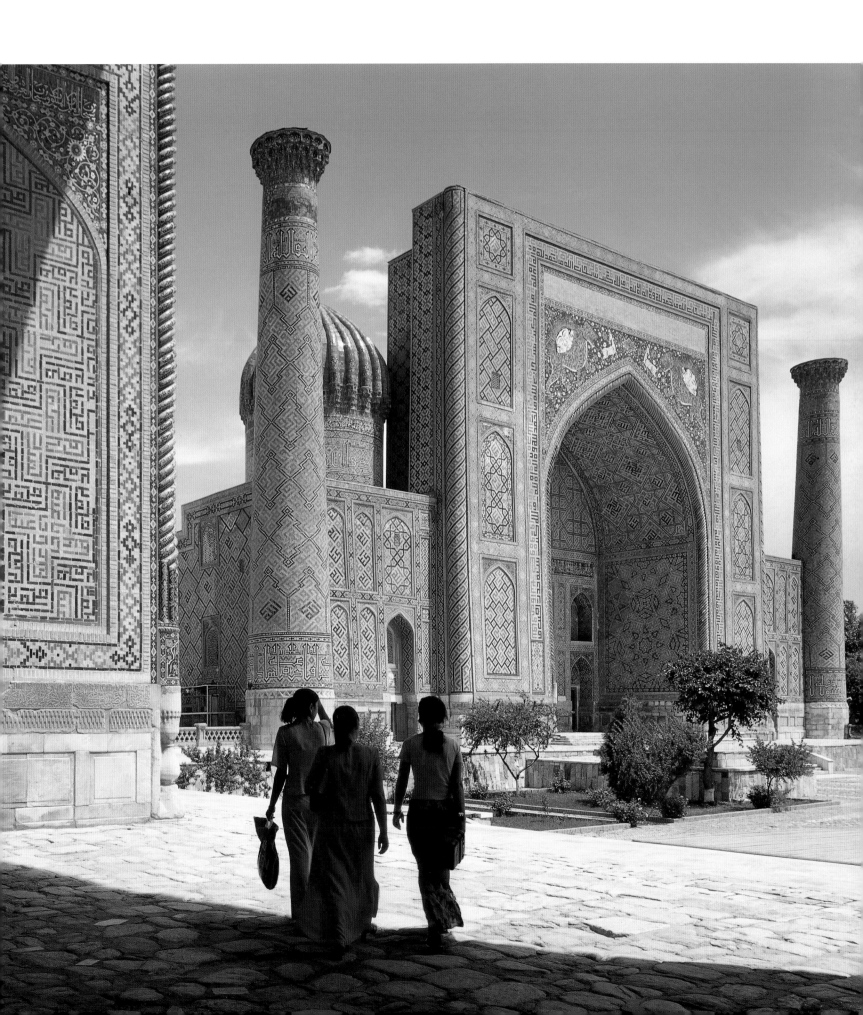

Every colour has a symbolic function In the Forbidden City. Yellow roofs represent earth, the origin of all things under the sun; red signifies fire, the source of light. These primary colours were the hallmarks of imperial palaces.

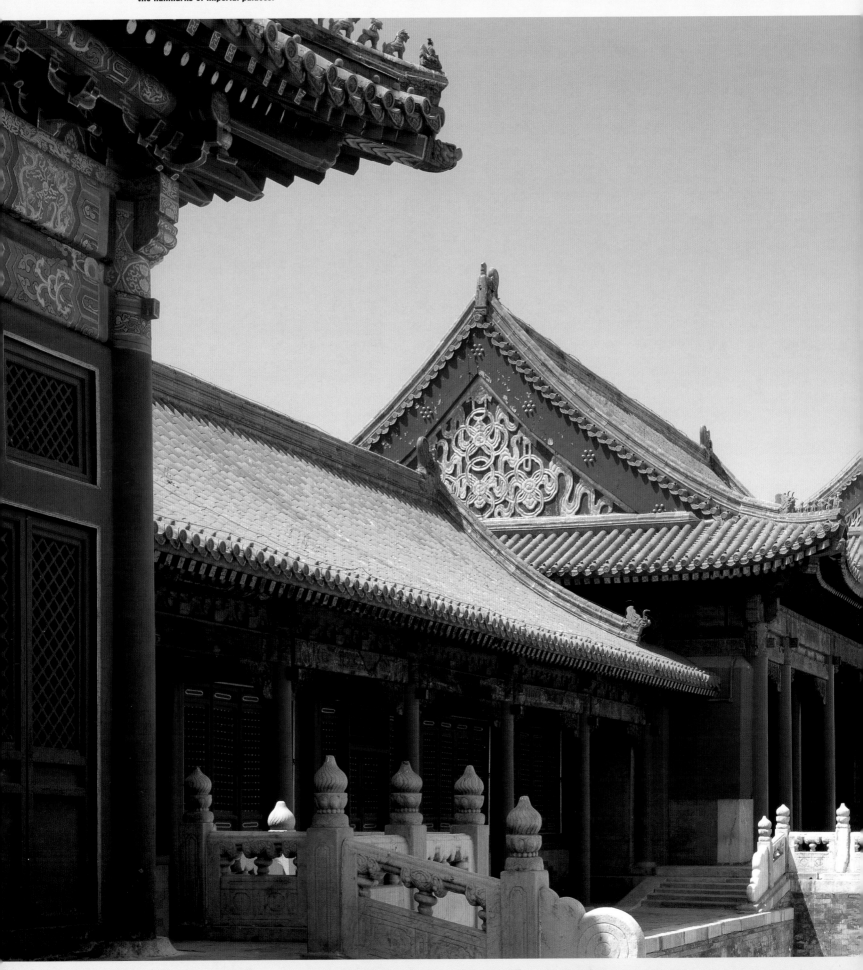

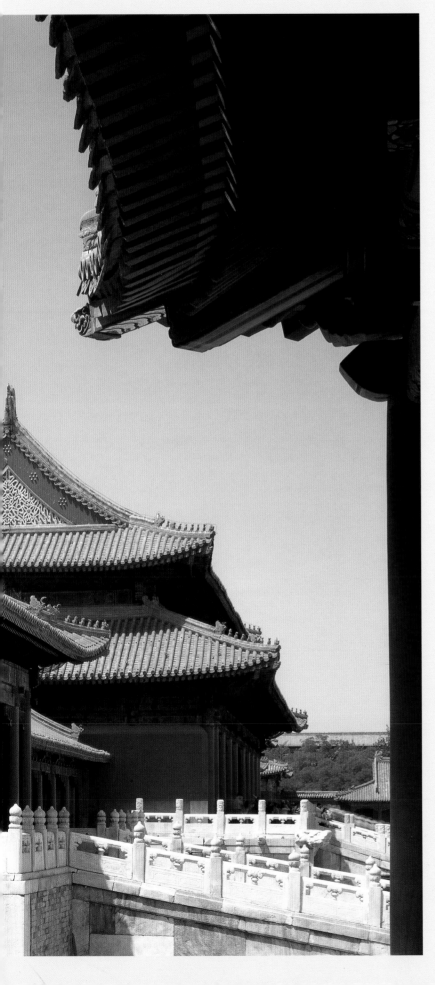

Forbidden City

The work of the philosopher Confucius (551–479 BC) has always had great influence on Chinese thought, including the practice of architecture. Confucian philosophy, as interpreted by later scholars, decreed that the ideal society was one that reflected the natural hierarchy of the universe both in people's relation to each other and to the state. As the emperor was appointed by heaven to rule over the earth it was vital that he be positioned correctly at the centre of the world. Thus the Forbidden City was a complex conceived as an architectural solution to a philosophical problem. In order to embed the emperor in the cosmically charged landscape, the Forbidden City was placed at the very centre of Beijing within a series of nested boxes, surrounded by the imperial city, inner city and outer city respectively. The name 'Forbidden City' – in Chinese, Zijincheng – is both a practical and symbolic description: *Zi*, meaning purple, is a reference to the pole star, the home of the supreme deity, while the forbidden part (*jin*) refers to the fact that nobody could enter or leave without the emperor's permission.

The interior arrangement of the complex is equally hierarchical. Like Beijing itself, the Forbidden City was strictly symmetrical, and was intended to harmonize with the heavenly forces of yin and yang. It was arranged on a north-south axis with a grand Outer Court, whose main ceremonial buildings are odd in number (signifying yang), and an Inner Court containing the Emperor's private quarters in an even number of buildings (signifying yin). In total there are over 800 buildings.

Remarkably the Forbidden City was built in just three years starting in 1417, occupying one million workers and 100,000 planners and craftsmen. The hardwood used, which is of exceptional quality, was gathered in the south-west province of Sichuan and brought 1,500 kilometres (930 miles) to Bejing. Many of these original structures were damaged in the 15th and 16th centuries but, as is common in China, they were replaced with identical structures in the 17th century.

There are more hierarchical relationships between buildings in terms of size, type of roof and complexity of detail. The largest building is the huge Hall of Supreme Harmony (Tai He Dian). It stands 28 metres (91 feet) above a stone terrace and is 64 metres (210 feet) wide and 37 metres (121 feet) deep. The ceremony of the emperor's enthronement took place here. Sitting on the imperial throne he could survey the thousands of courtiers prostrating themselves before him, and reflect upon his dual roles as temporal lord of all China and the son of heaven.

OPPOSITE

The Forbidden City contains over 800 buildings and 900 'chambers', defined in Chinese architecture as the space between four columns.

RIGHT

The 72 sets of wooden brackets that support the roofs of the watchtowers form a superb structure, even if they are militarily impractical. (The real fortification is underneath, in the form of huge stone walls.) Nevertheless, they indicate the essential theatricality that underlay the symbolic function of the building.

BELOW

The largest building in the complex, the Hall of Supreme Harmony, supports over 2,000 tons of roof with columns topped with nine wooden bracket sets.

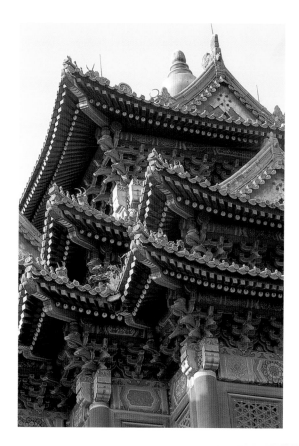

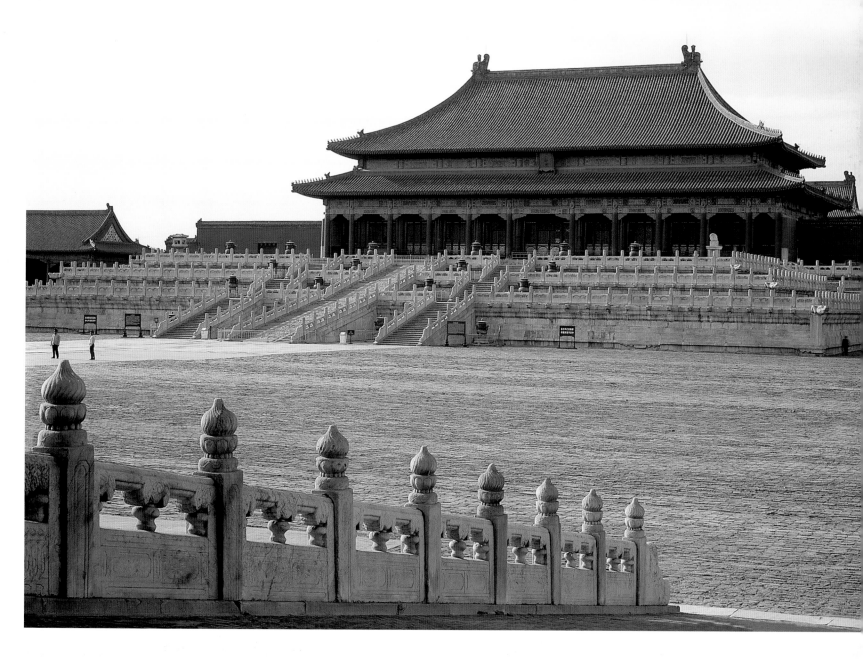

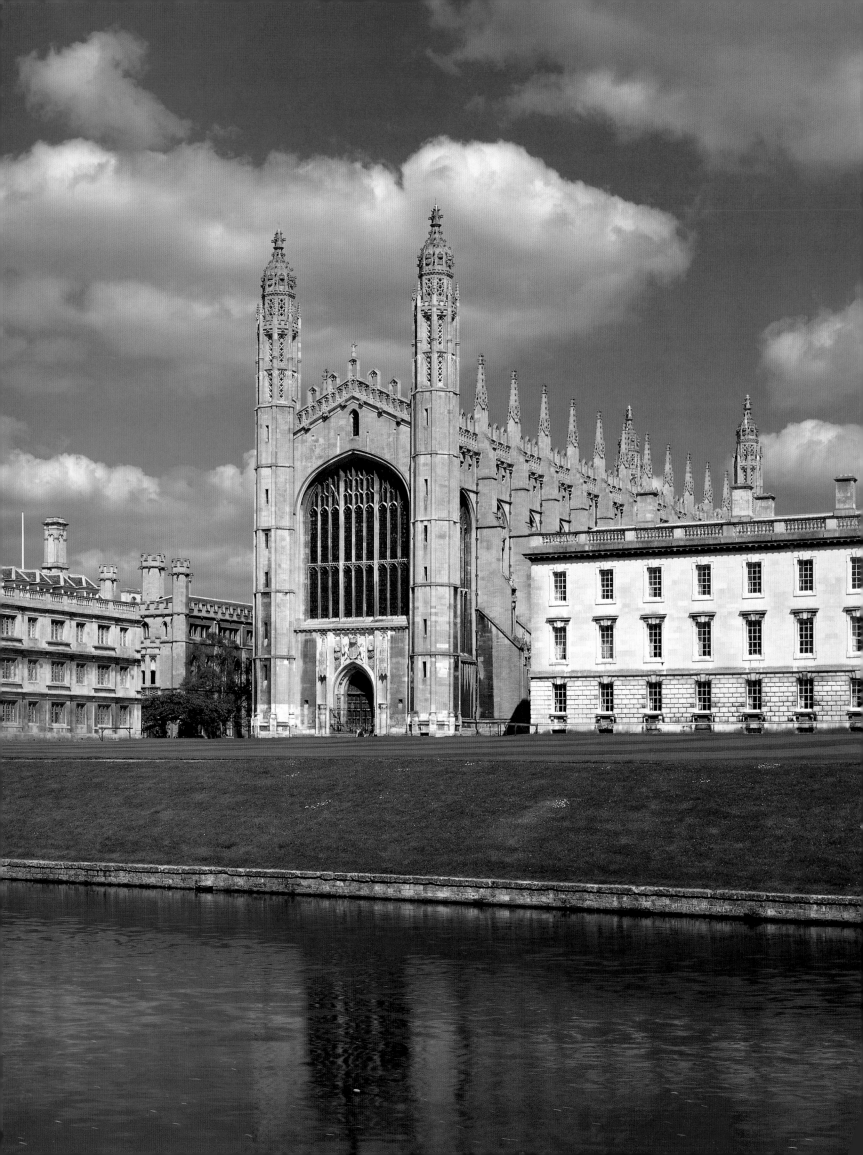

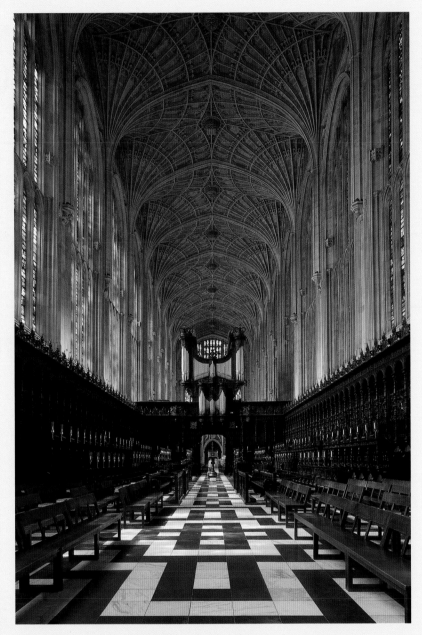

The 16th-century oak choir stalls had canopies added in 1675-8.

The chapel of King's College is surely the most magnificent of any university anywhere. It dominates the ensemble of university college buildings along the banks of the River Cam (collectively known as 'The Backs').

King's College Chapel

CAMBRIDGE ENGLAND

King's College in the University of Cambridge was founded by King Henry VI to provide a university education for students of his new school, Eton College. In his will of 1448 Henry even went so far as to draft a plan for a new scheme of buildings, but of this only the chapel, begun in 1446, was actually built. Its design was entrusted to architect Reginald Ely, and though he died in 1471, he had already determined the basic form – a long rectangle, entered by a south doorway near the west end.

The style is Perpendicular, the last period of English Gothic. However, research has shown that the chapel was built in three phases corresponding roughly to the reigns of Henry VI, Edward IV and Henry VIII, with long intervals in between – the structure was not finished until 1515, and the glazing went on for some time after that. By then tastes had changed and Reginald Ely's restraint gave way to a taste for sumptuous decoration. Ely certainly had not intended to build a fan vault, since he provided seven wall-shafts per bay when the fan vault needs only five; in addition, there is an apparent discrepancy between the top of the windows and the springing of the vault. However, in its final form the building appears to be completely and deliberately unified.

The interior space is both cave-like in the integration of wall and ceiling surfaces and dazzlingly light and open. At floor level transparent screens open into chapels between the buttresses. Above these the walls consist mostly of glass between vertical mouldings, which branch into the largest of all fan vaults. These famous vaults, and the decoration both inside and outside, belong to the third phase, when the architect in charge was John Wastell, who also worked at Canterbury (see p. 108). The sculpture, which stands out from the wall rather than being in shallow relief, is documented as being by Thomas Stockton and include figures, heraldic roses, portcullises and fleurs-de-lys. The stained glass windows, installed in the years after 1515, show Renaissance influence in their canvas-like depictions of the Life of Christ.

The huge choir screen was erected about 1535, in the middle of Henry VIII's reign. The very accomplished carving, again Renaissance in style, has been attributed to Italian or French artists. The choir stalls behind it, and their misericords, are English. On top of the screen stands the organ (dating to after 1605), crowned by two Baroque angels. The latest addition to King's College Chapel is perhaps the most controversial. In the 1950s the college was given a painting by Rubens depicting the Adoration of the Magi. It was decided to place this painting at the east end, which required the dismantling of some of the original panelling. Wonderful as the painting is, however, many feel that it is out of place in this fundamentally late medieval chapel.

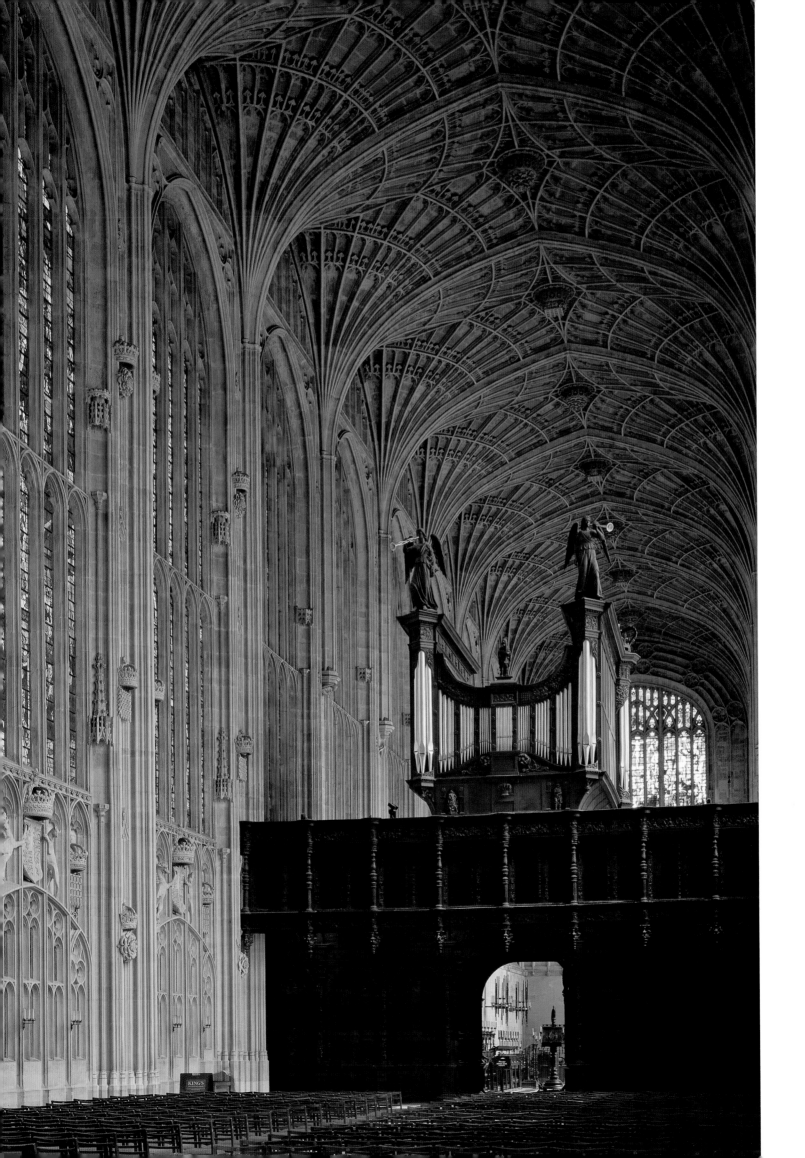

OPPOSITE

The cave-like character of the interior is a consequence of the world's largest fan vault, where ribs splay out from the tops of the piers creating a cone-like form.

BELOW

The supporting buttresses topped with pinnacles provide the structural support necessary to allow the façade to be devoted to windows.

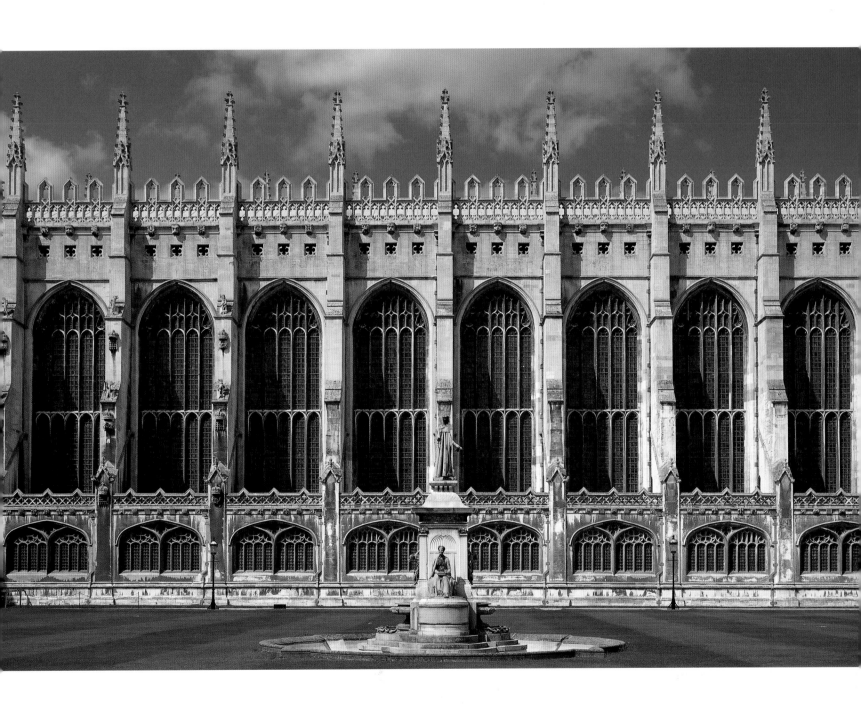

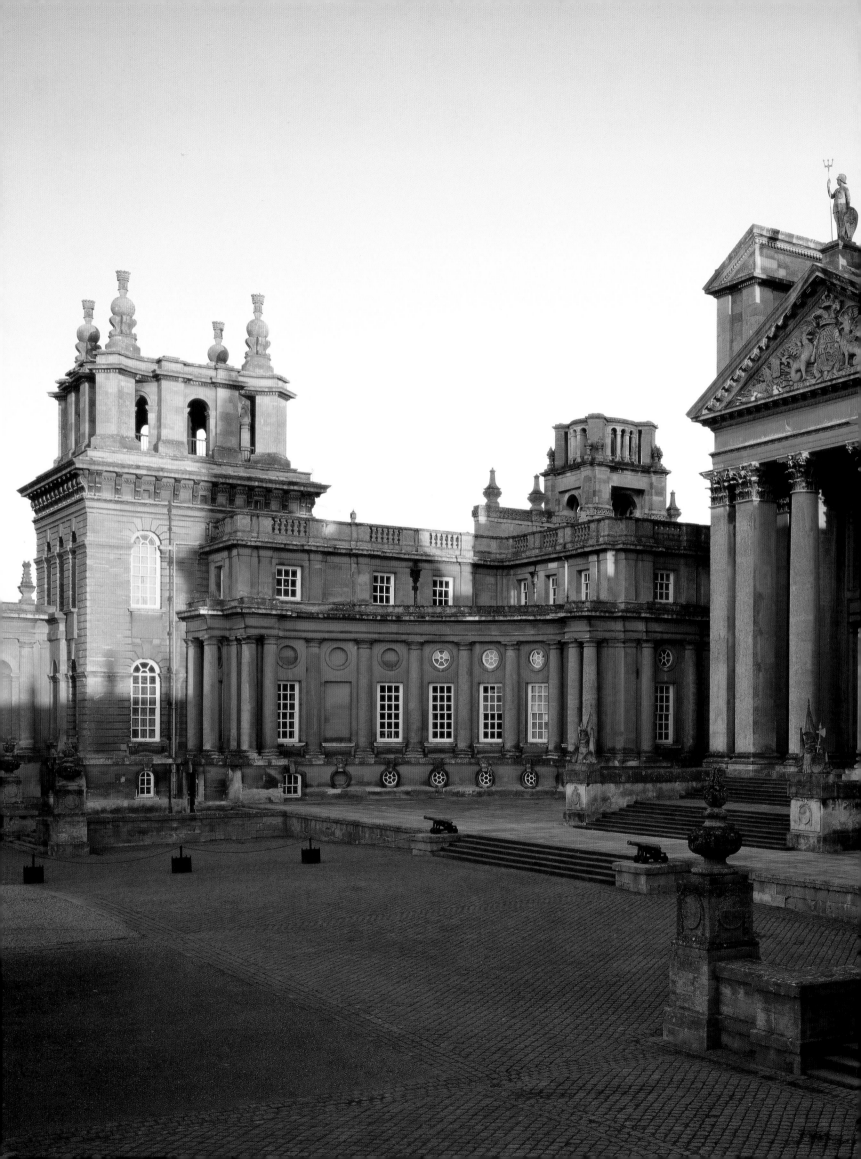

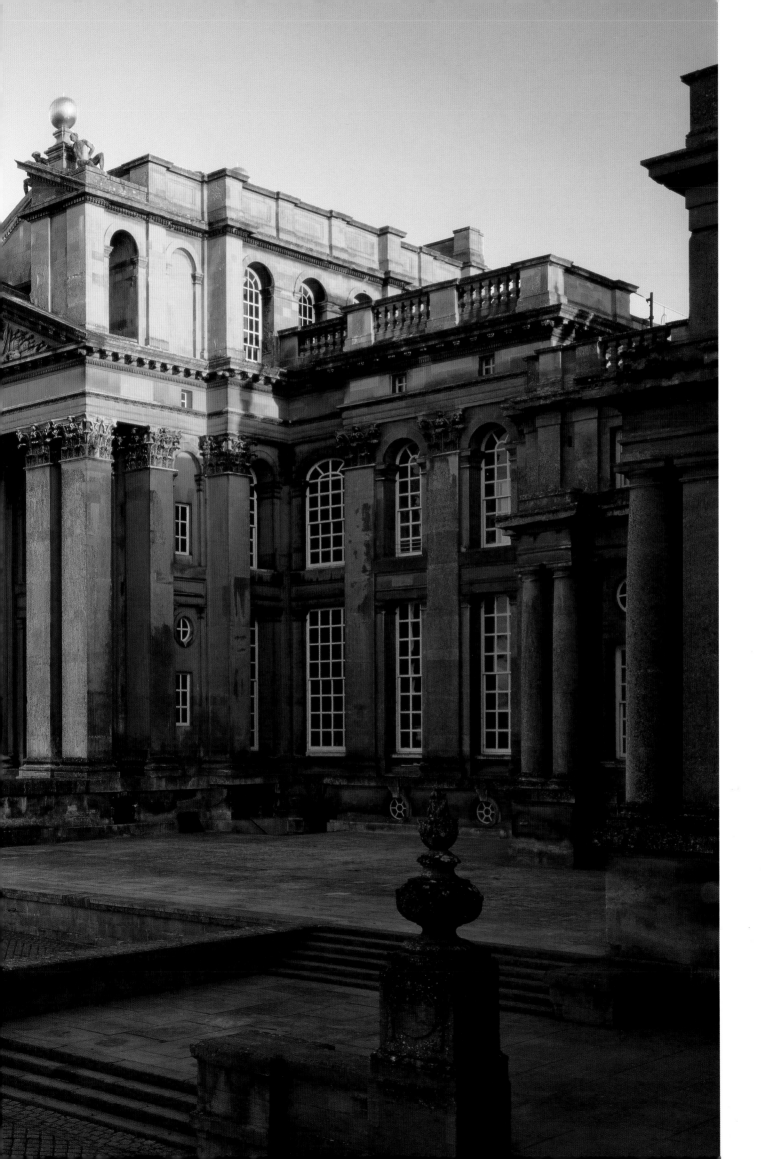

PAGES 156-157
Blenheim Palace, England.

OPPOSITE
The west front of the Cathedral of St Nicholas, St Petersburg (1753–62), was designed by the architect Savva Chevakinskii and translates the traditional five-domed Orthodox church into the Baroque.

INTRODUCTION

PART TWO AFTER 1500

Western historians use the turn of the 16th century as a convenient date for the start of the 'modern' era. This is because in Europe during the first half of the century the intellectual and cultural movement known as the Renaissance coincided with the religious revolution known as the Reformation. The combination of a wholesale revisiting of the art and thought of the Classical period and a profound questioning of the authority of the Roman Catholic Church paved the way for the birth of the secular, scientific Western world. The immediate impact of the Renaissance upon architecture was the application of the Classical language of forms, which by 1600 had definitively superseded Gothic across Europe.

These developments were limited to Europe, and elsewhere in the world native architectural traditions continued along their own paths. As it happens, however, the 16th century also marked the beginning of a golden age of Islamic architecture. While the dynasty established by Timur finally died out during this period, the reputation of the man and his monuments went on to inspire the architecture of his successors in the Islamic world – the Ottomans in Turkey, the Safavids in Iran and the Mughals in India. Each created their own unique, dynastic architectural traditions based on their own interpretation of Timurid forms. The best of these new buildings – the Selimiye Mosque in Edirne, the Shah Mosque in Isfahan and the Taj Mahal in Agra – are not only among the finest buildings in the Islamic world but also among the very finest of all time.

When the Byzantine city of Constantinople was captured by the Ottomans in 1453, the 21-year-old victor Mehmed II chose to transform the church of Hagia Sophia into the city's main congregational mosque. This was to prove a significant decision, since the church's massive form and engineering brio then became an appropriate template for Ottoman architecture (a tradition that already employed hemispherical domes over strong cubic forms). The Hagia Sophia would influence a whole generation of mosques that still harmonize with it across the skyline of Istanbul today. The second essential contribution in this great Islamic architectural tradition was made by a former Christian who became the greatest and most famous of all Ottoman architects. Sinan was probably born about 1490, somewhere in the Balkans. As a young man he was conscripted as a Janissary, a member of the elite military corps dedicated to the Sultan's service, and brought up as a Muslim. As a soldier he took part in a number of campaigns between 1514 and 1538, including the Battle of Mohács, and rose to high rank. It was during his time in the army that he learned the art of building. Sinan's architectural career became inextricably tied to the reign of Süleyman, the most avid builder of all the Ottoman sultans. Süleyman recognized Sinan's talent, and appointed him Chief Court Architect in 1538. During the next half century Sinan was responsible for at least sixty mosques as

well as madrasas, caravanserais, baths and bridges, among other things. By any reckoning he was among the most prolific architects who ever lived and his greatest mosques – Süleymaniye in Istanbul and Selimiye in Edirne – mark the high point of the Ottoman tradition. Moreover, Sinan's example inspired other architects to follow a set of rules of design – such as maintaining the integrity between the inner and outer profiles of the dome – that make that tradition unique. As a result of this approach, Ottoman public buildings are often beautifully engineered with meticulously executed details. The results are imposing, considered and reserved works of architecture, even if they are rarely innovative or flamboyant.

The Safavid dynasty was named after its originator, Sheikh Safi al-Din (died 1334), the religious leader of a Sufi order from Ardabil in north-west Iran. Despite a short period of stability under Timur in the 14th century, Iran had lacked strong centralized government. The Safavids changed this by combining elements from folk Islam, Sufism and extreme Shi'ism to turn their minor religious order at Ardabil into a revolutionary Shi'ite movement that swept across Iran. By making Shi'ism the official religion, the Safavids forged an ideology that not only strengthened the state but also helped to create a new sense of national identity that enabled Iran to avoid absorption into the aggressive neighbouring empires of the Ottomans and the Mughals.

During the 1530s the Safavids had lost control of the major Shi'ite shrines at Najaf and Karbala in Iraq to the Sunni Ottomans. This was followed, in 1589, by the dreadful loss of the holy shrine at Mashhad to the Sunni Shibanids. While they did later recapture it, its loss was an immense blow to Safavid honour. In the 1590s Abbas I (reigned 1588–1629) decided to consolidate power by relocating the capital from the insecure periphery into the stable centre of the country at Isfahan, establishing the city as a major economic and political centre. A massive building programme was introduced, and it was this that saw the creation of the great monuments of Safavid architecture.

Much of the power of Safavid architecture is a response to this conscious attempt to plan an imperial city. Its finest achievements lie in the harmonious integration of commercial, political and religious functions into large-scale urban ensembles. The royal Naqsh-e Jahan ('Design of the World') Square, which covered 8 hectares (20 acres), was designed and built in five years from 1590 for state ceremonies and sports. It was customized for commercial functions in 1602 with the introduction of two storeys of shops around the perimeter. The monumental Shah Mosque was integrated into its south façade between 1611 and 1630. Its entrance mirrors that of the bazaar that leads on from the north of the square.

The Mughal dynasty in India lasted from 1526 to 1858. It was established by Babur, a Chaghatai Turk who was descended on his

father's side from Timur and on his mother's from Chingiz Khan. They
formed the richest and most powerful Muslim dynasty in Indian history,
and viewed themselves as God's representatives on earth, prophet kings
as foretold in the Qur'an. Their Central Asian features distinguished
them from their Indian subjects and they spoke Chaghatay Turki in
private rather than the Persian of court. Indeed, in Persian 'mughal'
means 'Mongol' or 'Mongolian'. As foreigners ruling over a huge
empire of different races and cultures, the Mughals used architecture to
forge a unique and distinctive imperial identity. Their buildings mixed
indigenous architectural forms and Timurid and Persian features into
a new synthesis.

The design of the new imperial city of Fatehpur Sikri, founded
by Akbar in 1571, illustrates the way native architectural traditions
(in this case those of Gujarat) were incorporated creatively into the
Mughal architectural tradition. In fact, Gujarati sultanate architecture
already contained Jain and Hindu features. The most revealing Mughal
structure here is the tomb of Sheikh Salim Chishti (1580–81), which
sits within the congregational mosque. It is reminiscent of Gujarati
tombs that also have an inner chamber, wrapped by an ambulatory
walkway of latticework walls and surmounted by a dome. These walls
are protected by overhanging eaves, supported by exquisite serpentine
brackets. Breaking with precedent, however, Akbar denied the sheikh's
descendants custodianship, instead taking on that responsibility himself.
This act and the exceptional quality of the workmanship suggests that
Akbar was determined to use his patronage to take control of this
popular Islamic order.

Over time the style of Mughal architecture changed and new
features – for example, the ogee arch and the bulbous dome – were
absorbed into it. The Mughals built major congregational mosques
such as that at Delhi (1650–56) to emphasize their piety, but the dynasty,
more than any other, was characterized by its mausoleums – colossal
monuments surrounded by pools and formal gardens. The most powerful
and poetic of these visions of Paradise – Humayun's Tomb and the
Taj Mahal – have excited a Western imagination largely unaware of
their origins in Qur'anic scripture. They have inspired a romantic
vision of architecture, and in the Taj almost a symbol of the limits
of artistic possibility.

The architecture of these three great Islamic dynasties was
extraordinary both aesthetically and in their degree of technical
expertise. They were clearly the equal of anything being produced in
the West. But what distinguished Eastern and Western traditions from
one another in the Early Modern period of history was no longer solely
religious but also philosophical. In the case of the Ottomans, for example,
every architectural element, pier, arch or wall, is sublimated to the greater
purpose of supporting the dome – the symbol of the abstract Islamic
concept of God. Their mosques are entered via a portico preceded by a
courtyard that serves consciously to diminish the importance of men.
The Western Renaissance on the other hand prefigured the religious

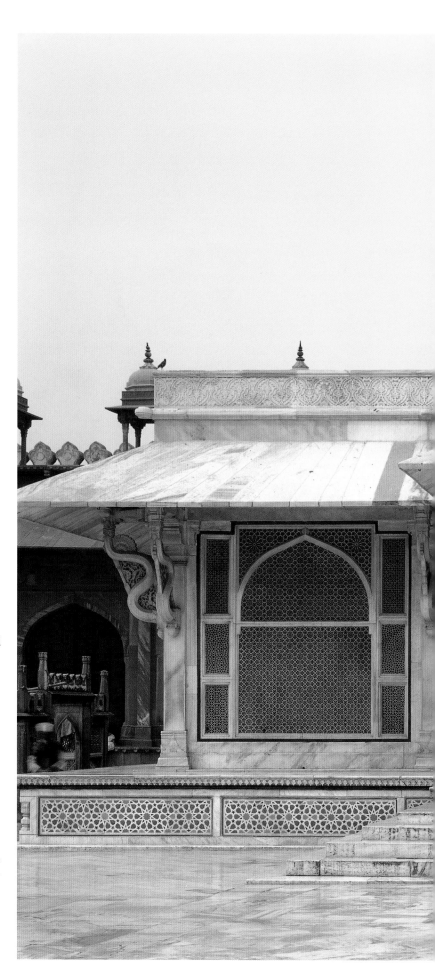

The tomb of Sheikh Salim Chishti (1580–81), in Fatehpur Sikri, is an outstanding example of Mughal architecture but on a tiny scale. Square in plan, the front porch is derived from those of Hindu temples. The superb marble lattice screens serve as a circumambulatory around the central tomb chamber. Each serpentine bracket is a single piece covered with floral and geometric patterns.

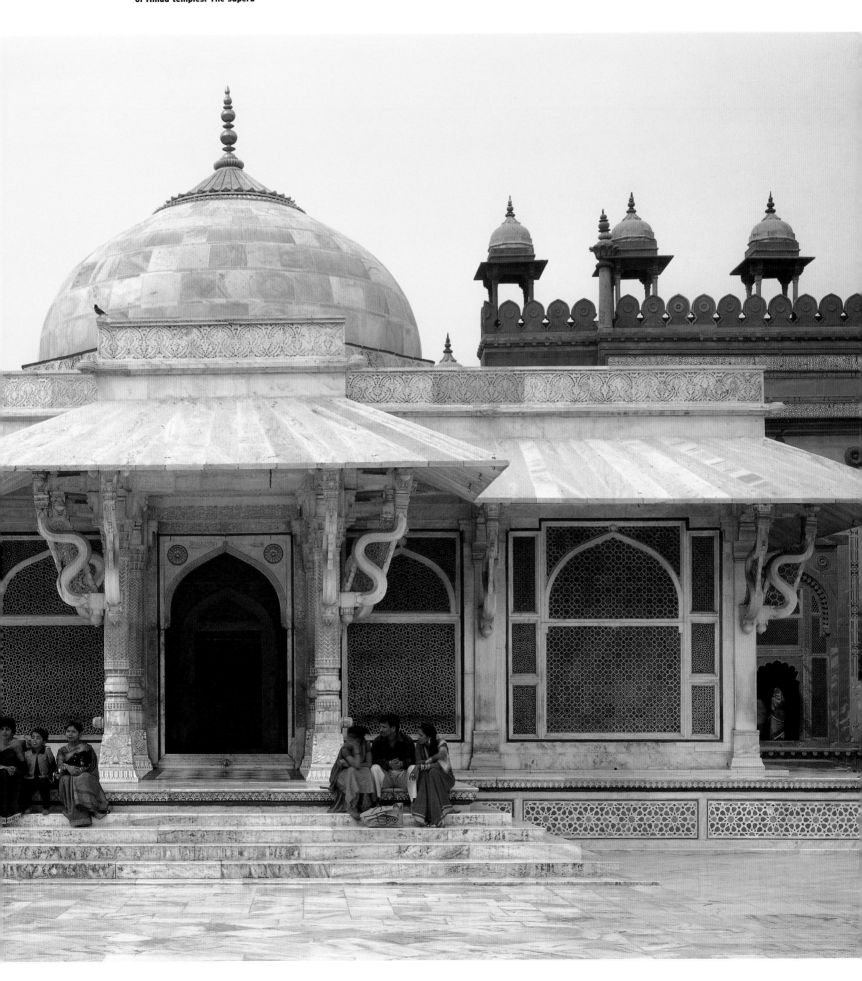

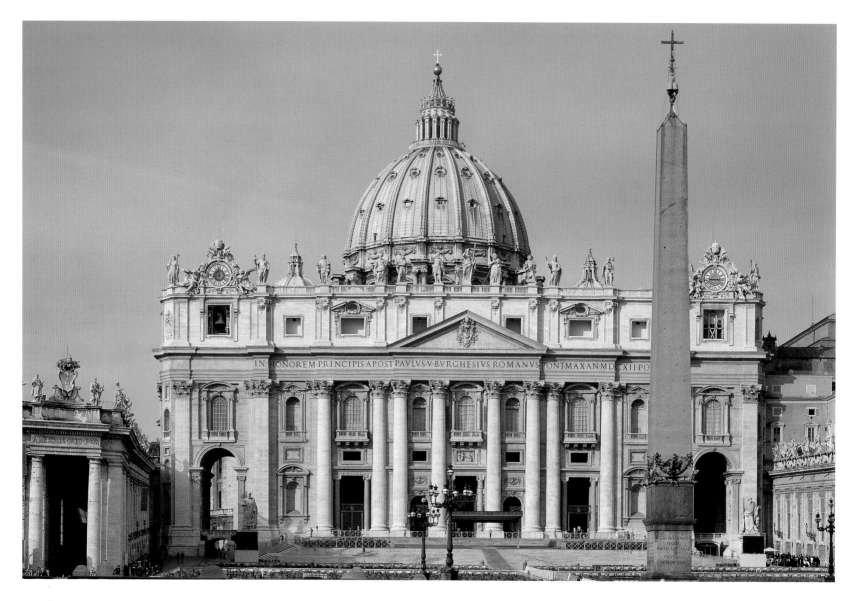

doubt of the Reformation period by reintroducing a pre-Christian view of the relative status of mankind, a status made manifest in their architecture. Renaissance churches are entered by fine west fronts, no longer the vehicle for didactic images of the Last Judgment but rather a grand and balanced expression of man's nobility and civilization.

The European Renaissance, then, was characterized in large part by its emphasis on Humanism. As much as this, however, it was defined by what it was not – that is, Gothic. This conscious distinction was made as early as Giorgio Vasari's *Lives of the Artists* of 1550, in which he referred to a *rinascità* (rebirth) of art starting in the 14th century and meaning that 'good art' had re-emerged after the ignorance of the medieval period. From this point on, art would once again be based on the empirical world, as it was in Antiquity – unlike the sculptures that adorned Chartres Cathedral, which instead sought to describe a priori ideas such as sanctity or sainthood. It marked the beginning of a gradual shift from a theocentric to an anthropocentric worldview.

The result of this philosophical shift was the most radical break from tradition in Western architectural history. There was no gradual, blurred transition as there had been from Romanesque to Gothic. Architects were quite suddenly faced with the task of inventing a completely new image of what a building, sacred or secular, should look like. The architectural language of the ancient world – Classicism – had to be customized for contemporary building types. In terms of church building this meant turning to the Greek and Roman temple as the source of inspiration. But more important than the application of the Classical

orders was the introduction of Classical proportional systems. The width of Classical buildings is defined in proportion to their height. The enormous but ultimately arbitrary heights of French Gothic cathedrals were replaced by a more horizontal architecture of carefully considered proportions. This can already be seen at the beginning of the 15th century in the work of the architect Filippo Brunelleschi, first in the dome of Florence Cathedral and then more fully in his churches of Santo Spirito and Santa Maria Novella.

The Papacy showed an unexpected enthusiasm for the new architecture, in spite of Classicism's Antique (and thus pagan) origins. When in 1505 the dynamic Pope Julius II decided to demolish the mother church of Christendom, St Peter's in Rome, and replace it with a new Classical building, it must have seemed to many in the Church a brutal rejection of all that they held sacred. Moreover, as there was no Classical precedent for a large Christian cathedral or basilica, Bramante, the original architect, had to be extremely inventive in reinterpreting Classical elements. The final building was the creation of a whole regiment of architects revising, experimenting with, improving and perfecting Bramante's model over a hundred years.

Bramante's first design was a textbook example of Renaissance planning. Its form was a Greek cross, one arm being the entrance, another the chancel, with chapels in the corners. The crossing was to be surmounted by a hemispherical dome modelled on the Pantheon. The centralized design, symmetrical in all four directions, was perceived by the clergy to place the attractions of Classical geometry above the practical

needs of the church. Bramante died before construction had progressed very far. The architects who succeeded him, including Giuliano and Antonio da Sangallo, Raphael and Peruzzi, had to grapple with two problems, one structural and one liturgical. The first was that the supports for the dome were far too weak; the second that the papal authorities decided that they wanted a more traditional church plan with a long nave. The first problem was solved by Michelangelo, who worked on the design from 1546 onwards. He strengthened the four crossing piers massively, so that they carried the dome, in the process burying all trace of Bramante's design. The second problem was solved by Carlo Maderno, who worked on the building from 1606 onwards, by adding a nave and distinct west front. The result was a compromise – to be repeated with St Paul's Cathedral in London over a hundred and fifty years later – between the rival interests of Classical architects and the clergy.

The ideal Greek-cross plan Renaissance church was only ever completed on a much smaller scale, as at Santa Maria della Consolazione in Todi. Conceived under the influence of Bramante, it displays geometric figures integrated in complete harmonic proportion. Rather than being made up of independent cubes, the main vessel and transepts are completely blended with the half-cylinders and half-domes of the wings supporting the hemisphere and central dome above. It marks the arrival at a perfectly balanced, stable architectural style – a pure academic interpretation of Antique architecture applied to contemporary building types. Having achieved this perfection, almost immediately afterwards architects began to experiment with more individualistic interpretations of Classical vocabulary in a style known as Mannerism.

During the 16th century the Classical style spread rapidly from its origins in Italy across Europe, along the way mutating and responding to regional traditions. This is perhaps most noticeable in France, Spain and England. This response to local tastes was accompanied by changes in patterns of patronage. These countries were now governed by increasingly centralized and powerful monarchies. François I of France built castles along the Loire that blend Classical and French Gothic features. Chambord, begun in 1519, is planned with round towers like bastions, but was never seriously intended to be defended. The steep

OPPOSITE
St Peter's, Rome, was designed by a whole legion of architects, beginning with Bramante and finishing with Bernini, who added the colonnades on either side of the square.

BELOW
The rebuilding of the old Louvre Palace in Paris was planned by François I in 1527 and Pierre Lescot was commissioned in 1546. The Pavilion de L'Horloge, which can be seen at the back of the court, was added by Jacques Lemercier from 1627.

PAGES 164-165
Chambord Palace (1519-47), France. While technically Classical, it resembles a medieval castle with circular towers and, on the roof, a fantastic collection of turrets, towers, chimneys, pinnacles and cupolas.

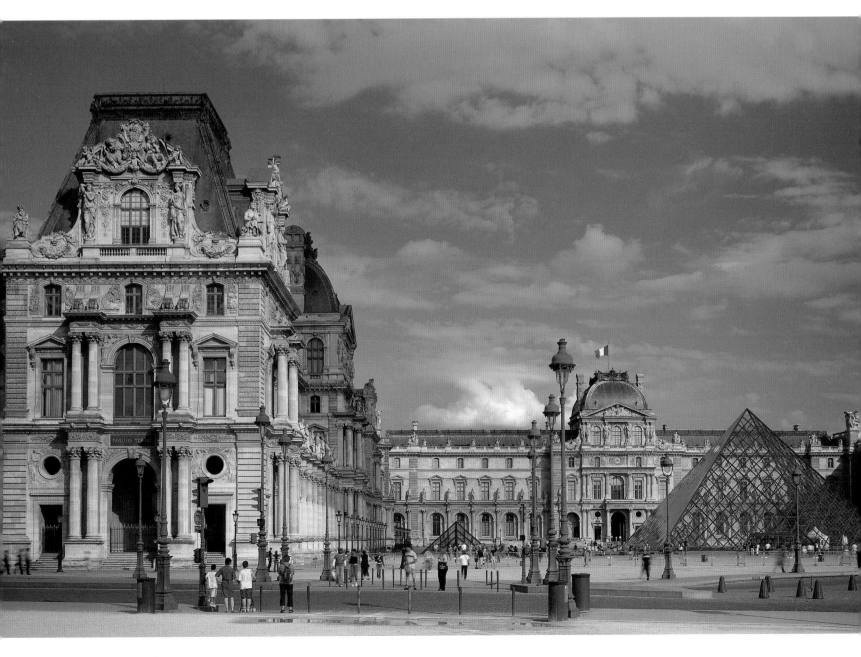

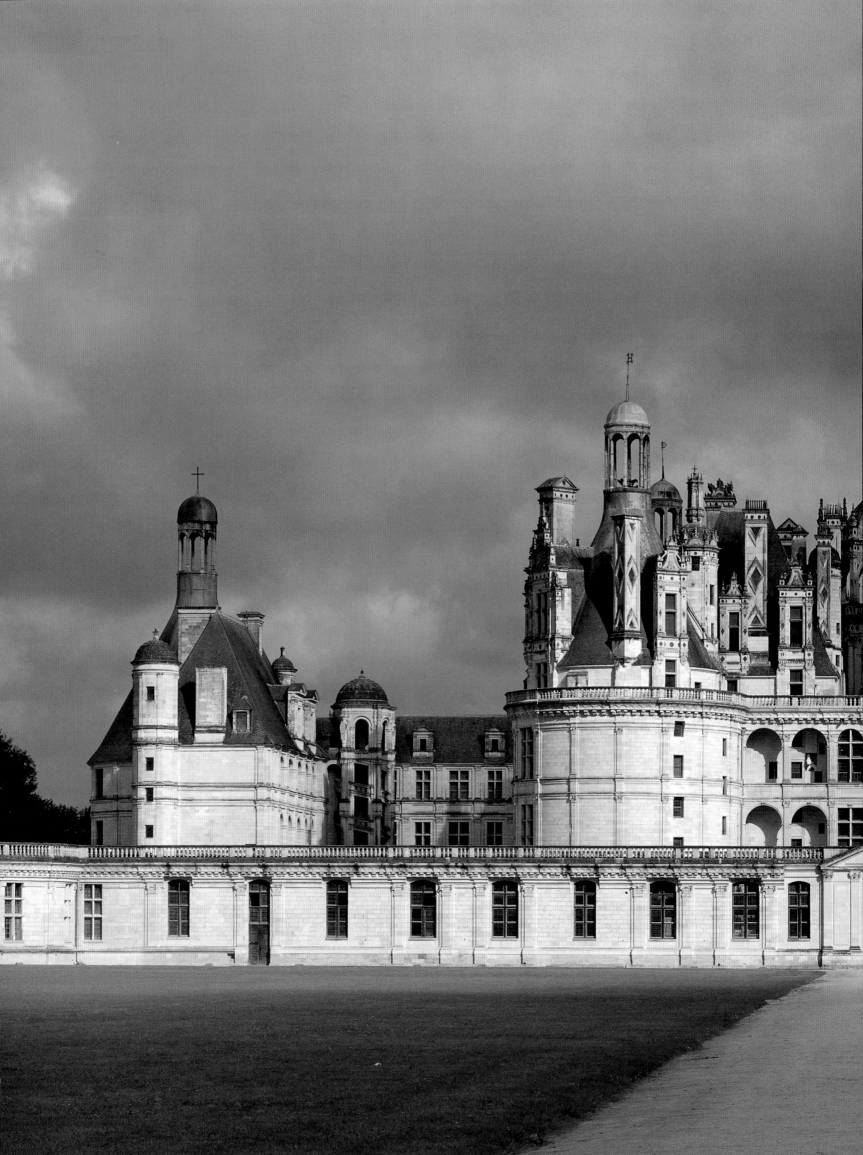

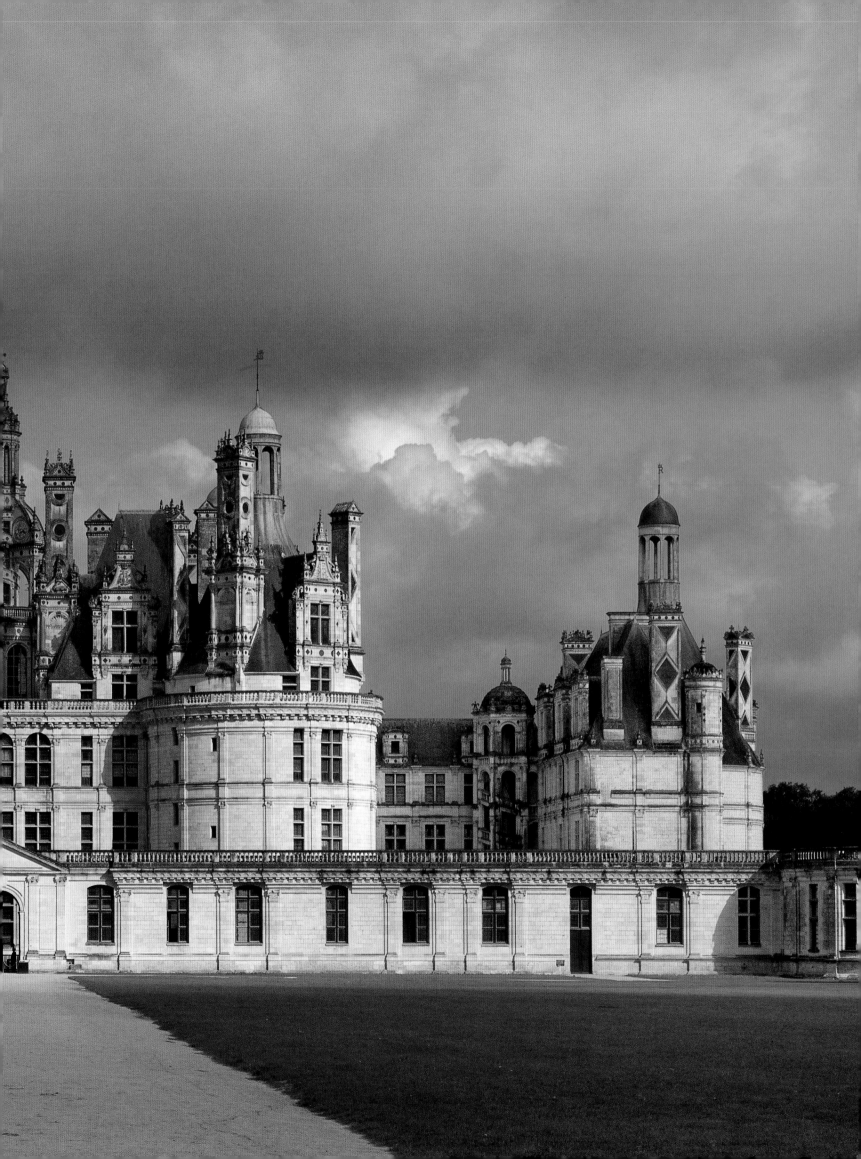

BELOW

El Escorial, near Madrid.
A monastery, palace and school
built in a severe Classical style.

OPPOSITE LEFT

Bernini's Sant'Andrea al Quirinale
is an essay in oval planning, here
placed transversely – the high altar
sits within a niche opposite the
doorway. Bernini also contributed
all the sculpture.

OPPOSITE RIGHT

The Cathedral of the Intercession
on the Moat (better known as
St Basil's Cathedral) in Moscow
actually consists of a central tower
tightly surrounded by eight self-
contained churches.

PAGES 168-169

The south façade of Castle Howard,
Yorkshire, England.

roofs, quintessentially French, hark back to a Romantic ideal of castle architecture in the Middle Ages. Some twenty or so years later the Louvre Palace in Paris was planned by Pierre Lescot. He designed an Italianate elevation to the courtyard using the Corinthian and Composite orders. The palace went on being altered and added to until the 19th century, although later architects followed the original designs with remarkable consistency.

In England Henry VIII not only dissolved the monasteries, one of the most important patrons of architecture, but also withdrew England entirely from the influence of the papacy. Classical architecture really only arrived in the British Isles with Inigo Jones, in the early 17th century. He had travelled in Italy and mastered the pared-down style of Palladio, and almost single-handedly revolutionized English architecture during the reigns of James I and Charles I. His Queen's House at Greenwich and Banqueting House in Whitehall, which use Ionic and Corinthian columns and pilasters in the correct Classical manner, had no precedent in the country and were to have a decisive influence on the Palladian movement of the next century.

In Spain the ideals of the Renaissance were introduced during the reign of Charles V. His palace at Granada, in the precincts of the Alhambra, was built by Pedro Machuca, in a High Renaissance style reminiscent of the work of Raphael. Charles's son, Philip II, adopted the Classical language on the very grandest scale for his austere palace-

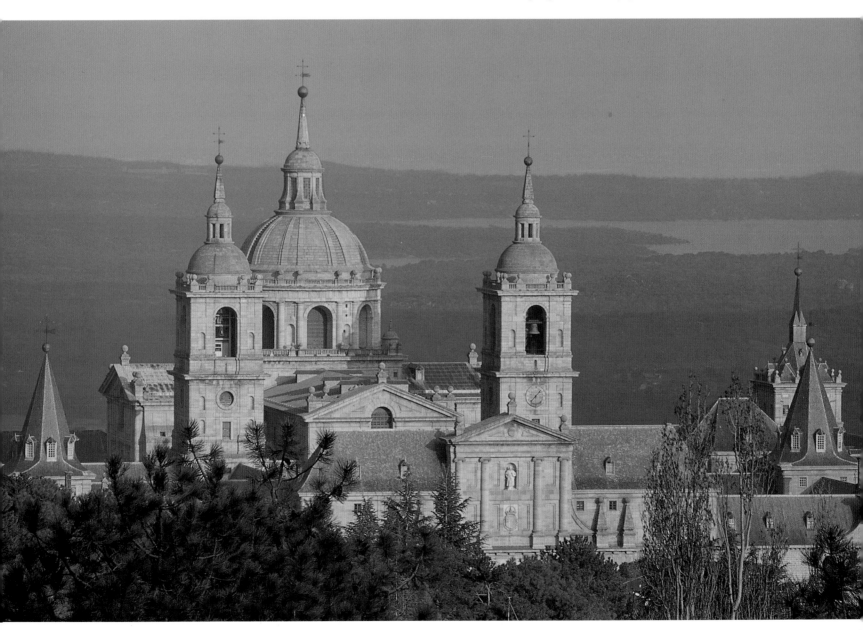

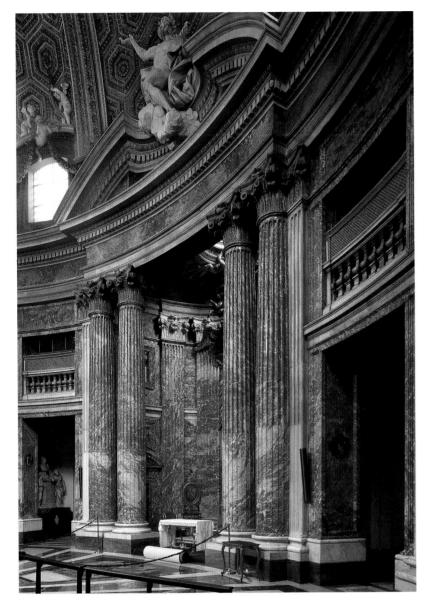

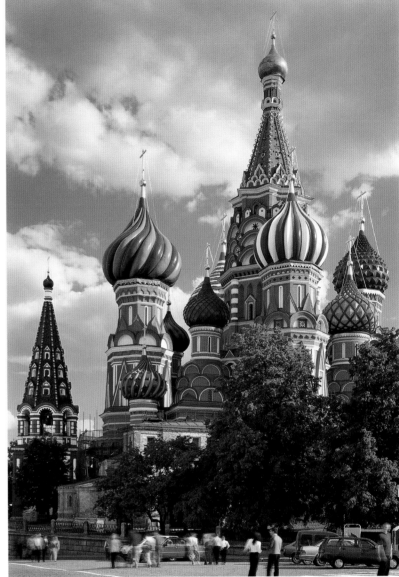

monastery of the Escorial, begun in 1562. Philip demanded 'severity in the whole, nobility without arrogance, majesty without ostentation' and personally oversaw the building process. The result is a sober and monumental architectural style that submitted Antique precedent to a formal simplification and geometric abstraction. A champion of Catholicism, Philip believed Classical architecture to have divine origins and based its proportional system upon the Temple of Solomon.

Other parts of Europe remained isolated from Classical architecture until much later. The construction from 1553 onwards of the Cathedral of the Intercession on the Moat (better known as St Basil's Cathedral) in Moscow, shows that the architectural traditions of the Eastern Orthodox Church were still untouched by developments in the West. This cathedral consists of a central tower tightly surrounded by eight integrated chapels. The profusion of towers and onion domes continues the Russian tradition of forms originally devised in wooden architecture, but later transposed into stone. Travellers to Russia in the 17th century such as Adam Olearius note that the church was called simply 'Jerusalem'. The Heavenly City is represented not only by this agglomeration of towers and domes, but also by association with Moscow itself.

The dispersal of Renaissance forms throughout Europe coincided with the Reformation, which began in Germany in the 1520s. This movement against the authority of the Catholic Church had a far-reaching effect on architecture. Protestant countries such as England and Germany turned against the representation of saints and divine persons in sculpture, painting and stained glass, seeing them as idolatry. With the suppression of images, churches became plain and severe, and this effect spread even to secular buildings. The reaction of Catholic countries to this threat was deliberately spectacular. The so-called 'Counter' or 'Catholic' Reformation, particularly in Italy in Spain, promoted an art of spiritual ecstasy, the worship of relics and the invocation of saints, and led, directly or indirectly, to the style known as Baroque. In this style, architecture was used to promote mystical devotion by means of a theatrical appeal to the senses. Bernini's Sant'Andrea al Quirinale in Rome of 1658 makes its impact as much by the integration and blending of architecture and sculpture (for example, in the soaring figure of St Andrew carried up to heaven above the altar) as by the sculptural manipulation of the space itself. The plan is a transverse oval – a dynamic form, and not one found in conventional Classical architecture – and is clearly expressed in the exterior.

Protestant England was sceptical of the use of Baroque in a religious context – only St Paul's Cathedral in London might be considered a Baroque church. However, there was more enthusiasm among private patrons, specifically in the design of great country houses. The work of Sir John Vanbrugh showed distinct Baroque leanings. His first major house, Castle Howard, in the north of England, was begun in 1699. Its long south façade consists of three sections of nine bays each, the central one of two storeys; on the north this block opens into a courtyard defined by quadrant wings. The central hall is crowned

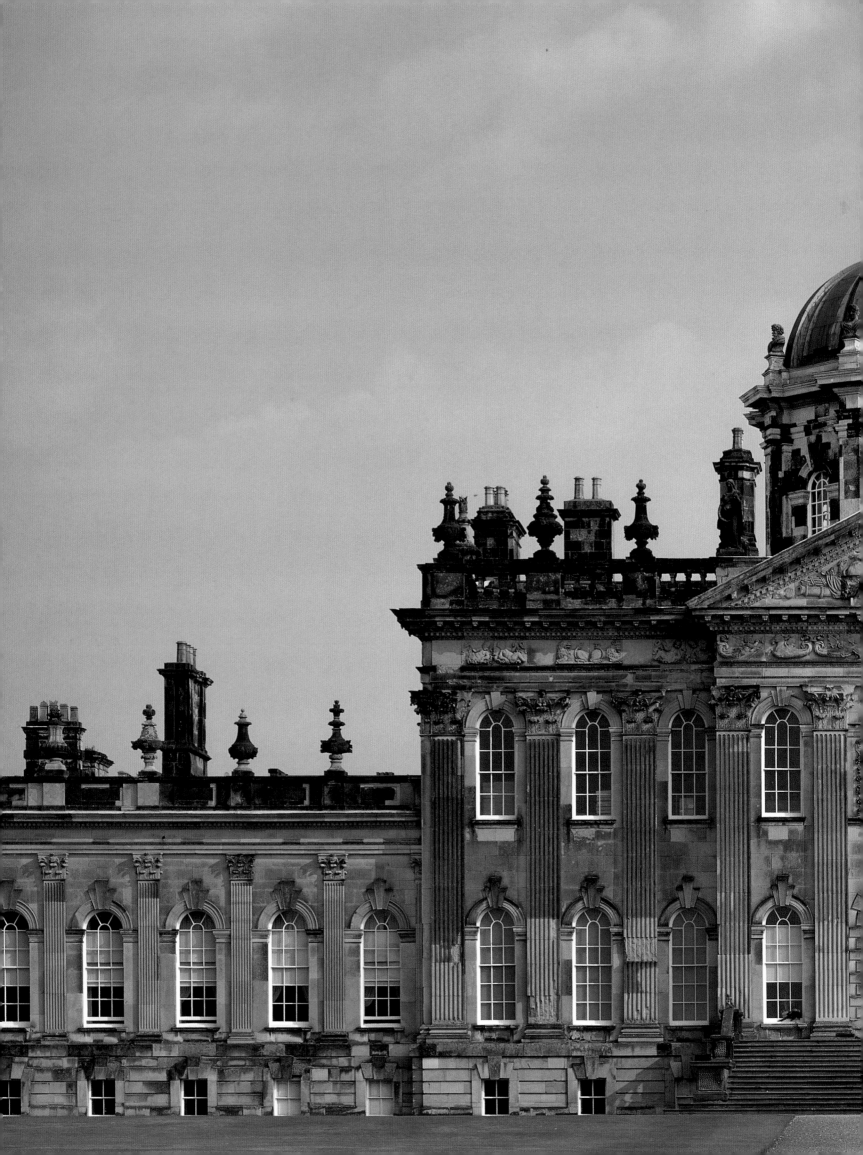

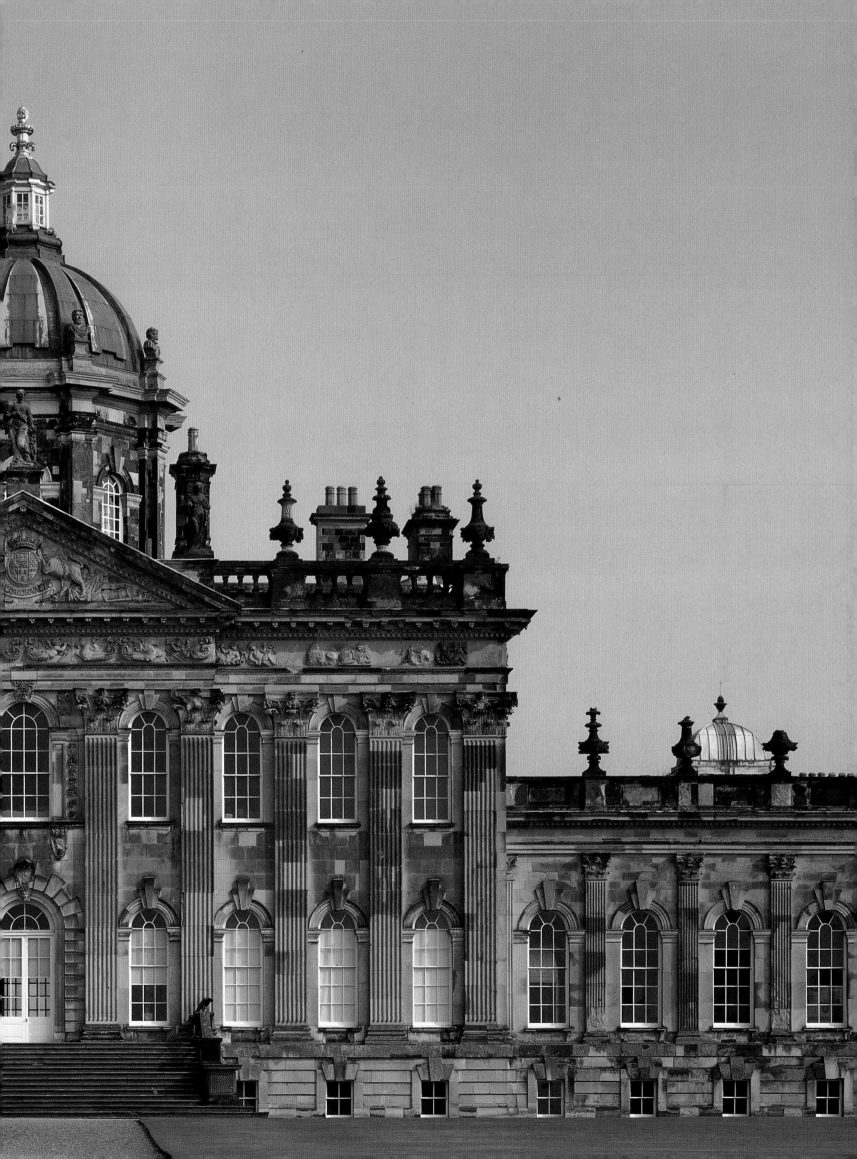

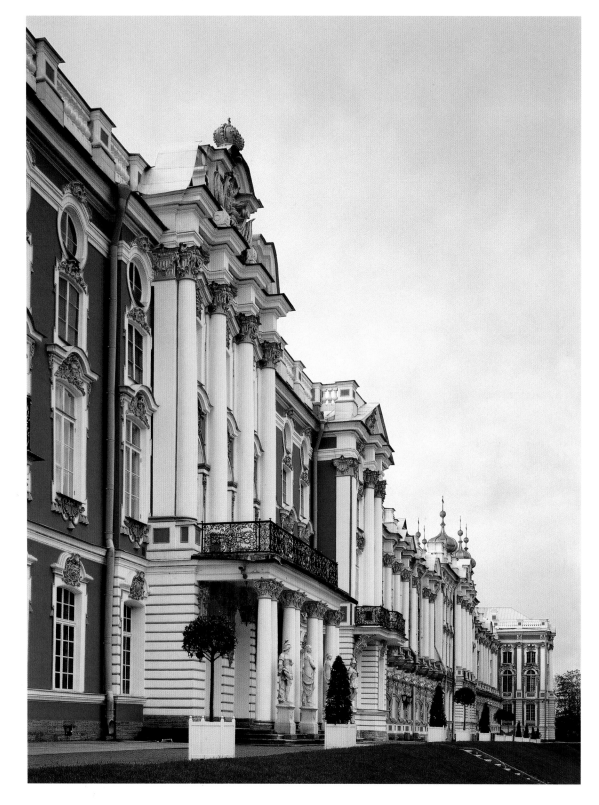

LEFT

Catherine Palace, Tsarskoe Selo, near St Petersburg. Built between 1751 and 1756, it was largely the work of Rastrelli, who created this majestic façade 300 metres (985 feet) long.

BELOW

The Winter Palace, St Petersburg. It was completed in 1762 by Rastrelli, assisted by Yury Fel'ten.

by a dome (one of England's few domes in a country house) and contains two staircases partially hidden behind piers. He repeated this latter device in his masterpiece, Blenheim Palace.

English Baroque was never particularly expressive, however, and by the later 18th century English architecture had reverted to a more sober and conventional Classical style based on Palladio's work. On the Continent, however, a lighter, generally more secular and more obviously charming style developed – the Rococo. This style reached its zenith in Germany and Austria, in buildings where Classical architecture is merely the starting point for an all-out assault on the senses. Interiors are white, of enormous plasticity and colossal decoration, and are enhanced further by *trompe l'œil* decorative techniques.

In St Petersburg, Russia, two Rococo palaces were built by the architect Bartolomeo Rastrelli (who had arrived in Russia from Italy at the

age of sixteen). The first, dating to 1749, is today known as the Catherine Palace, and was built just outside the city at Tsarskoe Selo. The second, from 1754, is the Winter Palace, on the bank of the River Neva in the city itself. Both convey an impression of lightness and relaxed happiness, with coloured stucco façades and a multiplication of columns and pilasters with gilded capitals. Subtle projections and recessions relieve the monotony of the very long façades.

A younger contemporary of Rastrelli, Savva Chevakinskii, worked with him at Tsarskoe Selo, and in 1753–62 built the Cathedral of St Nicholas in St Petersburg. In his hands the traditional five-domed Orthodox church is transformed into an expressive Baroque structure, combining a cruciform plan and rigorous symmetry with a profuse handling of ornament. On the north, south and west façades, triple Corinthian columns frame the entrance portal. They support a semicircular pediment with elaborate decorative sculptures. The

emphasis is on the horizontal with superb proportions – the central dome does not dominate but sits harmoniously within four outer domes that crown bays 'inserted' into the corners of the plan.

Further west, the 18th century saw the beginnings of a reaction against the emotional excesses of the Baroque and Rococo. Following a pattern that can be traced in the other arts, freedom was succeeded by a renewed discipline. By this time the first properly scientific archeology of the ancient sites in Greece and Rome had taken place. Architects returned to the ancient architecture of Rome and devoted themselves to developing a more authentic interpretation of the Classical language. Of course, the results were never merely replicas of ancient prototypes, but works of their own time.

A glance at Buddhist architecture after 1500 shows just how unmoved Asia was by the European revolution in taste. In Japan the tradition of building wooden buildings continued as it had done for

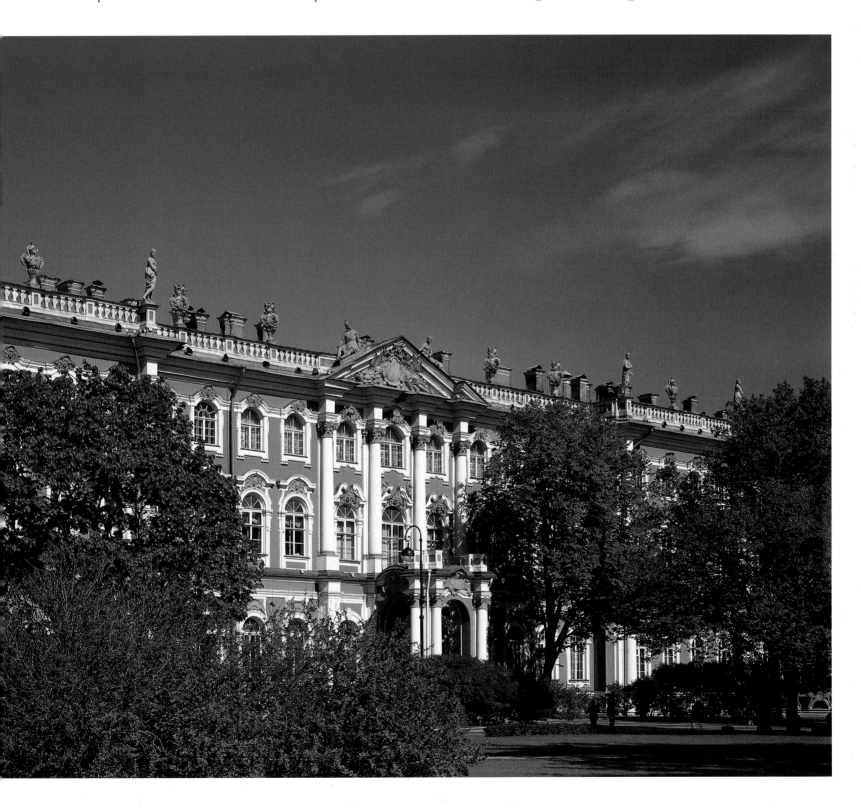

centuries. Even fortifications were built from wood. Hime-ji Castle, built in the 17th century, was conceived from the beginning as an utterly up-to-date military proposition. However, unlike its Western equivalents, which were turning into low-slung forts in order to accommodate canon, this castle still resembles the medieval model, with a series of fortified compounds surrounding a final redoubt. But its keep is much more than a purely military building – it is also an expression of authority of great power and subtlety. There are cusped gables and gable ornaments, decorative bell-shaped windows and flamboyant curved eaves. This complex range of profiles enhanced by a covering of white plaster gives the castle the appearance of a great bird spreading its wings for flight, hence its popular name, Shirasagijo, or 'White Heron Castle'. Thus the power of the Shogun was not just clearly evident but also given symbolic form.

In Thailand imperial power during the early modern period remained in the hands of the Thai monarchs, who reinterpreted and recreated Buddhist temple architecture to form a new imperial vocabulary. The Grand Palace in Bangkok was built in the early years of the reign of Rama I (reigned 1782–1809), and was expanded by his successors. The traditional form of the Thai Wat is replicated but embellished with layers of jewelled ornamentation associated with monarchy.

Back in Europe empires also continued to grow, but social hierarchies were changing. One key development in industrializing nations was the growth of a middle class. These were educated people who took an interest in culture, and who required a particular type of dwelling. As a result a new form of architecture was developed, invariably in

BELOW

The central keep of Hime-ji Castle, Japan. Hime-ji is the finest castle to have survived from the Momoyama period (1568-1600). The central keep is supported by just two huge tenoned tree trunks.

OPPOSITE

The freestanding pavilions of the Grand Palace, Bangkok, Thailand, show the way that the traditional was simply embellished to create a royal palace.

PAGES 174-175

The Royal Crescent, Bath, England, was designed by John Wood the Younger and built 1764-74. The hemicycle is entirely open to the south. The huge façade is given a consistent rhythm by a giant order of Ionic demi-columns.

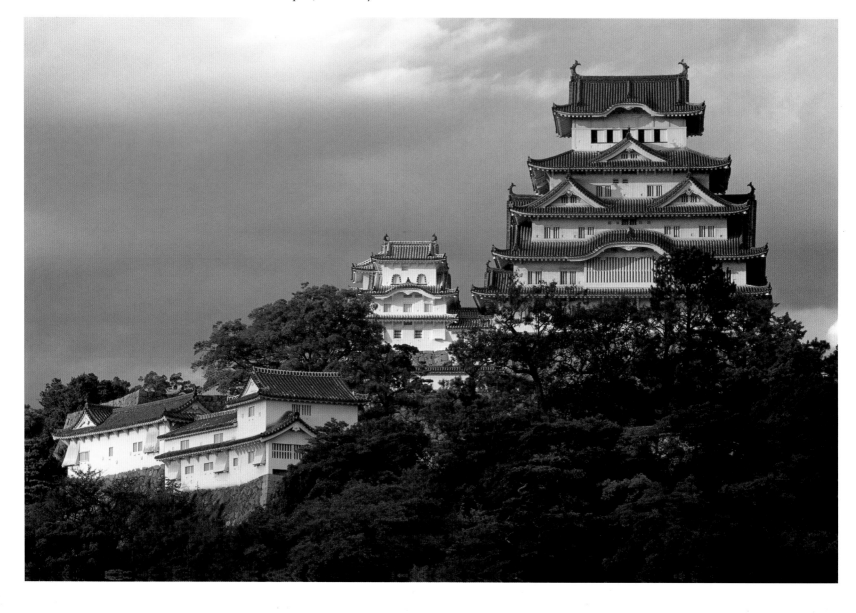

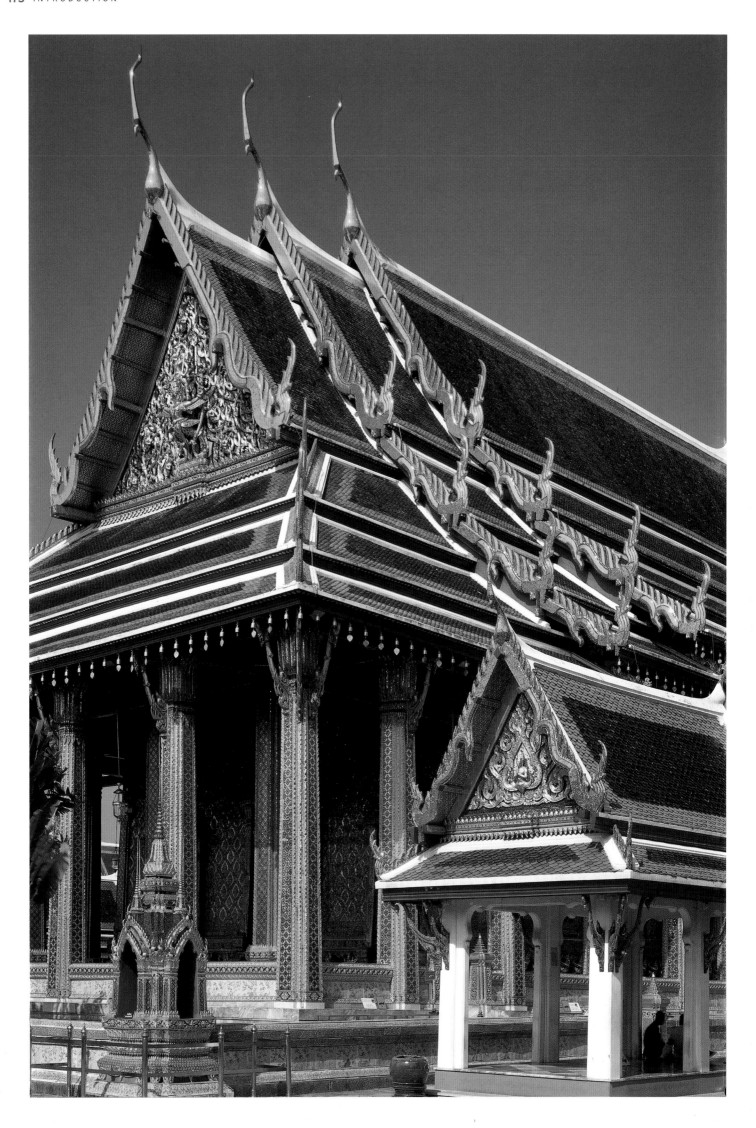

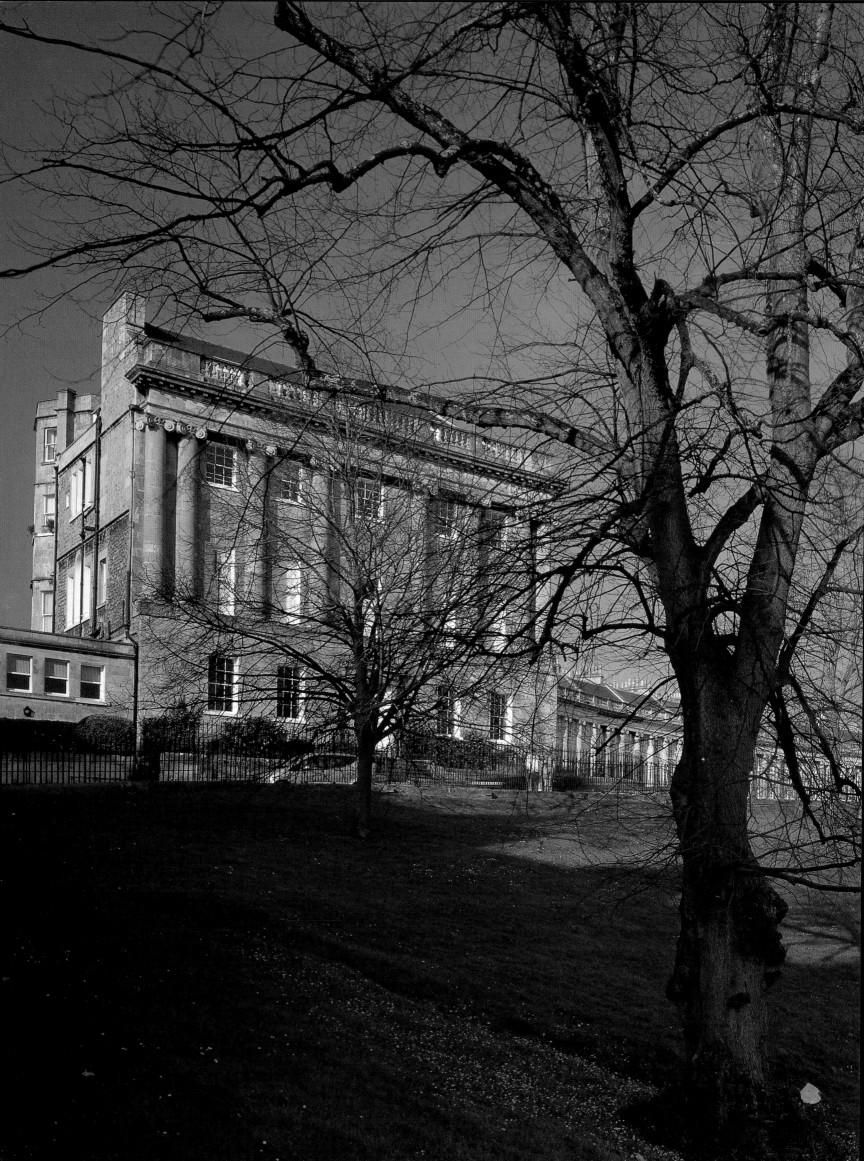

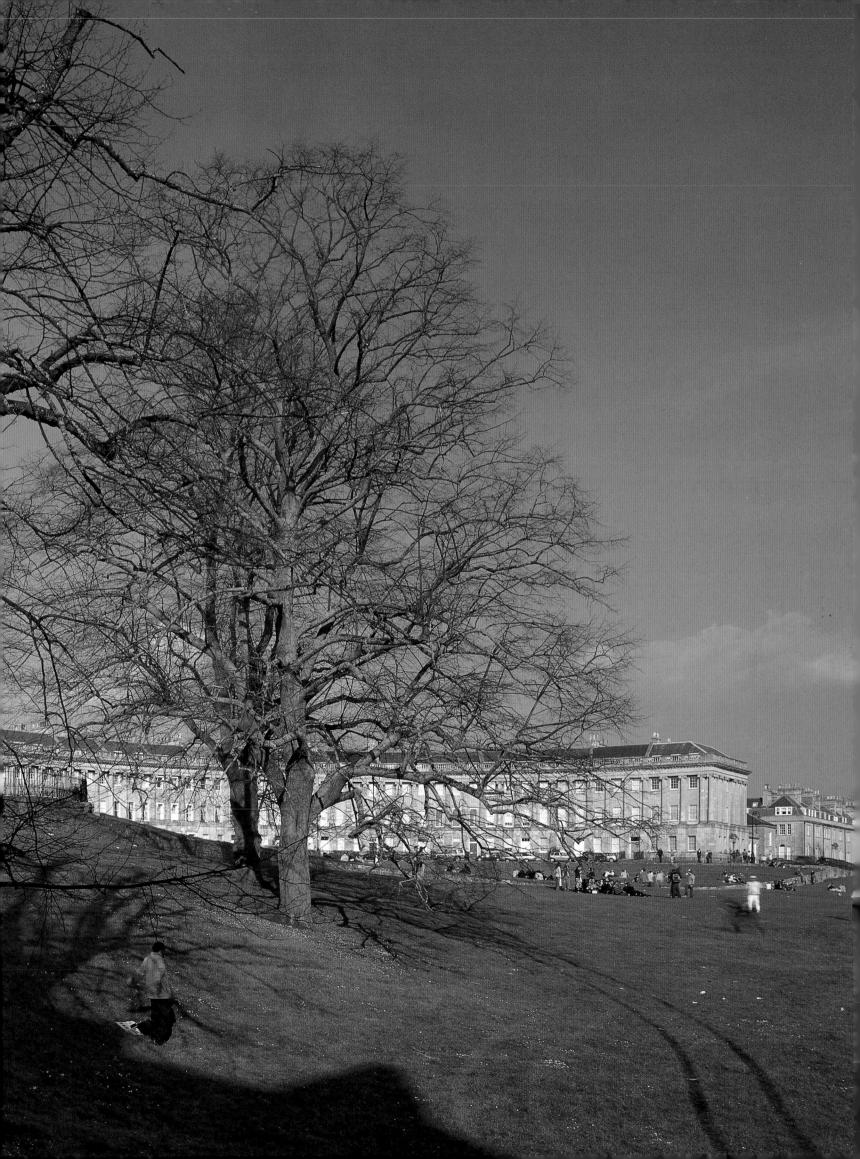

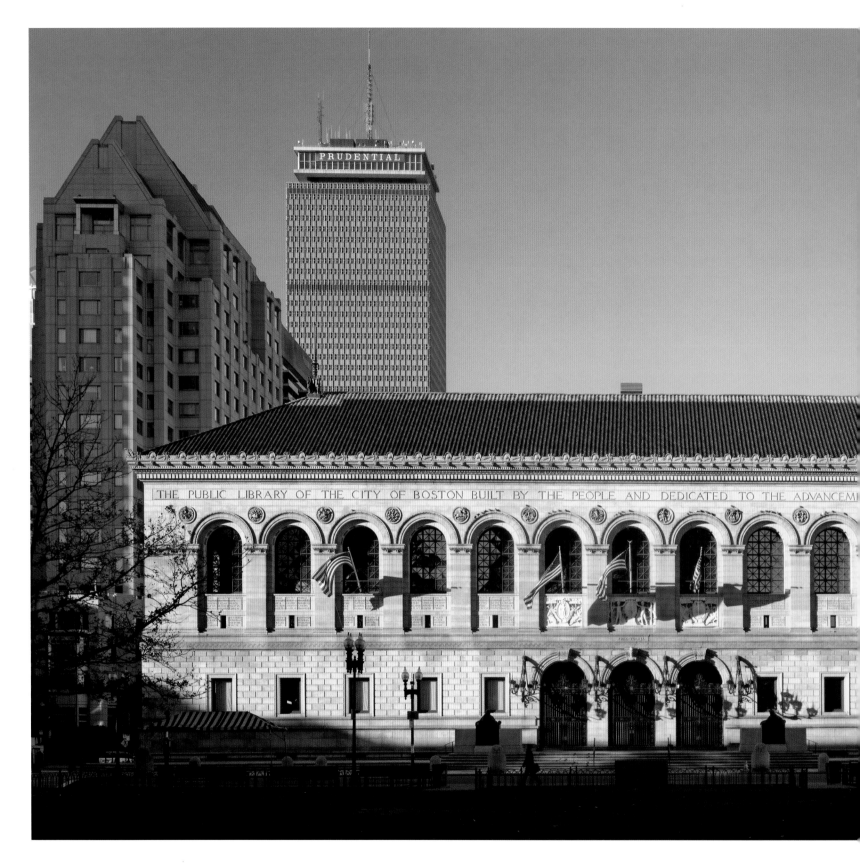

'Neoclassical' style. The term 'Neoclassical' suggests a certain measure of grandeur – a royal palace, a great country house, a public institution, a museum. However, it was also used in the first mass-housing projects, the earliest products of building developers. These were the terraced streets of European cities. In Britain the idea of combining a dozen small private dwellings behind a great unified façade modelled on a nobleman's palace was something new in the world of domestic architecture, but it became the formula for the ubiquitous London square, the New Town of Edinburgh and the Circus and Royal Crescent of Bath. It was a formula easily imitated by small builders, but which in the hands of a master could lead to domestic buildings of a majestic dignity not seen since Ancient Rome.

Neoclassicism became a truly international style throughout Europe and North America in the late 18th and early 19th centuries. Its greatest practitioner was the German Karl Friedrich Schinkel, whose prolific *oeuvre* demonstrates how it could be made to work on any scale, from a huge museum to a small villa. The Altes Museum in Berlin is a vast square building with a rotunda in the centre. Behind a row of eighteen giant Ionic columns a monumental staircase rises to the upper storey, achieving an interpenetration of interior and exterior that Schinkel was to make peculiarly his own.

By the early 19th century European architecture had reached an *impasse*. Knowledge of exotic and historical styles became so widespread and discipline so far relaxed that architects could do virtually whatever

they pleased – a licence that could lead to buildings that responded to literary or romantic ideals. The finest display a fertile imagination and a real mastery of architectural form. The Royal Pavilion at Brighton, for instance, was remodelled by John Nash from 1816 into an exuberant folly for the Prince Regent. Its style – described, rather desperately, as Hindu-Islamic-Chinese – shows considerable knowledge of those cultures, but is ultimately purely whimsical. Its astonishing exterior is surpassed by the rooms inside, crammed with extravagant decoration and furnishings such as a huge chandelier hanging from a Chinese dragon.

Only one revived style, Neo-Gothic, gained general currency. Most dominant in churches and cathedrals, it was also widely used for public buildings. Christopher Wren had employed a type of Gothic revival for his Tom Tower, Christchurch, Oxford, while Strawberry Hill House in West London is a wonderful example of late 18th-century Gothic playfulness. Perhaps the most stately example of Neo-Gothic, however, is the Palace of Westminster (also known as the Houses of Parliament) in London, which in time was used as a model for several other parliaments. That of Budapest (1882) by Imre Steindl, for example, is just as lavish in its

ABOVE

Boston Public Library (1887–95) was designed by McKim, Mead and White in the Neo-Classical style.

RIGHT

The Altes Museum, Berlin, by Karl Friedrich Schinkel, built 1825–8. The main façade, with a colonnade of 18 Ionic columns, overlooks the Lustgarten. Two main storeys are revealed underneath the portico, which offered shelter to those in the public square.

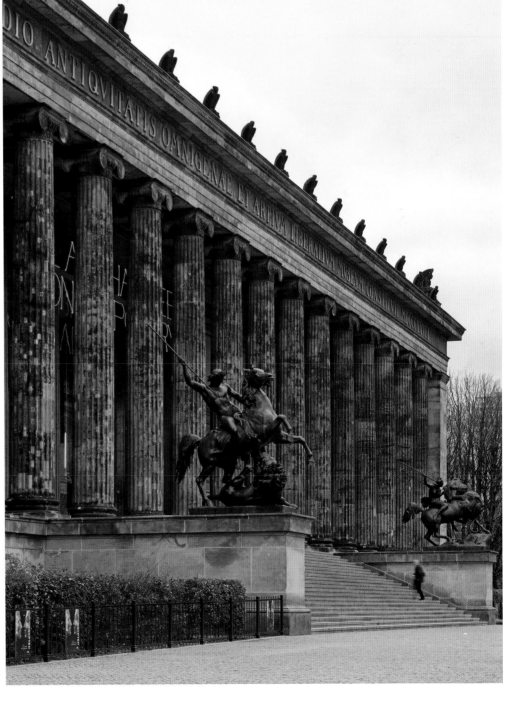

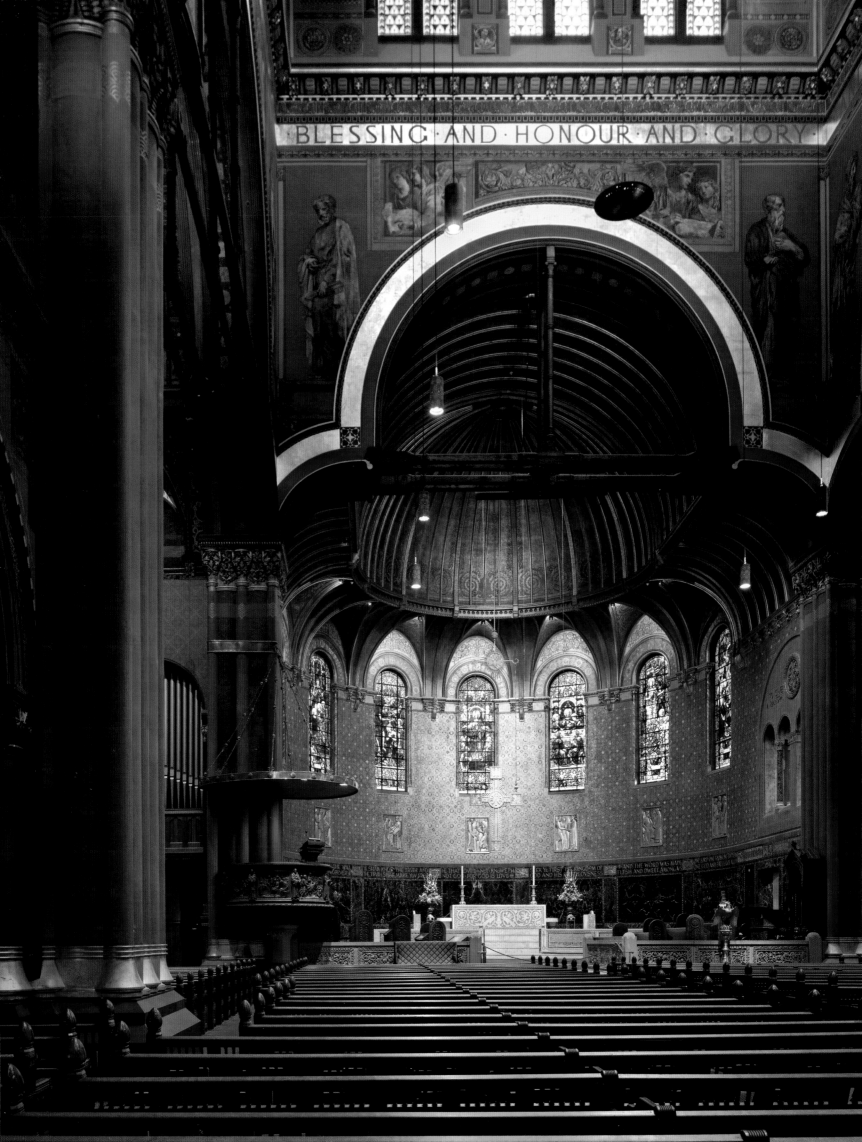

OPPOSITE

Trinity Church, Boston (1874–7), by H. H. Richardson. Outside the style is Romanesque revival, but the interior is more reminiscent of an Early Christian basilica.

BELOW

The Dining Room in the Brighton Pavilion, England. The Pavilion was radically transformed by John Nash (1815–23) into 'Neo-Mughal' on the outside, while this Oriental fantasy interior was added by Frederick Crace.

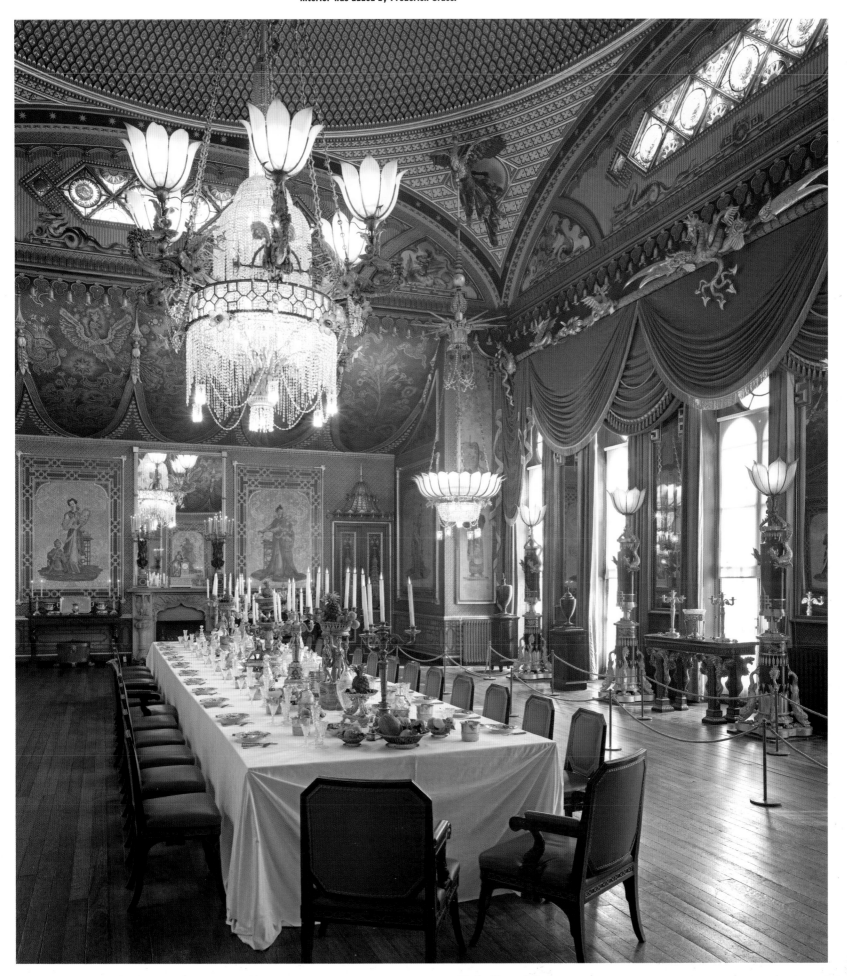

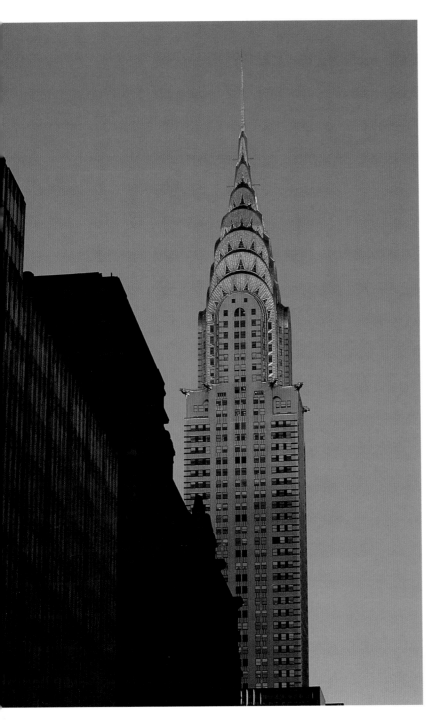

The Chrylser Building (1928–30) by William Van Alen. Its exterior decoration includes references to car design (including hubcaps and mud flaps) and a stainless steel spire. The interior establishes its Art Deco credentials with murals and marquetry from the period. It is 318.52 metres (1,045 feet) high, and has 77 storeys.

The Parliament Building, Budapest (1882) by Imre Steindl.

decoration, and it copies the plan – a central domed lobby with debating chambers right and left – exactly.

In North America Henry Hobson Richardson extended Neo-Gothic into something closer to a Neo-Romanesque. In his Trinity Church at Boston he followed the Romanesque principle of clearly articulating the separate elements of the building and devised a series of almost detached blocks in rugged masonry surmounted by a squat rectangular tower.

Clearly during this period any style was deemed viable. Some architects were worried by this – 'In What Style Shall we Build?', asked Heinrich Hübsch's famous 1828 treatise – but others eagerly embraced the freedom that it gave them. Orthodox Classicism was by no means dead and was promoted vigorously by the Ecole des Beaux-Arts in Paris. The American firm of McKim, Mead and White chose to use it for their public library in Boston, finding their inspiration in the Italian palazzo.

The Catalan architect Antoni Gaudí produced works that had no precedent anywhere or at any time though they are loosely grouped with an array of buildings all over Europe (to which most of them have scant

resemblance) under the heading of Art Nouveau. His expiatory temple of the Sagrada Família in Barcelona (begun 1883 and still being built) could equally well be called the last gasp of the Gothic Revival, with its use of pointed arches.

It was partly in reaction to all this individualism that Modernism was born. For its practitioners it was a way out of the dilemma of style – a style without style. During the 20th century, doctrinaire theorists liked to present its history as a logical process determined solely by practical considerations. The late 19th and early 20th centuries were seen as years of experiment (beginning with the Crystal Palace in London,

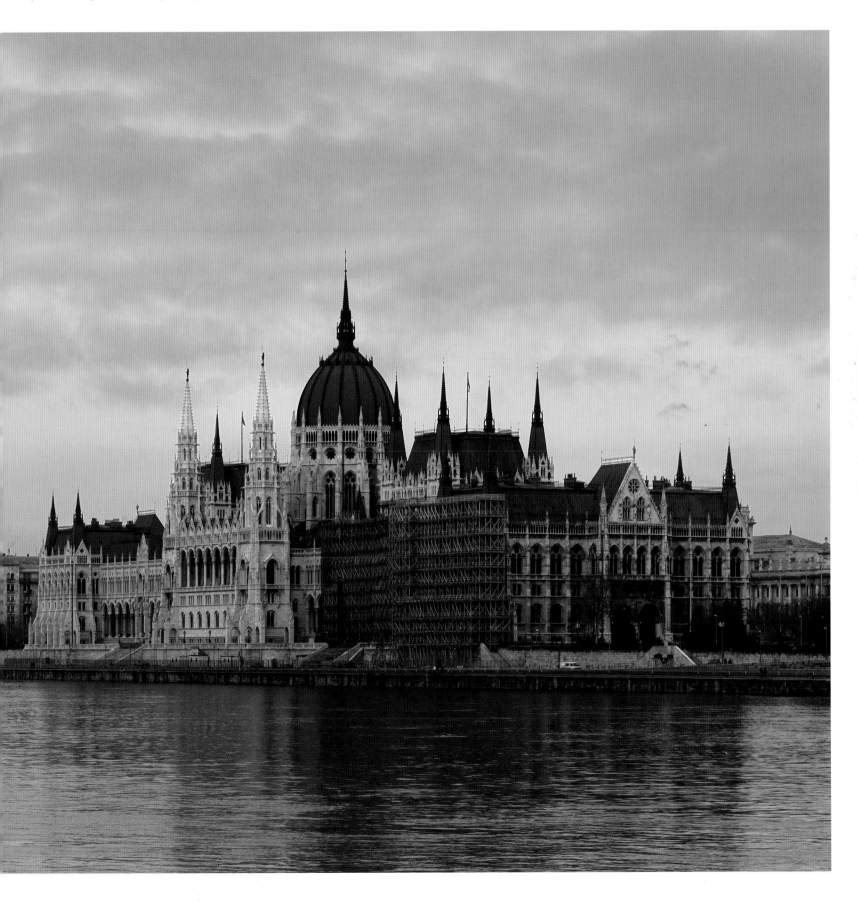

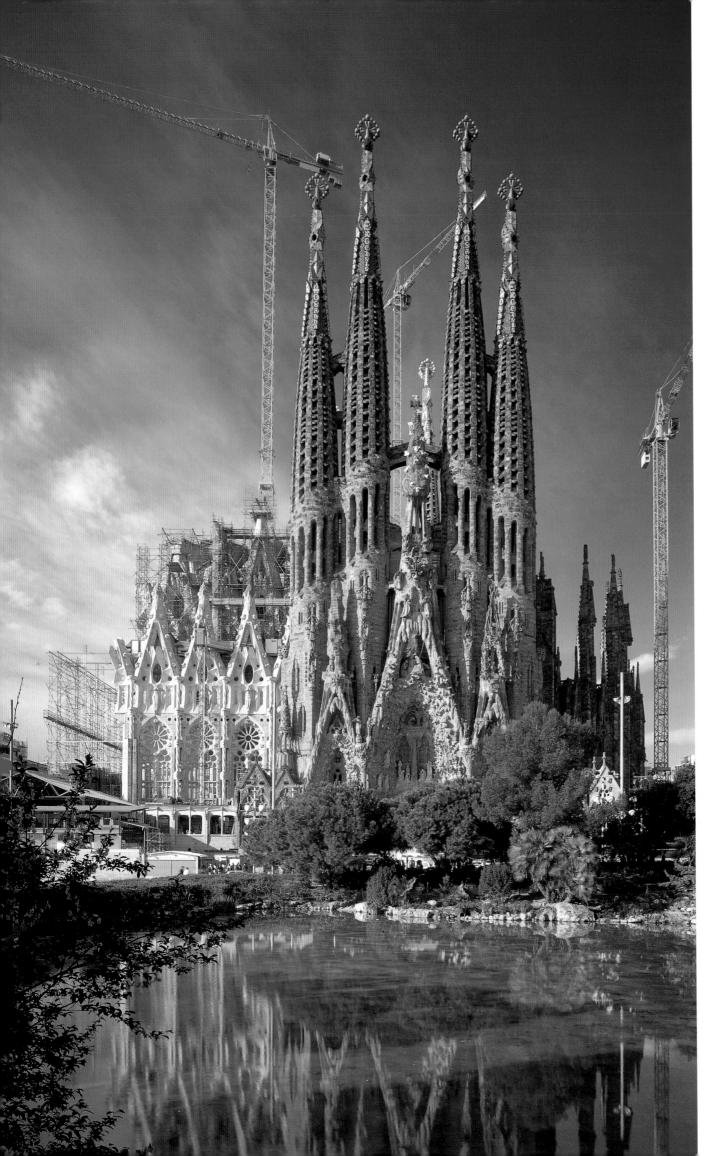

built for the 1851 Great Exhibition), which rejected historical styles and conventions from the past. Through the application of new materials, new technologies, new mass-production methods, and new specialist skills – heating, lighting, ventilation, access, health and safety – eventually architects would produce the perfect building.

Certainly the 19th century saw great structural breakthroughs – the most important quite possibly being the invention of the steel frame, which opened up the opportunity of building higher than ever before, giving impetus to the first skyscrapers. The Monadnock Building in Chicago of 1889–92 by Burnham and Root is sixteen storeys high, the tallest that could be built using load-bearing brick. It was modern in its renunciation of ornament; shape and articulation were expressed only in the subtle projections of the bow-windows. In contrast, the 1928 steel-framed Chrysler Building in New York by William Van Alen is 77 storeys high. Early skyscrapers such as Louis Sullivan's Wainwright Building in St Louis, Missouri, have the proportions of a large piece of furniture. (This approach was replicated with kitsch exactitude by Philip Johnson in 1984 when he built the AT&T Building in New York to resemble a Chippendale tallboy.) The problem was that skyscrapers were so tall that it was impossible to maintain visual proportions across the whole structure – indeed, quite often it was difficult even to see the whole structure. Therefore the building would be allowed to grow to the height

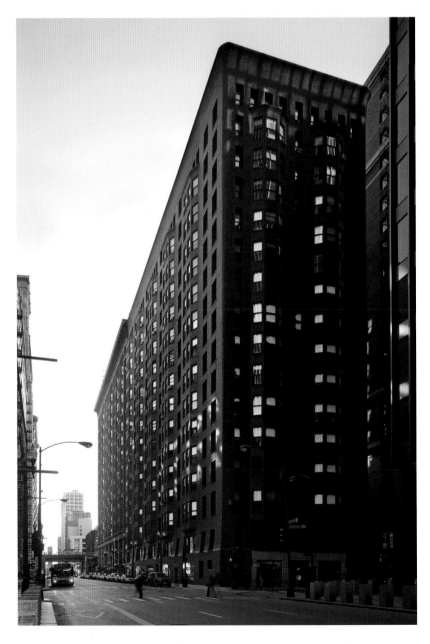

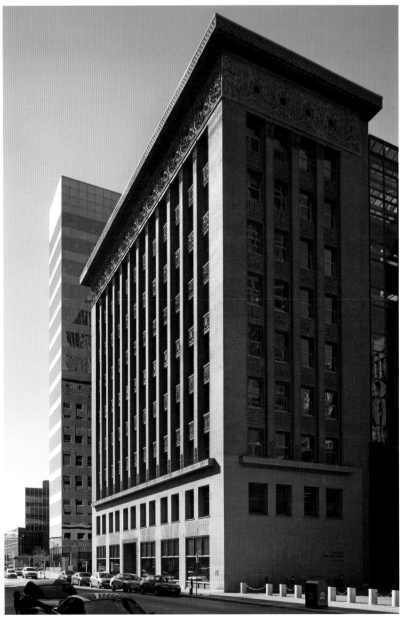

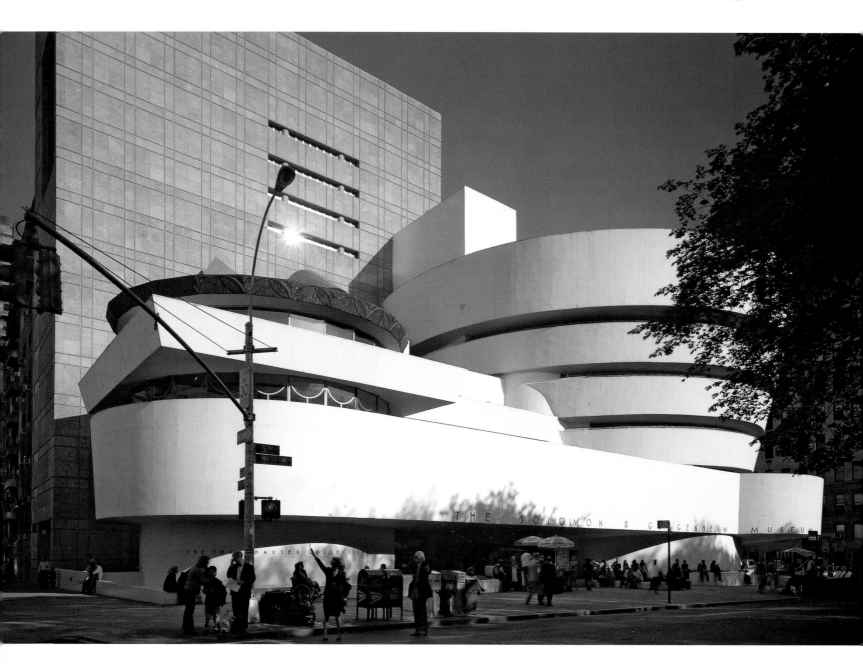

that ambition or economic exigency dictated and then the top would be crowned with a decorative 'hat'. The Chrysler Building has one of the best hats, an Art Deco ornament including a spire of overlapping discs and the emblematic Chrysler birds. The first Modernist skyscraper built by a European Modernist architect – the Seagram Building by Mies van de Rohe – indicates the alternative approach. Mies viewed a skyscraper not as a conventionally proportioned object in the Classical sense but as a big abstract sculpture.

The paradoxes of Modernism soon became apparent, however, not least in the fact that the architects who subscribed to the same philosophy of Modernism were all producing strikingly different buildings. W. M. Dudok's 1928 Hilversum Town Hall, in the Netherlands, with its clear, rectangular forms and abstract geometry, avoids any suggestion of eccentricity, whereas Frank Lloyd Wright's Guggenheim Museum in New York, with its spiral descending ramp so at odds with the comfortable viewing of paintings, seems to flaunt it.

During this period there were always architects building houses for private clients who wanted not textbook examples of doctrinaire theory but aesthetically rewarding houses expressed through finesse and originality. The brothers Greene and Greene belong to this category. Their beautifully crafted houses at Pasadena, Los Angeles, such as the Gamble House (1908), were precisely the kind of building considered

anachronistic by practitioners of the Modern Movement, who, buoyed by a neo-Hegelian philosophy, recognized only a select series of buildings as reflecting the zeitgeist.

The early champions of the Modern Movement, such as Walter Gropius and Le Corbusier, believed that once their experiments had borne fruit, all buildings would be subject to the same iron laws of necessity and logic and would necessarily look the same. To some extent this happened. Government buildings, theatres, libraries, museums, hospitals, prisons, hotels, banks, warehouses, department stores, factories, blocks of flats and universities increasingly resembled each other. One logical conclusion to this trend was that it would be better to design multipurpose buildings that could be adapted to any use. During the 1960s a new generation of technologists who had been inspired by the example of the visionary inventor Buckminster Fuller took this idea further. They championed a view of architecture as impermanent and subject to constant future adaptation. While little in the way of adaptation actually took place, buildings like Richard Rogers and Renzo Piano's Pompidou Centre (1977) and Norman Foster's Hong Kong and Shanghai Bank (1986) have now been absorbed as permanent monuments in architectural history.

More recently a familiar process seems to be repeating itself. After the imposition of the strictest orthodoxy, the urge towards freedom

OPPOSITE

The Solomon R. Guggenheim Museum (1956–9), New York, shows Frank Lloyd Wright at his most daring. The bold form has been counterpoised by a new orthogonal addition behind it by Gwathmey Siegel and Associates (1992). Wright had originally planned a tower for artists' studios and apartments.

RIGHT

Hilversum Town Hall by W. M. Dudok (1928) obeys the principles of composition of the De Stijl group, with a series of taut planes and cantilevered roofs.

BELOW

The Gamble House (1908) by Charles and Henry Greene was influenced by the Arts and Crafts movement and the writings of John Ruskin. As a consequence its superb craftsmanship and graceful Japanese-inspired composition were largely ignored by the architectural press.

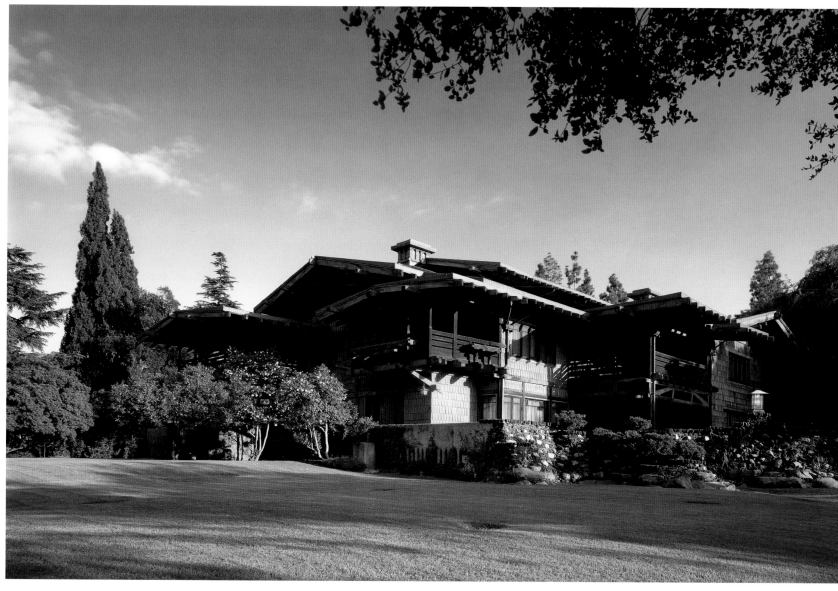

has become once more irresistible and we have witnessed a plethora of architectural styles all of whose practitioners would describe themselves as 'Modernist'. This approach has generated a range of wilfully unusual and complex forms by such international figures as Frank Gehry, Zaha Hadid and Santiago Calatrava.

Indeed, if there is a consistent theme it seems to be that the more exuberant the form of a structure the more likely it will receive enough publicity to one day be considered 'great architecture'. The buildings that seem, at least to their contemporaries, to be marking their places in the history books are those like the Guggenheim Museum, Bilbao. Designed almost deliberately as an icon, the museum has been an enormous success in putting an otherwise rather grey northern Spanish city on the international cultural map. Since then similar tactics have had a similar effect upon other sites. It can only be hoped that quieter, more considered, buildings such as Peter Zumthor's Thermal Baths at Vals are not missed out of the history books in favour of the larger, flashier projects. Perhaps like the Mausoleum of the Saminids they will be overlooked by the Mongol hordes and survive a thousand years for analysis more sophisticated than our own.

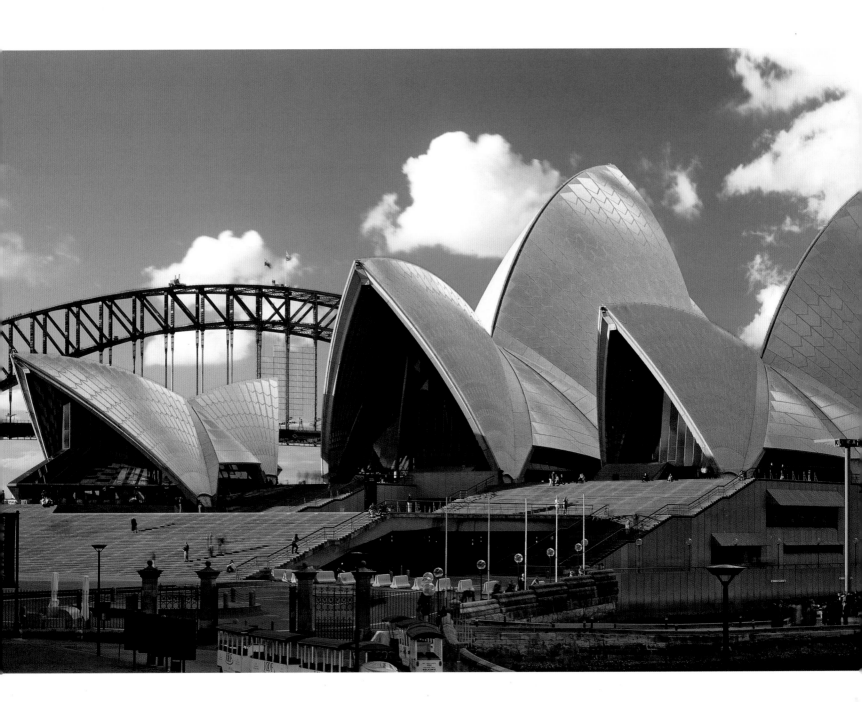

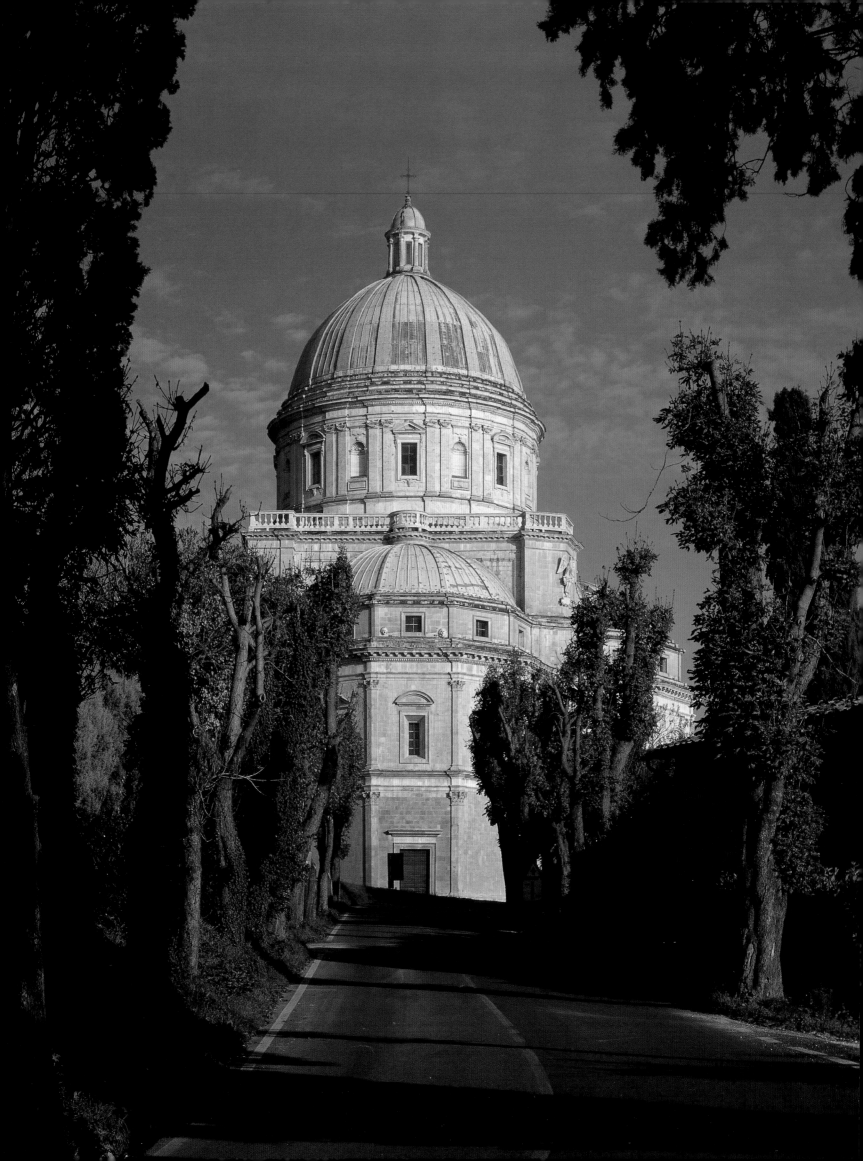

Santa Maria della Consolazione

TODI ITALY

The pilgrimage church of Santa Maria della Consolazione, near Todi in central Italy, is a notorious puzzle for architectural historians. The surviving documents are surprisingly plentiful, which makes it all the more frustrating that they do not name the designer. It was certainly begun in 1508, under the supervision of the little-known Cola da Caprarola, who is called *capomaestro* (interpreted by most authorities to mean 'contractor' rather than architect). Payments to him continued until 1515. Thereafter decisions seem to have been taken by a series of consultants, including many of the most famous figures in Renaissance architecture, from Peruzzi to Vignola. The name most frequently invoked by modern historians, however, is that of Donato Bramante, who died in 1514. Santa Maria is almost a demonstration model of his principles, which in turn were developed from those of Leonardo da Vinci. In fact, the plan very closely follows a drawing by Leonardo made many years earlier in Milan.

The church was built to commemorate a miraculous image of the Virgin and Child. The designer took the opportunity to build a centrally planned Classical church, an obsession for Renaissance architects, if not so much for Renaissance priests. The design is based on a cube expanded by four apses into a quatrefoil plan. Some small concessions were made to the perfect symmetry in favour of legibility when seen from outside: three of the four apses are polygonal while the sanctuary apse is distinguished by being round. At the upper level the cube supports a tall drum articulated with alternating windows and niches, and this drum in turn supports a dome with a lantern. The architectural details show a similar scholarly finesse, and the interior is given a dramatic aspect with the use of a giant order pilaster (that is, a pilaster that runs from floor to ceiling) to define the corners. As an exercise in pure geometry the church is unsurpassed, its grandeur increased by its isolated position on a hillside.

The attribution to Bramante, who today is best known for the original plans for St Peter's (which share some elements with Santa Maria della Consolazione) and the Tempietto in Rome, has been made largely on stylistic grounds. However, it is strengthened by a document of 1574, which records an instruction that the church should be finished, 'according to the modello of the architect Bramante'. 'Modello' could mean either a wooden model or a drawing. Work then went on, with interruptions, until April 1617, when it was finally inaugurated. In light of such a protracted construction, perhaps the only sensible conclusion is that there was an original design by Bramante that a succession of architects interpreted in their own way. In any case, few would dispute that this enigmatic building was anything less than a masterpiece.

OPPOSITE

The four sides of the church are almost identical, except that the entrance side has a door and one of the apses is semicircular instead of polygonal. Such symmetry was an embodiment of Renaissance theory, in which geometry, and in particular the circle, was an expression of the divine.

PAGES 190-191

The church in its setting, dominating the open countryside that surrounds the ancient city of Todi.

ABOVE

The view looking up into the central dome. Four arches lead into half-domes pointing north, south, east and west. The Classical language of architecture derived from Ancient Rome – using cornice, capital, pilaster, shell-niche, balustrade – is here used with careful attention to correct precedent, but at the same time with an originality and inventiveness that give it new life.

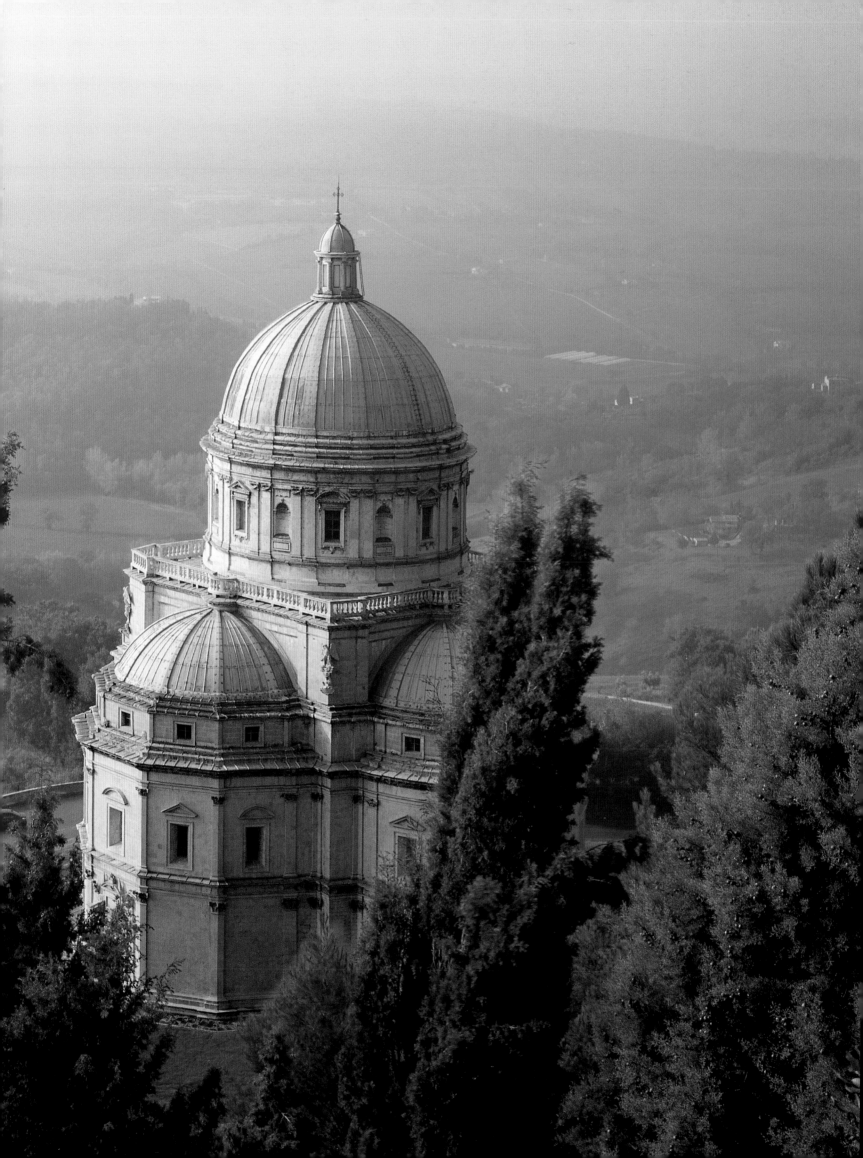

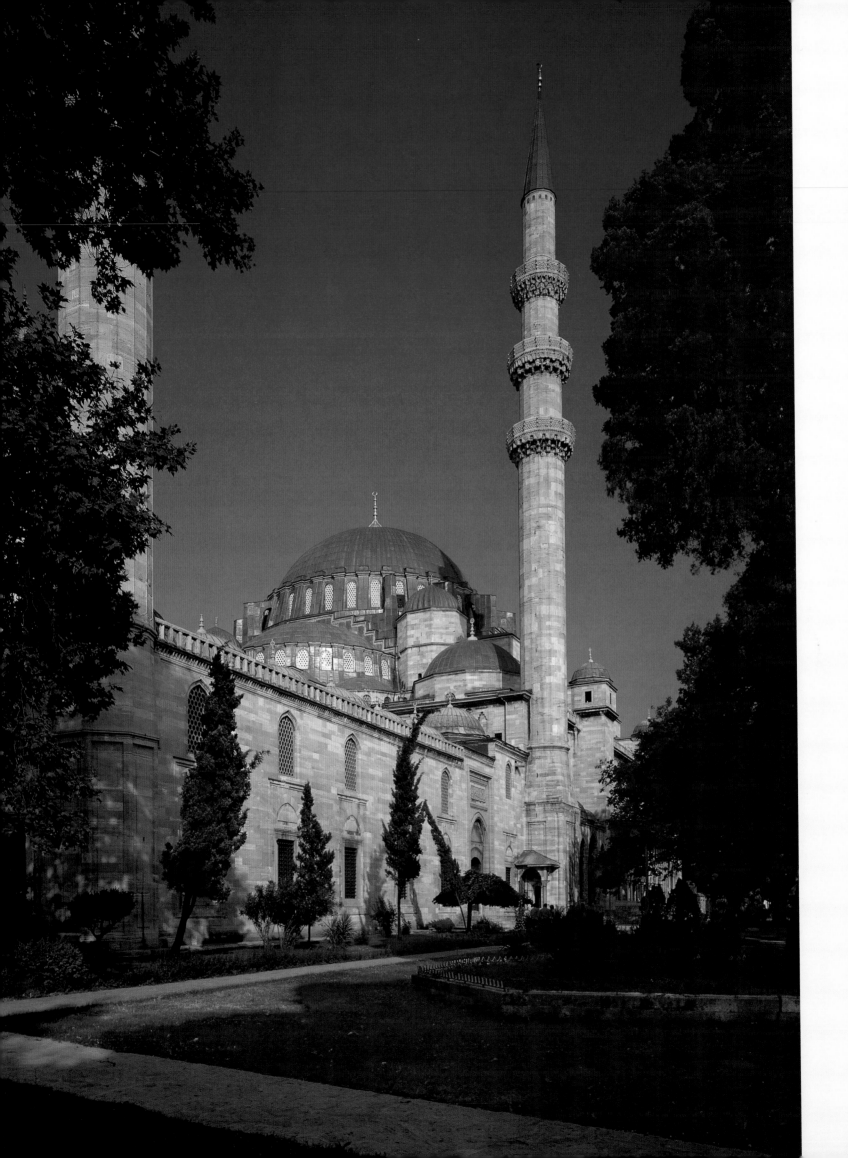

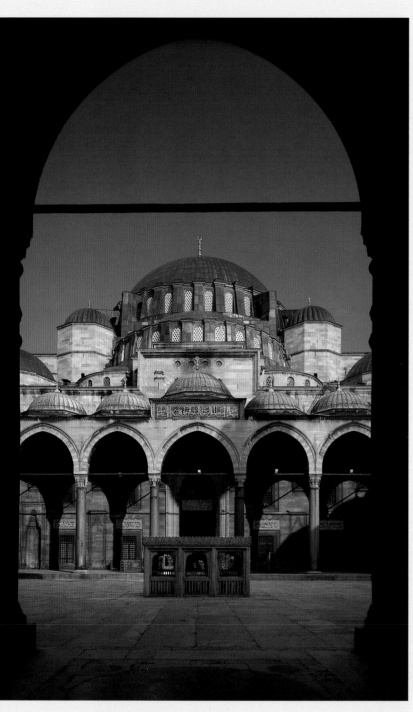

Süleymaniye Mosque

ISTANBUL TURKEY

The Süleymaniye is the biggest and most conspicuous mosque in Istanbul. Commissioned by Süleyman the Magnificent, it was begun soon after 1550 and finished within five or six years. The complex to which it belongs is almost a miniature town, occupying a 7-hectare (17-acre) site overlooking the Golden Horn. In addition to the mosque the celebrated Ottoman architect Sinan built four general madrasas, two specialized madrasas (for medicine and hadith), a caravanserai, the tombs of Süleyman and his wife, a library, baths, cemetery, shops, school, hospice, kitchens, stables and Janissary barracks.

The mosque stands in the middle of a massive walled enclosure measuring 126 by 144 metres (413 by 472 feet); this is preceded by an arcaded courtyard measuring 44 by 57 metres (144 by 187 feet), which has a fountain in the middle and a minaret in each corner. The building follows the model of Hagia Sophia (which Sinan clearly knew well) in that it is essentially a vast dome supported by four giant piers over a square plan. However, the buttressing system is a more sophisticated version of that seen at the Hagia Sophia: two half-domes stand on the axis of the *qibla* and huge arched walls filled with windows stand on the cross-axis. The monumentality and scale of the structure were also cleverly accentuated: the dome, for example, is supported by a ring of flying buttresses that, when see from outside, make it look larger and more imposing than it actually is. The careful layering of domes and half-domes gives the mosque a coherent form from every angle, while the overlaying of screens on the exterior ensures that the building retains a human scale.

The interior is flooded with light. There are 249 windows, and except for those that encircle the base of the dome they are all filled with patterned, coloured glass. The nave and screened aisles were designed to form a single space for prayer, interrupted only by the four massive piers supporting the dome. Aside from this careful manipulation of space, the aesthetic effects of the building rely on an austere palette of muted ivory-white stone and dark grey lead roofing. Decoration is used sparingly, but to great effect: the main arches are emphasized with red and black painted tiles, while screens between the galleries' columns are patterned with exquisite carvings.

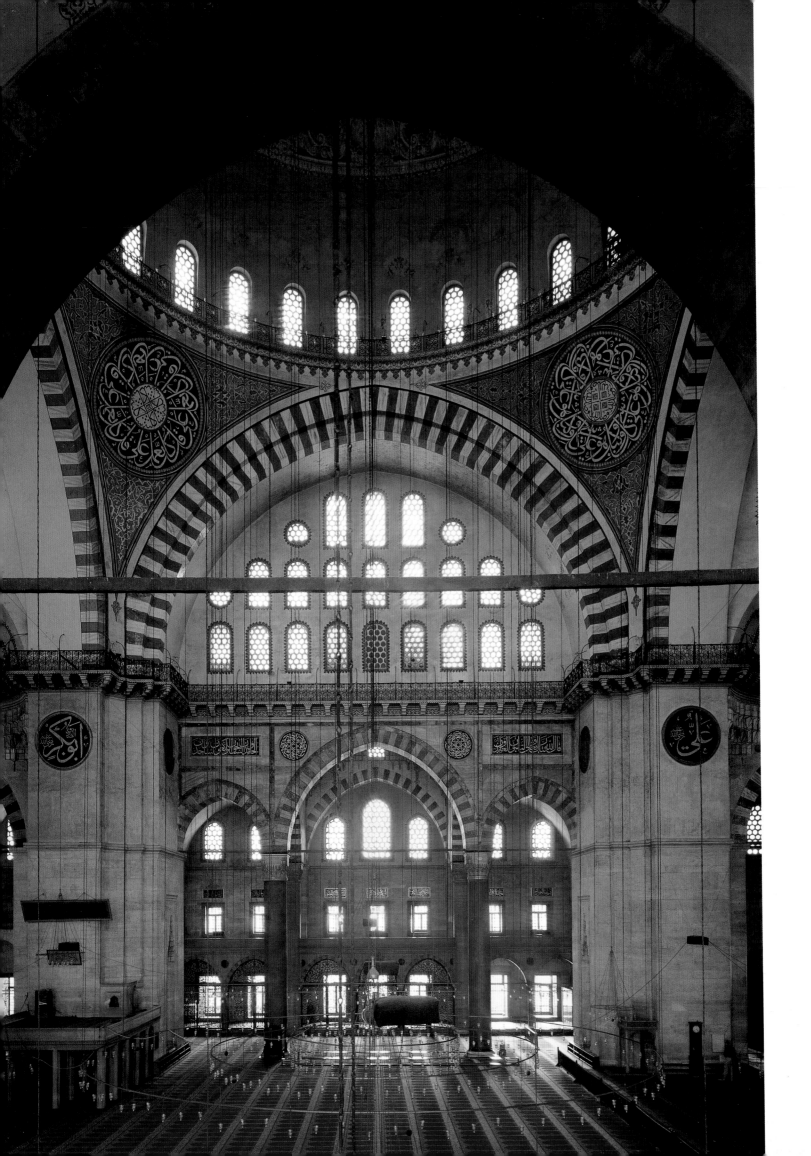

OPPOSITE

The view from a gallery above a side aisle across the main space. These side aisles are open and integrated into the nave to maximize the space for prayer. The mosque's wonderful glass is attributed to Sarhos Ibrahim (Ibrahim the Drunkard).

RIGHT

Because the courtyard arcades are lower than the portico of the mosque, a curious composite capital had to be invented to make the transition in the corners.

BELOW

Seen from across the Bosphorus, the Süleymaniye appears as an imposing pyramidal mass of domed units punctuated by four slender minarets. The two closer to the dome are taller and have three balconies, emphasizing this pyramidal form.

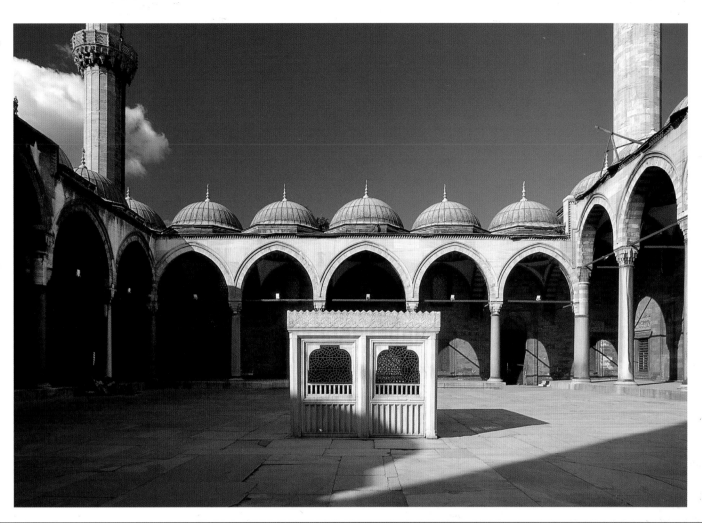

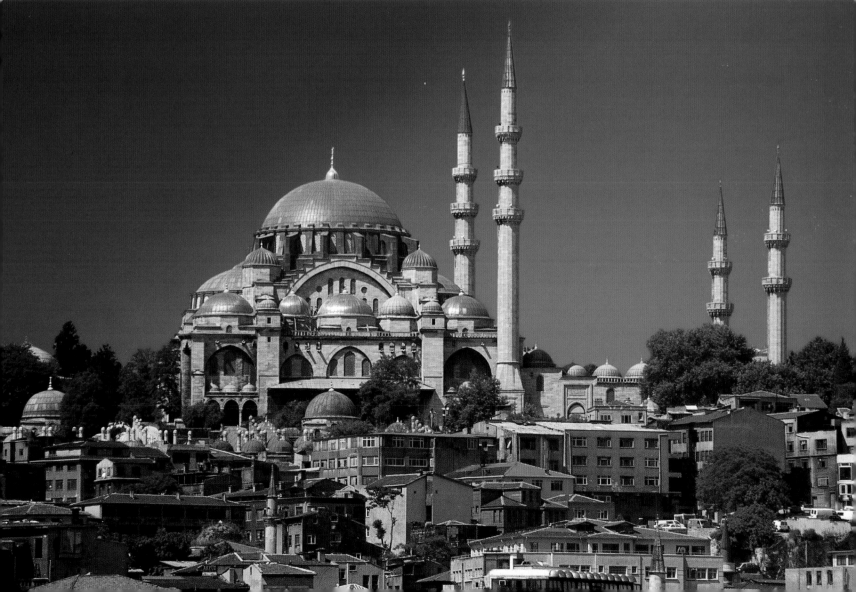

Agra Fort

AGRA INDIA

The Mughal dynasty, as well as erecting extraordinary individual monuments such as Humuyan's Tomb and the Taj Mahal, was responsible for palace complexes that are today simply described as 'forts'. The most remarkable of these was that at Agra, the capital of the Mughal empire during the emperorships of Akbar (reigned 1556-1605), Jahangir (1605-27), Shah Jahan (1628-58) and Aurangzeb (1658-1707).

Akbar founded his new fortress on the site of the adobe fort of the defeated Lodi dynasty. His 22-metre (72-foot) high walls enclose a roughly semicircular plan 2.5 kilometres (1.6 miles) in circumference, with the flat side defined by the Yamuna River. Inside the fort only two palaces remain from Akbar's reign – the misleadingly titled Jahangiri Mahal ('Jahangir's Palace') and the only partly preserved Akbari Mahal. Each has a compact design orientated around a set of courtyards that originally backed onto the river. The Jahangiri Mahal with its formal façade and central iwan decorated with geometrical mosaic work is the more splendid of the two. Stylistically the work is influenced by the Timurid tradition (in the carved geometric surface decoration), and the domestic architecture of Hindu India (in overall appearance). Indeed, its flat lintels and intricately carved corbels are suggestive of the architecture of Gujarat.

When Shah Jahan became emperor, he replaced the rest of Akbar's and Jahangir's palaces with his own white marble-clad buildings. In 1637 he had the Hall of Public Audience (Diwan-i-am) built as the formal symbol of his authority – from here Shah Jahan would hold court twice daily. At the time it was described as 'Forty-Pillared', a reference to the forty pillars of the ruins of Persepolis in ancient Iran clearly aimed at reinforcing the Mughals' Timurid lineage. Behind this public building were Shah Jahan's private quarters where he would meet his most important dignitaries and his sons. Here he would be visited in a small but exquisite pavilion, known as the Shah Burj. Behind the building, covered terraces overlooked the walls of the forts and the river below, and from these the Emperor would appear before his subjects every morning.

To the north of this complex is the octagonal tower known today as the Musamman Burj where Shah Jahan replaced Jahangir's conventional riverfront tower with a full imperial pavilion decorated with white marble inlaid with precious stones and covered by a gilded copper dome. When his son Aurangzeb deposed him in 1658, Shah Jahan was kept prisoner in his private quarters where he died seven years later. From here he could look out over his most famous architectural legacy – the Taj Mahal – from this luxurious prison of his own design.

ABOVE

The ornately carved columns of the Jahangiri Mahal. According to the contemporary account of Abu al-Fazl, the sandstone (which had been quarried at Fatehpur Sikri) could be worked even more finely than wood.

OPPOSITE

Red sandstone walls are inlaid with white marble details that describe grandeur as well as strength.

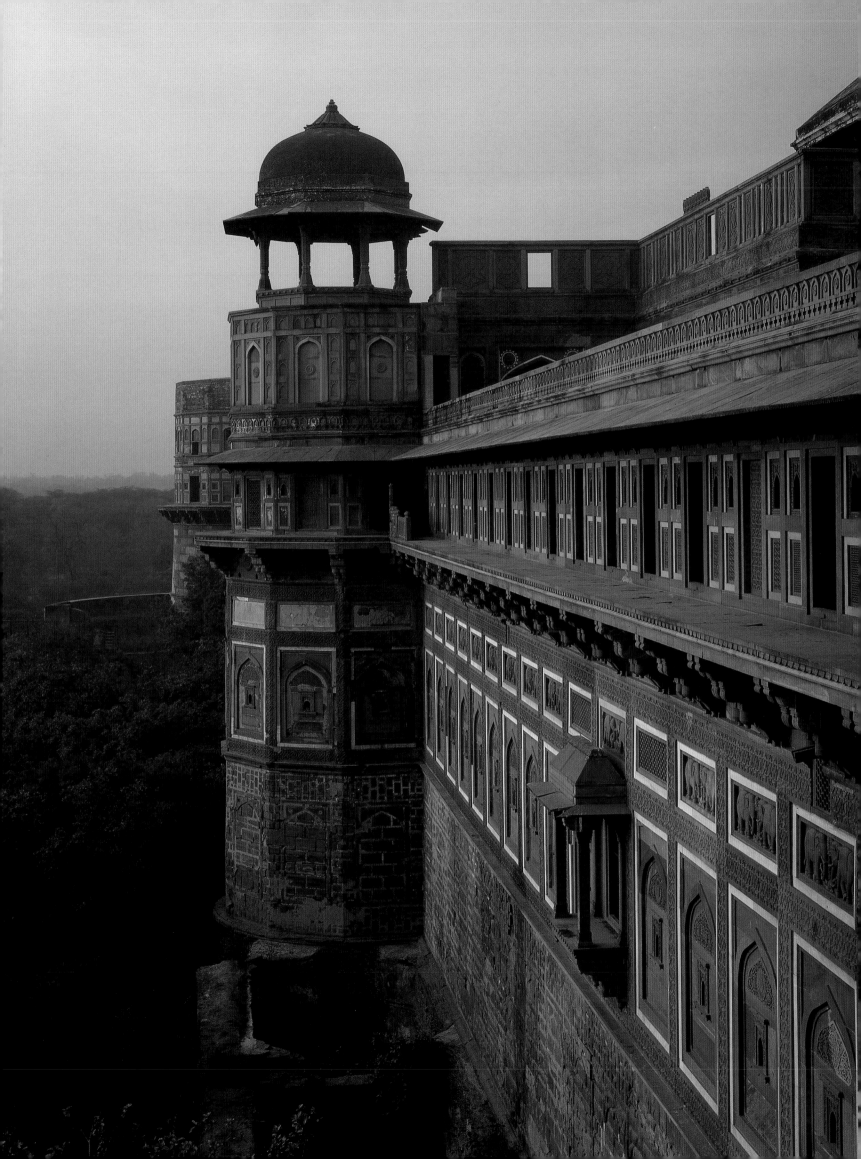

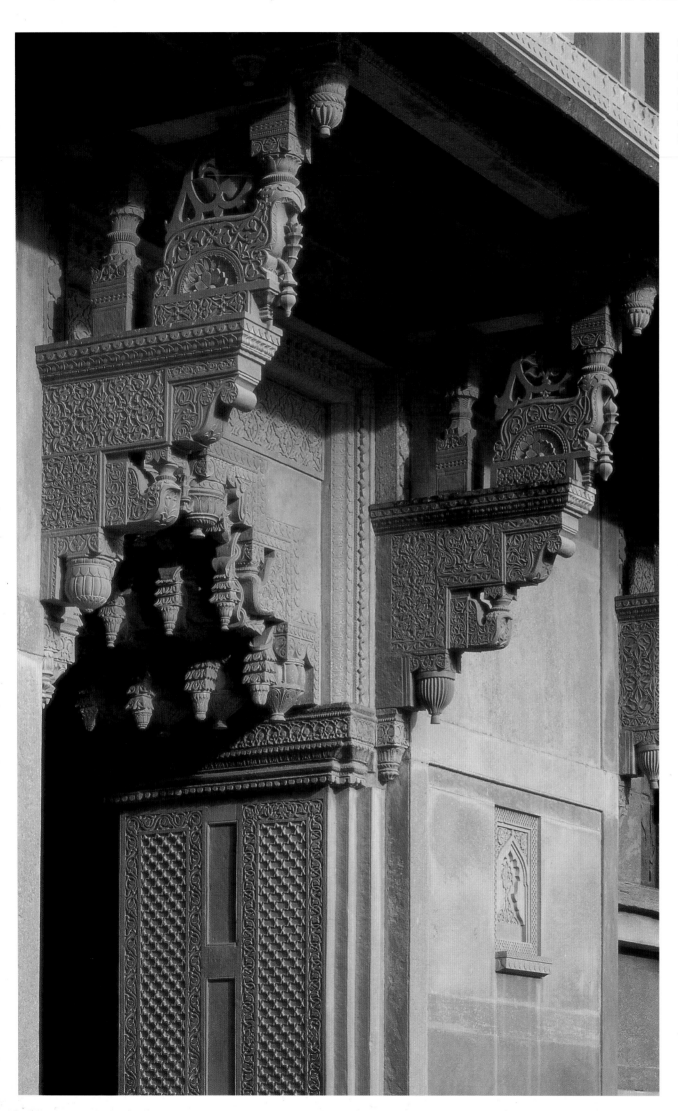

LEFT AND OPPOSITE
Inside the Jahangiri Mahal. A small rectangular pavilion with a veranda on three of its sides sits on the roof of the palace. Its brackets are exquisitely carved and suggest the influence of wooden architecture.

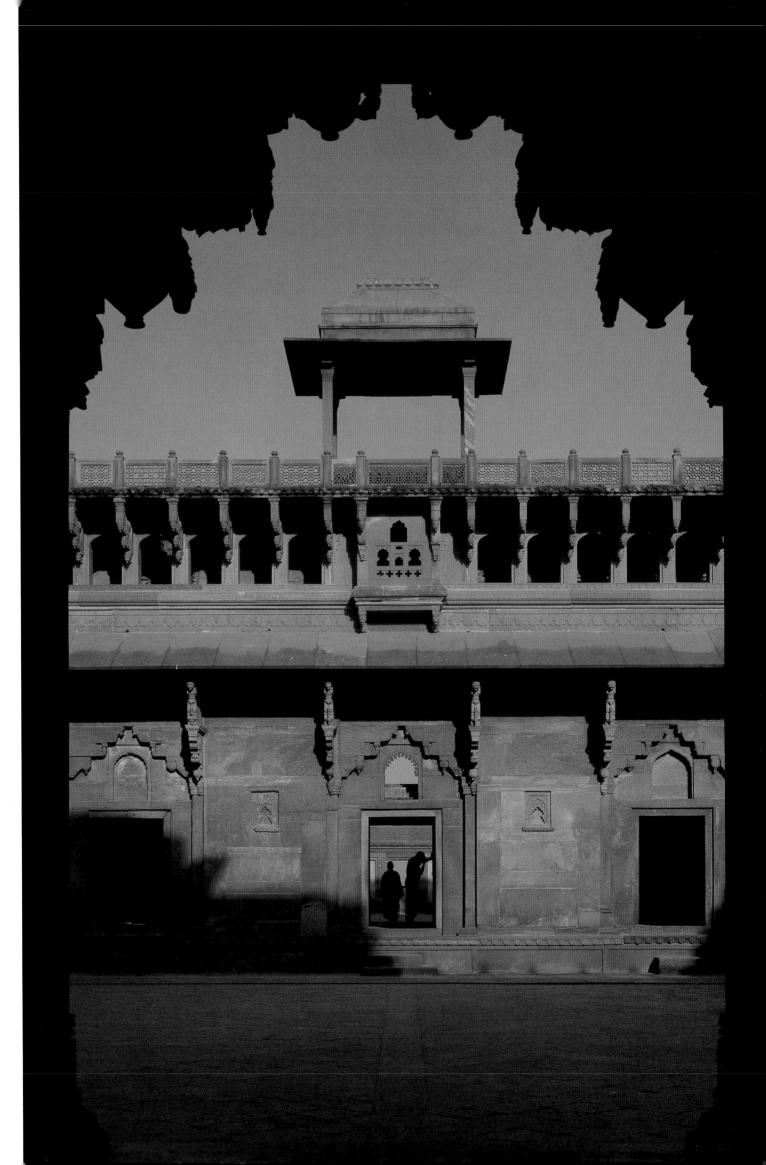

RIGHT

The interior arcade of the Jahangiri Mahal.

BELOW

The façade of the Akbari Mahal, which was probably a women's palace.

OPPOSITE

The formal front façade of the Jahangiri Mahal.

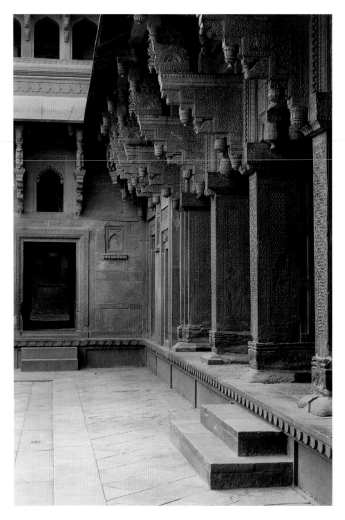

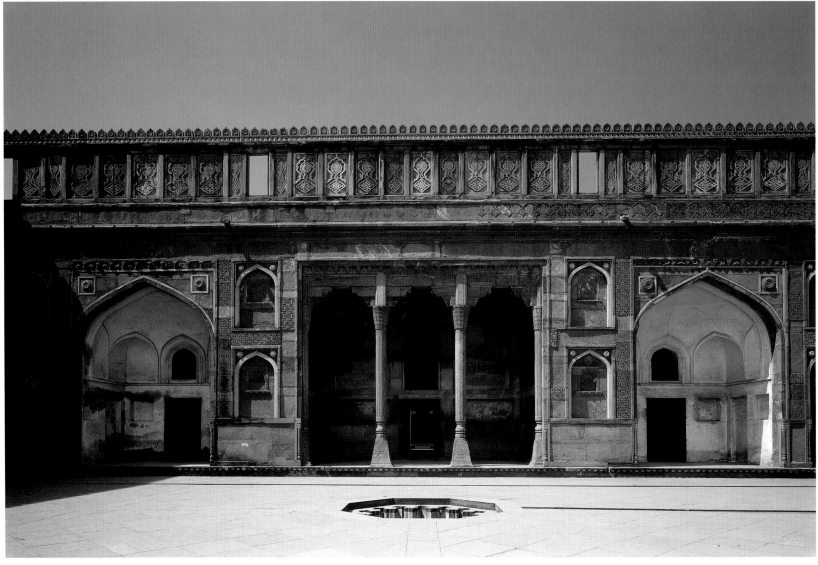

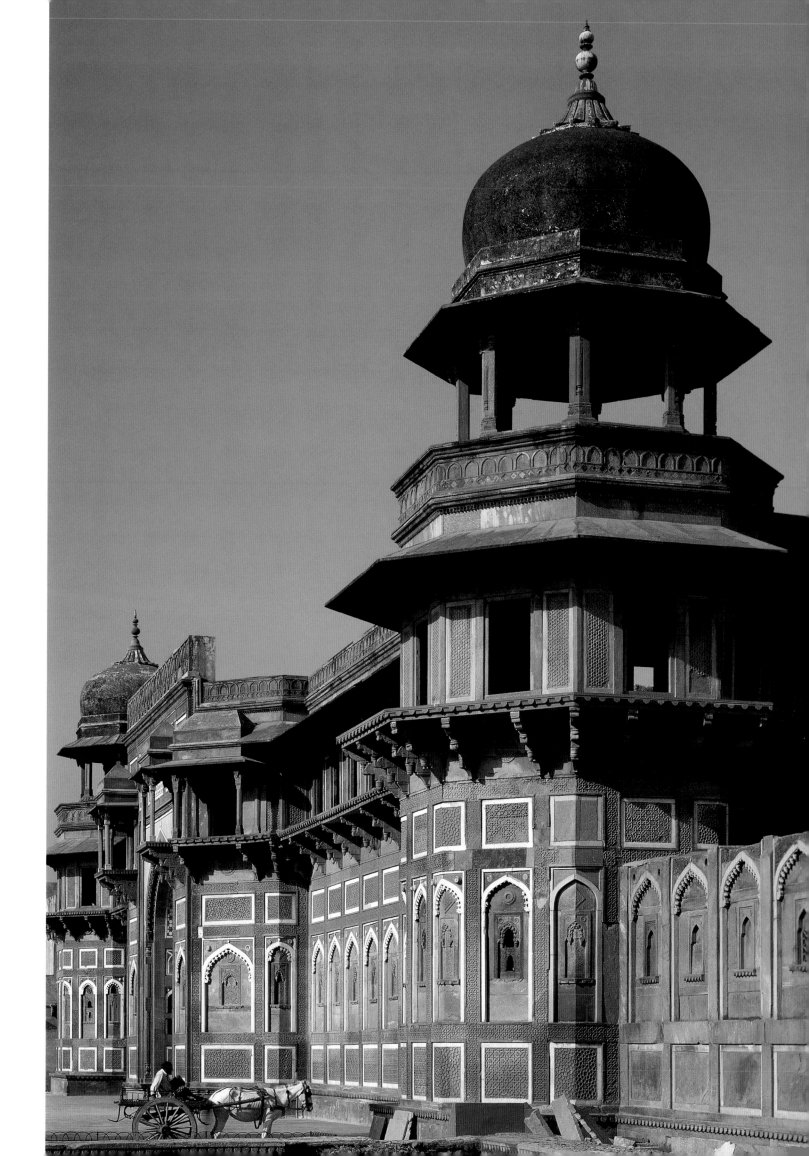

OPPOSITE

The Diwan-i-am or Hall of Public Audience was completed in 1637. Here the emperor would hold court twice a day and personally attend to the administration of his empire.

RIGHT AND BELOW

The Shah Burj, Shah Jahan's private quarters where he met his most important dignitaries and his sons. This exquisite pavilion sits alongside a luxurious sunken pool.

Each façade of the square mausoleum is 45 metres (148 feet) long. The arched plinth upon which it sits measures 90 metres (296 feet) on each side.

Humayun's Tomb

DELHI INDIA

The Mughal emperor Akbar the Great, who ruled from 1556 to 1605, inherited a small, precarious kingdom from his father Humayun. By the time of his death he had expanded it into a great empire stretching from Kabul to the Deccan in the south of India. A great patron of architecture, Akbar began the construction of Agra Fort (see pp. 196–203). He also built this grand mausoleum for his father.

Humayun's Tomb took eight or nine years to construct and was finished in 1571. Its appearance is far more Timurid than other buildings from Akbar's reign, perhaps due to the fact that the architect, known variously as Mirak Sayyid Ghiyas and Mirak Mirza Ghiyas, was Iranian and had come from Bukhara to design the tomb.

The mausoleum and its gardens were conceived as an amalgamation of paradisiacal imagery. The garden is laid out in Persian *charbagh* style, a rectangular plot split into four parts by two walkways (*char* means 'four' and *bagh* means 'garden'). The channels that divide the garden disappear right under the building, thus evoking a Qur'anic verse that refers to rivers flowing beneath Paradise.

The mausoleum is square in plan with chamfered corners, and sits on a great square plinth. Each façade has a prominent central iwan, suggesting the influence of the architecture of Delhi's 15th-century Sayyid and Lodi dynasties. The picking out of the structural elements of the façade in a palette of red sandstone and white marble was also derived from earlier Indian practice but was to become a common characteristic of Mughal imperial architecture.

The simplicity of the exterior is not carried through to the interior, where on the ground floor a central octagonal chamber contains a cenotaph marking the position of Huyamun's grave – another cenotaph on the floor above reinforces this position. This central space is surrounded by eight chambers connected by diagonal corridors that allow circumambulation of the central space. This rigidly symmetrical plan was an interpretation of a typical Timurid *hasht-bihisht* ('eight paradises') design in which the eight ancillary chambers were intended to evoke the eight paradises of Islamic cosmology.

From the beginning Humayun's Tomb functioned almost as a place of pilgrimage, with later emperors dutifully visiting the tomb and performing a ritual circumambulation. Even though such veneration of a place of burial conflicted with Islamic orthodoxy, the mausoleum was now established as the signature building type of the Mughal dynasty.

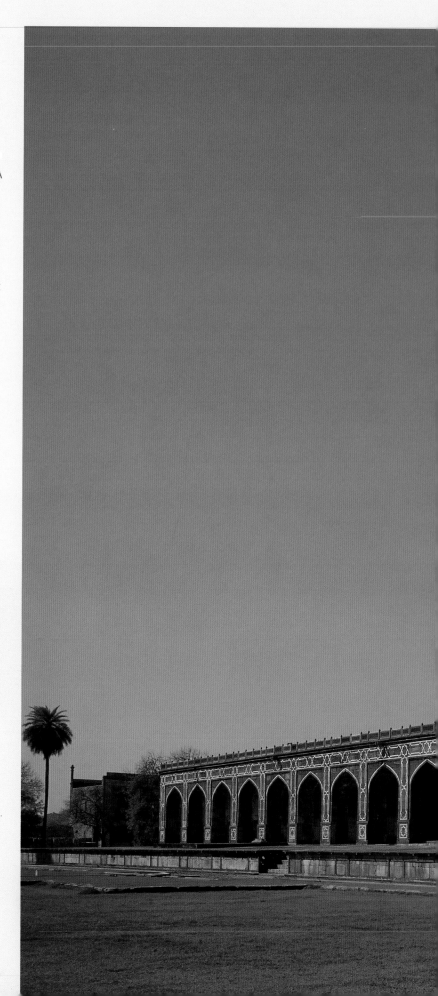

PAGES 206-207

Eighth-century Sanskrit texts on architecture and art recommended the colour white for houses of the priestly Brahmin class, and red for the Kshatriyas, the warrior class. By mixing the colours of the two most important Indian castes the Mughals were associating themselves with the highest levels of Indian society.

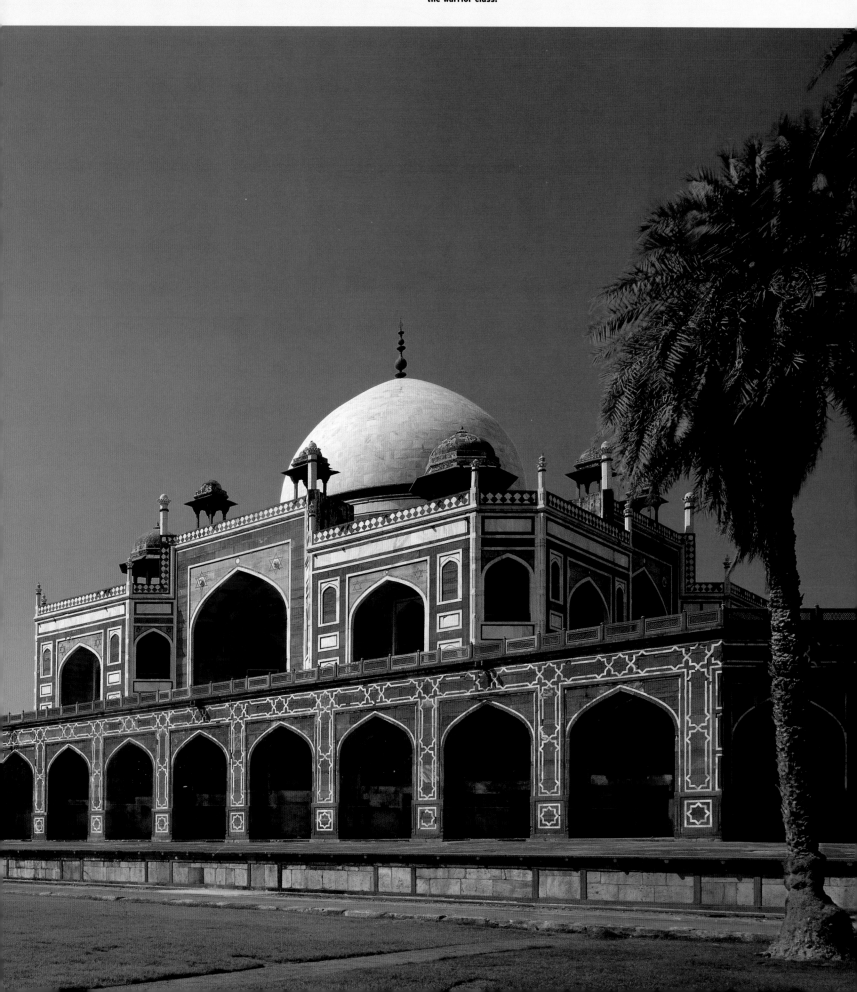

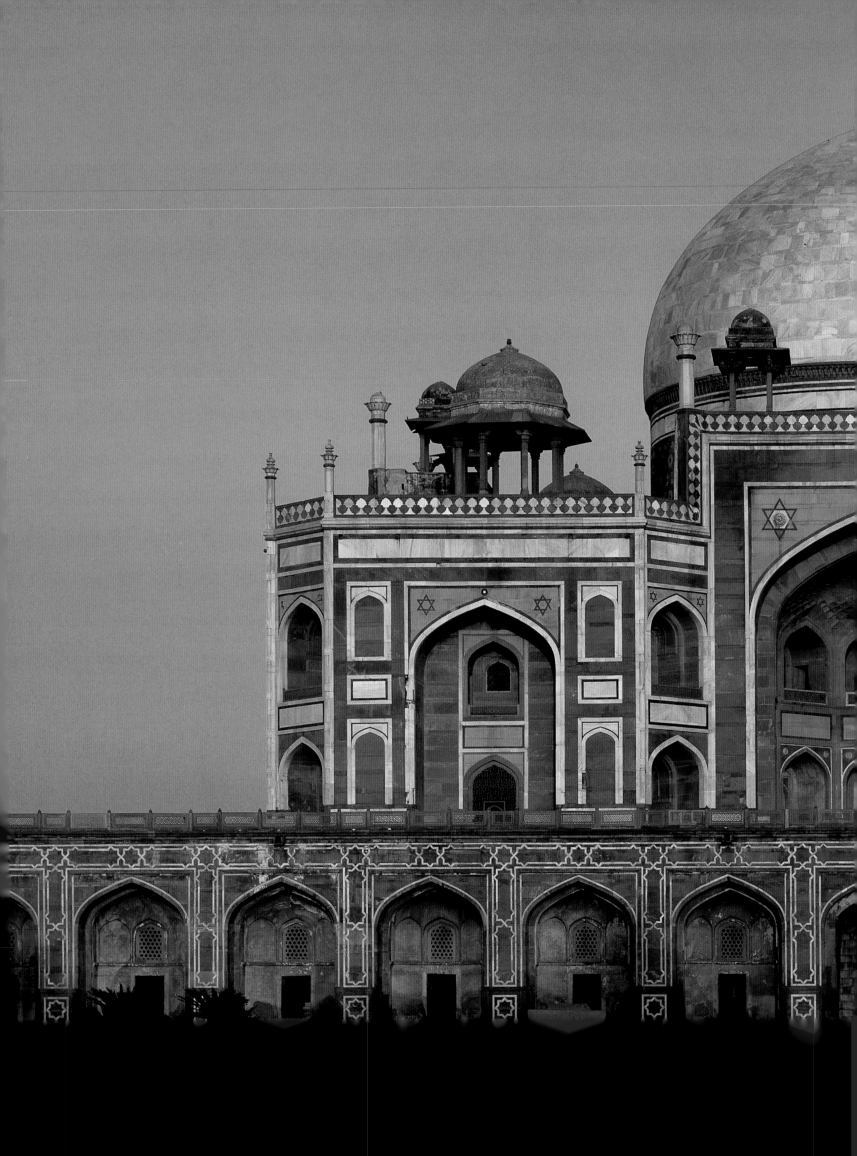

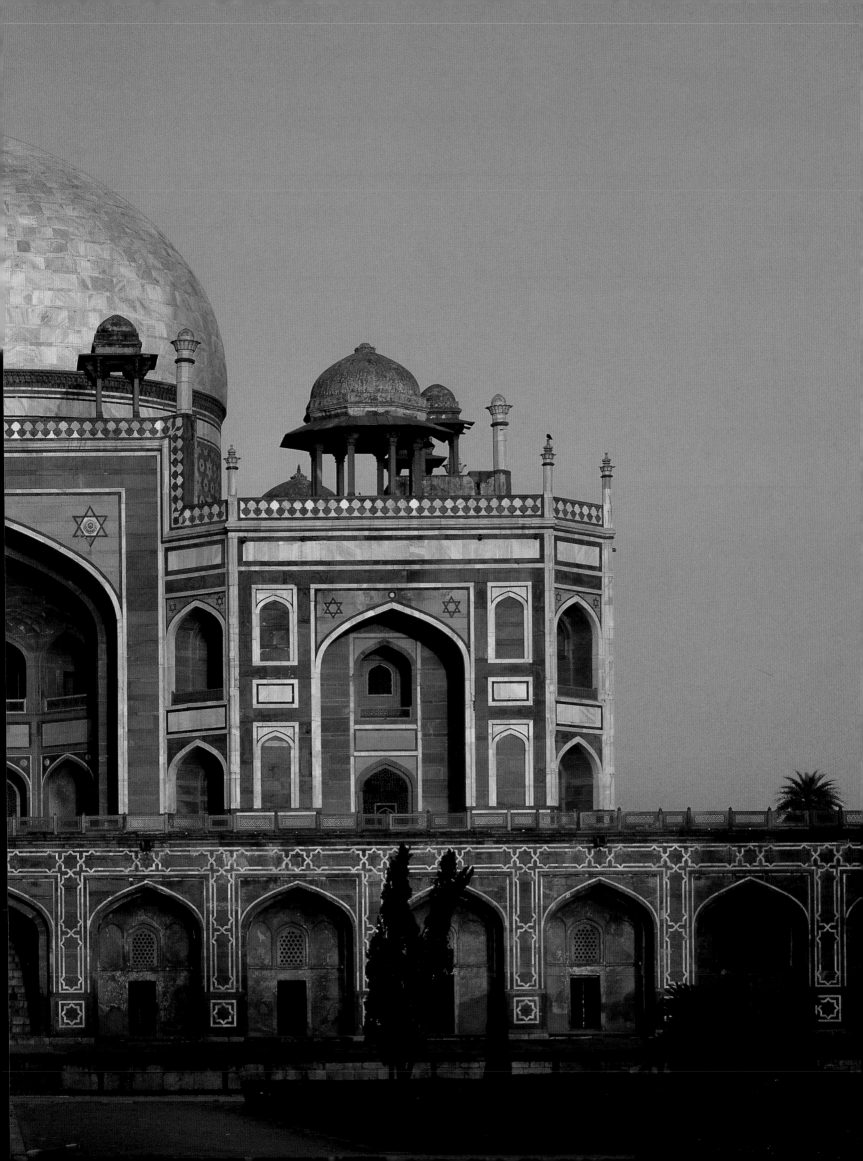

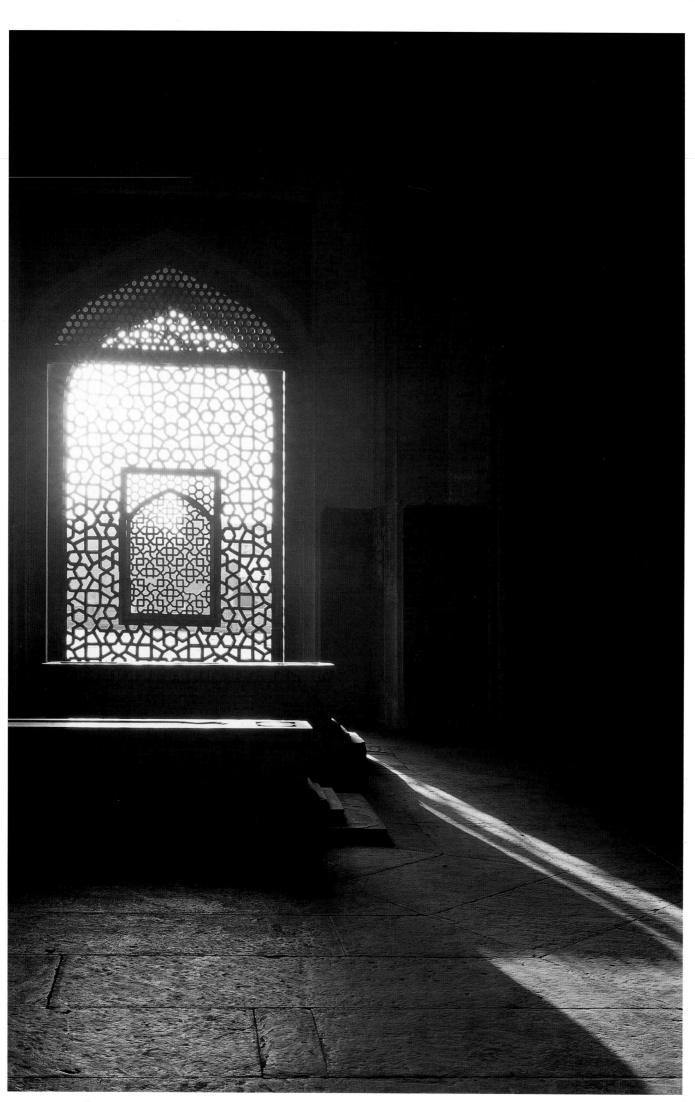

LEFT

The cenotaphs of Humayun's relatives lie in the chambers arranged around the central space. The layout of these chambers enabled a ritual circumambulation of Humayun's own cenotaph.

OPPOSITE

This pavilion in the grounds of Humayun's Tomb mirrors the great monument though at a smaller scale. Behind it, to the right, can be seen a mausoleum from the earlier Lodi dynasty.

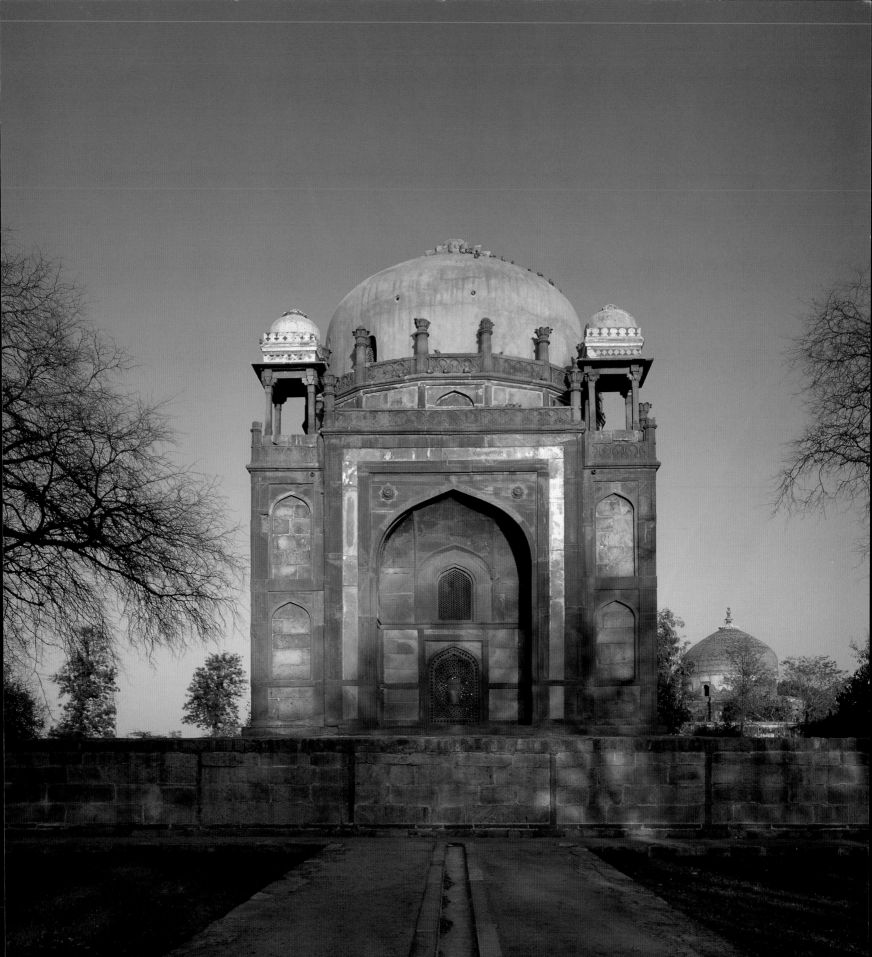

San Giorgio Maggiore

VENICE ITALY

The island of San Giorgio Maggiore in Venice has been the site of a Benedictine monastery since 982 when the whole island was donated to a monk. This monastery was considered particularly important since it claimed to possess the body of St Stephen, and every year on the day of this saint's feast (26 December) the doge would solemnly process by boat to the church, bringing with him the choir of St Mark's Basilica and a large crowd of spectators.

The present church was built from 1566 onwards by one of the greatest (and most influential) figures in Renaissance architecture, Andrea Palladio. The author of four churches in Venice, Palladio understood the dynamics and theatricality of the city perfectly, and used this spectacular site, most often seen across the lagoon from the main island, to best advantage. Its prominent dome, tall red brick campanile and gleaming white façade are all archetypically Venetian.

The church has a Latin-cross plan, with a spacious aisled nave, transepts with rounded ends, a crossing covered by the main dome, a square chancel, and beyond that (behind a series of columns) the monks' choir. One of Palladio's main concerns was to provide enough space for both the regular monastic choir, as well as, on occasion, the choir of St Mark's and a huge number of spectators. The whole church is meticulously Classical, the bays separated by engaged Composite half-columns on pedestals, carrying a full entablature and cornice. The size and number of windows in Palladio's churches, as well as their orientation and the monochrome surfaces, give their interiors a unique light. Anything that is not architecture (for example, sculpture or paintings) is accommodated in a niche: as a result they feel not like additions but like integral elements in the design. At the same time all the separate elements seem to interpenetrate so that the interior has a sense of movement that in certain respects looks forward to the Baroque.

The main façade of the church was built between 1607 and 1611, and is often said to be by Vincenzo Scamozzi. However, it follows a scheme invented by Palladio and that he used in three of his Venetian churches. This scheme overlays two temple fronts: the taller, central one corresponds to the nave and has four large columns on high bases supporting a heavy pediment, while behind this runs a continuous cornice line suggesting a second pediment, supported by pilasters, covering the aisles. It was an original and ingenious solution to a problem that had dogged architects since the first churches were built - how to reconcile the façades of a Christian church with the Classical language of architecture.

ABOVE

The view up into the dome over the crossing. The dome is supported by four arches and pendentives.

OPPOSITE

The nave looking towards the altar. The lower part of the elevation is full of clusters of columns, which support a Classical entablature and a plain barrel vault.

PAGE 212

The southern aisle seen from the transept, looking towards the entrance. Sculptures and paintings are accommodated in niches between half columns.

PAGE 213

The ingenious double-pediment system of the west front. One expresses the volume of the nave, the other that of the aisles.

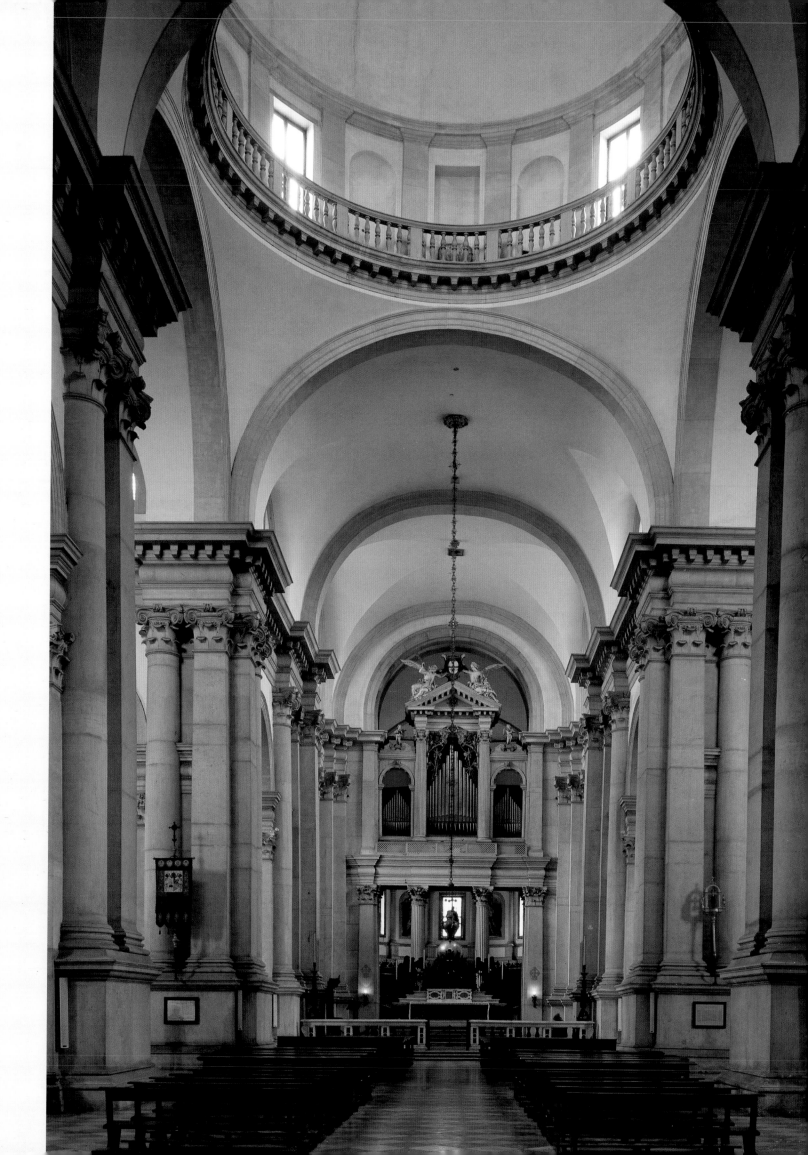

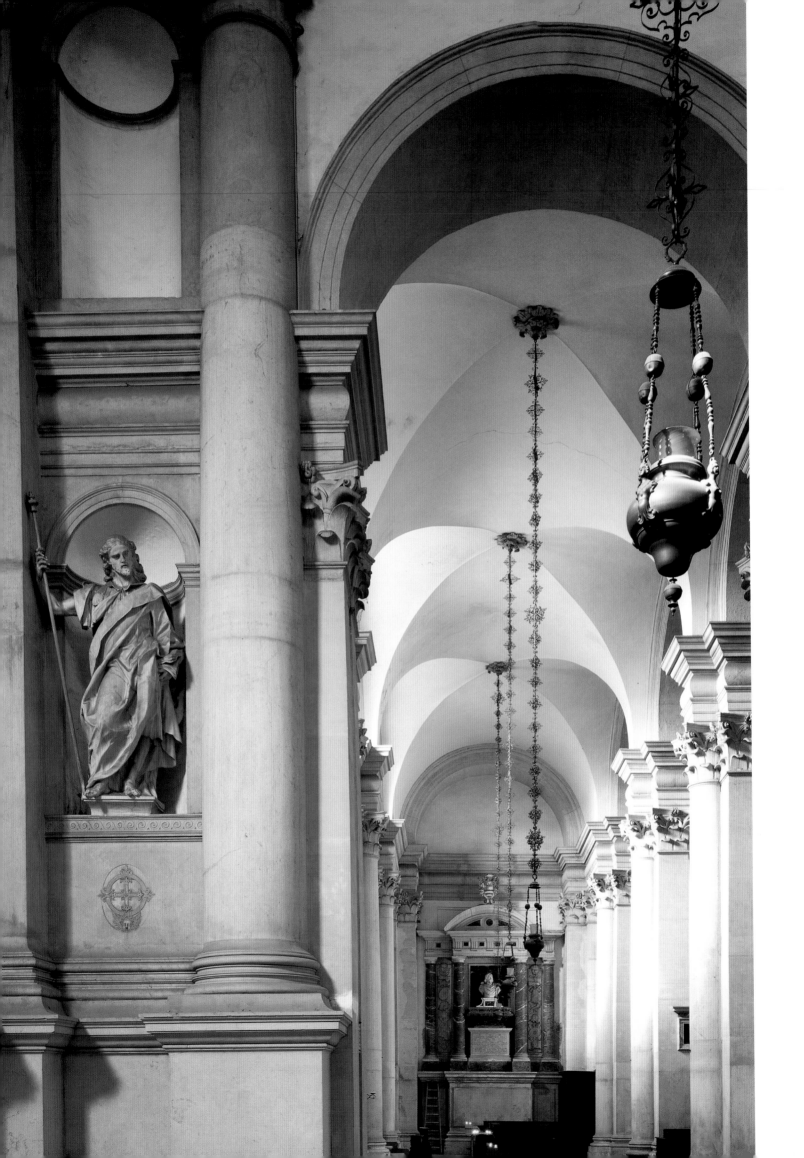

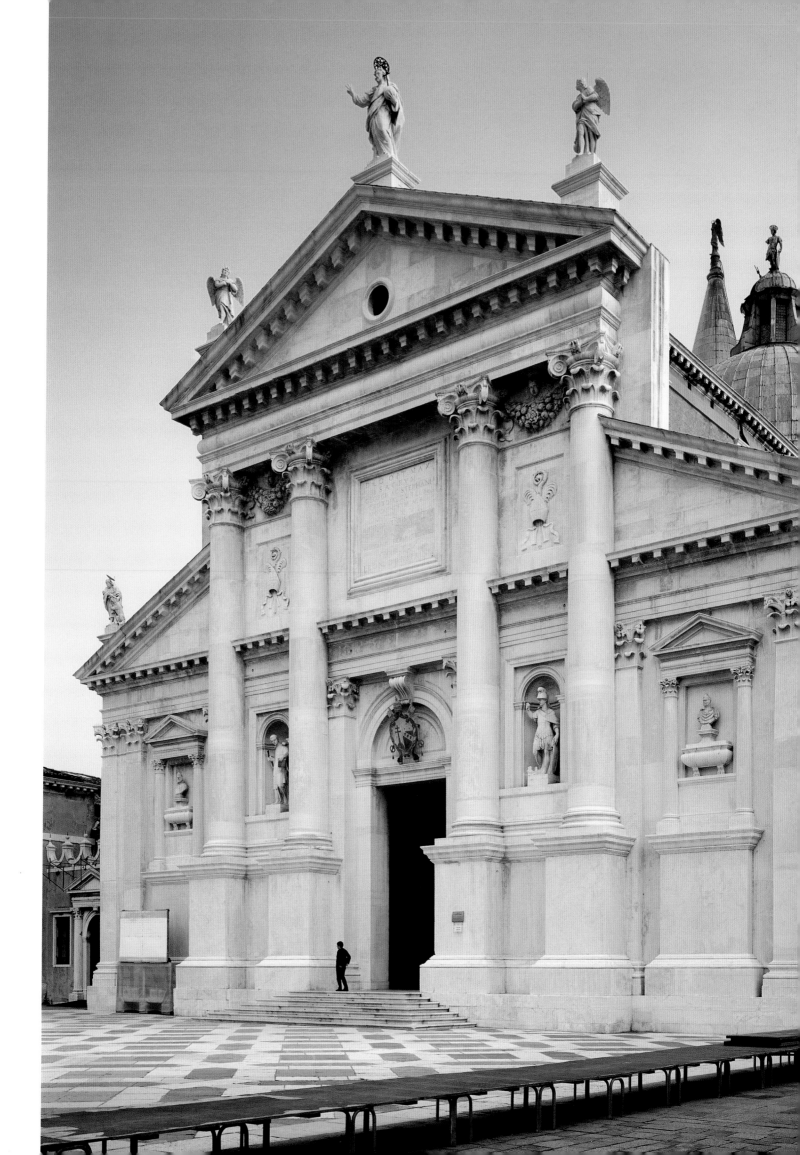

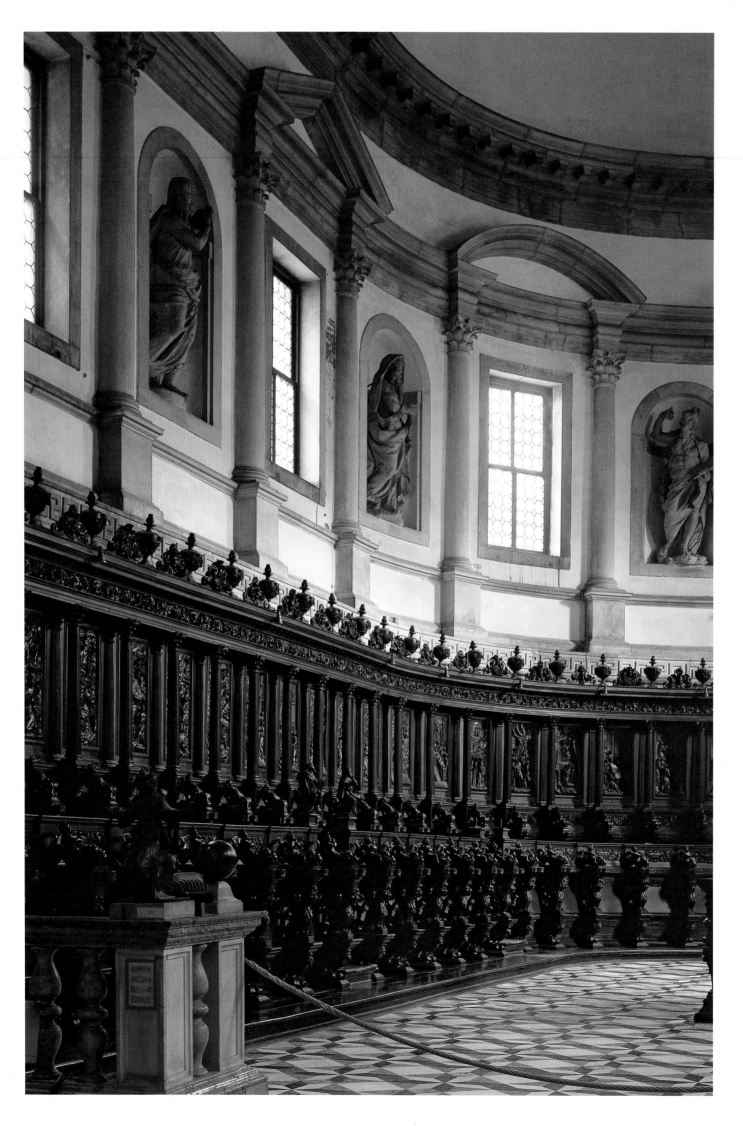

OPPOSITE

The choir is separated from the main church, a unique solution in Italian Renaissance architecture.

RIGHT

The crossing. The arches running down the sides of the nave spring from piers with half-length pilasters, while the entablature is supported by half columns. The thermal windows that form a clearstorey above echo the form of the arches.

BELOW

The church seen from Piazza San Marco.

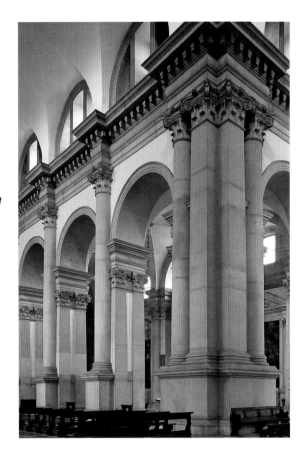

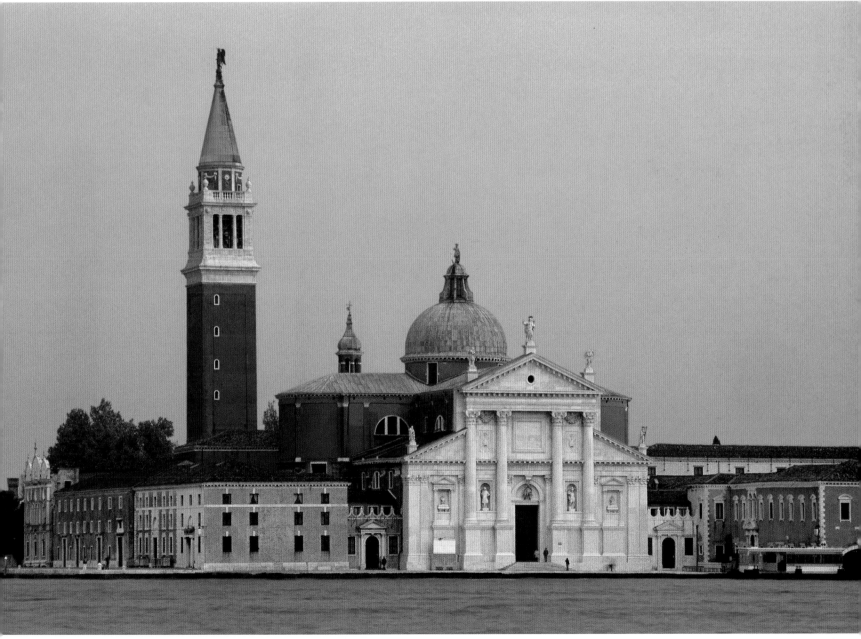

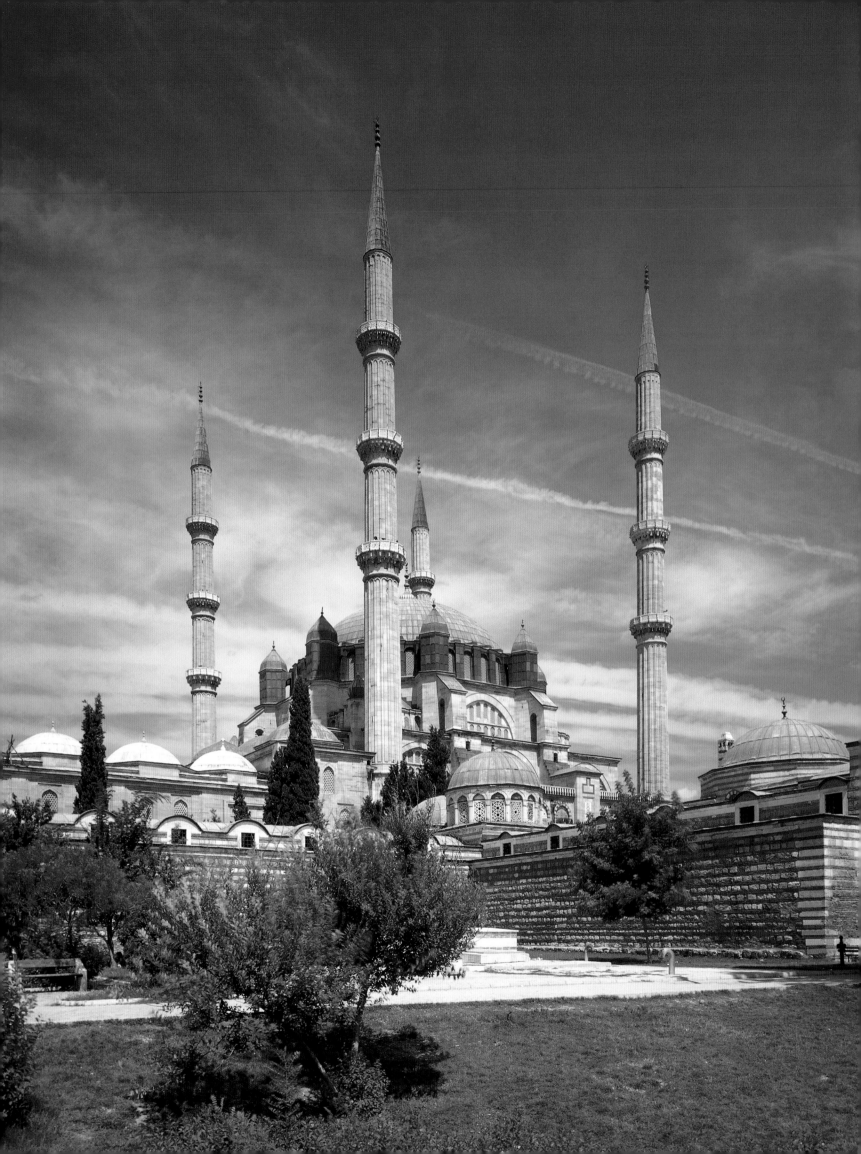

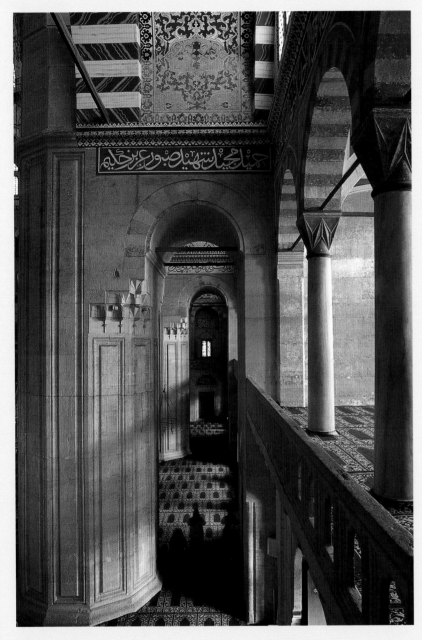

ABOVE

The view along the space between one of the eight piers (left) and the outer wall (right, with a gallery).

OPPOSITE

The hemispherical shape of the high central dome is set within a square marked by minarets; some 70 metres (230 feet) tall, these add force to the vertical thrust of the building.

PAGE 218

The mosque is approached by a grand courtyard. The portico has five arches, three large, two small. The central one, over the entrance, is distinguished by a higher dome.

PAGE 219

The use of eight major piers allowed Sinan to set the mihrab back into its own apse, lighting it from both sides and above and ensuring that it did not distract from contemplation of the dome.

Selimiye Mosque

EDIRNE TURKEY

The Selimiye Mosque was begun in 1568 when its architect Sinan was at the height of his powers. Sinan was also the architect of the celebrated Süleymaniye Mosque (see pp. 192–5), but whereas that dome rests on four piers, the dome of the Selimiye rests on eight – and it is this apparently simple shift that makes the Selimiye so groundbreaking. These eight piers, and the eight major arches created between them, allowed Sinan to construct a space of extreme subtlety yet great rationality: a reconciliation of circle and square, of rounded apse and straight corner. Of all the eight major arches, one is accentuated by leading into a single apse crowned by a semi-dome – this is the mihrab, the niche that traditionally indicates the *qibla*, or direction of prayer. Less traditionally, however, the mihrab has been moved right back so that the apse can be lit by windows on three sides. Of the other seven major arches, three lead to flat walls, while the four on the diagonals lead into corners, where they divide into two smaller arches.

Instead of any approximation to a capital, each of the eight piers terminates in a plain, abstract shape that incorporates consoles from which the arches spring – thus, both arch and pier create an integrated form. A continuous gallery running around the edge of the building unites the various spaces to define the square contained within the octagon. Each individual element within the mosque makes its own impact: the tall, narrow mihrab of Marmara marble; the steep, lofty minbar (pulpit), whose exquisite carving has been compared to lace; the profusion of calligraphic ornament in tile and terracotta; the wooden doors. However, none distracts from the singular visual emphasis up into the dome.

Sinan was very proud of this mosque. He declared: 'Those who consider themselves architects among the Christians say that in the realm of Islam no dome can equal that of Hagia Sophia; they claim that no Islamic architect would be able to build such a large dome. In this mosque, with the help of Allah and the support of Sultan Selim Khan, I have erected a dome six cubits higher and four cubits wider than the dome of Hagia Sophia.' Actually, he was wrong. Sinan's dome is not quite as high, nor quite as wide, as that of Hagia Sophia.

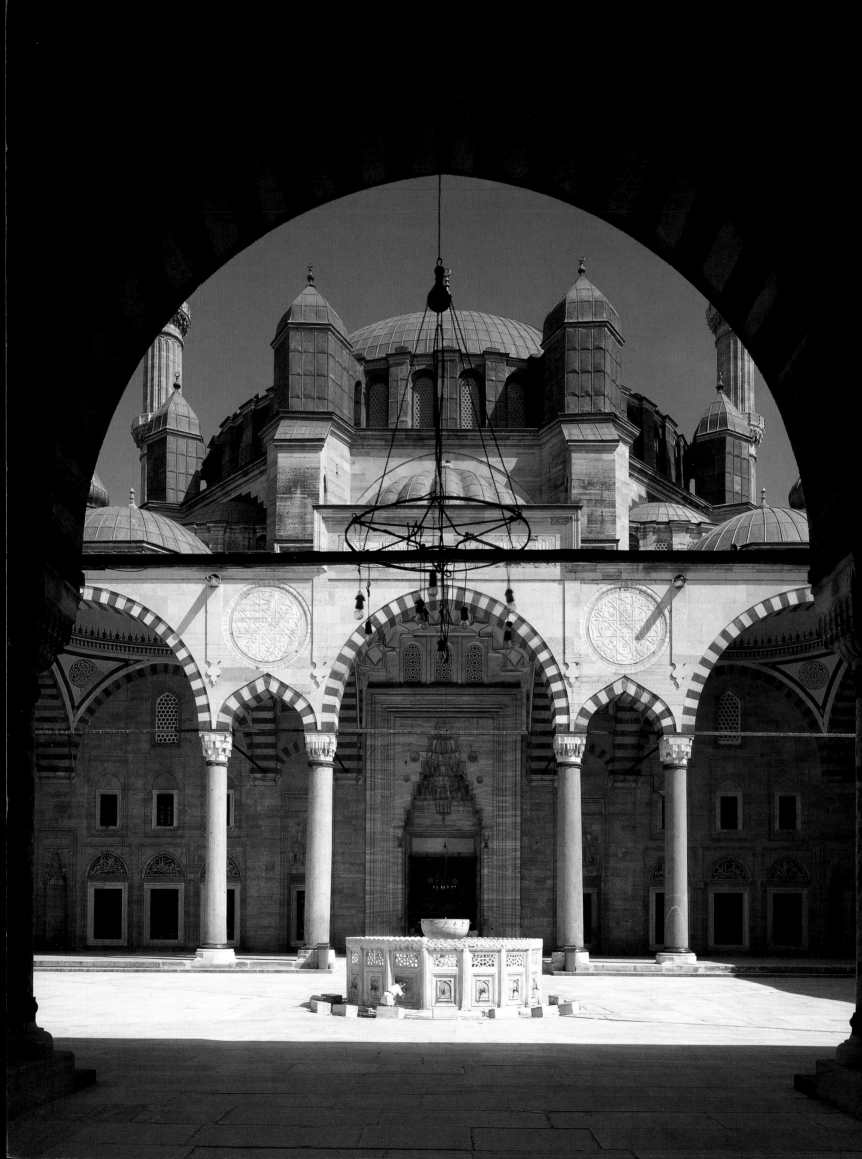

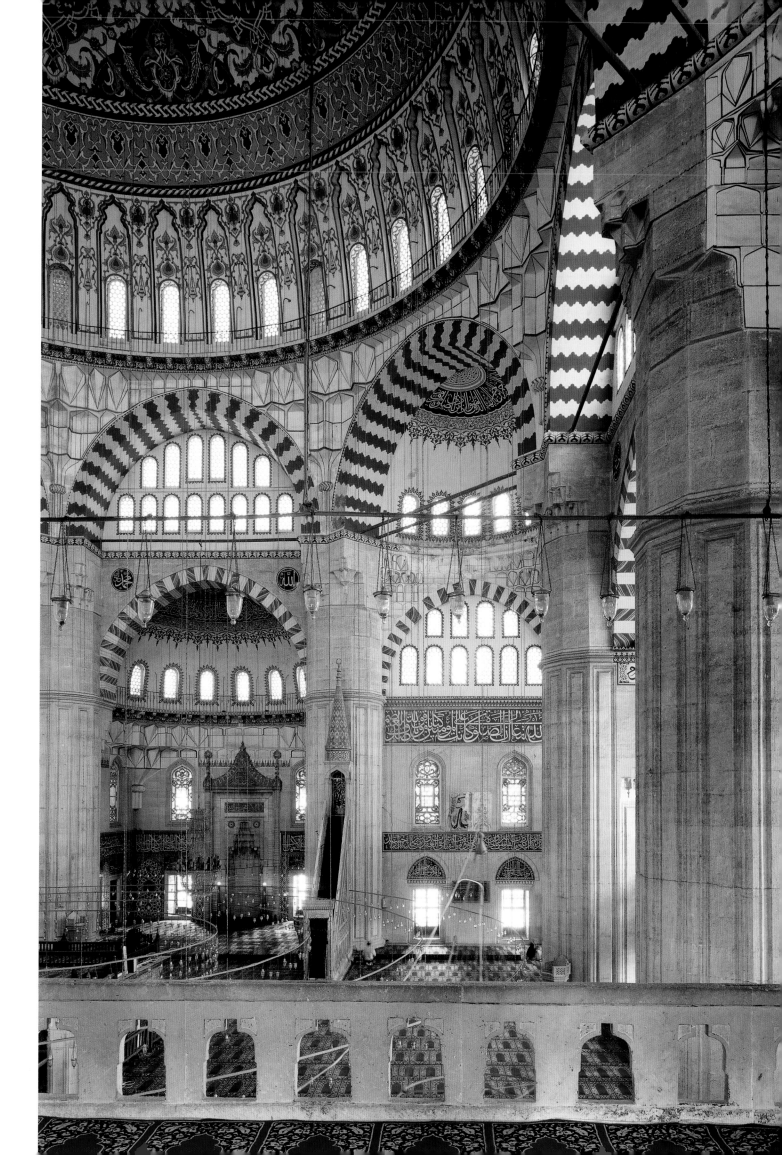

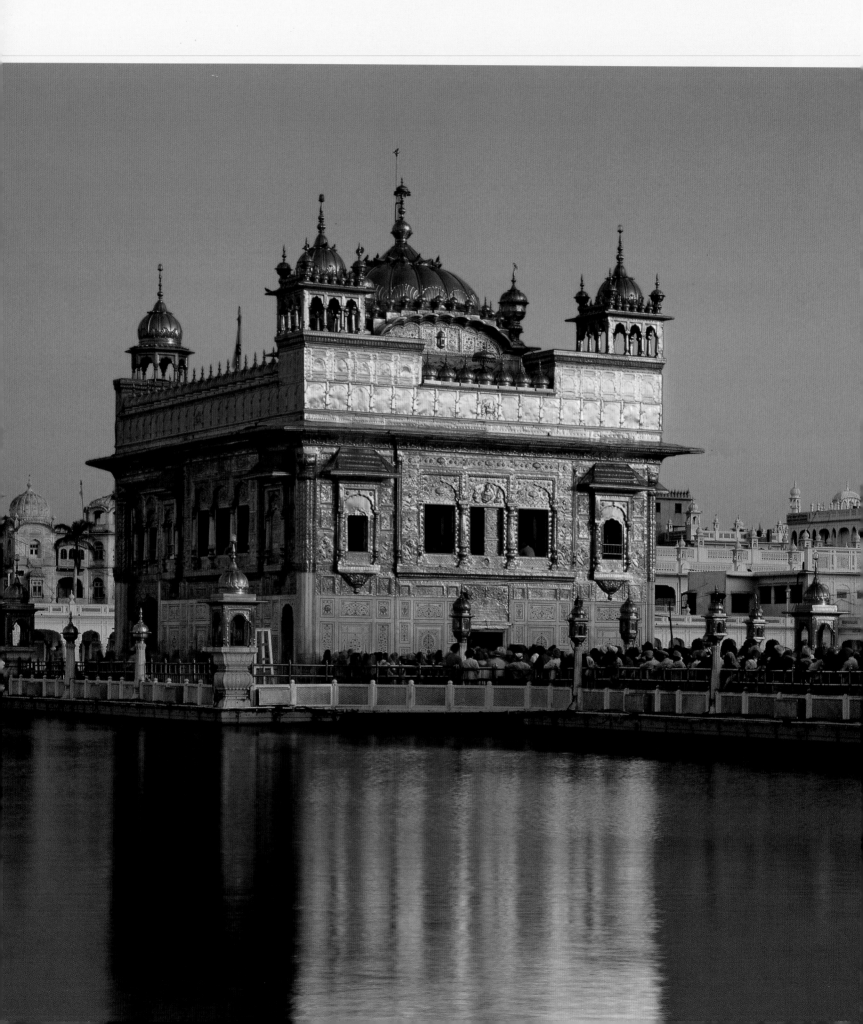

The Golden Temple seen from the
south-west within its sacred pool
or *sarowar*.

Golden Temple

AMRITSAR INDIA

In the early 16th century, during the defence of northern India from Muslim forces, a group of military leaders known as Sikhs took over the Punjab and formed a new, militant religious sect. The word *sikh* means 'disciple', since Sikhs follow the teaching established by ten gurus between 1507 and 1708. Each guru extended and reinforced the message taught by the previous one, so that the religion's first sacred scripture, the Adi Granth, was not completed until 1604 by the fifth guru, Arjun. Arjun also built the principal shrine of Sikhism, the Harmandir Sahib at Amritsar, more commonly known as the Golden Temple.

Sikh sanctuaries are called *gurdwaras*, derived from *guru* (master) and *dwara* (gateway or seat). They generally take the form of a domed central building housing either the remains of a guru or a sacred text and surrounded by a pool of water called a *sarowar*. The Golden Temple was originally built in the last quarter of the 16th century but since then has been pulled down and rebuilt three times; the last rebuilding was in 1764-5. The temple sits upon a square island in the *sarowar* and is accessed via a 60-metre (197-foot) long causeway over the water entered through a two-storey entrance pavilion called the Darshani Deorhi. In fact, the *sarowar* (which is known as the 'Pool of Nectar' or *amritsar*, hence the name of the city) predates the temple, having been excavated by the fourth guru earlier in the 16th century. Like the island upon which the temple stands, the *sarowar* is almost square, measuring 155 by 149 metres (510 by 490 feet) at the surface and 149 by 143 metres (490 by 470 feet) at its bottom; it is five metres (17 feet) deep. Around the edge of the pool runs a marble pavement (*parikarma*) 18 metres (60 feet) wide, and connecting the pavement and the pool are ten steps with platforms from which to enter the water, for the ritual washing of the body that accompanies prayer.

The island sanctuary itself is neither Hindu nor Muslim in appearance. It is crowned by a low dome with a fluted surface believed to be inspired by a lotus flower. Four smaller domes surmount kiosks called *chhatris* standing at each corner. The whole upper portion is covered with gilded copper plates, which give the temple its more common name. Unlike a Hindu temple the Golden Temple has four doorways to indicate that it is open to all the main caste divisions of Hindu society.

OPPOSITE

Devotees are required to step downwards from the entrances to remind themselves of the humility required to know God. In this photograph the walkway around the tank is being ritually washed with milk and then water.

RIGHT

Penitents complete a sacred circumambulation of the building.

BELOW

A penitent ascends the steps leading to the *sarowar* after washing himself in the sacred waters at dawn.

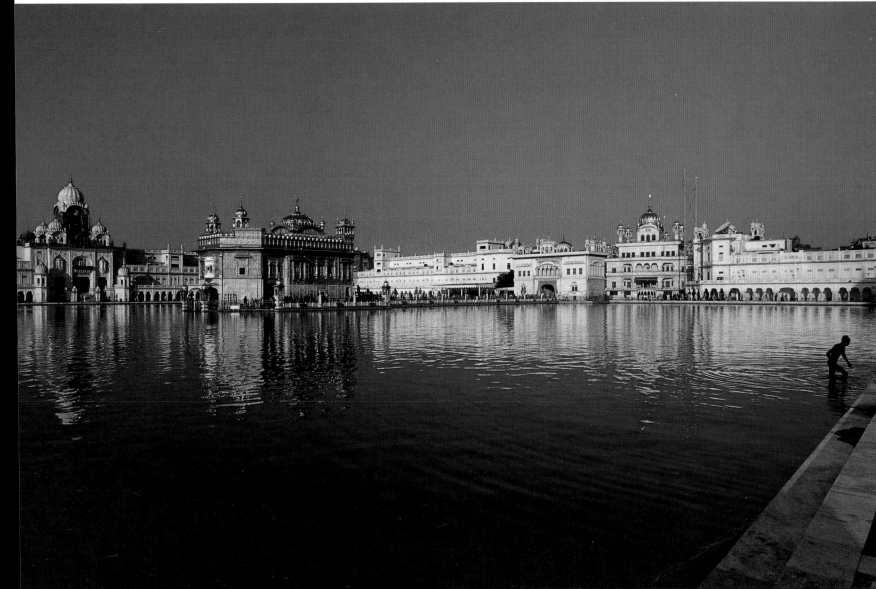

The mosque's six minarets climbing
above the surrounding trees allow
the size of the complex to be
appreciated from a distance.

Blue Mosque

ISTANBUL TURKEY

The Sultan Ahmed Mosque, more commonly known as the Blue Mosque due to its liberal use of that colour, is perhaps the best-loved in Istanbul. It was commissioned by the young Ahmed I from Mehmet Aga (Sinan's successor as Imperial Architect), and construction began in 1609. Like Sinan, Mehmet had been born a Christian and he died in the same year as his sultan (1617) at the age of 67. Even though, architecturally, it may not match the Hagia Sophia (see pp. 48–51) or either of Sinan's two great mosques, Mehmet Aga's work merits consideration on the basis of its many, uniquely Ottoman, strengths.

Perhaps above all the Blue Mosque is an astute work of urban planning. The first thing that one notices when viewing it from a distance is that it has six minarets instead of the usual four. (In contemporary eyes, this laid it open to the charge of sacrilege since the Grand Mosque in Mecca also had six.) These six minarets allow the length of the building and surrounding spaces to be distinguished above the buildings and trees crowded around it. Its long flanks stand along the coast of the Sea of Marmara on a north–south axis and in so doing complete the large square that was once home to Constantinople's hippodrome.

The mosque is entered through an impressive deep gate with a fine *muqarnas* semi-dome leading into a spacious court. This court covers an area equivalent to the mosque itself; at its centre is a beautiful fountain whose roof is mirrored by a triangular inscription on the central cupola of the mosque's portico. The proportions of the mosque itself are unusual. The plan is a large quatrefoil, defined by four large piers that support four arches. The 17th-century traveller Evliya Efendi described these piers as 'elephants' legs', and certainly they are rather wide. Each of the four arches opens into a trefoil-shaped apse. The space is configured to allow maximum visibility from all parts of the mosque into the centre. Light comes from rows of large windows going right down to the floor, which lend the space an almost domestic character. The coloured glass in these windows came from Venice. The decoration of the masonry, as mentioned above, is mainly carried out in blue paint.

The Blue Mosque is one of the noblest sights in Istanbul but it also marks the end of an era. Sultan Ahmed's reign was notable for its lack of military success, leading to the weakening of the Ottoman Empire. The reluctance or inability of future sultans to build on the same grand scale effectively marked the close of the golden age of Ottoman architecture.

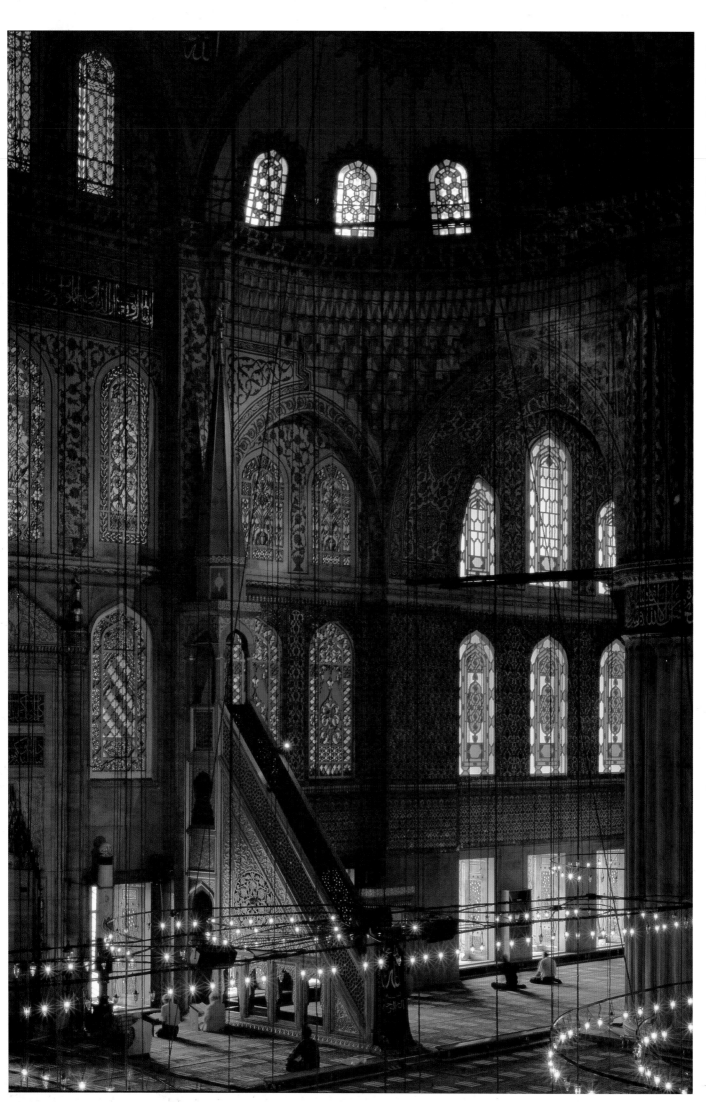

LEFT

The mihrab wall, showing the stacked rows of windows that allow light to flood in. The coloured glass came from Venice.

OPPOSITE

The predominately blue palette of the interior lends the Sultan Ahmed Mosque its more common name.

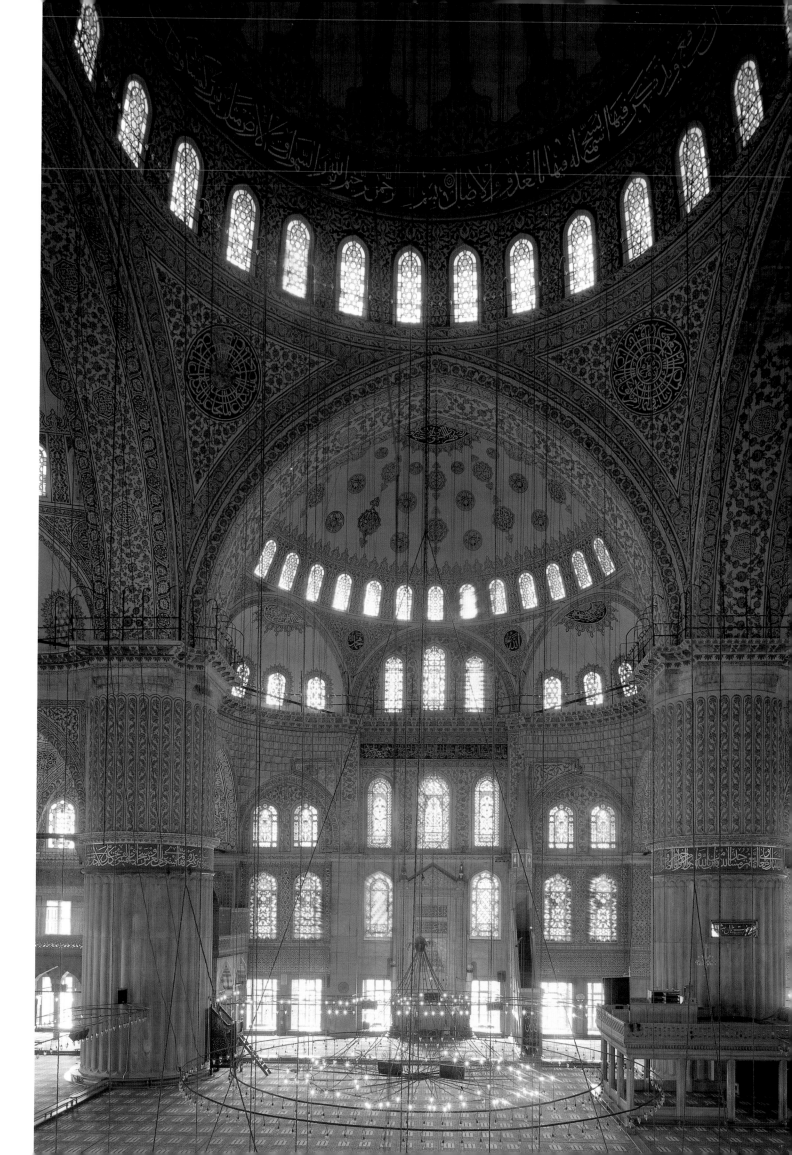

Shah Mosque

ISFAHAN IRAN

Between the 13th and 15th centuries the Safavids grew from a small Sufi order in north-western Iran to a powerful dynasty that dominated Persia, and would continue to do so until the early 18th century. Many of the Safavid rulers were keen builders, and together they left a number of exceptional architectural achievements. Perhaps the most impressive of these was the expansion of the city of Isfahan into one of the major centres of the Middle East. It was one of the most radical town-planning schemes ever seen in any Islamic country, and at its centre they created a great public space, the *maidan*, which at 512 by 159 metres (1,680 by 523 feet) remains one of the largest squares in the world. And on the south side of this square was erected the Shah Mosque (today also known as the Imam Mosque).

The mosque was begun by Shah Abbas I in 1611, and finished by his successor Safi in around 1630. Only the entrance façade is aligned with the south side of the square since the rest of the building is rotated by 45 degrees to face south-west, the direction of Mecca. The central court has iwans on four sides and a large pool in its centre. While the iwan to the north-east forms part of a skewed space with the entrance vestibule, the south-east and north-west iwans provide access to small domed oratories. The south-west iwan, meanwhile, leads to a vast domed sanctuary, flanked by rectangular chambers. These chambers are roofed by domes and in turn lead to two smaller courts in either corner. Nearly all the upper surfaces of the mosque are clad in colourful glazed tiles. The predominant colour is blue, but the rectangular chambers contain a great range of yellow-green shades. Minarets flank both the entrance portal and the iwan leading to the sanctuary. These and the dome are clearly visible from the courtyard beyond. The great courtyard dome is surprisingly light in appearance, despite its high drum, since it rests on two side arches that channel the forces unobtrusively to the ground.

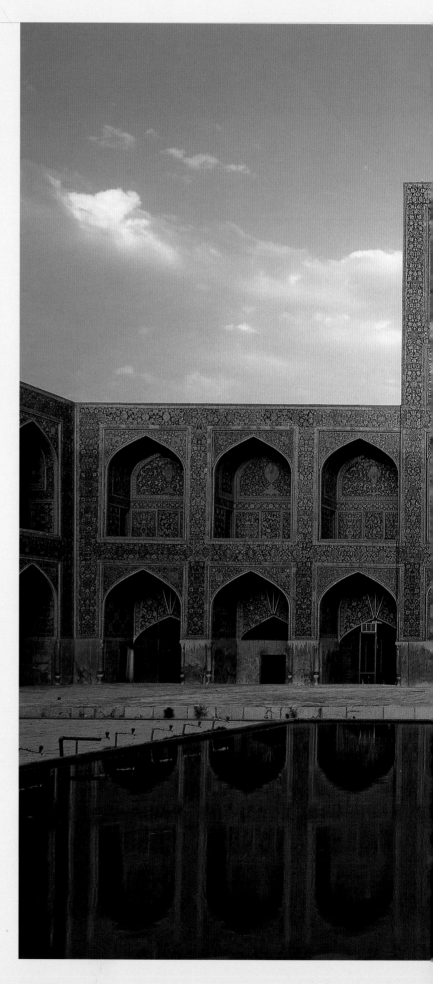

The iwan to the south-east of the
central square provides access to a
small domed oratory.

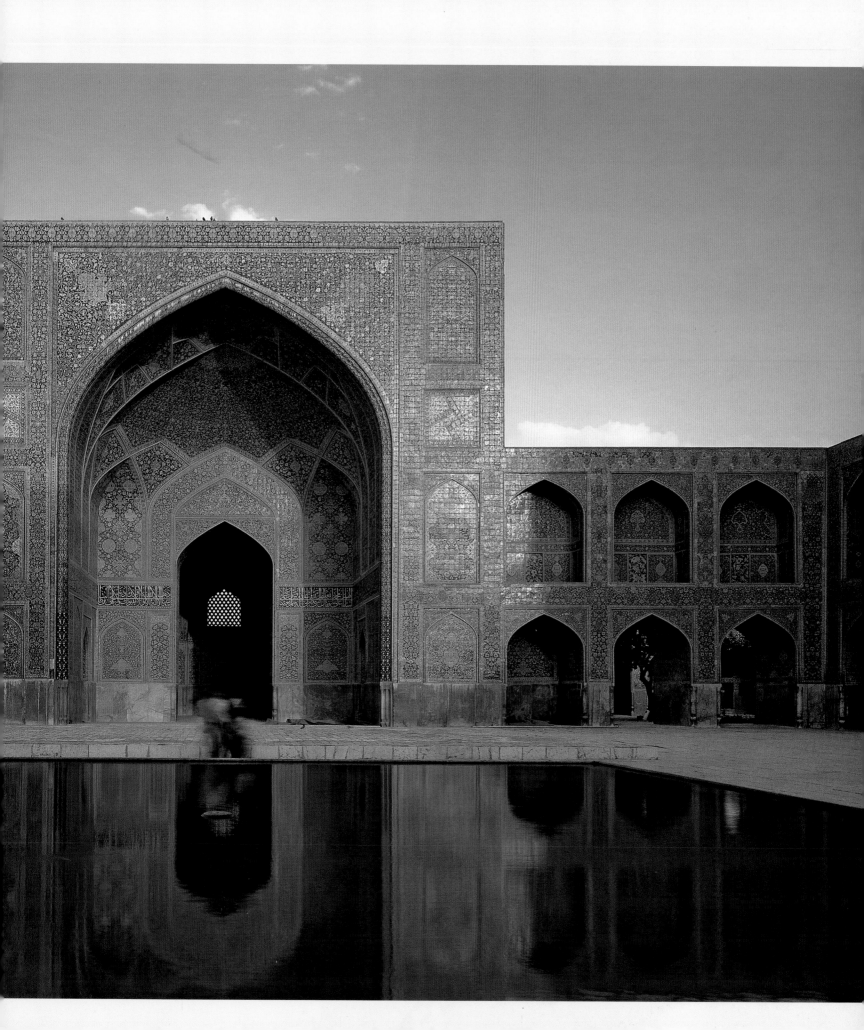

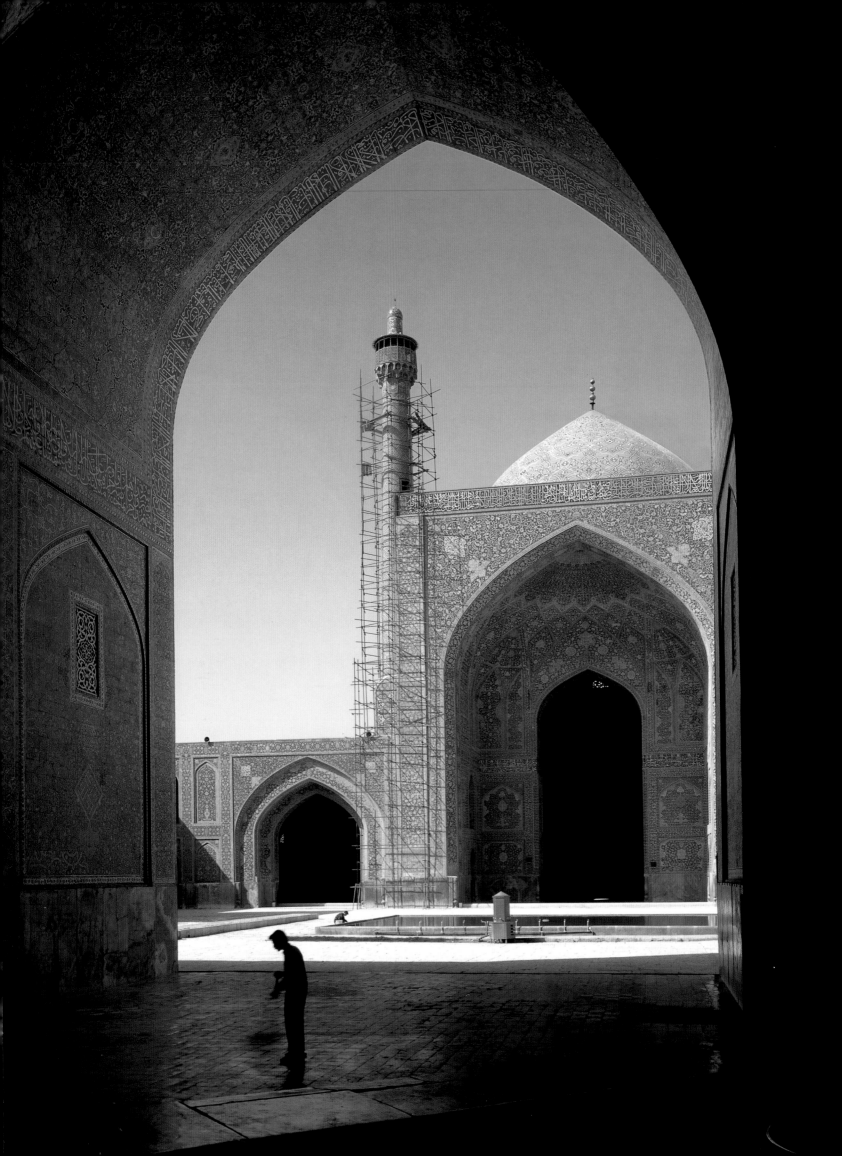

OPPOSITE

The junction space between the entrance iwan and that which leads to the square. The main building is orientated towards Mecca, while the entrance corridor maintains the rotated orientation that meets the square.

RIGHT

The interior of one of the halls to the north of the courtyard illustrates the quality of terracotta tiles used at the mosque.

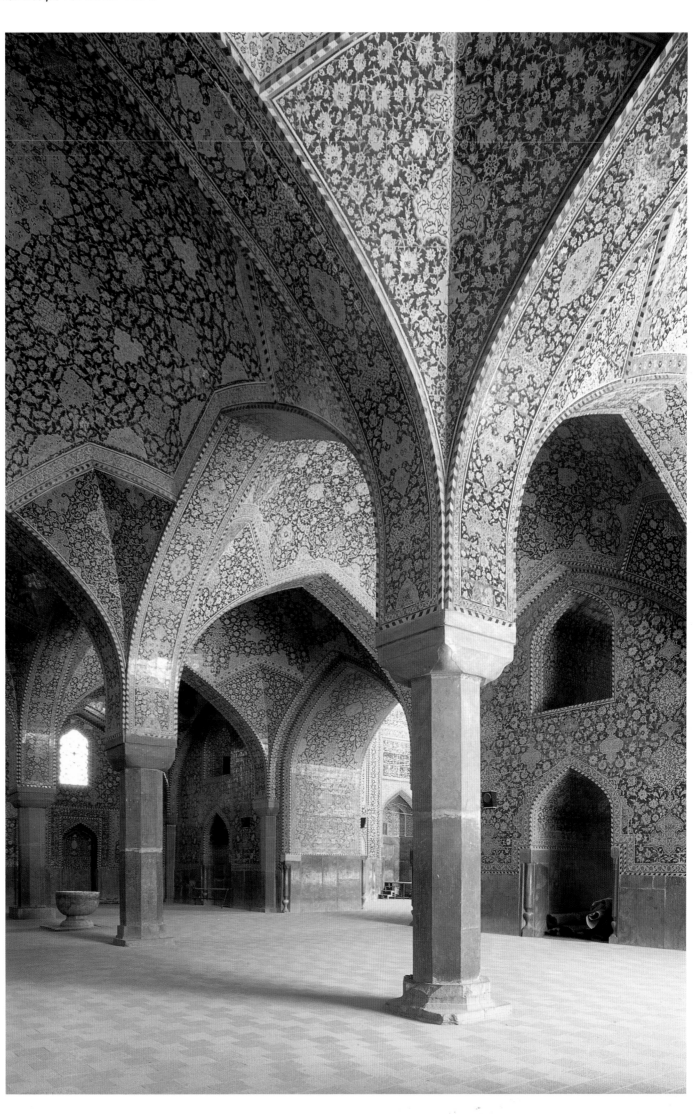

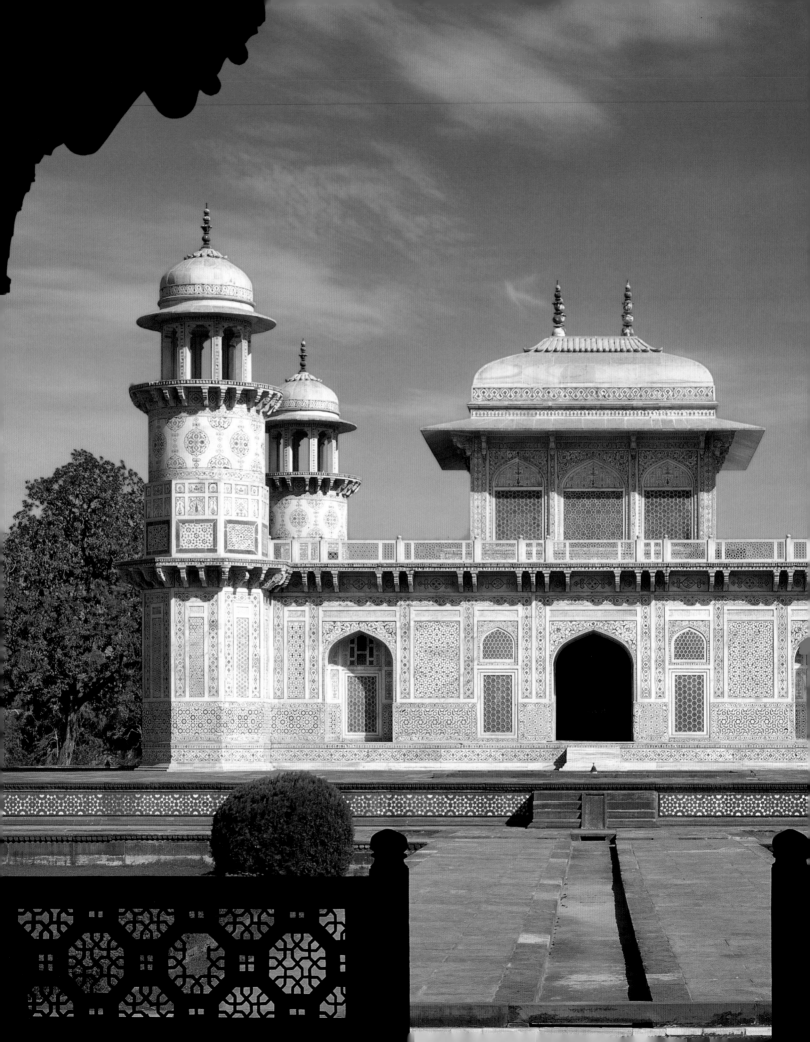

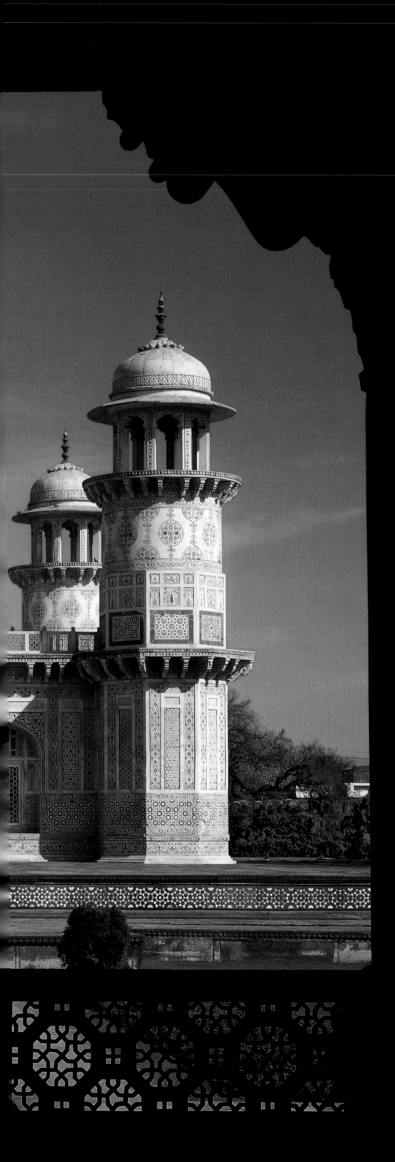

Itmad-Ud-Daulah's Tomb

AGRA INDIA

This spectacular tomb was built by Nur Jahan, queen of the emperor Jahangir, for her parents. Her father, Mirza Ghiyas Beg, was an Iranian courtier who had travelled to India with his family in search of work and had found it in the court of the Mughal emperor Akbar the Great. He continued to work for Akbar's successor, Jahangir, and rose so greatly in rank that he took the title 'Itmad-Ud-Daulah', meaning 'Pillar of the State'. His daughter eventually became a wife of Jahangir and as the emperor's health deteriorated, Nur Jahan became virtual ruler; today she is remembered as the most powerful woman in Mughal history.

Itmad-Ud-Daulah died in 1622 shortly after his wife, and their joint tomb was completed by 1628. Like most Mughal mausolea it stands within a *charbagh* garden; unlike most others, however, it is entered from the east, probably in order to make the most of the backdrop of the river in the west. Water channels connect the tomb with the four gateways built in red sandstone. The finest of these gateways is the westernmost, which overlooks the river. The paradisiacal imagery of the water garden includes cascades, lotus ponds and fountains, some of which are set into the plinth of the tomb.

The tomb itself is a low, square building with minarets at each corner. In the centre of the roof is a pavilion capped by a low-angled dome. It is a handsome structure, but unique in Mughal architecture. The extraordinary richness of the building's decoration gives it the appearance of a huge reliquary – the external surfaces are entirely covered in geometric and floral patterns executed in pietra dura, a technique involving the inlay of precious stones into marble. There are depictions of fruit, cypress trees and wine vessels, all subjects derived from Persian poetry and suggesting Safavid sources. Fruit is promised in paradise in a number of Qur'anic verses and though Islam forbids alcohol, according to sura 56 of the Qur'an paradise contains a pure wine that causes neither inebriation nor hangover. The palette of the inlay is limited almost entirely to black, grey and ochre.

The intricately carved marble screens of the top floor are similar to those on Sheikh Salim Chishti's tomb in Fatehpur Sikri. They control and direct the light that enters the room, training it to play across the tombs, a reminder of the divine light of God in the face of death.

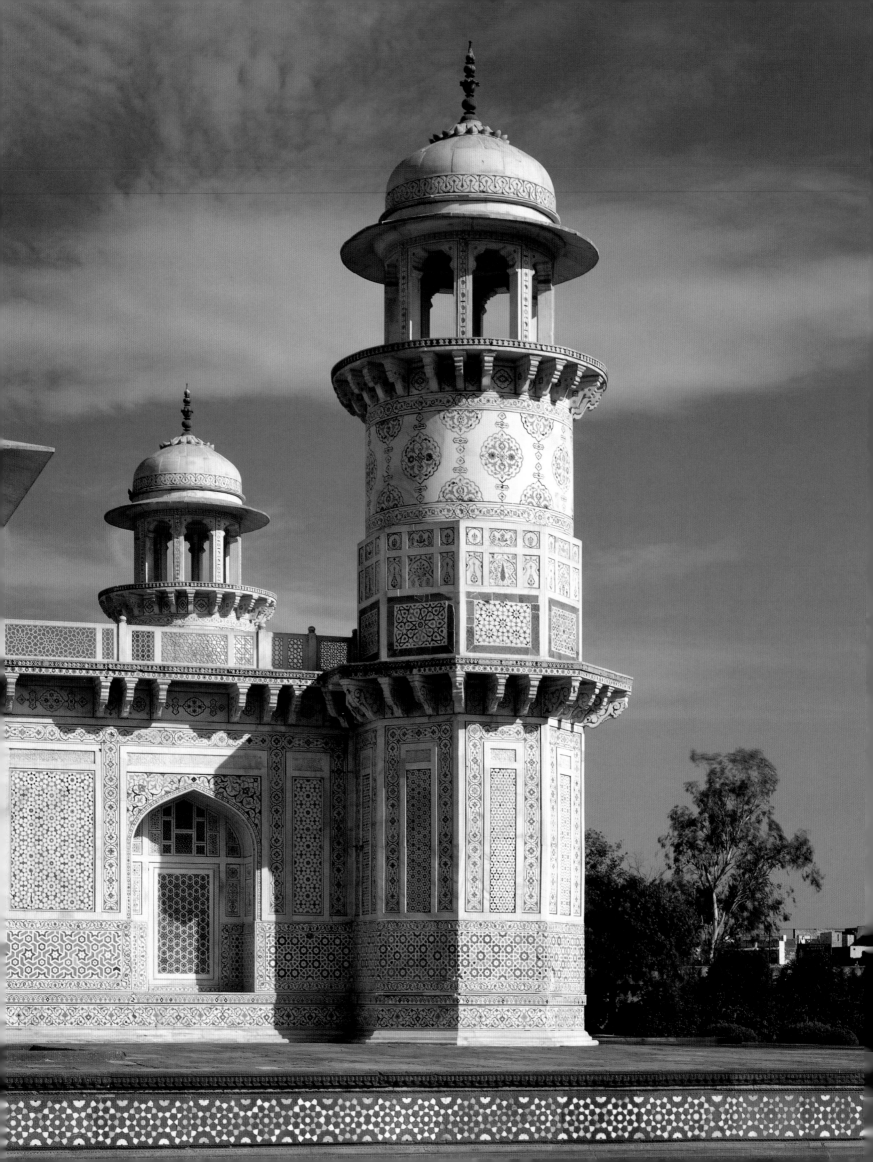

OPPOSITE

The white marble surfaces are covered with pietra dura inlay of exceptional quality. Each of the four minarets measures about 7 metres (23 feet) in diameter.

RIGHT

Each tomb stands in front of a latticework screen on the first floor. On the floor below are the actual graves.

BELOW

The view along the east bank of the Yamuna River from the two-storey western gateway.

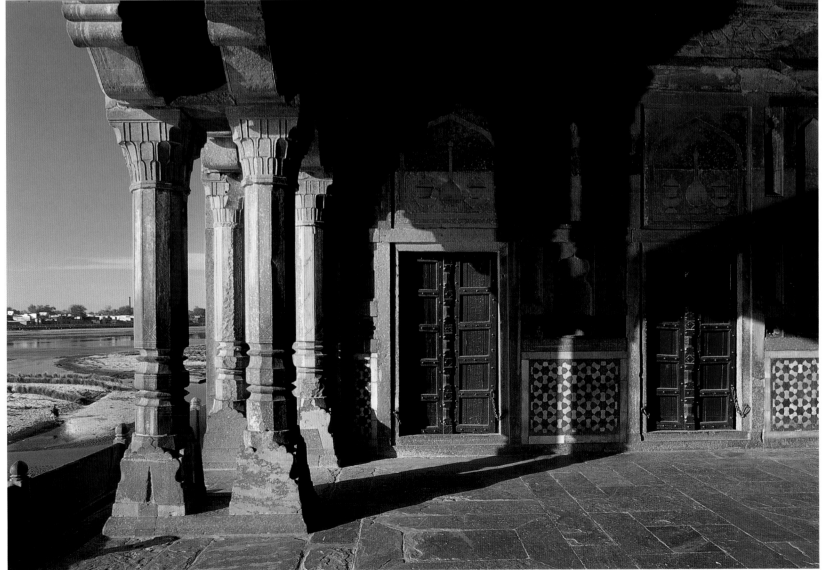

Santa Maria's two domes (the
smaller belonging to the choir)
seen from the roof of San Giorgio
Maggiore – one of the iconic images
of the city.

Santa Maria della Salute

VENICE ITALY

In 1630 plague came to Venice. To combat it, the Patriarch ordered displays of the Holy Sacrament, processions in honour of the Virgin and finally, with the Senate, the promise of a church dedicated to her if she would intercede with the Almighty. Santa Maria della Salute (*salute* means both 'health' and 'salvation') was the result of that bargain.

The commission was given to the young architect Baldassare Longhena (1598–1682), who, before he was thirty, had already built a palace on the Grand Canal and a cathedral at Chioggia. The site chosen was perhaps the most spectacular in the whole of Venice, at the tip of the western part of the city opposite the Piazza San Marco. Longhena took full advantage of the position by designing a large octagonal church: 'the dedication of this church to the Blessed Virgin made me think...of building the church in *forma rotonda*, that is in the shape of a crown'. Palladio had wanted to use a circular plan for his own plague church, Il Redentore, but the Venetian Senate had made him use a more conventional Latin-cross plan. This time, however, aesthetic perfection won over liturgical practice, and the Senate approved Longhena's circular plan.

And it is an ingenious plan. The main octagonal space functions as the nave, surrounded by an ambulatory. On one of the eight sides is the entrance, and opposite this an arch opens into a chancel (with transversal apsidal ends) and beyond that a rectangular choir. The other six arches of the main space lead into chapels each with its own altar. These altars incorporate frames that use variants of the Doric, Corinthian and Composite orders. In the management of these columns and pilasters we can see how Longhena learned much from Palladio, but the geometry of the plan is entirely his own, and his use of painting and sculpture goes beyond Palladio, even if not all of it was his own initiative.

On the outside Longhena stressed the entrance with a majestic triumphal arch, while each of the six chapels have square Classical bays with big thermal windows. The back elevation, of the choir, is almost as striking as the entrance, with a minor dome flanked by twin towers. The main dome, meanwhile, follows the Venetian tradition of a simple hemisphere covered in lead (unlike the ribbed masonry domes of other parts of Italy). Its enormous lantern and giant scrolls, on which stand statues of the Apostles, give clear volumetric distinction to its curvature, as well as being flamboyant, playful and self-consciously dramatic. The ensemble functions as a city landmark when seen from the sea, as much a *coup de théâtre* as an ex-voto to the Queen of Heaven.

The Salute occupied Longhena for the rest of his life, and was not completed until 1687, five years after his death. As a votive church, its main function was ceremonial, and to this day the end of the plague is celebrated every 1 November when the Patriarch's successor and officers of Venice cross the lagoon to the church on a bridge of boats.

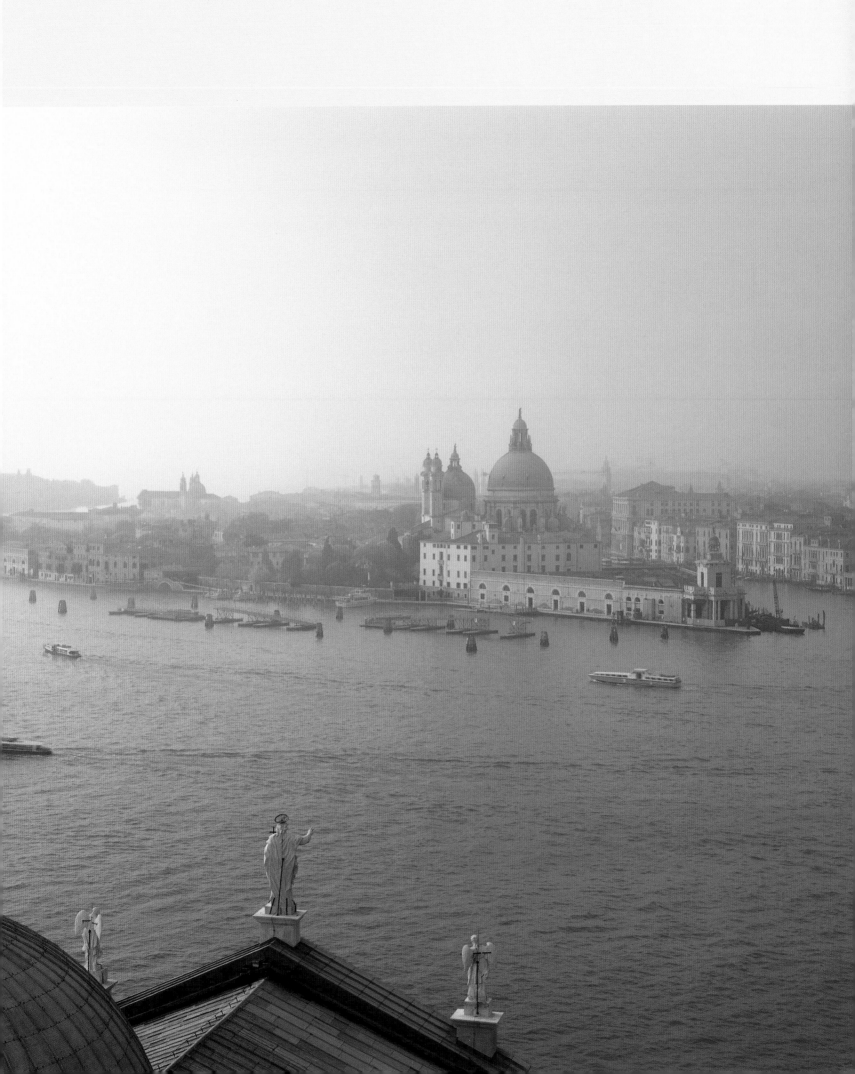

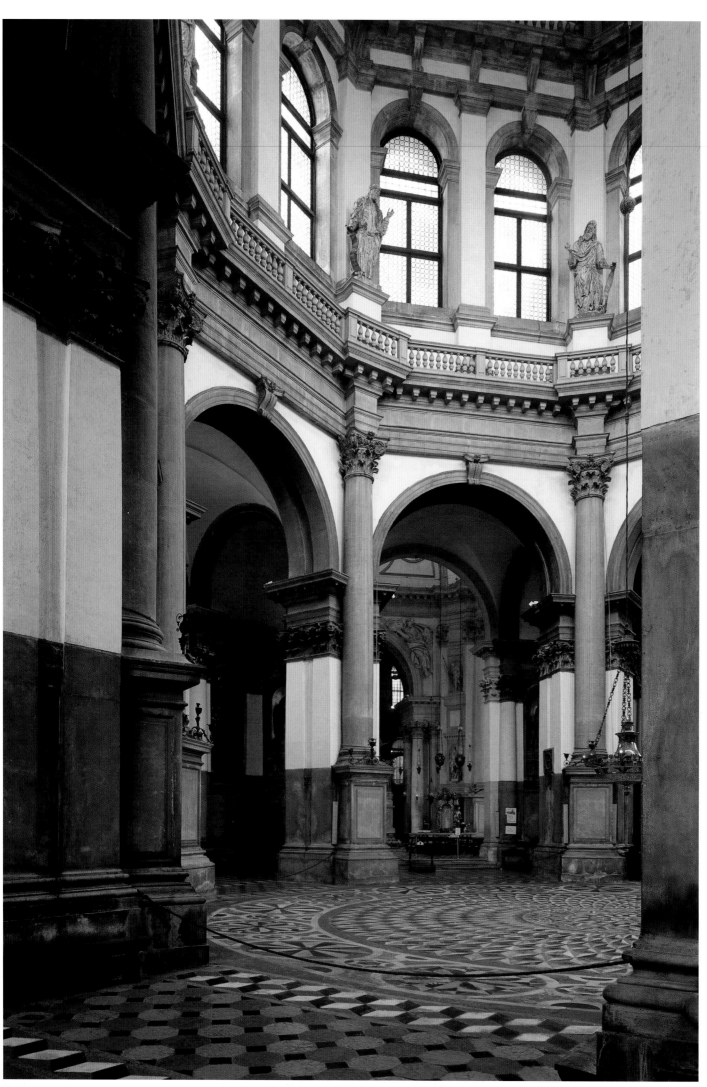

The octagonal nave, defined by piers and arches that create an outer arcade, recalls the classic Byzantine or Carolingian design, while also being an adaptation of San Giorgio Maggiore.

The entrance, seen here on the right, recalls a Classical triumphal arch with its massive pediment and 'giant order' Composite columns. To the left of this we see the ends of two of the six chapels, each with a high 'thermal' window. This type of window was found frequently in Roman public baths (*thermae*), hence its name. The dome above is buttressed by twelve heavy scrolls, which also add a touch of flamboyant drama.

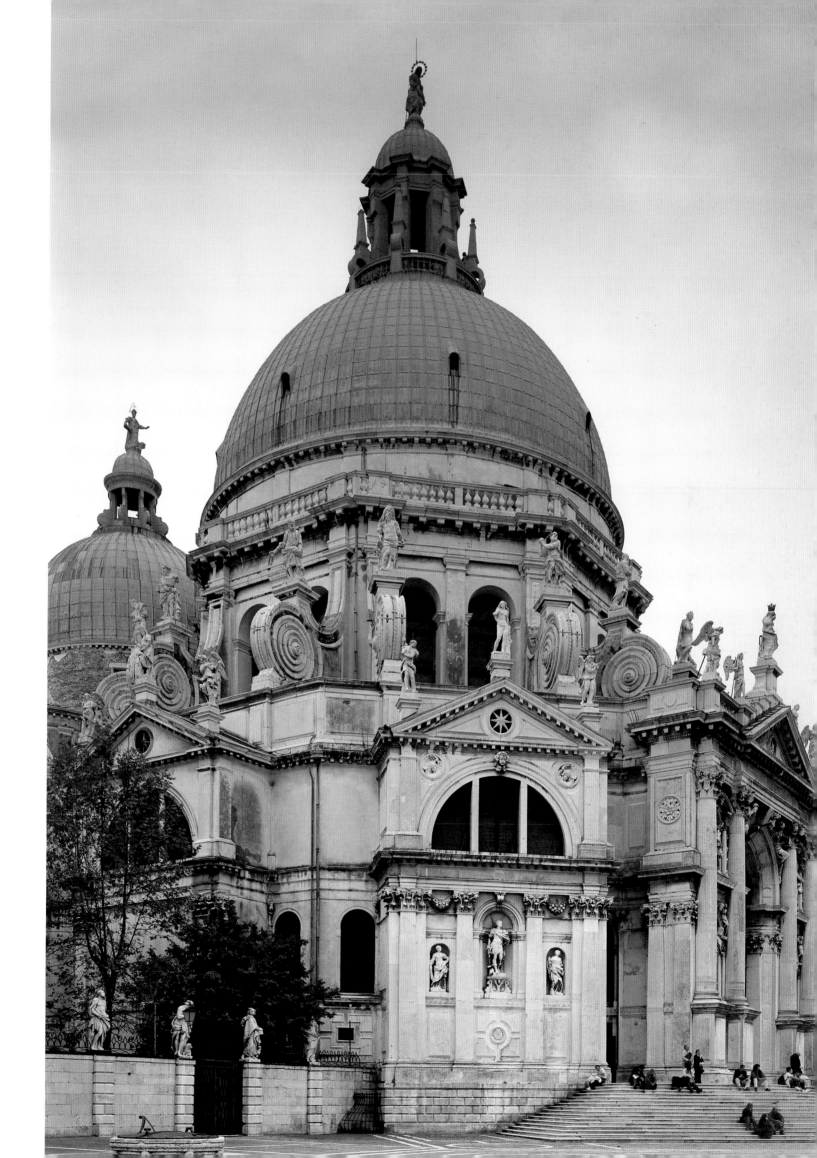

Taj Mahal

AGRA INDIA

When his favourite wife died in 1631, shortly after giving birth to their fourteenth child, the inconsolable Mughal emperor Shah Jahan determined that her mausoleum would be the most spectacular ever built. Today it is generally known by a corruption of the queen's title, Mumtaz Mahal ('Chosen of the Palace'), into 'Crown Palace' - Taj Mahal.

The great mausoleum is only one element of a much larger complex of landscaped gardens and buildings designed by the architects Makramat Khan and Abd al-Karim. These are arranged according to a series of geometrically related grids that harmonize the entire composition. Instead of being placed at the centre of a garden, in the traditional *charbagh* formation, the mausoleum stands at one end overlooking the river. It is flanked to the left by a red sandstone mosque surmounted by white marble domes, and to the right by an identical building referred to in contemporary texts as a guesthouse. The garden in front is divided by two wide waterways that meet at a large central pool.

The initial impact of the mausoleum comes from its sheer size: each of the four façades is 56 metres (186 feet) across, and the height from the bottom of the podium to the top of the finial is over 73 metres (240 feet). Gradually, however, the viewer becomes aware of more subtle relationships between the different elements of the composition. For example, excluding the finial and podium, the height of the tomb equals the length of the sides, so that its extremities define an invisible cube. The corners are chamfered, with the face of each chamfer equal to the side panels of the four façades - which is to say that between each of the four double-storey iwans there are three equal faces, drawing the eye around the monument. And the openings in these panels mirror the shape of the central iwans, which in turn break above the façade. Opposite each chamfered corner stands a minaret, connected to the tomb by a common white-marble plinth almost six metres (20 feet) high. At the summit rises the great dome, which unlike most Mughal architecture is not obscured by the iwans below but rises triumphantly above them.

Apart from these proportional relationships the beauty of the building is due to its superlative materials. From a distance the Taj looks white, but on closer inspection a vast range of colours appear in the inlay work covering the structure. Lapis lazuli, chalcedony, agate, coral, jasper, onyx, turquoise and amethyst are all worked into thousands of exquisite floral patterns that continue the paradisiacal imagery of the tomb. A single black Qur'anic inscription runs around the border of each iwan, telling of the Day of Judgment, divine mercy and the paradise promised to the faithful.

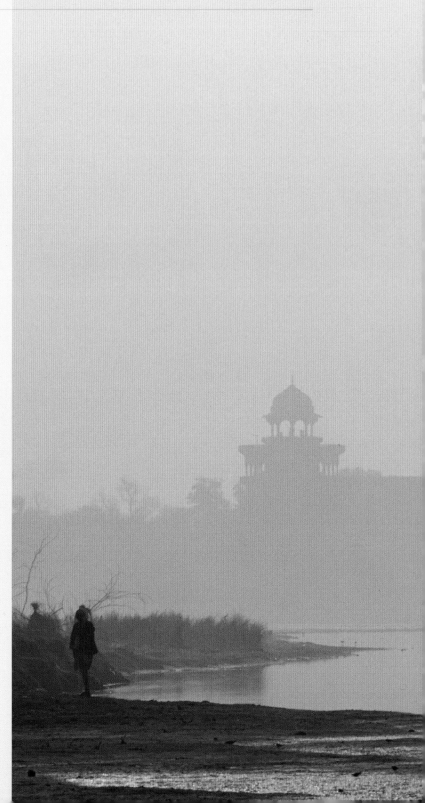

The Taj Mahal seen at dawn from further along the Yamuna River. Two architects, Makramat Khan and Abd al-Karim, supervised the project.

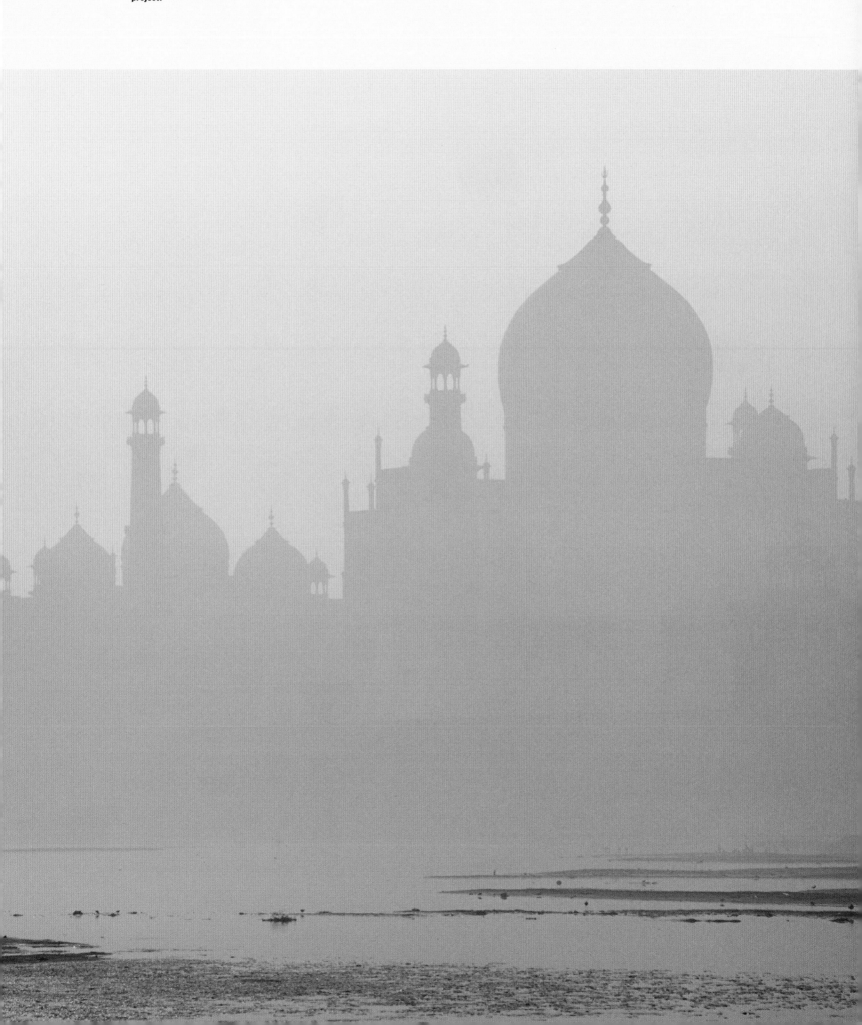

BELOW

**The mausoleum seen from across the
Yamuna River. The superb quality marble
was quarried at Makrana in Rajasthan.**

OPPOSITE

**Visitors swarm towards the entrance
iwan, which is decorated with calligraphy
of Qur'anic verse.**

PAGES 244-245

**The main axial entrance to the Taj Mahal
seen from across the central waterway.
The building and gardens formed part of
a conscious attempt to evoke Paradise.**

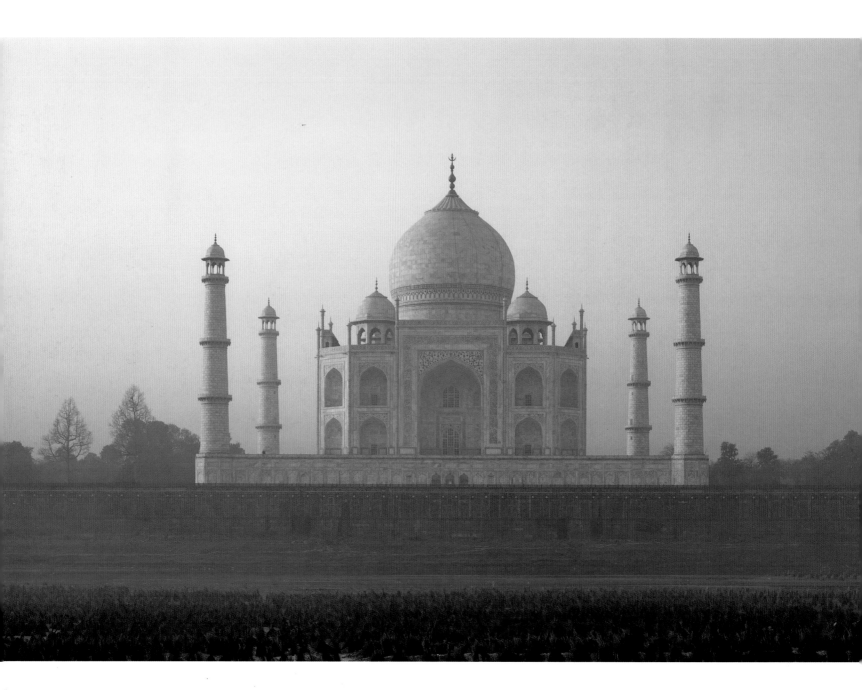

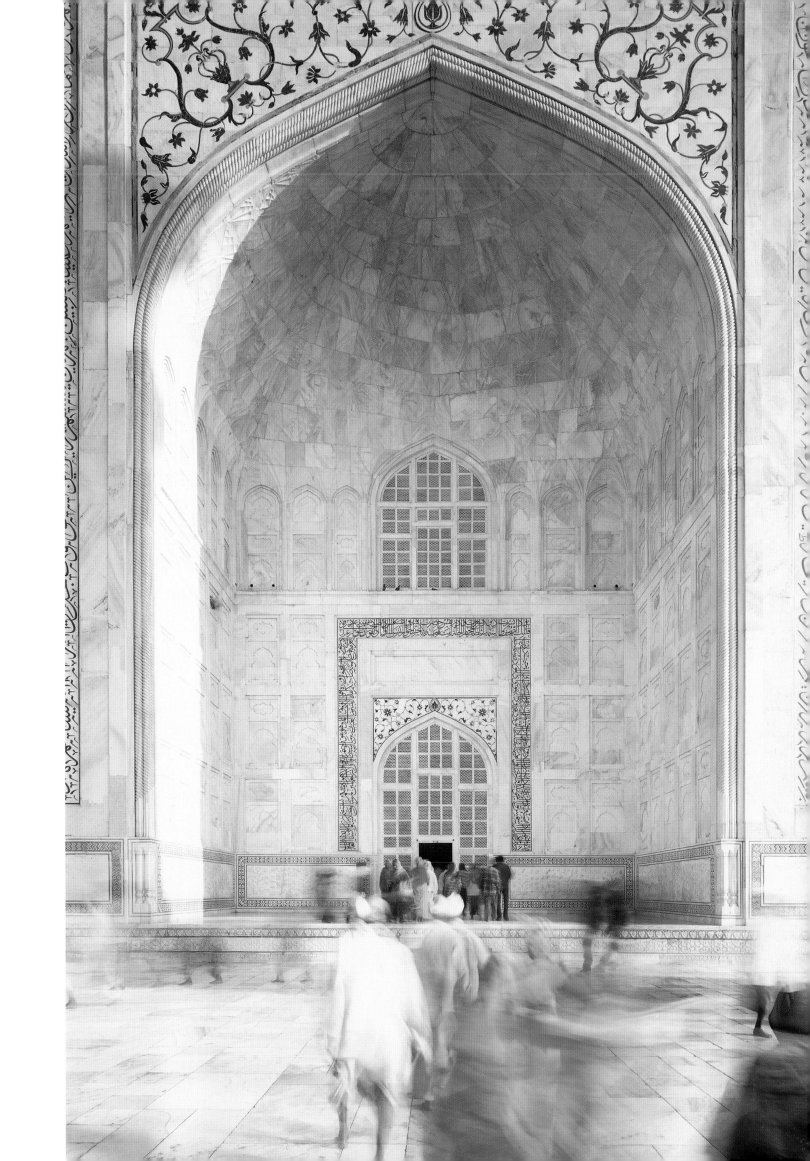

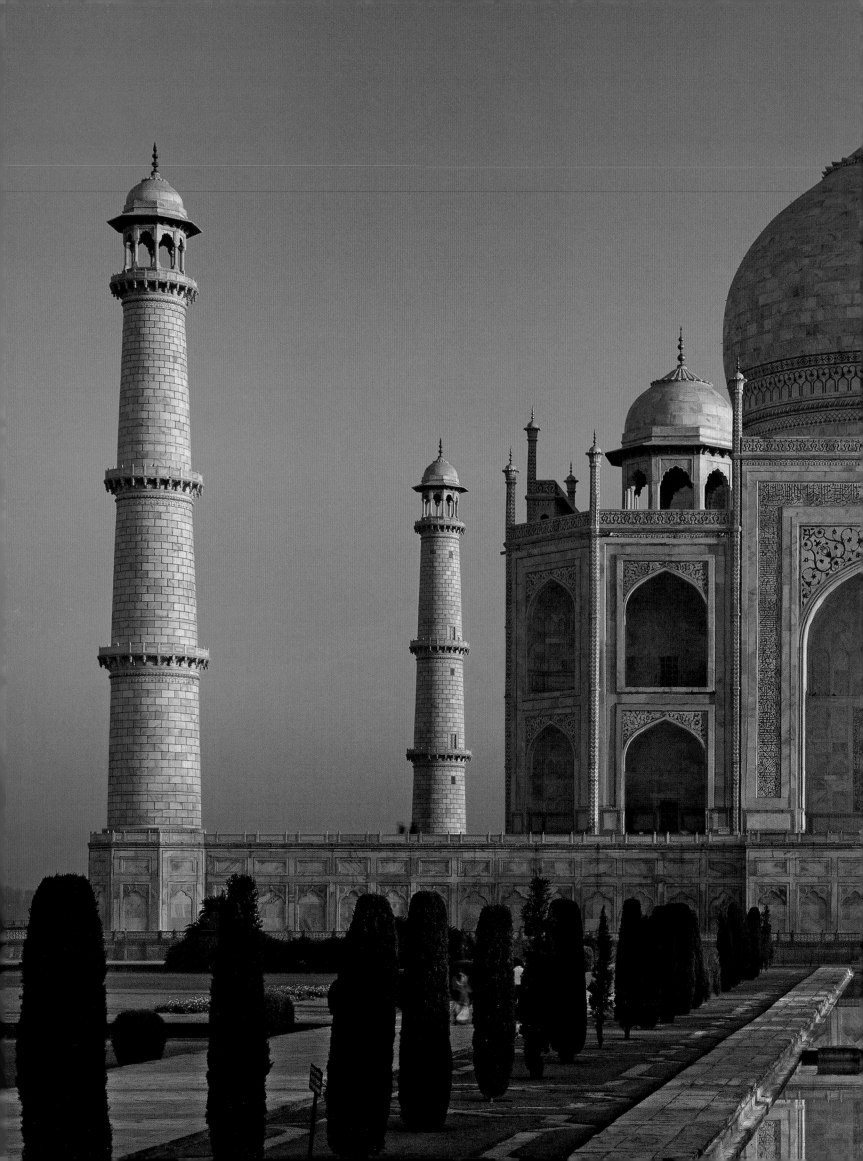

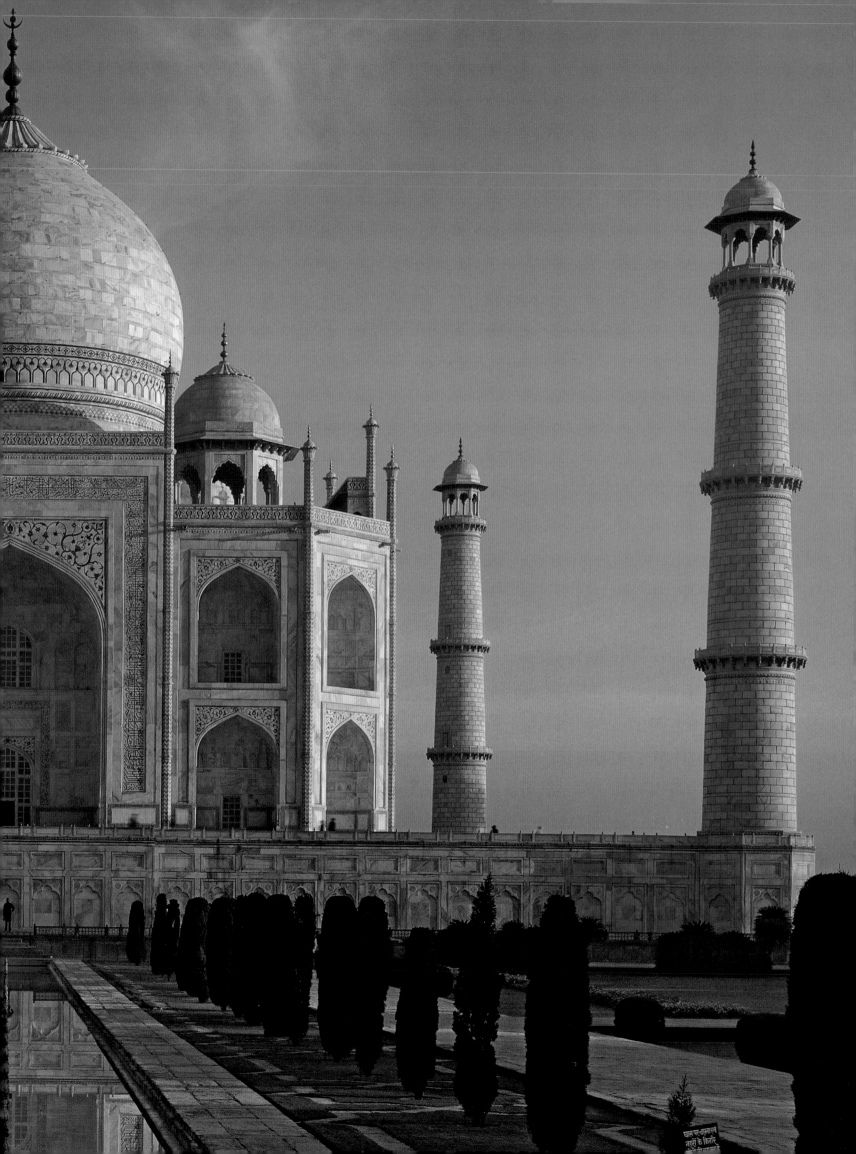

San Carlo alle Quattro Fontane

ROME ITALY

San Carlo alle Quattro Fontane, popularly known by the diminutive 'San Carlino', is one of the smallest buildings in this book, and yet perhaps the most full of ideas. It stands on a busy crossroads in Rome, each corner of which has a fountain, and was built for the Barefoot Trinitarian order, whose mission was the ransoming of prisoners enslaved by the Turks.

Its creator, Francesco Borromini, was the most inventive of all Baroque architects. The chapel of San Carlo, begun in 1634, was his first independent commission, and the site was both awkward and small. He began with an unconventional plan – essentially a diamond shape made from two equilateral triangles. However, this geometry was then hidden by four concave walls, within which he created what are essentially huge niches or recesses. Articulating these walls are three-quarter columns, which in turn support a very pared down entablature. The heads of the niches touch a cornice in the shape of an oval (a very Baroque shape, at odds with the perfect circle of Classical architecture), and upon this cornice rests an oval dome. The ceiling of the dome is perhaps the most striking part of the ensemble, being split into a pattern of octagons, hexagons and crosses, which fit together like the pieces of a puzzle. The closer to the summit these shapes get, the smaller they become, making the dome appear higher and deeper than it actually is. At its apex is an oval lantern that admits light and at the top of the lantern a triangle, symbol of the Trinity (for the Trinitarians); enclosed within this triangle is a dove. The whole is full of movement in every direction, from the billowing walls through to the receding dome.

Borromini also designed the accommodation for the monks and a small cloister on the same site. For the cloister he paired Tuscan columns to support six arches that run a ring around the space, two on each of the long sides and one at either end, creating a rectangle with chamfered corners. The Procurator-General of the Trinitarians was delighted with the result: 'Many times, looking down from the *tribuna* or the lattice-screen of the church, we have seen visitors acting just like this, unable either to tear themselves away or to say a word for a long time…. It seems to me that this work has in it something of the imitation of the Divine.'

ABOVE
The double columns of the corners of the cloister turn a rectangle into an octagon. Even here they are not joined by a straight line but by a dynamic curve.

OPPSOSITE
Diminishing, interlocking geometric shapes are used to give the impression that the dome is higher than it actually is.

PAGE 248
In 1665 Borromini returned to design the façade, but died before it was completed. Only the lower part, with its alternating concave-convex-concave rhythm, is his. The upper part with the curious oval (which was designed for a painting) was finished later by his nephew.

PAGE 249
It is difficult at a glance to group visually the 16 columns that ring the perimeter of the chapel, not least because of the billowing cornice above them. The pediments above the cornice are far from orthodox.

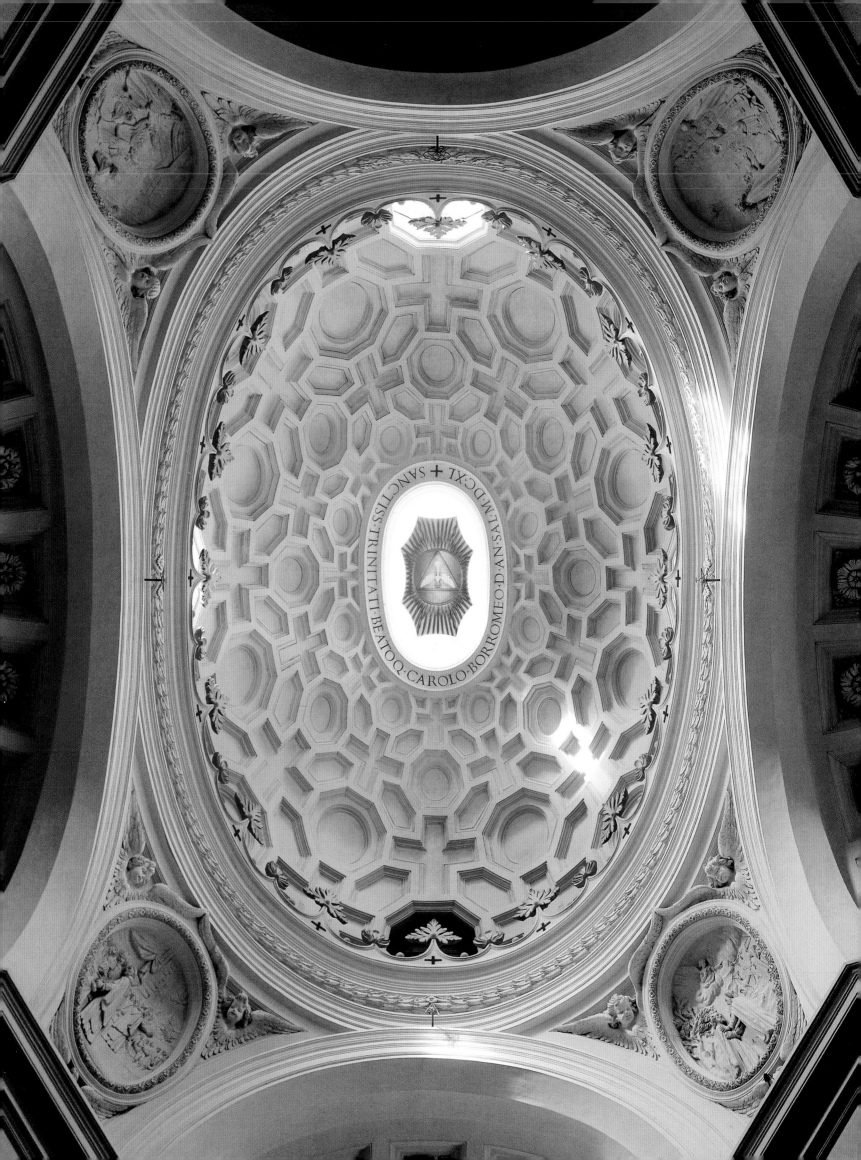

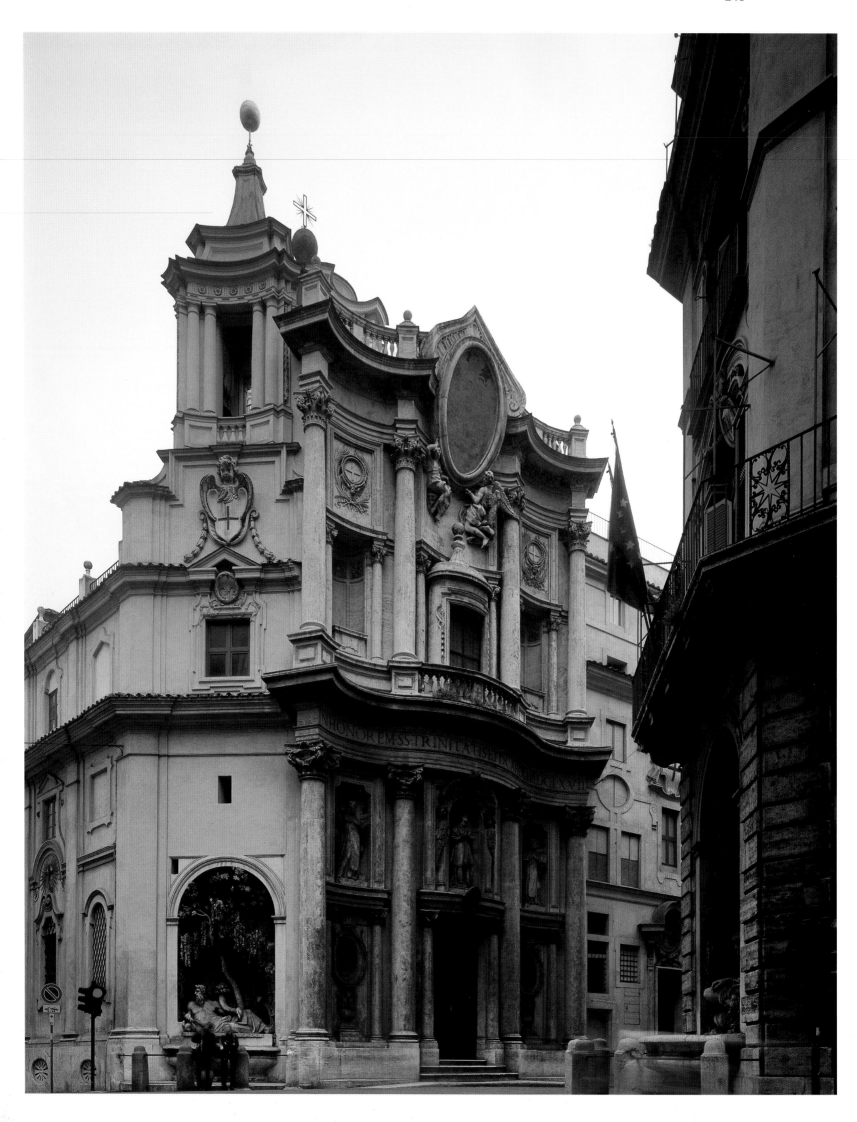

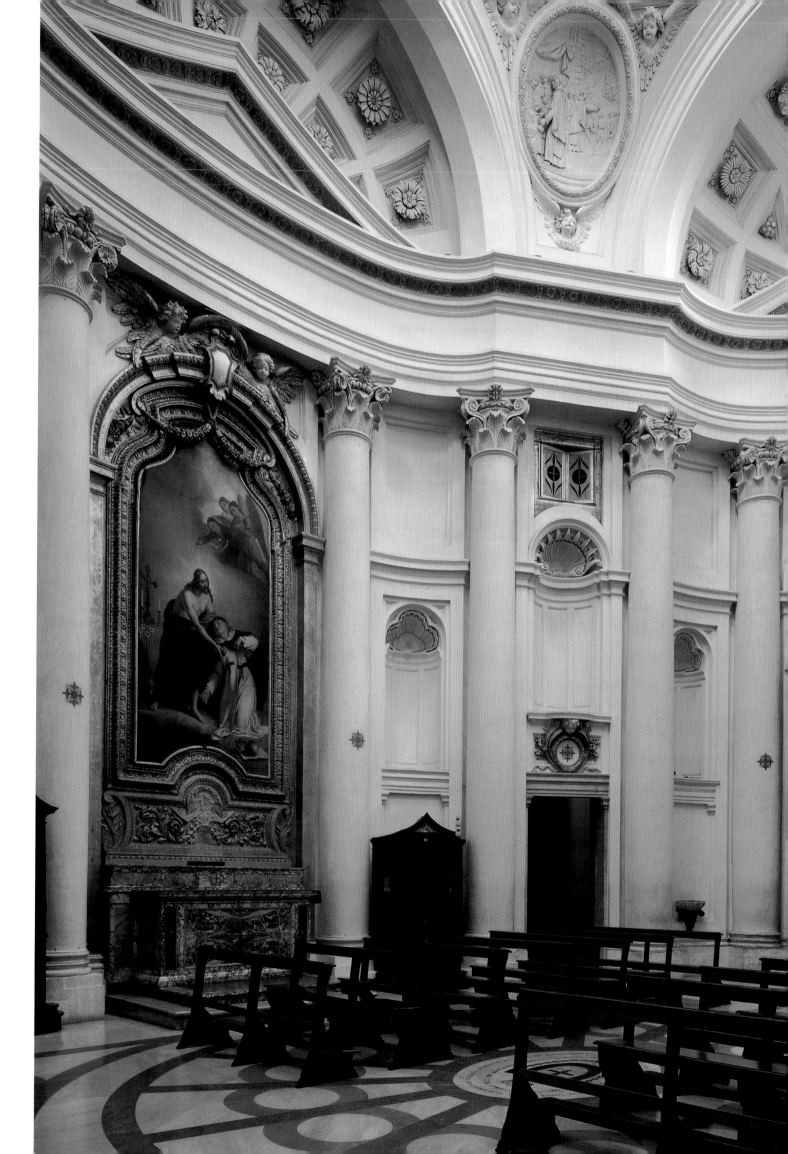

Jama Masjid

DELHI INDIA

In 1639 the Mughal emperor Shah Jahan decided to create a new urban centre to the north of the existing capital around the Red Fort in Agra. This new development, called Shahjahanabad (and today known as Old Delhi), needed a suitably grand mosque, so in 1650 the emperor ordered the construction of a 'Masjid-i-Jahan Numa' ('World-Displaying Mosque'), which today it is best known as the Jama Masjid (Friday Mosque). When it was finished in 1656 it was the biggest mosque on the subcontinent.

The mosque complex is built upon a rock outcrop and is approached by three sets of steep steps on the north, south and east sides. Inside the walls is a huge enclosed courtyard measuring 92 by 100 metres (302 by 328 feet), which is edged by a roofed arcade or *chajja*. To the west of this space, which can accommodate thousands of worshippers, stands the prayer chamber. Its façade, which is 27 metres (89 feet) tall and 61 metres (200 feet) wide, contains eleven cusped arches, the largest fitted within the central iwan, which is the focus of prayer in the square. Two tall minarets are integrated into the design of this façade and are visually mirrored by smaller corner turrets on either side of the iwan. Contemporary architects clearly considered this design to be a success, since it inspired a number of imitations – indeed, it soon became the standard Mughal form. Three bulbous domes appear above the façade, their undulating shape emphasized by thin black vertical stripes. This emphasis on line and colour, rather than mass and volume, is a characteristic of later Mughal architecture.

The smaller domes on either side of the central dome mark the entrances to the prayer chamber. Above each entrance the calligrapher Nur Allah Ahmad added a lengthy Persian inscription in black stone praising the building and its creator, Shah Jahan. In fact, the emperor stayed in the mosque while it was being built. One reference to this dual function (as a place of worship and as a temporary palace) may be seen in the columns that appear inside the prayer chamber and around the perimeter of the courtyard supporting the *chajja*, which are of a design previously used exclusively on imperial buildings. As if to reinforce this message, one of the mosque's inscriptions tells us that Shah Jajan is the 'strengthener of the pillars of state...[and] the promulgator of...faith.'

ABOVE

Men meet and talk under the *chajja* that runs around the periphery of the huge courtyard.

OPPOSITE

Panels above the cusped entrance arches carry inlaid inscriptions in Persian praising the building and its creator Shah Jahan.

PAGES 252-253

The great innovation of the design of the façade was to integrate the minarets into the screen and then echo them in corner turrets on either side of the central iwan.

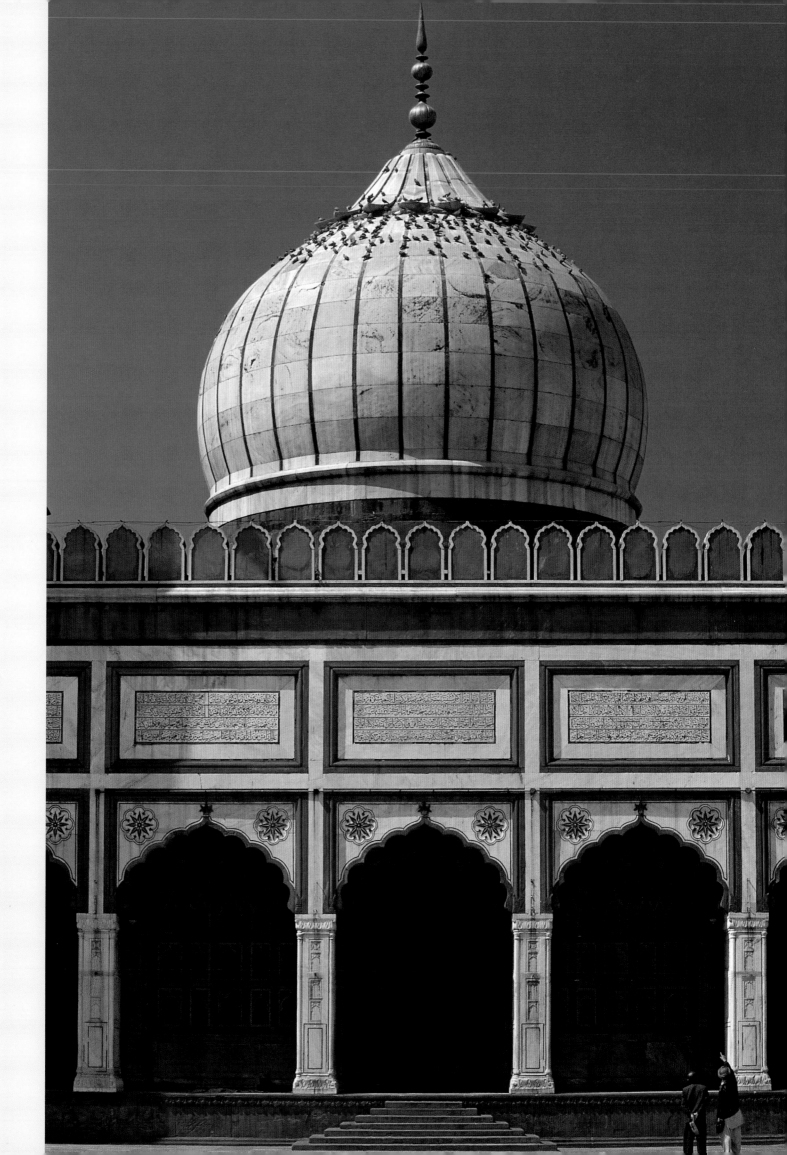

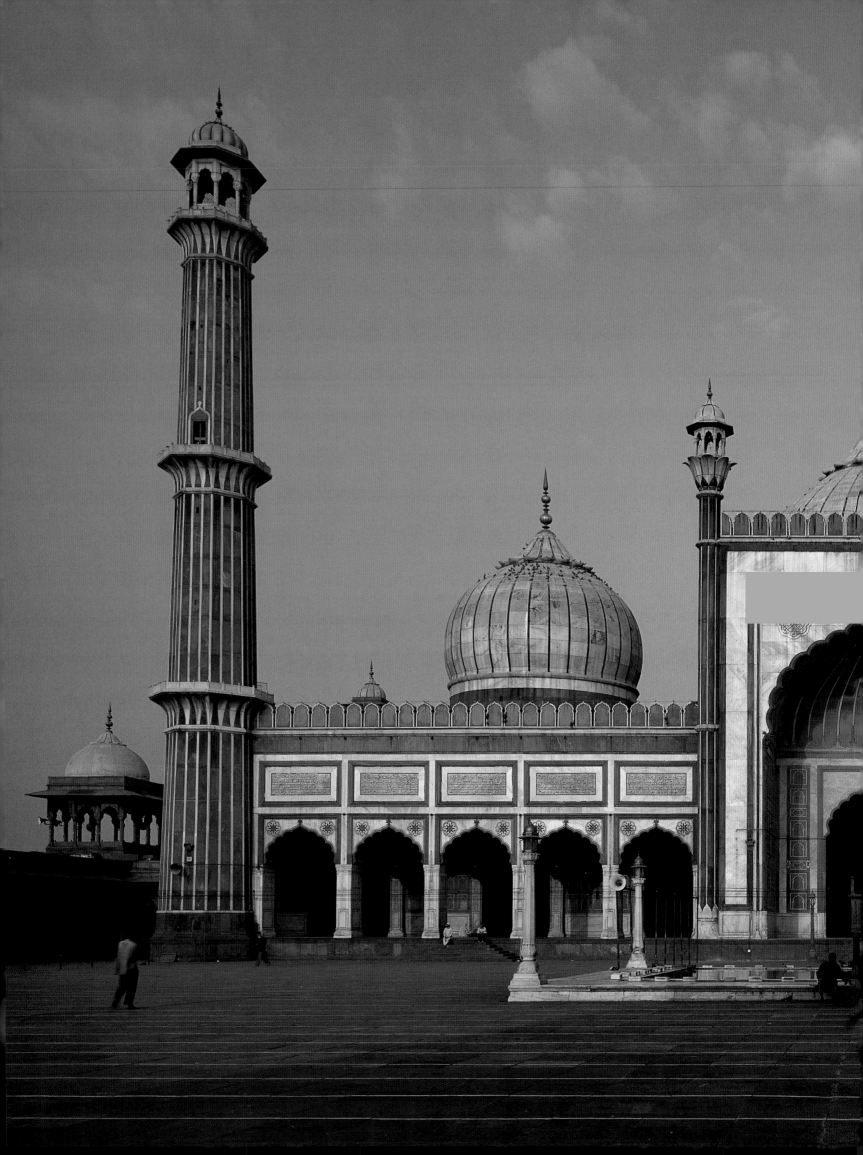

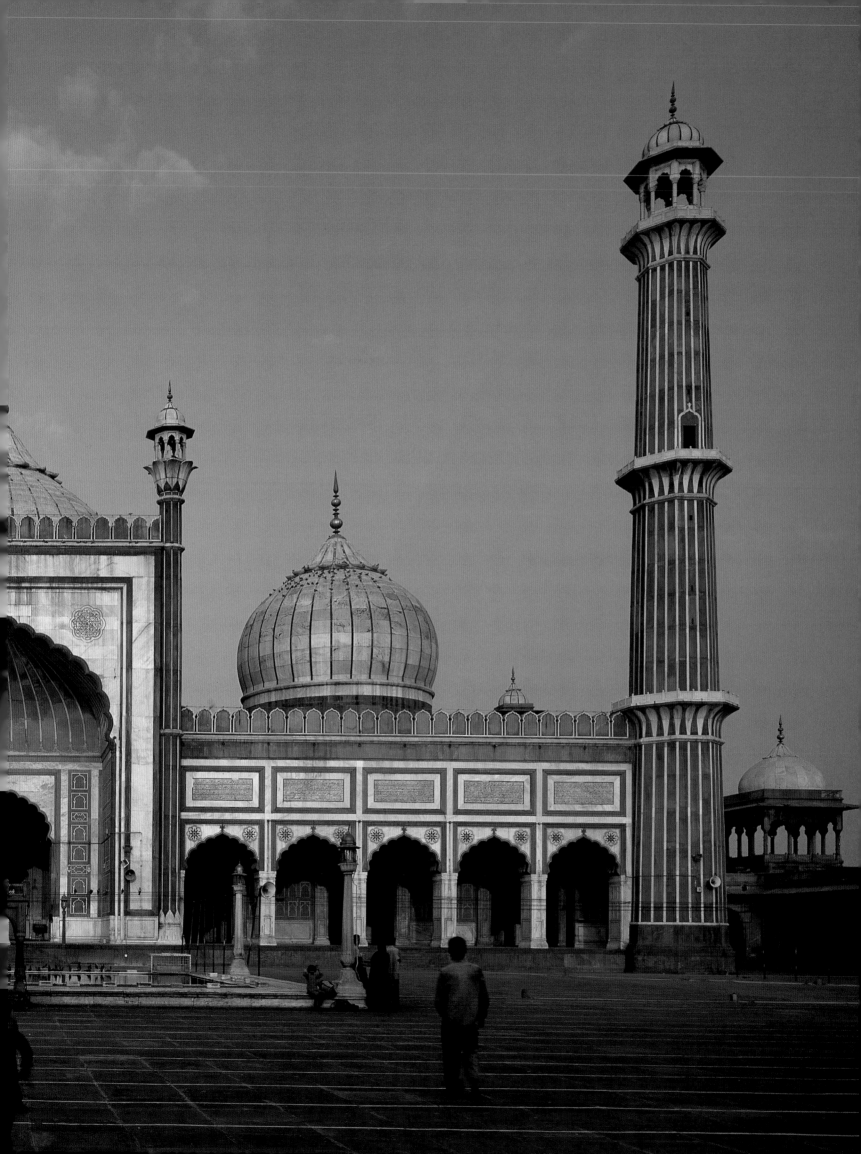

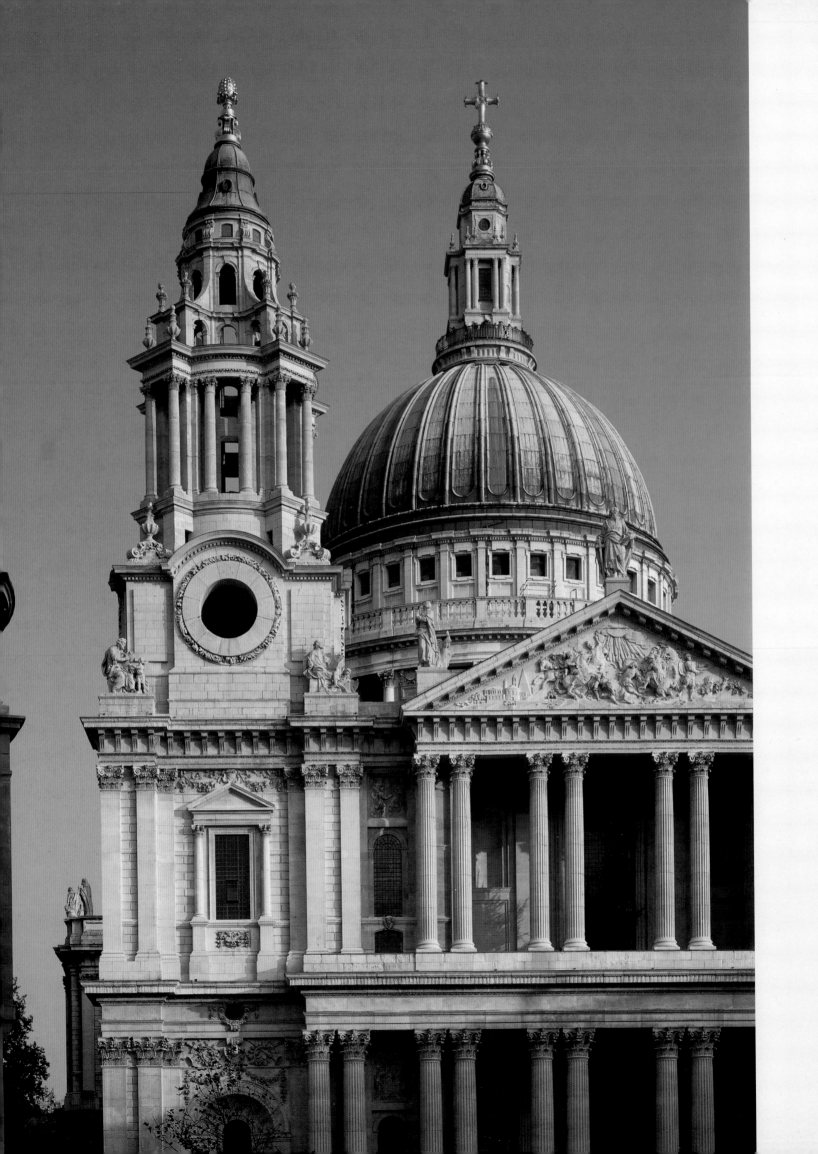

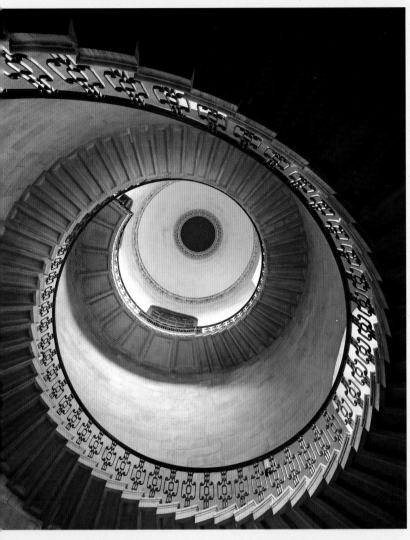

ABOVE

Each step in the Dean's staircase in the south-west tower supports the one above it. The wrought iron balustrades are by Jean Tijou.

OPPOSITE

The west front. Wren's original design had used a colossal order to support the pediment, as at St Peter's in Rome, but in the end two storeys of columns were used. The horizontality of the Classical entablature is counterpoised by the verticality of the Baroque north-west tower and the lantern of the dome behind.

PAGE 256

The cathedral benefited enormously from the quality of craftsmen who worked on its fabric. The superb choir stalls were designed by Wren and built by the great wood carver Grinling Gibbons. The mosaics on spandrels and ceiling were added at the end of the 19th century.

PAGE 257

The view along the nave, across the area underneath the dome and into the choir beyond. The nave vault is made up of a series of shallow 'saucer' domes.

St Paul's Cathedral

LONDON ENGLAND

Christopher Wren built St Paul's Cathedral as a replacement for the Romanesque-Gothic cathedral destroyed by the Great Fire of London of 1666. His initial proposal, based upon a Classical Greek-cross plan, proved too radical for the authorities, who insisted that Wren use a conventional Latin-cross plan with a long nave and aisles, transepts and long chancel (though they did accept the central dome). Wren complied, but buried this essentially Gothic layout beneath a tour-de-force of Baroque illusionism.

Wren disguised the Latin-cross plan by opening up the west end into a wide chamber and leaving the nave and choir with the same number of bays. This gave the plan symmetry and placed additional visual emphasis upon his great dome. The transepts were shortened so that they appeared as broad projections of the whole mass rather than Gothic 'arms'. They also provide additional cross supports for the main arches that carry the dome, thus combining structural and visual ingenuity.

The vault of the nave, meanwhile, was supported by a series of flying buttresses. Wren hid these fundamentally Gothic features behind a screen wall that encircled the whole of the top part of the cathedral. Visually, this provides a satisfying base for the drum of the dome. In addition, the single height of the nave inside becomes two storeys outside; the upper 'storey' appears to be filled with windows, though they are in fact aedicules inspired by the Renaissance architect Serlio; the actual clearstorey windows are hidden behind the screen wall. Wren also used coupled pilasters to further reduce the longitudinal emphasis. The result is a single great mass with a complex elevation whose dominant lines are vertical.

The same lack of relation between interior and exterior can be seen in the famous dome. Until the 20th century it dominated the London skyline, yet inside it seems low and intimate. Wren, like Michelangelo at St Peter's, used two domes, with a brick cone running in between them, which supports the lantern (thus allowing the outermost dome to be constructed from wood sheathed in lead). Stylistically, this lantern links the Classical dome and the Baroque western towers, which play with convex and concave forms.

By combining many different requirements and elements, Wren made a building as rich and diverse as any English medieval cathedral within the space of a single lifetime.

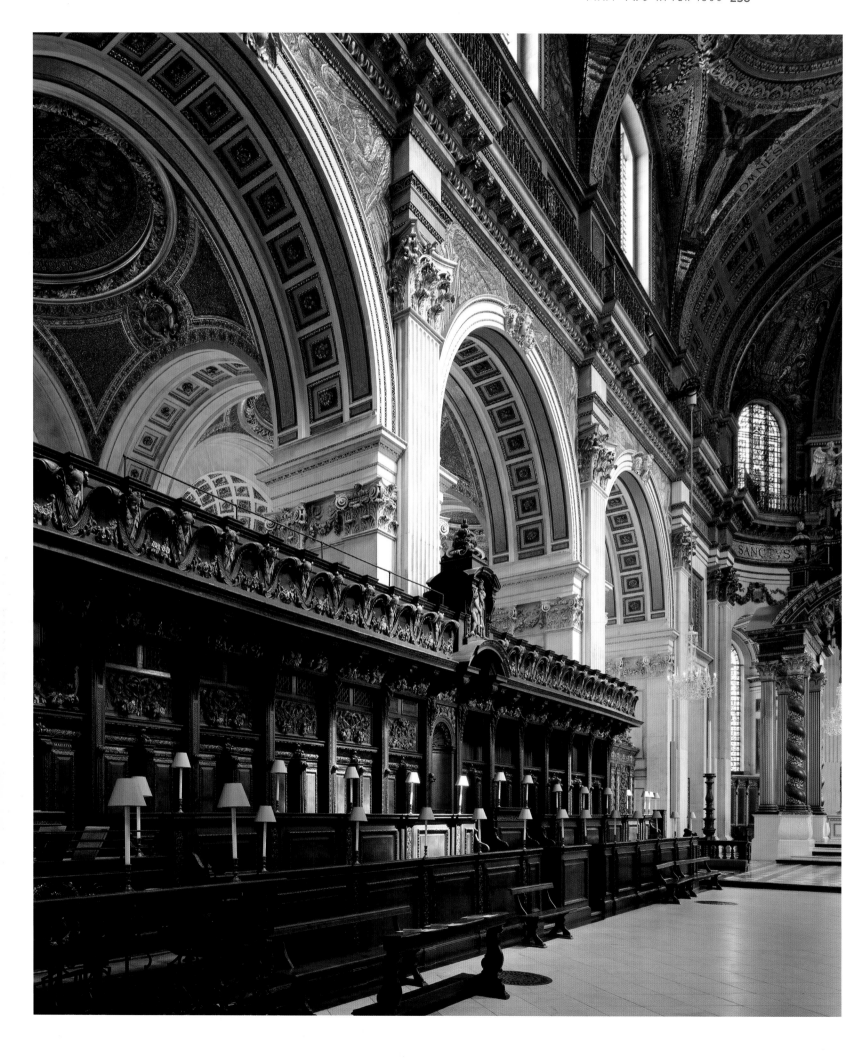

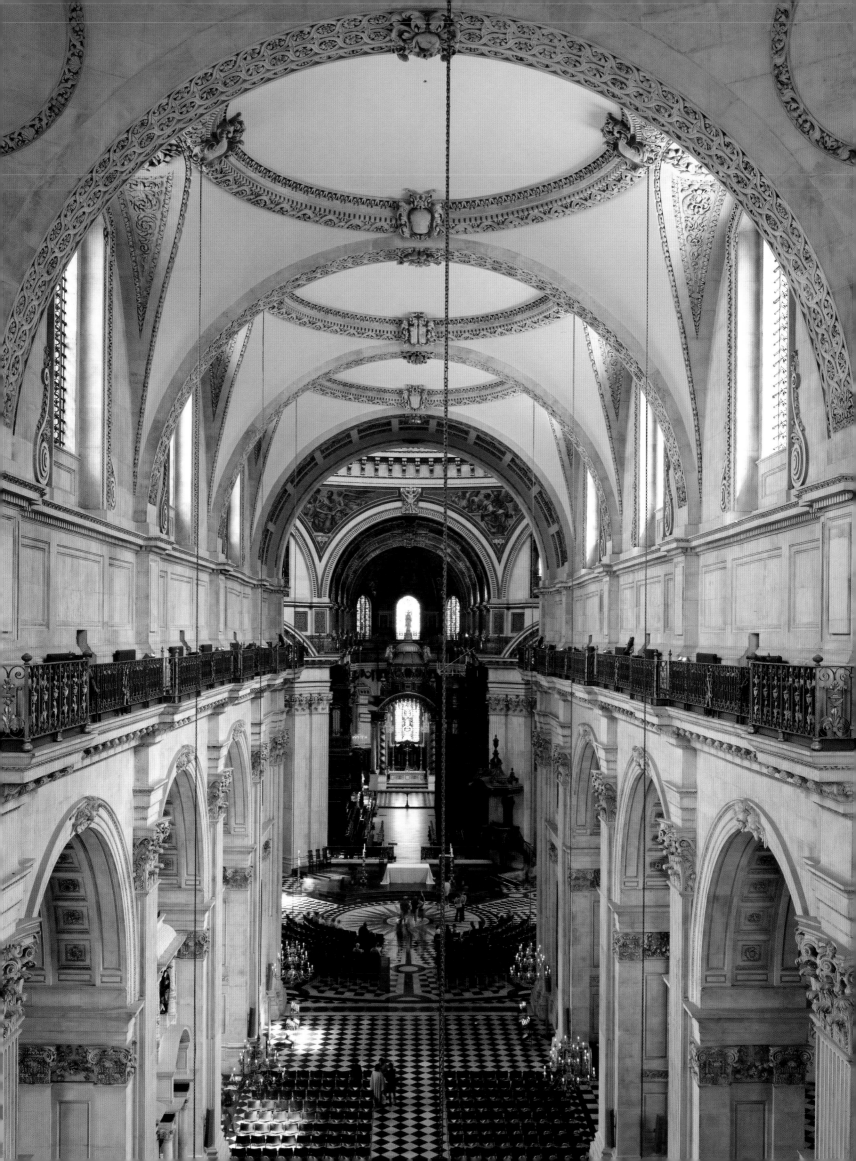

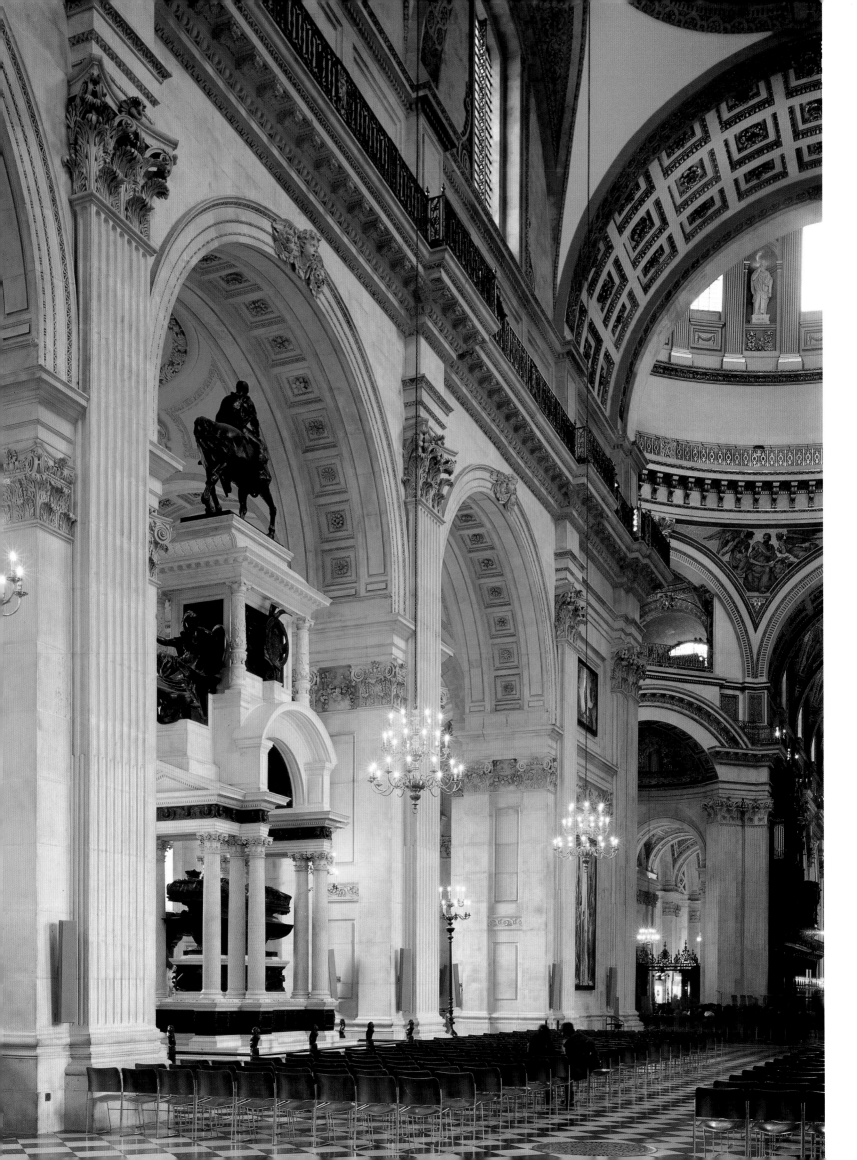

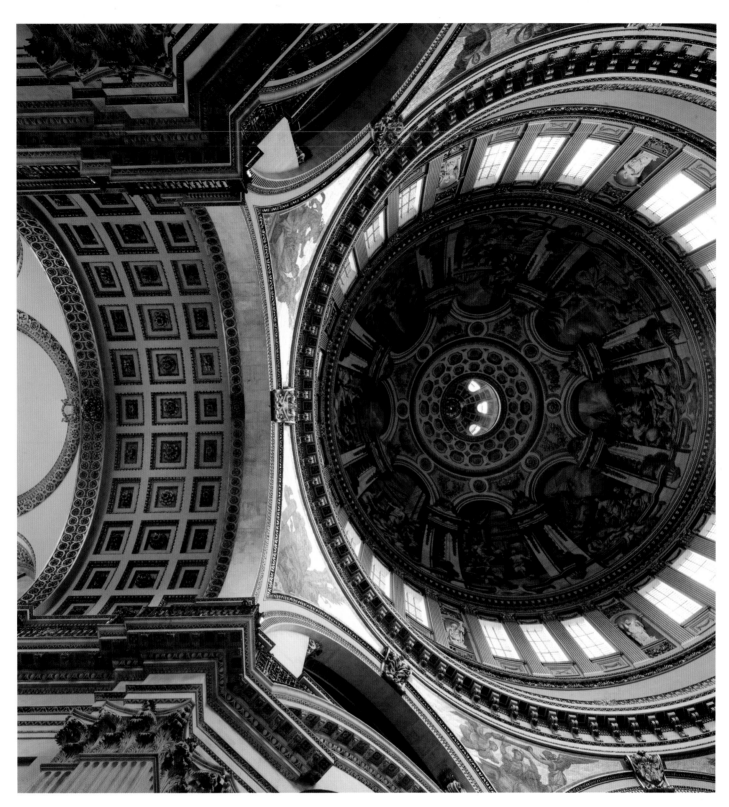

ABOVE

**The inside of the dome showing
eight scenes from the life of St
Paul, painted by James Thornhill
between 1715 and 1721. The
famous Whispering Gallery runs
around the inside of the drum.**

OPPOSITE

**The nave facing towards
the dome.**

Chatsworth House

DERBYSHIRE ENGLAND

Chatsworth House, the seat of the Duke of Devonshire, has been continuously occupied since at least the 16th century. The first Chatsworth was a square house with four wings and a courtyard in the middle. Over a period of nearly two hundred years it was rebuilt in stages, and it is this piecemeal reconstruction of the original Elizabethan house that makes Chatsworth unique. In the process, it gave new currency to the old Elizabethan emphasis on a building's plan, countering the new Classical obsession with formal elevations, while its four façades exhibit some of the most innovative work of the English Baroque.

The rebuilding began in 1687, when the first Duke replaced the south front with a building by William Talman. The new façade was nothing short of revolutionary, with Talman raising the height of the parapet wall to hide the roofline and doing away entirely with the attic storey, a previously ubiquitous feature of Classical domestic architecture. This left just two tall storeys, sitting on a very heavy base and supporting a substantial entablature. In the end bays giant Ionic pilasters rise the height of the façade, while the middle six bays have exaggerated keystones. The closer spacing of the windows in the centre intensifies the drama, as does the unusual choice of an even number of bays (twelve in all). Unfortunately the original curved staircases, which would have drawn the eye to the centre, were replaced by James Wyatt with quadrants that block the façade.

Wyatt also partially altered the later east façade that had been added by Talman in 1688. This wing contained the two-storey painted hall and grand staircase on the site of the Elizabethan Great Hall. The ceiling and walls of the hall were decorated in the 1690s by Laguerre and Ricard with scenes from the life of Julius Caesar. Laguerre and Ricard also decorated the walls of the chapel with scenes from the life of Christ and the ceiling with his Ascension. Samuel Watson completed the marble, black stone and alabaster altarpiece to a design by Gabriel Caius Cibber, who also worked at St Paul's Cathedral. Cibber also added the statues. The paintings on either side of the altarpiece were completed by Laguerre, while Antonio Verrio painted the canvas of the Doubting Thomas over the altar.

A little later, in 1700-1703, it was the turn of the west front, but the Duke had quarrelled with Talman (who seems to have been a difficult man) and the new architect is not definitely known (though most likely it was Thomas Archer). This handsome front has a wide pediment on four columns, flanked by giant pilasters. Finally, Archer added a new north wing between 1705-7. Many later alterations were made by Jeffry Wyatville, the nephew of Wyatt, though rarely for the better.

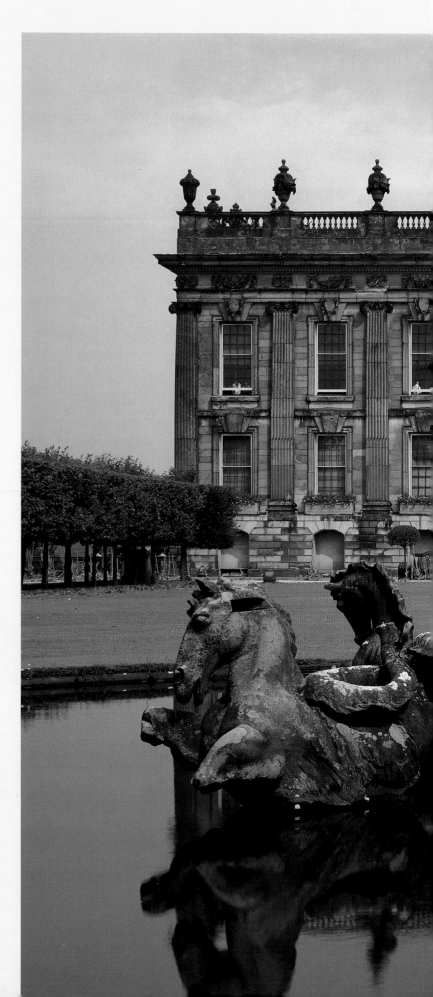

The revolutionary south façade
by William Talman.

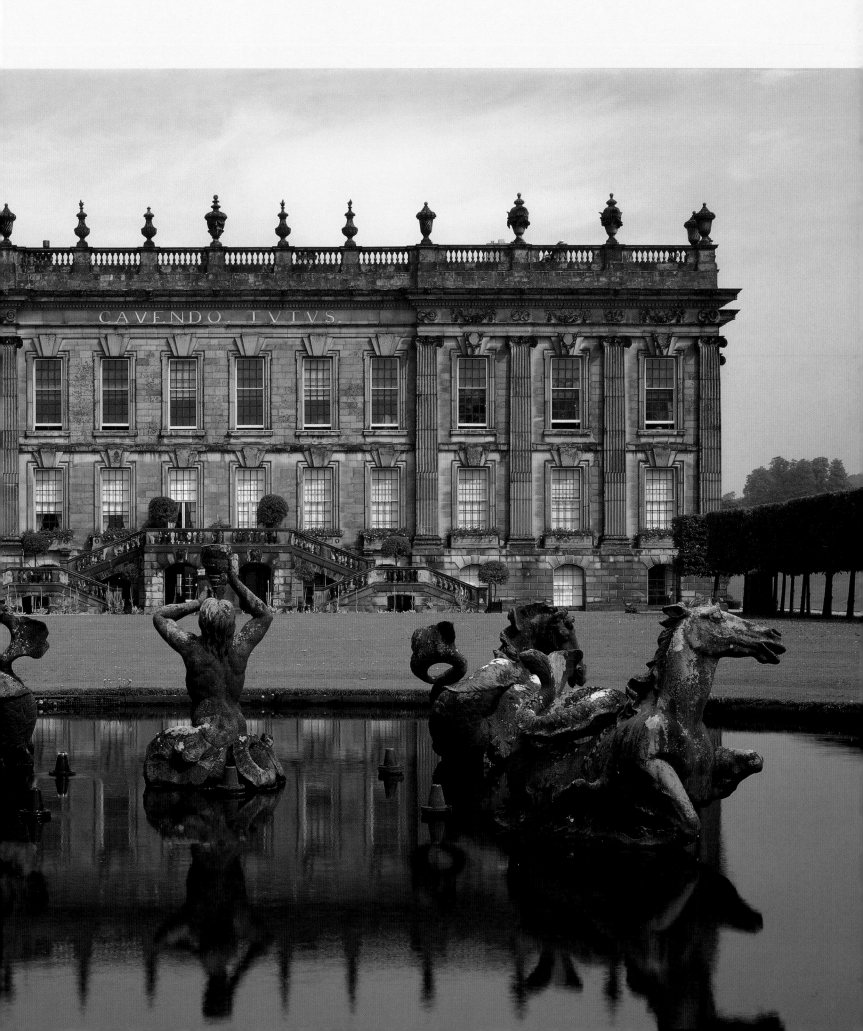

CAVENDO. TVTVS.

OPPOSITE

The sculpture gallery
was added during further
remodelling of the house
in the 19th century.

RIGHT

The Chapel, the most
lavish space in the house
of Talman's period, is
panelled with limewood
carving in the manner of
Grinling Gibbons and has
a magnificent Baroque
marble reredos designed
by Caius Gabriel Cibber.

PAGE 264

The Painted Hall, on
the site of the earliest
Elizabethan hall, was
painted by Louis Laguerre
with scenes from the
life of Julius Caesar.
Beneath the Great Stair
is a grotto containing a
French sculpture of Diana
of about 1600. The stairs
and gallery were added in
1911–12.

PAGE 265

The Dining Room.

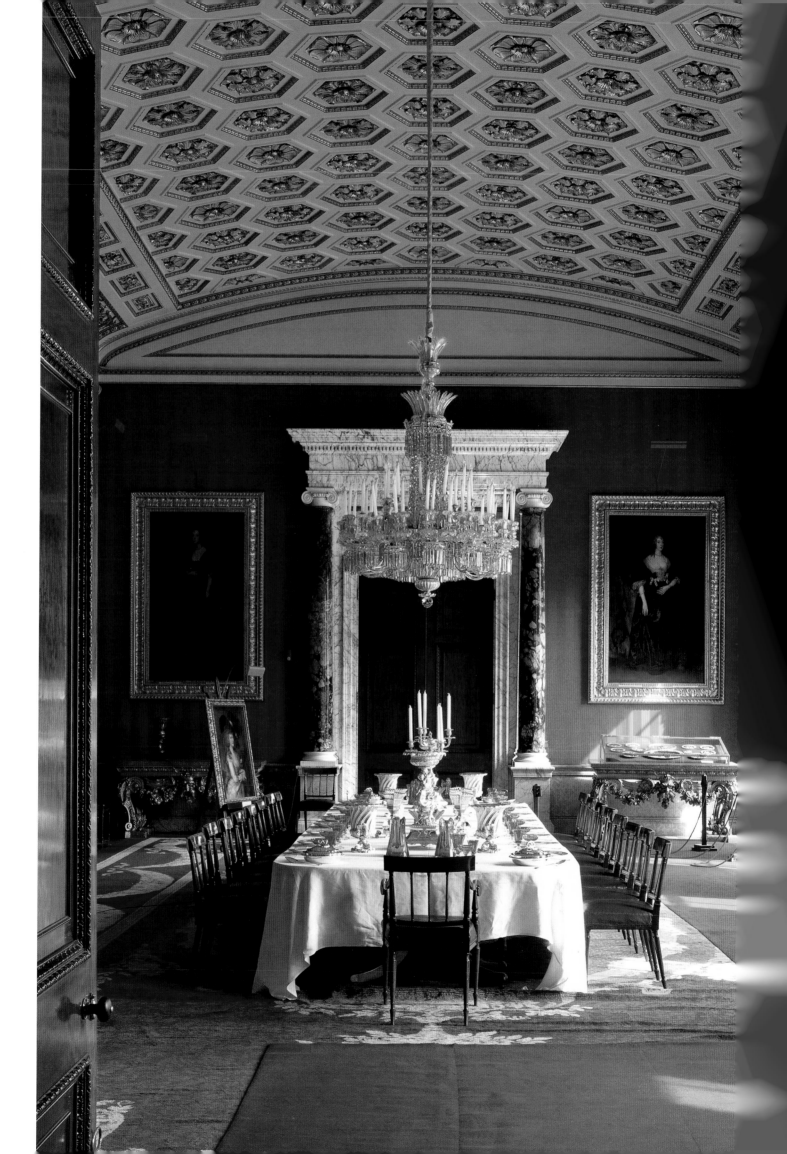

The south façade. In the centre of the entablature is a bust of Marlborough's defeated foe Louis XIV, a trophy taken during the sacking of Tournai. It decorates the façade with all the subtlety of a head on a stake.

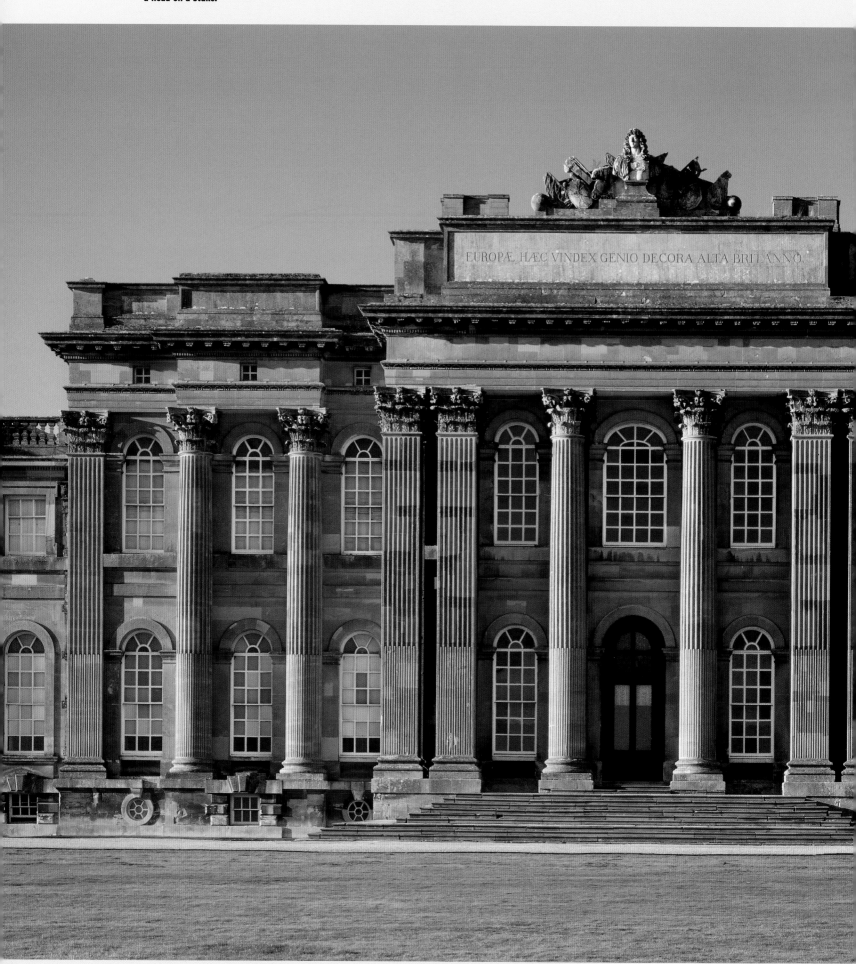

EUROPÆ. HÆC VINDEX GENIO DECORA ALTA BRITANNO.

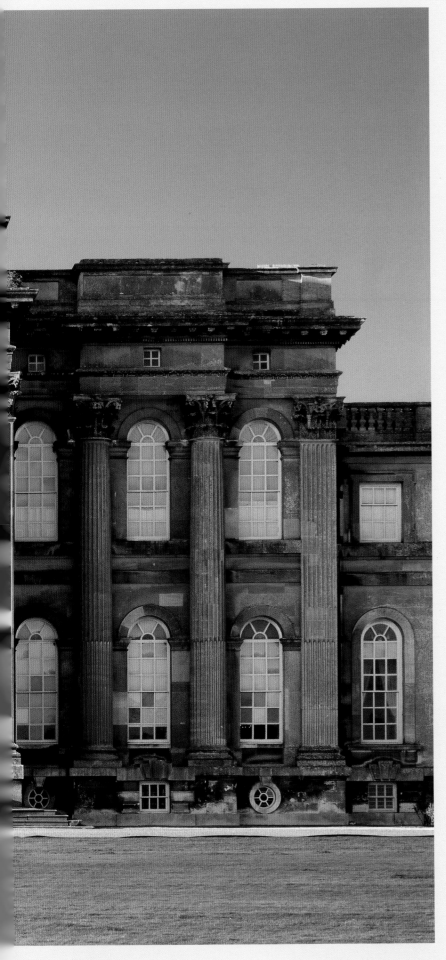

Blenheim Palace

OXFORDSHIRE ENGLAND

On 13 August 1704, during the long War of the Spanish Succession, John Churchill, Duke of Marlborough, attacked a French and Bavarian army near the village of Blindheim, in southern Germany, and won an overwhelming victory. This victory helped turn the tide of the war, and in recognition of this a grateful Queen Anne presented the Duke with the park of Woodstock in Oxfordshire and the sum of £240,000 with which to build a palace. This palace was to be named after the site of the battle and the Duke chose John Vanbrugh as his architect. Vanbrugh's career up to this point had been varied – a junior merchant in the East India Company, a soldier and diplomat, a marine, a successful London playwright and finally an architect. He had had no formal training in any of these jobs, but was well connected, quick to learn and could count on the professional support of Nicholas Hawksmoor. Their house for the Earl of Carlisle, Castle Howard, had won many admirers.

Blenheim was the Duke's seat, but also a publicly funded national monument – and the only non-royal or religious building in England to be called a palace. There was no precedent for such a building, yet Vanbrugh succeeded brilliantly in devising what the nation wanted, a magnificent reminder of military glory. It was not, however, what the Duchess of Marlborough wanted, nor was Vanbrugh the architect she preferred, and her personal antipathy to Vanbrugh dogged the project from the outset.

The palace was planned on the grandest scale. It was designed so that its massing would make a considerable visual impact from a distance. The main façade, which faces north, consists of a two-storey block with a full-height portico and another pediment glimpsed behind it. On either side quadrant arms reach forward, ending in square pavilions. From these pavilions two ranges extend to form a large forecourt, which, via monumental triumphal arches, lead to the stables and kitchen court. The complex roof line of the building is embellished with sculptures, referred to by Hawksmoor as 'eminencys'. Conceived by Vanbrugh (but designed and built by Hawksmoor), these took inspiration from both the Baroque work of Borromini and the Gothic forms on medieval castles.

Such grandeur afforded few domestic comforts, and Blenheim's enormous cost mushroomed beyond projections, compounding the Duchess's grievances. After the Duke's death she refused to allow Vanbrugh into the building, which was eventually finished by Hawksmoor. Vanbrugh never received another major public commission, in part because national taste had changed just as the building was completed. The new reserved Palladian style was considered more appropriate to English Protestant sensibilities. But Vanbrugh had succeeded in creating a Baroque masterpiece and one of the world's most magnificent country houses.

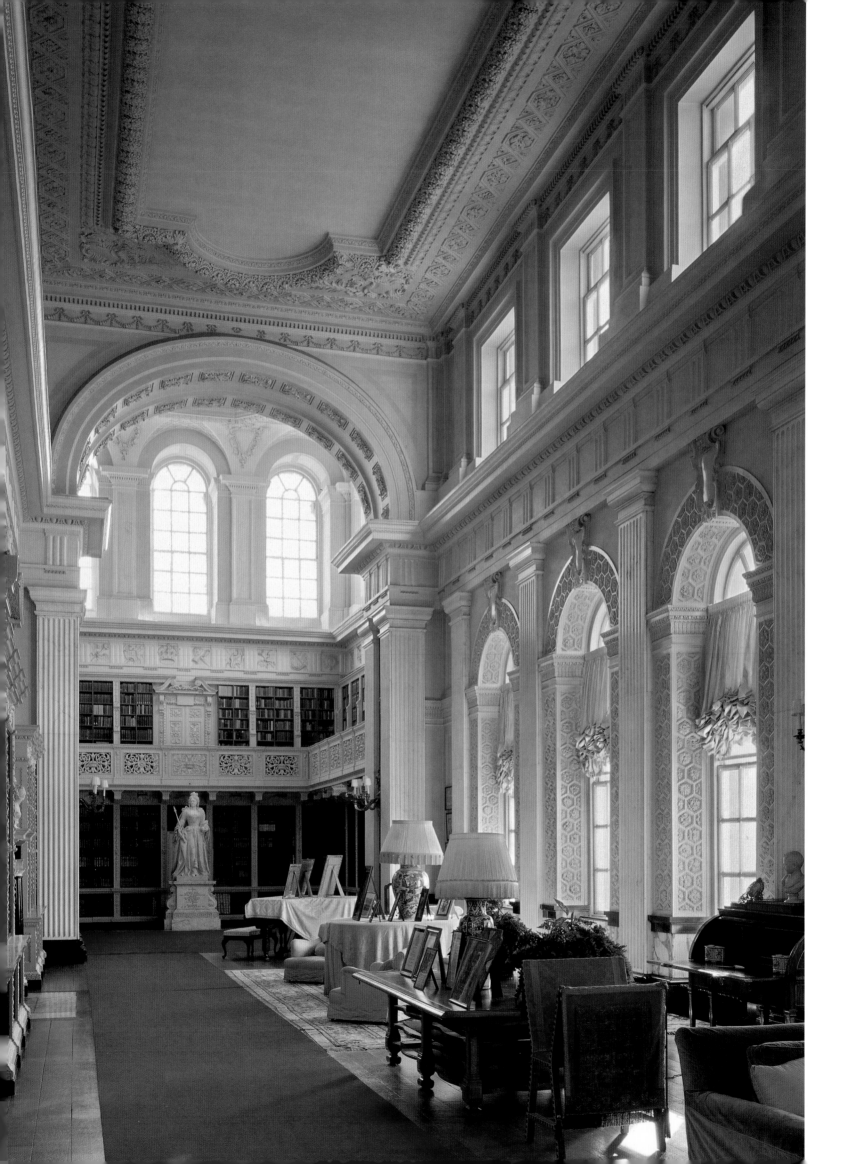

OPPOSITE

The long library was intended by Vanbrugh to contain a picture gallery. Hawksmoor transformed it into a grand series of spaces of different width and height enlivened by Isaac Mansfield's plasterwork. The ceiling would have contained paintings by Sir James Thornhill had the Duchess not found his fees too high.

RIGHT

The interior was completed with carved architectural decoration by Grinling Gibbons in a more restrained Classical style.

PAGES 270-271

The three state rooms are filled with paintings and tapestries, many of them relating to the Duke's military achievements.

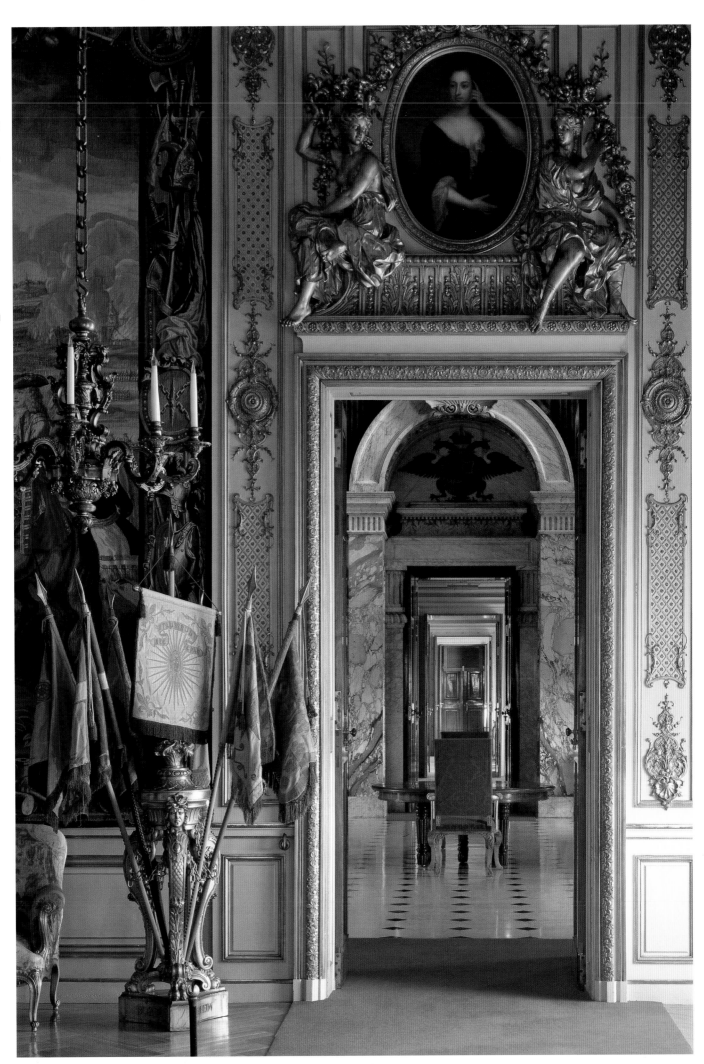

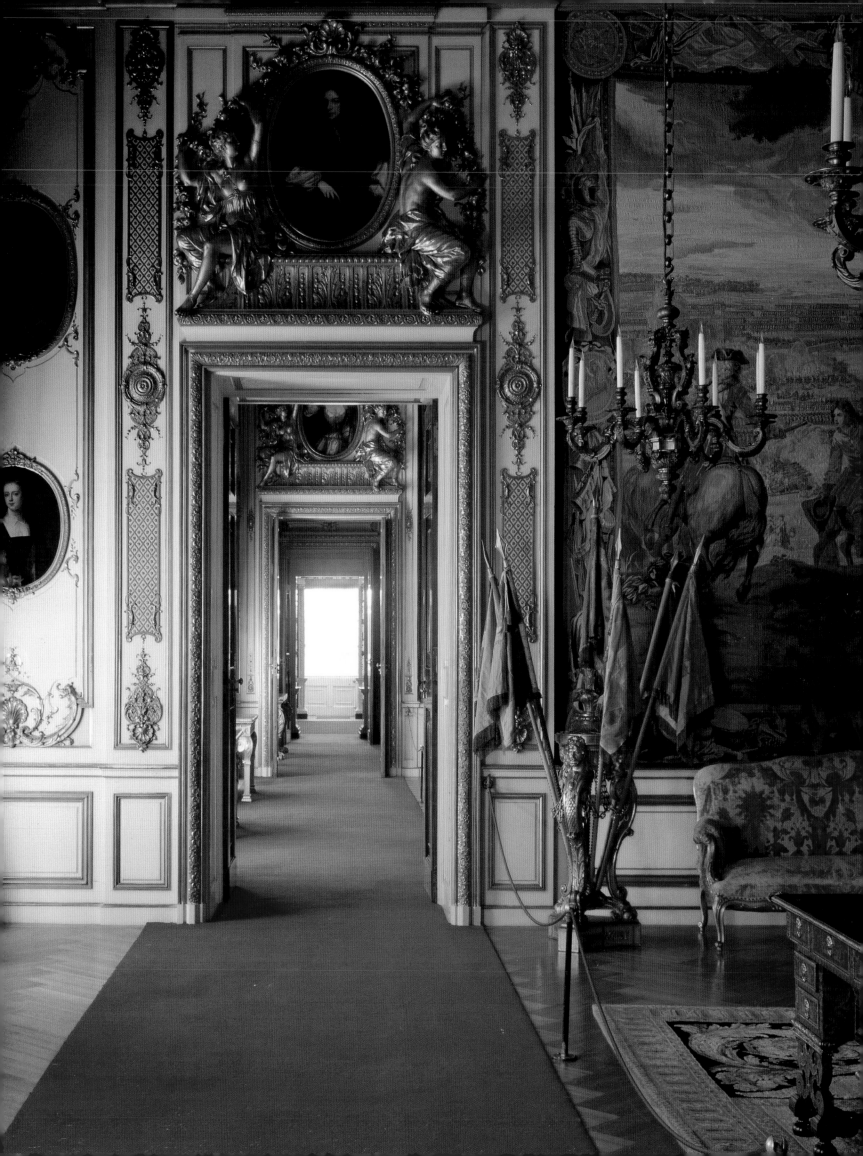

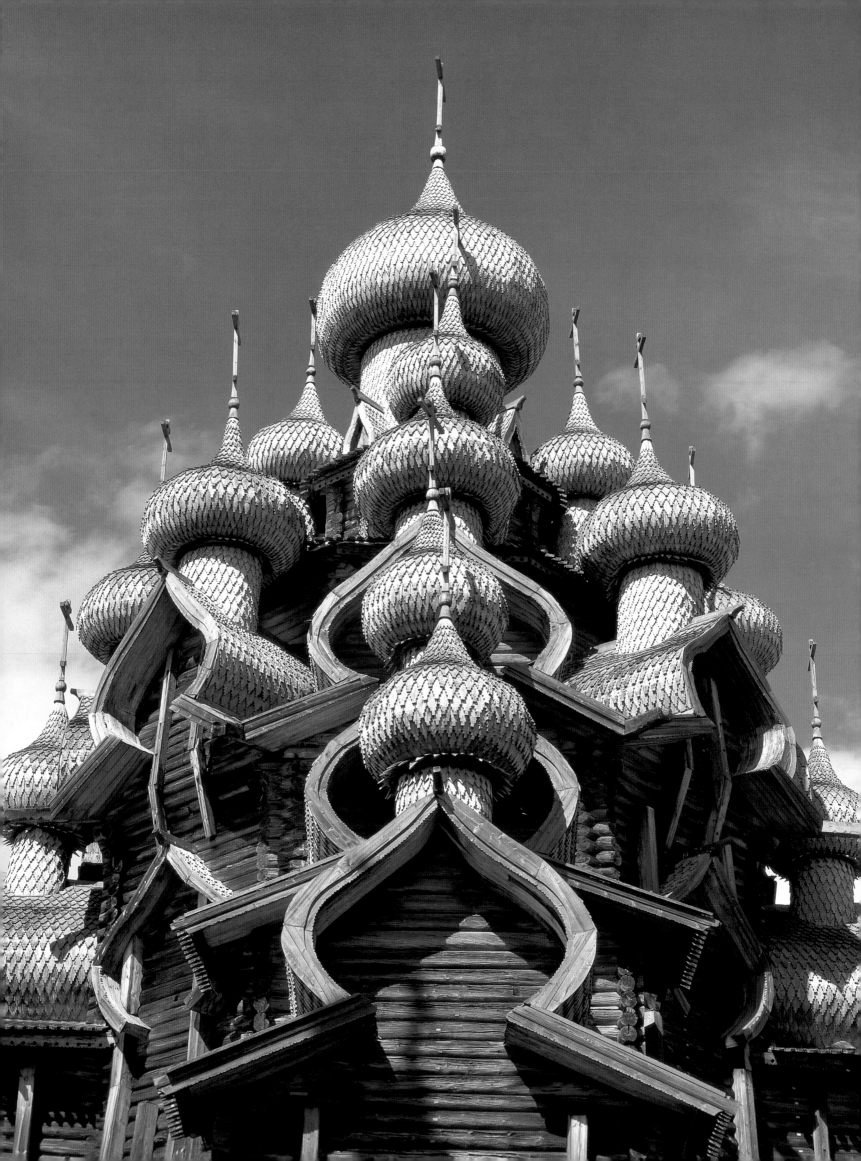

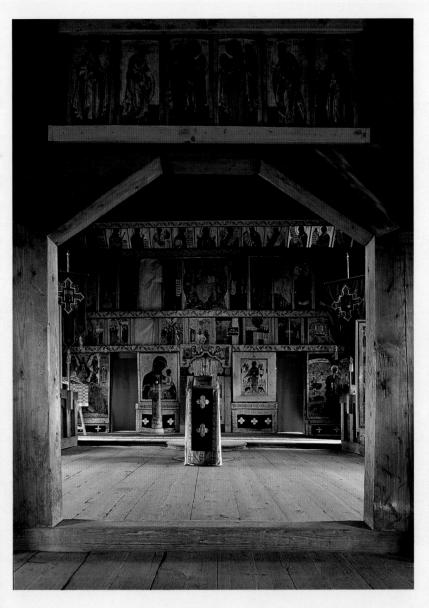

ABOVE

The interior of the Church of the Intercession looking from the entrance hall into the nave. Both the church and the cathedral have low, small interiors designed to retain as much heat as possible.

OPPOSITE

The magnificent Cathedral of the Transfiguration is covered in aspen shingles.

Cathedral of the Transfiguration

KIZHI RUSSIA

Legend has it that when the master carpenter Nestor finished the Cathedral of the Transfiguration he threw his axe into Lake Onega declaring: 'The world never before has seen, and never again will see, its like!'

This is the last of the great pyramidal churches to survive from the reign of Peter the Great and was built in 1714 during the Northern War with Sweden (1700-1721) that established Russia as a European state. It sits within a clerical *pogost* – a group of buildings surrounded by a fortification that was common in this part of northern Russia – on Kizhi Island in Lake Onega. Next to the cathedral parishioners later built a church for use during the bitterest months of the year, called the Church of the Intercession (1764). This lower structure, which has nine domes, serves as a horizontal foil to the cathedral.

Both buildings were constructed with the same limited technology of all wooden architecture in Russia, being entirely cut, shaped and detailed by axe and assembled using a single type of joint. The walls of the cathedral are made up of layers of logs arranged in the form of an octahedron. On top of this core two further, smaller, octahedrons rise in stages, and at the very top sits the largest of the twenty-two onion domes. The overall profile of the building is that of a pyramid, a shape cherished by the Russian population but outlawed by the Orthodox Church in the 17th century. To disguise this pyramidal shape, the architect added a raft of acceptable symbols of orthodoxy, including *bochkas* (ogee-shaped roofs that support the domes) and, of course, the onion domes themselves. Each dome is made of yet another octagon of tree trunks laid on top of each other, which is then sculpted with an axe to form the distinctive shape.

Although constructed from wood, the cathedral reaches a height twice that of the Cathedral of St Basil in Red Square. It is a building of enormous technical brio and distinctive personality. There are more famous Russian churches such as the St Basil and the Church of the Ascension in Kolomenskoe but their form is simply a translation of wooden architecture into stone.

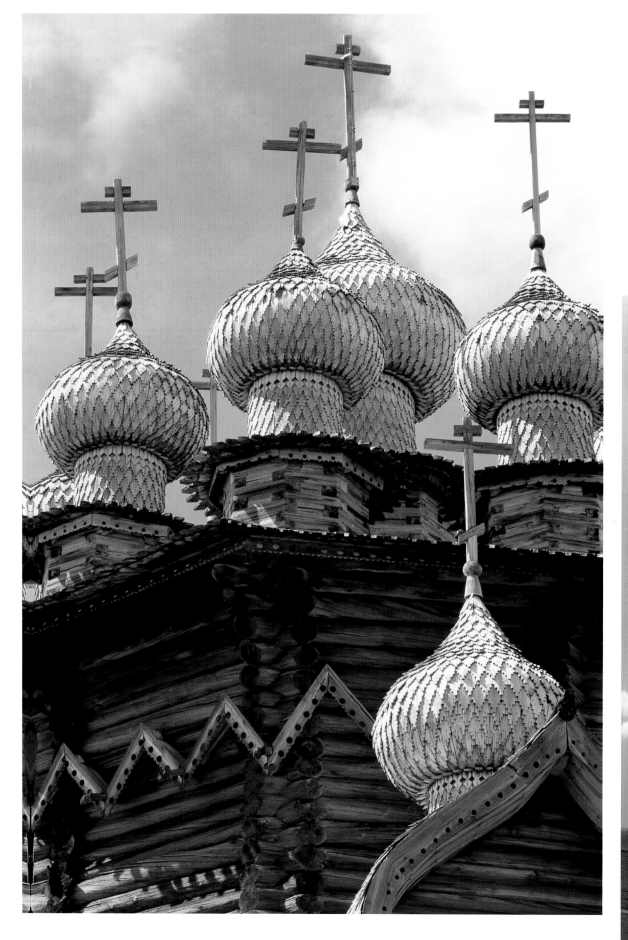

LEFT

The onion domes of the Church of the Intercession lie on a low roof and act as a visual foil to the great pyramidal shape of the cathedral

BELOW

Twice the height of the Cathedral of St Basil in Moscow, the cathedral was designed to be seen from great distances across the lake. The Church of the Intercession can be seen to the left.

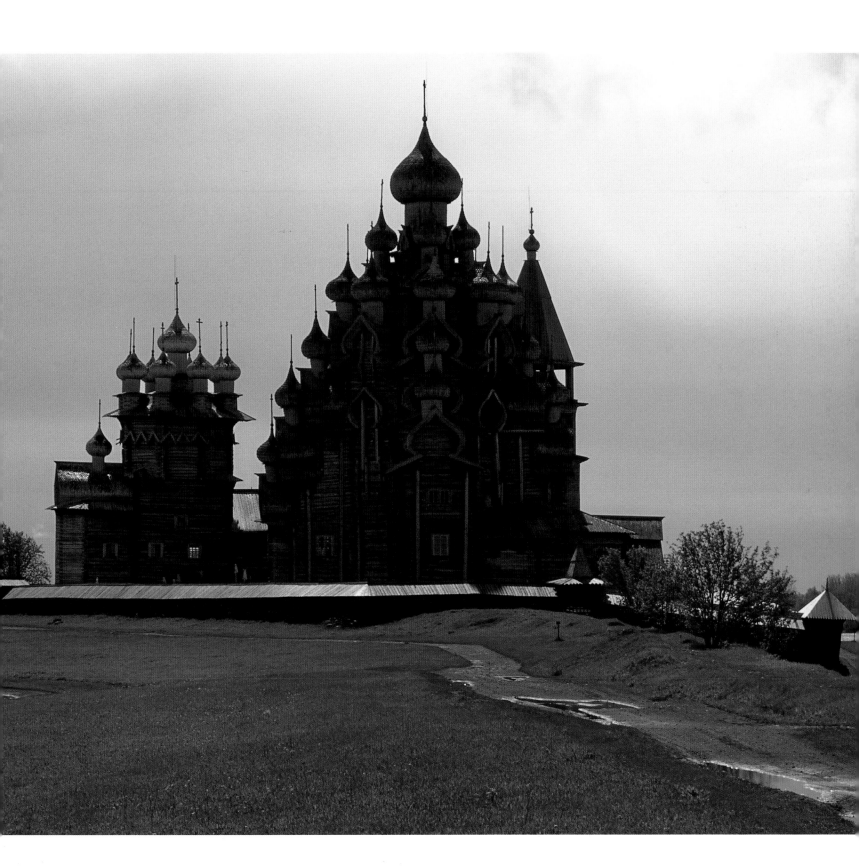

Basilica of the Vierzehnheiligen

NEAR BAMBERG GERMANY

This church overlooking the River Main in south-central Germany commemorates the site where in the 1440s a shepherd had visions of the fourteen helper-saints (Vierzehnheiligen) who would intercede on behalf of mankind in times of plague. Consequently this place became a popular place of pilgrimage, and the first church was constructed in 1457. In 1735 Abbot Stephan Mösinger of the Cistercian monastery at Langheim proposed a much larger building.

In the early 18th century the conventional approach would have been to erect a basilica on a Latin-cross plan, with a dome above the pilgrimage shrine at the crossing. Balthasar Neumann, the architect commissioned to design the church, maintained part of this conventional scheme. His Latin-cross plan places the shrine at the intersection within a broadly rectilinear outer vessel. Inside the church, however, Neumann modelled an undulating spatial form that remains one of the masterpieces of Baroque architecture.

The interior is composed of a longitudinal sequence of three intersecting ovals. The western oval pushes the west façade out to create a convex central bay, and recedes into the church to be supported by two freestanding piers. The central (and largest) oval is supported by a series of great half-columns attached to massive piers. It stands freely within the centre of the church and contains the shrine. The shrine, designed by Johann Jakob Michael Küchel and added in 1762, is a baldacchino supported by Rococo volutes. And while it sits, as expected, at the crossing, it is covered not by a dome but by the intersection of two of the ovals with the vaults of the transept (in fact the lowest point of the roof). While the shrine remains the visual focus it also, simultaneously, encourages the viewer to seek out the lighter spaces of the interior around it – a characteristically Baroque emphasis on visual movement. For in spite of the logic of Neumann's composition, it was the sensory effect that was most important. The interior is deliberately difficult to comprehend, a barrage of painted, sculptural and plastic stimuli that create an extraordinary impression prior to the composition of the space being understood. Nearly all the surfaces are covered with painted decoration. The columns, pilasters and vaults are marbled to contrast with the white walls. Other stuccowork is grey and gold, giving the impression that lines of gold have been threaded through the composition.

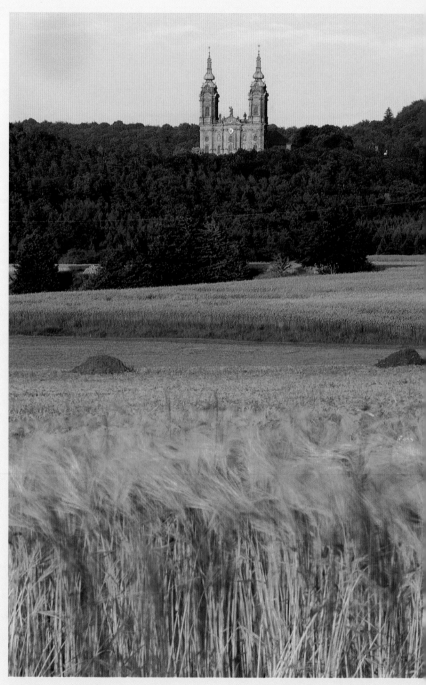

ABOVE AND OPPOSITE
Standing isolated on rising ground above the river, the church is a focal point for a whole region. The convex façade, a favourite Baroque feature, here reflects the internal plan.

PAGES 278-279
Interior and exterior are conceived in the same spirit of dancing curvilinear forms – the former shining in coloured and gilded stucco, the latter expressed in hard, sober stone.

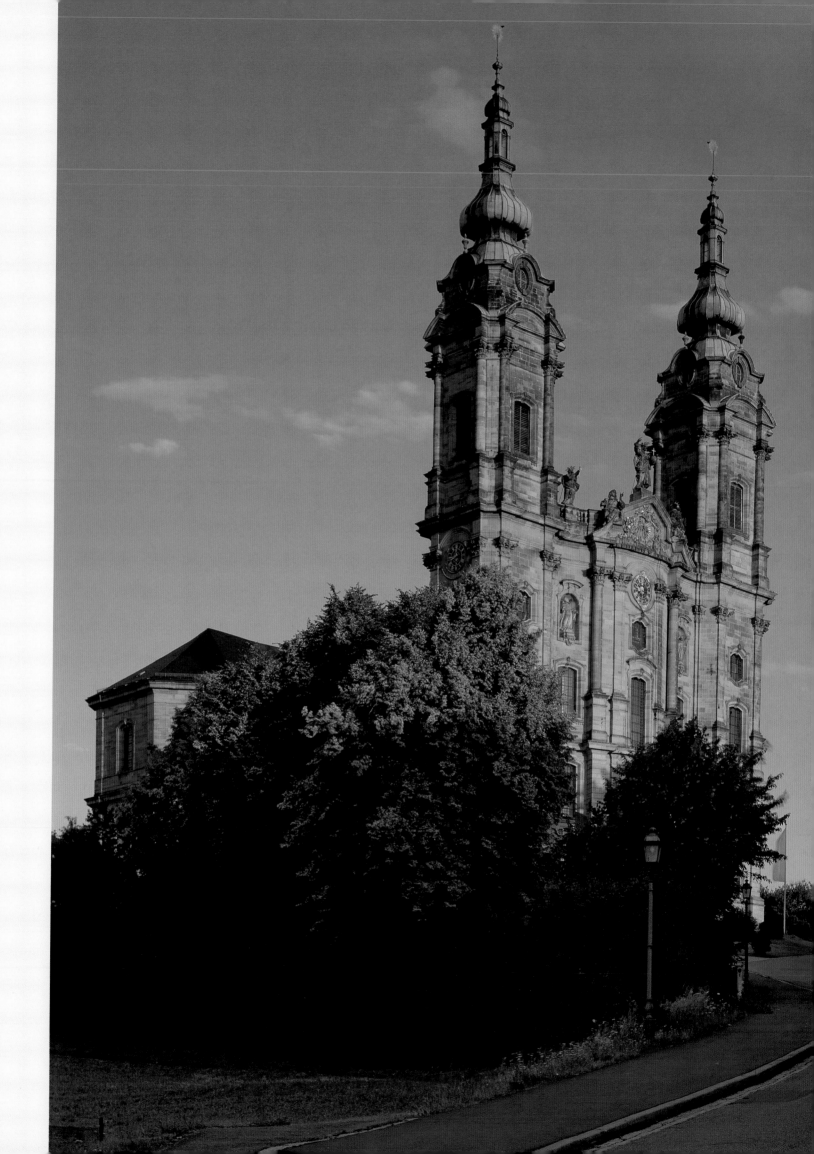

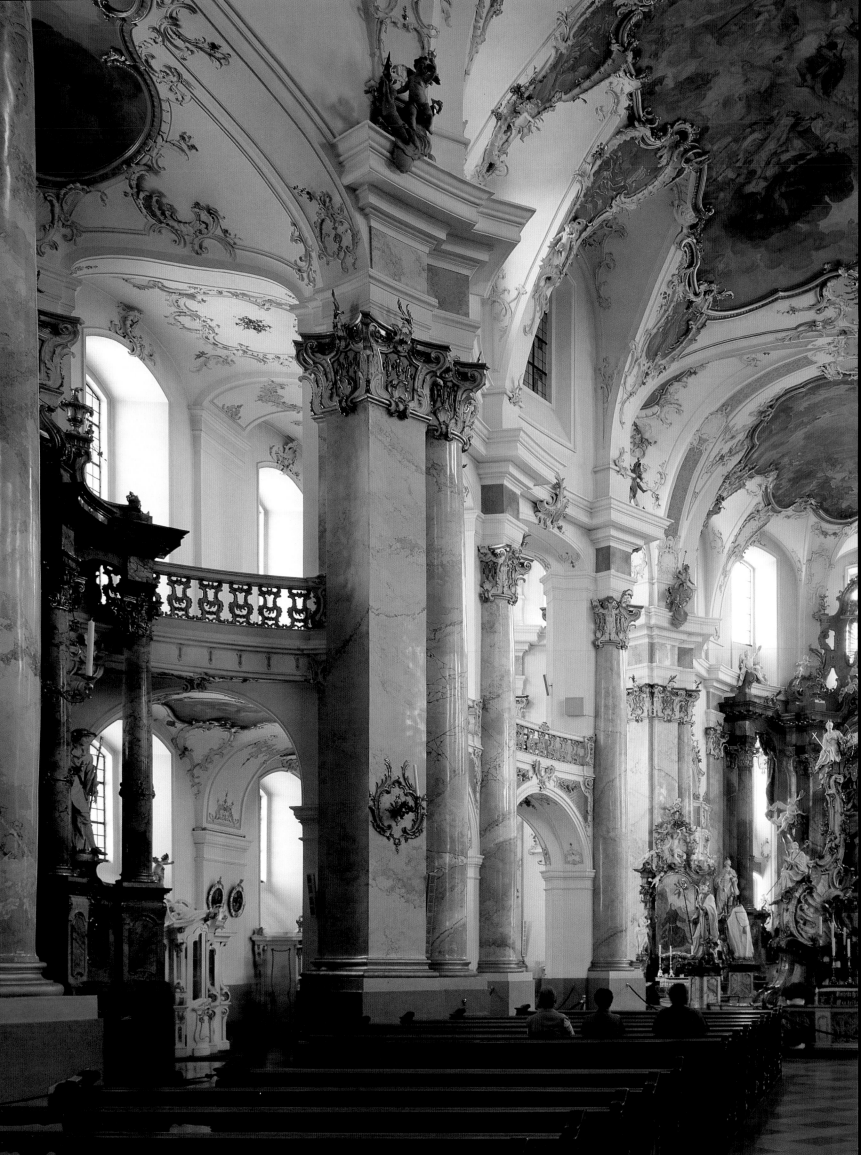

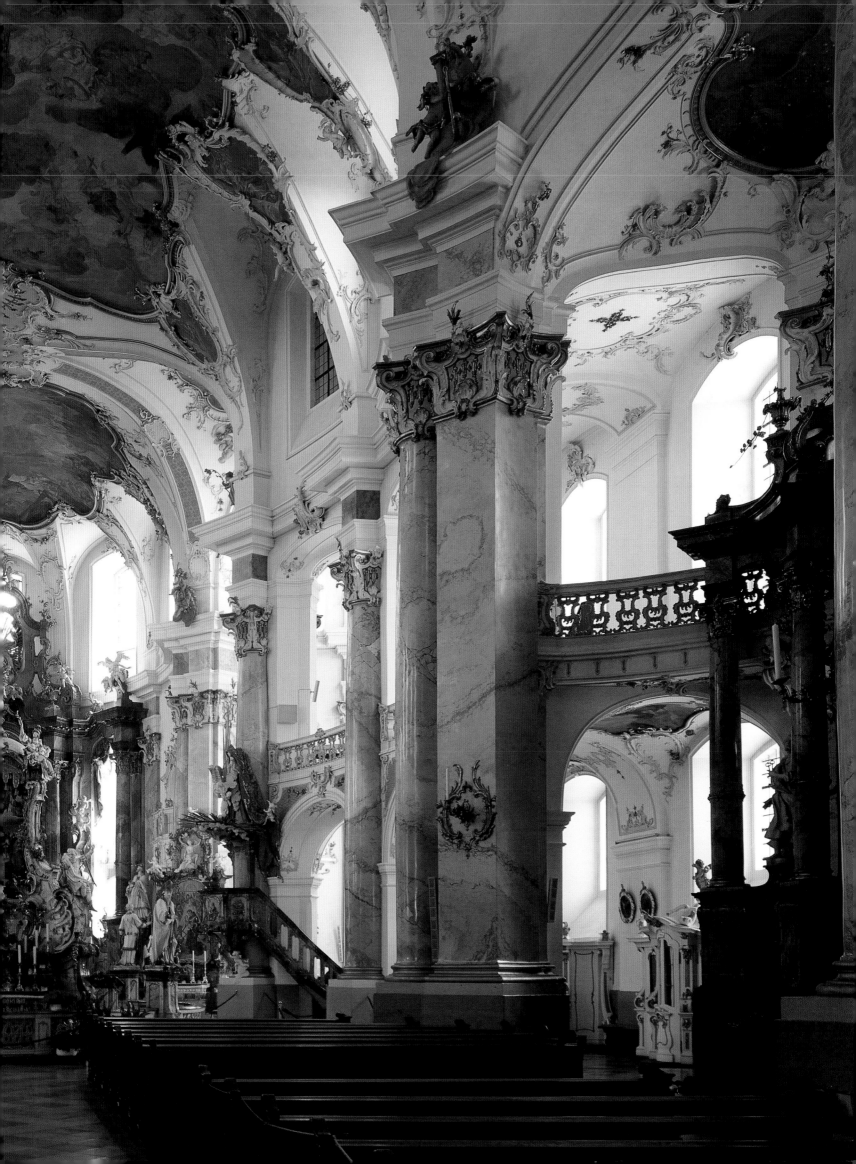

A view of the church from the
south. An elaborate façade covers
the east end of the building (to the
right), while a bell tower stands at
the west.

PAGE 284

Freestanding paired columns define a
narrow ambulatory around the nave.

PAGE 285

A view towards the main entrance
from the choir.

Pilgrimage Church

WIES GERMANY

The Wies Pilgrimage Church was built between 1745 and 1757 to house a miraculous image of the flagellated Christ. This rather crude wooden figure, which today stands on the altar, was carved in 1730 for a nearby monastery; some years later, while in the possession of the steward's wife, she noticed that it was weeping, and soon after the local peasantry erected the church on the site of this miracle.

It is the work of the Zimmermann brothers, Dominikus and Johann Baptist, who were born in 1685 and 1680, respectively. This church, their final collaboration, represents the highpoint of South German Rococo, though this could hardly be guessed from the deliberately sombre exterior.

The church is entered by a semicircular vestibule, which leads to a high-roofed, oval nave; at the other end of the nave is an essentially rectangular choir. Upon first sight of the interior, solid material seems to have lost its weight, and twists and writhes like a living substance. Initially it is difficult to distinguish the individual parts of the building since they are linked together by a mass of ornamentation. Sections of the church are instead identified by colour - white and gold in the nave, blue and red (for God's blessing and Christ's blood, respectively) in the choir.

Slender freestanding columns are paired around the perimeter of the nave, supporting arches that suggest (rather than actually constitute) a narrow ambulatory. This allowed pilgrims to walk around the miraculous image located at the high altar without disturbing those praying. It also helps obscure the boundaries of the church. The arches of this 'ambulatory' in turn support a stucco border above, which periodically overlaps with the ceiling painting in a series of wave-like forms. This stuccowork forms a transitional zone between the architecture and the illusionistic painting. Throughout lip service is paid to the Classical language of the orders - the language of columns, capitals, entablatures, cornices - though in reality these elements have become dynamic, decorative devices.

The ceiling painting in the central space represents a type of Last Judgment in which the threat of judgment is implied rather than made explicit. Christ sits upon a rainbow below which angels sound the trumpets. Pilgrims leaving the church can read just above the portal the inscription: 'Tempus non erit amplius' - 'There shall be time no longer'. A trompe l'œil depiction of a closed doorway describes the unknown future that will come after death.

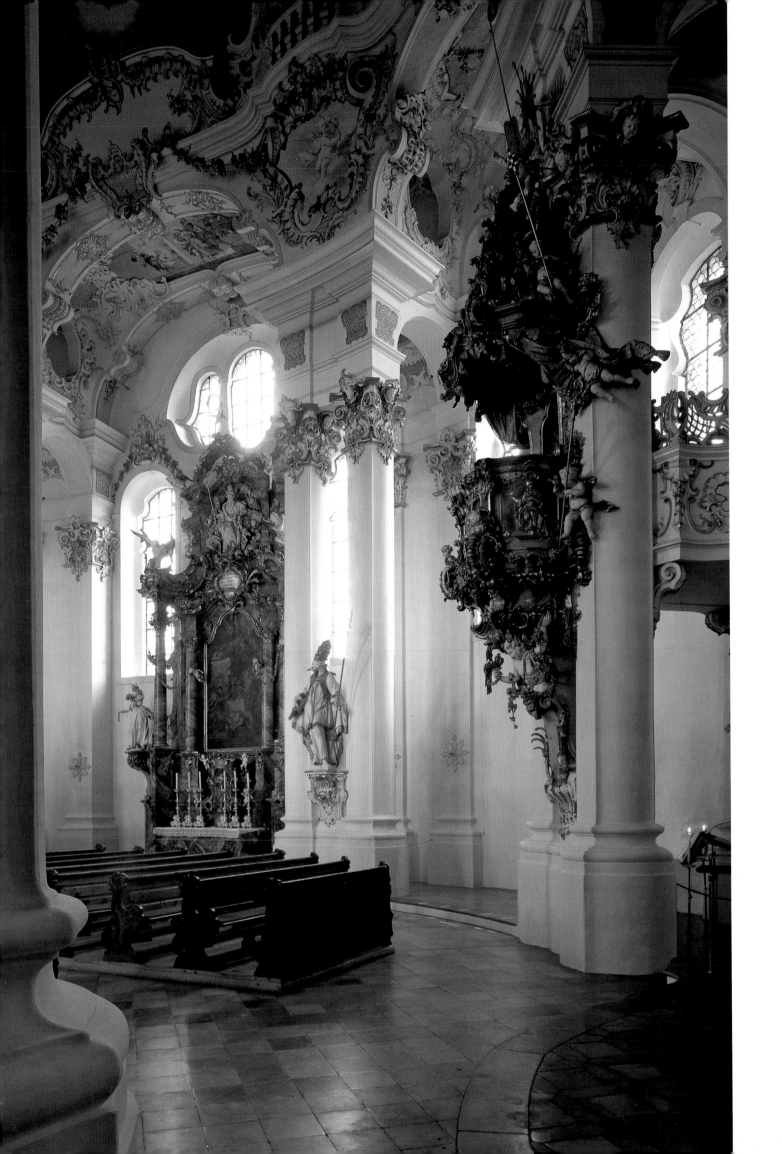

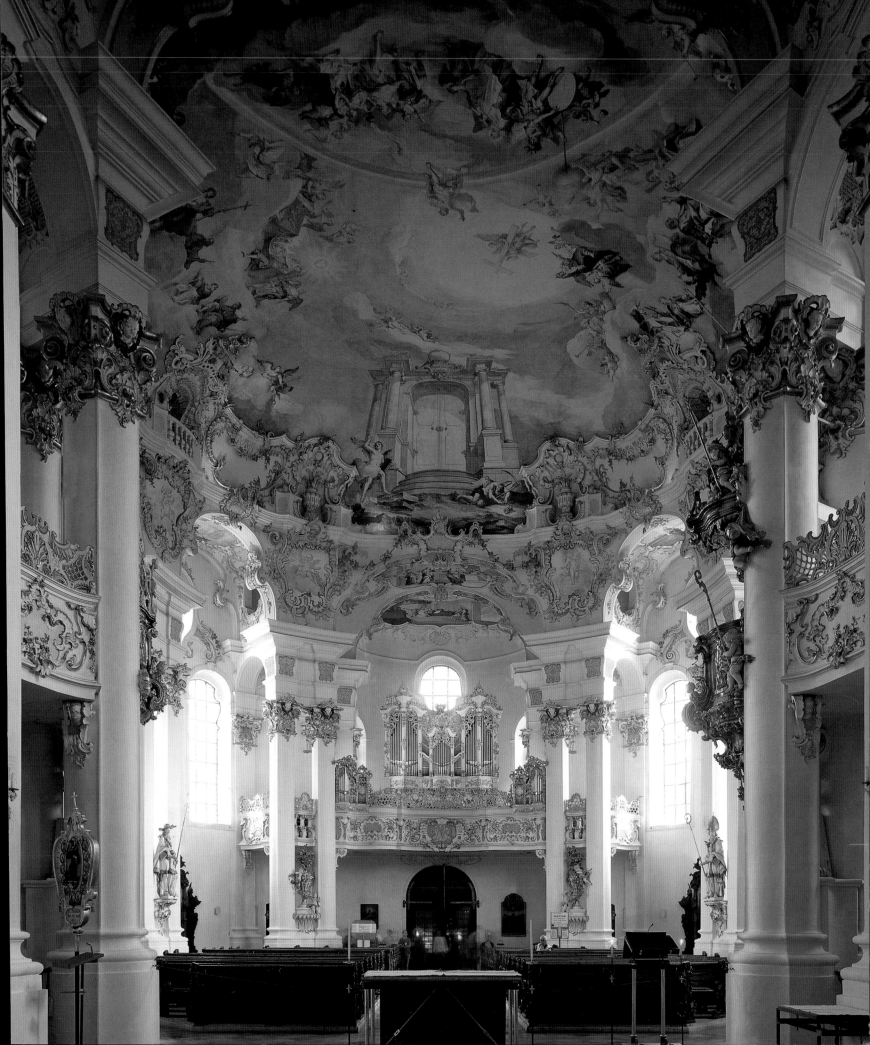

The Victoria Tower and the south
façade of the Houses of Parliament.
When completed the Victoria Tower
was the largest and highest square
tower in the world.

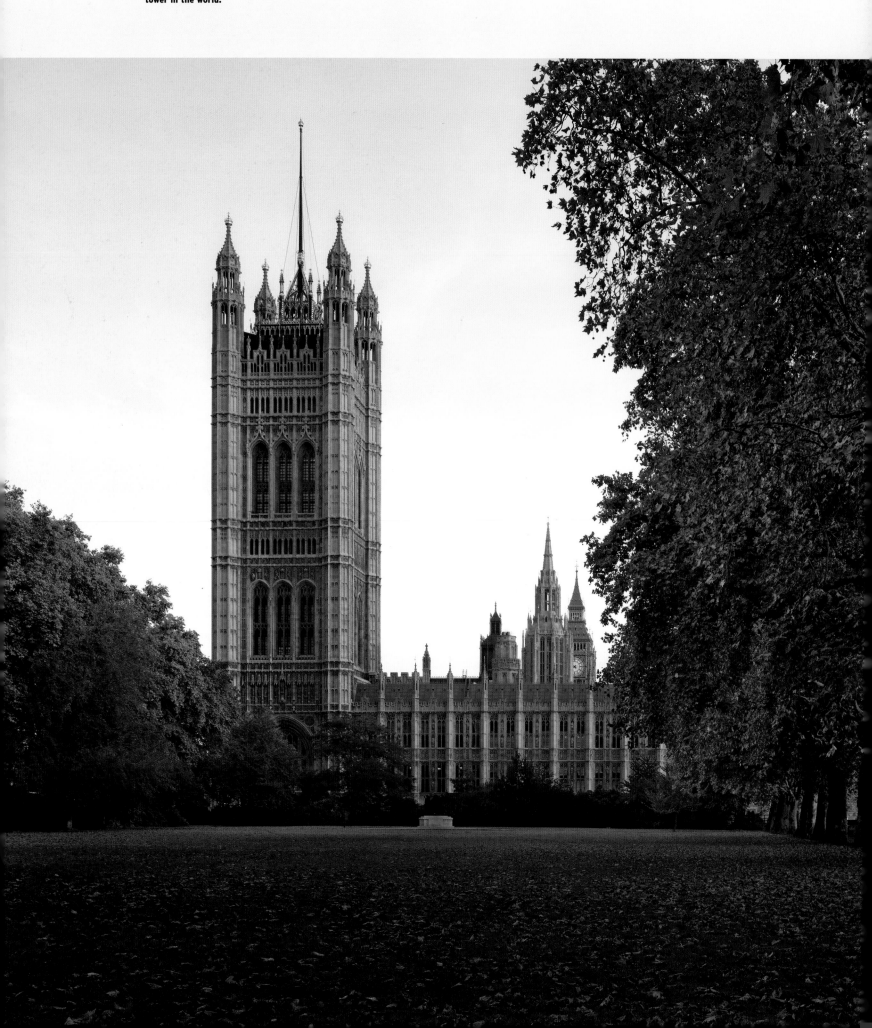

Houses of Parliament

LONDON ENGLAND

When, in October 1834, the Palace of Westminster was destroyed by fire, many must have seen an opportunity as well as a loss. The old Palace had been an untidy collection of disparate buildings that was never meant to function as a seat of government; the new one could be better organized, efficient and, moreover, a proud symbol of what was then the most powerful nation on earth. The committee responsible for organizing the competition to select a new design ruled that the architectural style should recall the 'Golden Ages' of British history – that is, 'Gothic or Elizabethan'.

Charles Barry was a successful and experienced architect, but he was a Classicist by temperament and his previous Gothic proposals followed the 'picturesque' tradition of the early Gothic Revival, which captured the flavour of the Middle Ages without any great comprehension of Gothic principles. Fortunately for Barry, he could rely on a real scholar of medieval architecture (as well as a superb draughtsman), A. W. N. Pugin. The two had already collaborated on the Neo-Perpendicular design for King Edward's School, Birmingham, and their winning scheme for the new Palace of Westminster, like that for the school, outlined a Perpendicular building planned by Barry and detailed by the expert Pugin.

The brief was to preserve those parts of the old palace that had survived and around them to build new chambers for the Lords and the Commons. The brief also included a variety of ancillary spaces: lobbies, ceremonial rooms, offices, dining rooms, as well as endless corridors, halls and staircases. All of them had to be adequately lit and ventilated. It was a job of staggering complexity.

Barry preferred symmetrical plans and placed an octagonal lobby in the centre of the building. From here corridors led left to the Commons' chamber or right to the Lords', a logical and elegant solution that has functioned efficiently ever since. The preservation of Westminster Hall meant that the side facing inland was informal. Facing the river he risked symmetry, offset by the asymmetry of two towers: the larger Victoria Tower marking the royal entrance at one end of the building, and the slender Clock Tower at the other. However, in Pugin's famous words, the exterior remains 'Tudor details on a Classic body.'

The climax of the building is the Lords' chamber. Based on the Classical shape of the double cube (27 by 13.5 by 13.5 metres, or 90 by 45 by 45 feet), the long sides are punctuated by six pointed windows and the short by three shallow arched recesses. Like the building itself, the details betray a mixture of styles. The focus of the room is the throne inspired by the 14th-century Coronation Chair in the neighbouring Westminster Abbey, and beautifully carved by a team supervised by Pugin.

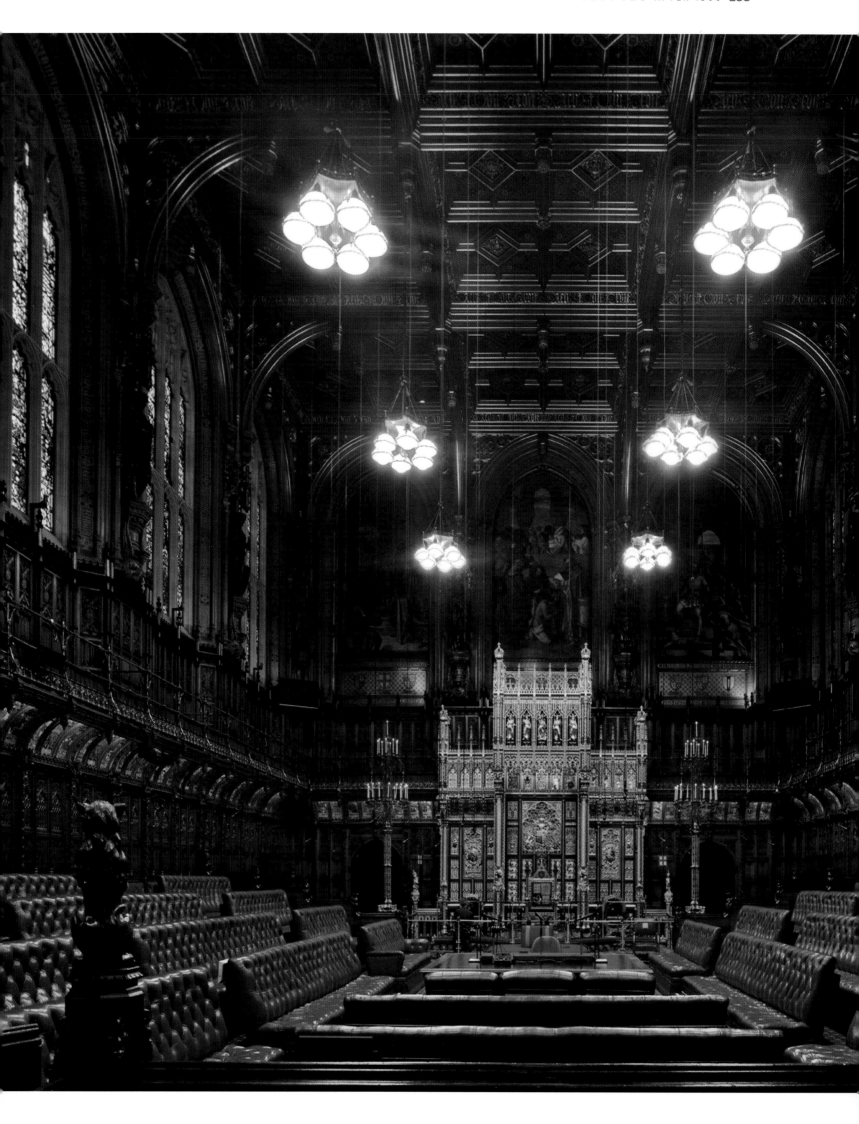

LEFT

The debating chamber of the House of Lords.

BELOW

The plainer debating chamber of the House of Commons was designed as a foil to that of the Lords. It was rebuilt by Sir Giles Gilbert Scott after damage in the Second World War.

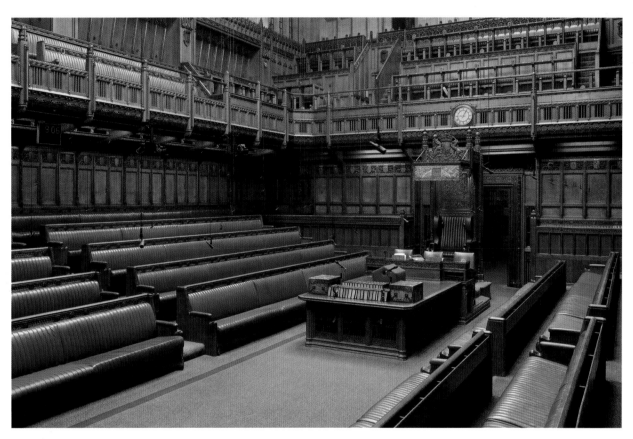

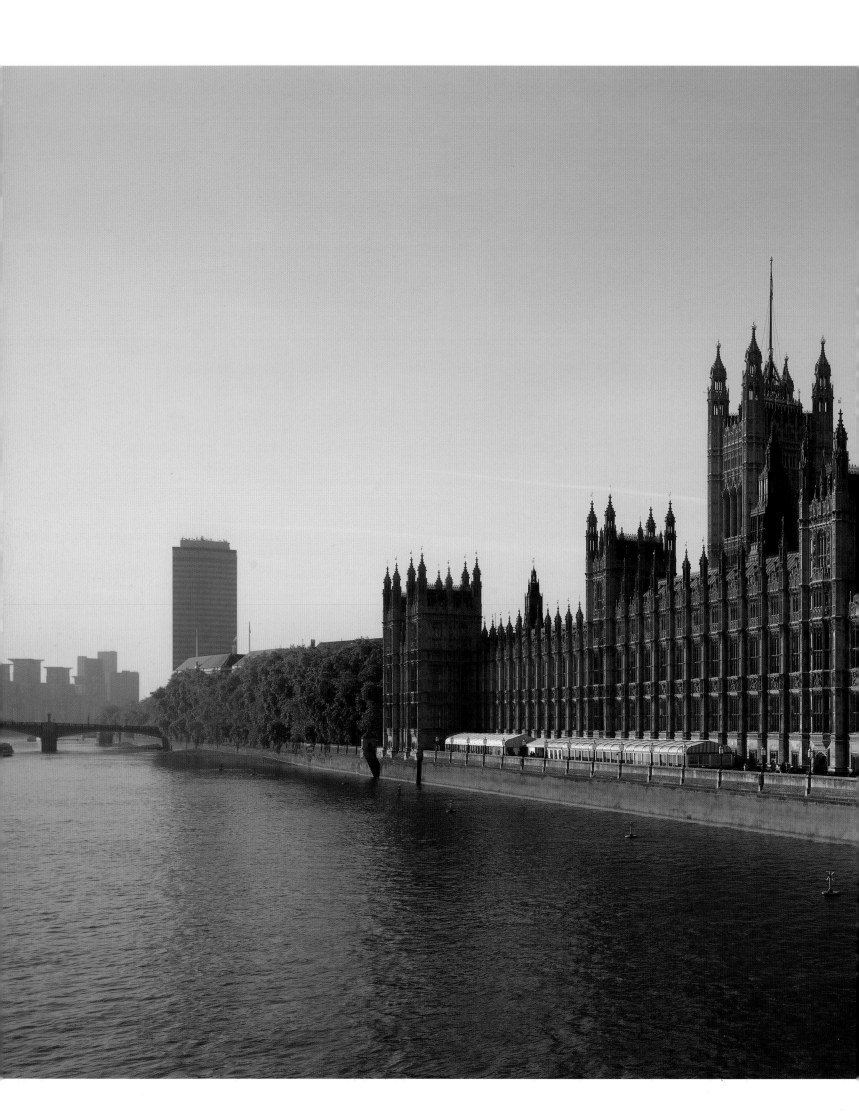

**The Houses of Parliament seen
from Westminster Bridge.**

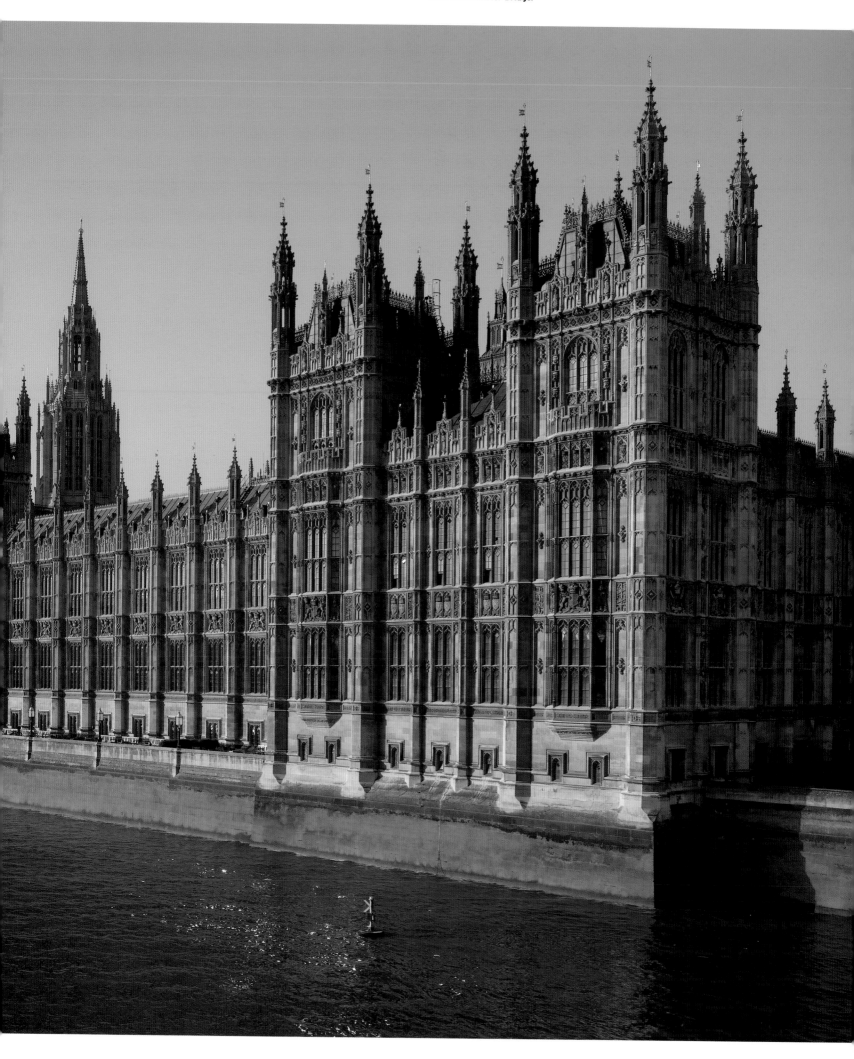

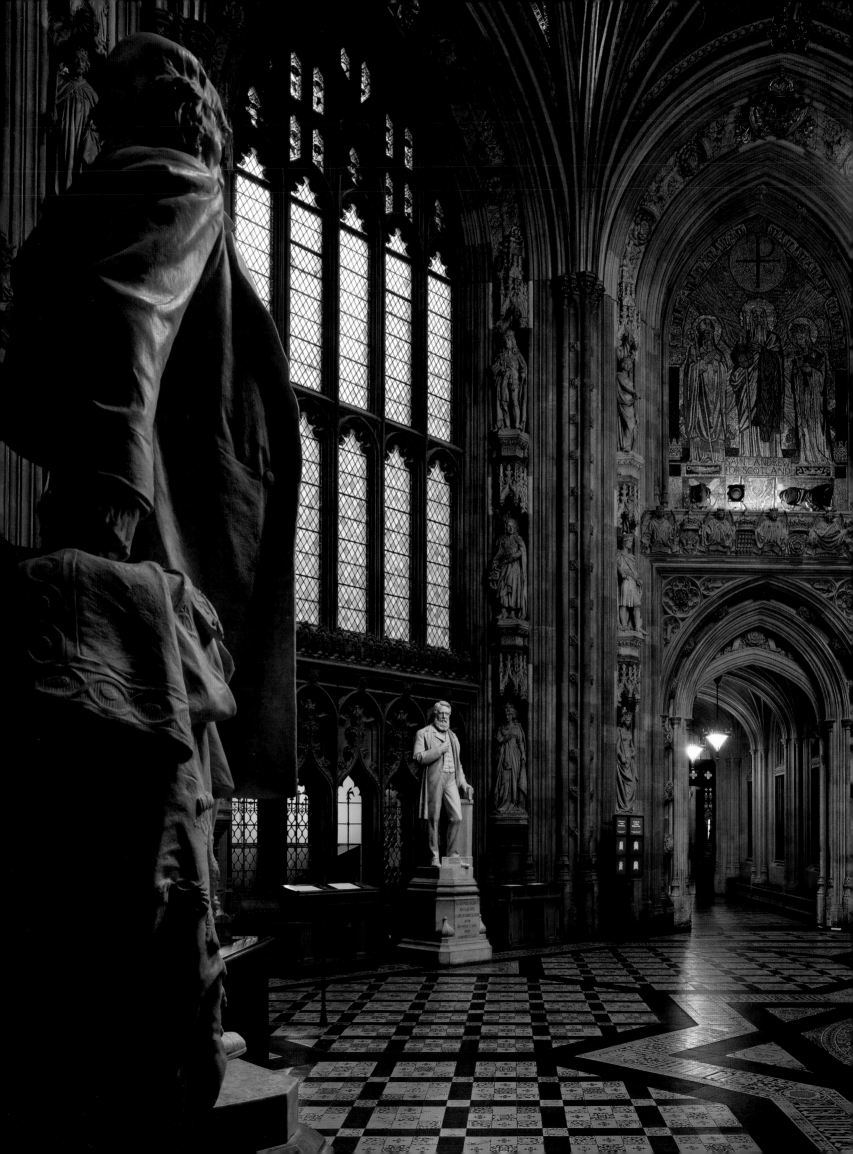

OPPOSITE

**The octagonal lobby in the
centre of the plan is decorated
with statues of former
Prime Ministers.**

BELOW

**The Royal Gallery looking towards
the Prince's Chamber is one of
the splendid spaces through which
the monarch approaches the
Lords during the State Opening
of Parliament.**

The perfectly symmetrical
front façade.

Glass House

NEW CANAAN USA

In 1945 the architect Philip Johnson purchased five acres of land on a hillside in New Canaan, Connecticut, to build himself a house. However, other commitments, including his directorship of the Department of Architecture at MoMA, held up the process and he did not finalize the design until 1947 and start construction until the following year. An early advocate of the Modern Movement, Johnson was instrumental in raising awareness in the United States of European architects such as Walter Gropius (a teacher at the Bauhaus), Mies van der Rohe and Le Corbusier. These architects encouraged the use of 'modern' materials like steel and glass to create neutral, multifunctional spaces. In 1952 Johnson decided to build a demonstration of this ideal – a glass and steel pavilion without internal partitions to be used as a weekend retreat.

While inspired by Mies's Farnsworth House, the Glass House also indicates Johnson's preoccupation with history and when in 1950 he wrote an article for *Architectural Review* in which he listed his influences for the house, he included not only Mies van der Rohe but also Le Corbusier, Claude-Nicolas Ledoux, Kazimir Malevich, Karl Friedrich Schinkel and the De Stijl movement. The form of the house is incredibly simple. It is a symmetrical glass box held up by a dark grey steel structure (which also supports the flat roof). The interior of the box has a brick floor that matches the Brick House opposite; importantly the floor is set only slightly higher than the surrounding grass, thus linking the interior and exterior spaces. A full-height central brick cylinder contains the bathroom and fireplace. The only other permanent elements in the interior were some walnut cabinets, one of which contained the kitchen units – the rest of the interior was completely flexible.

The house is very carefully located in its surroundings. The land falls steeply away below it offering views across the tree line of this heavily wooded valley. Outside the steps and railings are of white granite. Paths lead to the accompanying Brick House, with its library and guest bedroom, and across to other pavilions added by Johnson over the years. It is this superb sense of balance, in terms of the limited contents of the house and its relationship with the landscape and the carefully chosen objects he placed in the rest of the grounds, which makes the Glass House so successful.

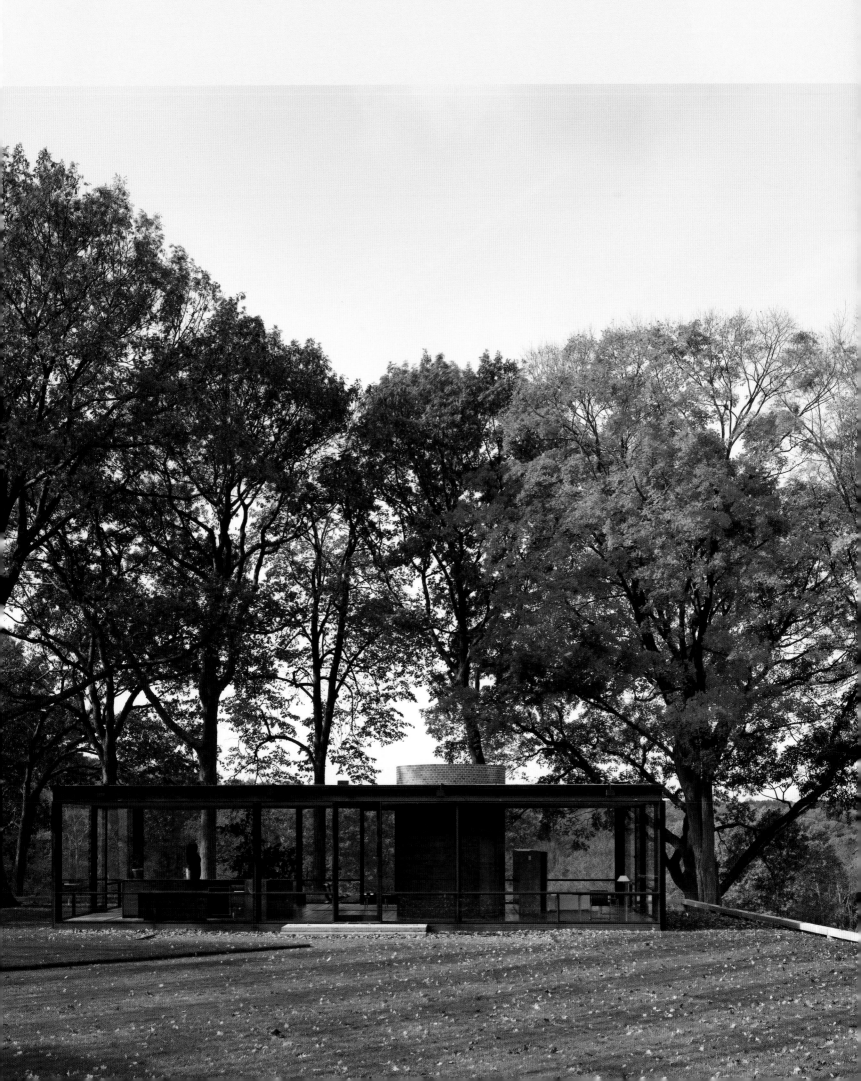

OPPOSITE
**Philip Johnson's desk. The floor is
set only fractionally higher than the
grass outside, further weakening
the boundary between interior and
exterior.**

BELOW
**The interior, including two
Barcelona chairs designed
by Mies van der Rohe for
his Barcelona Pavilion.**

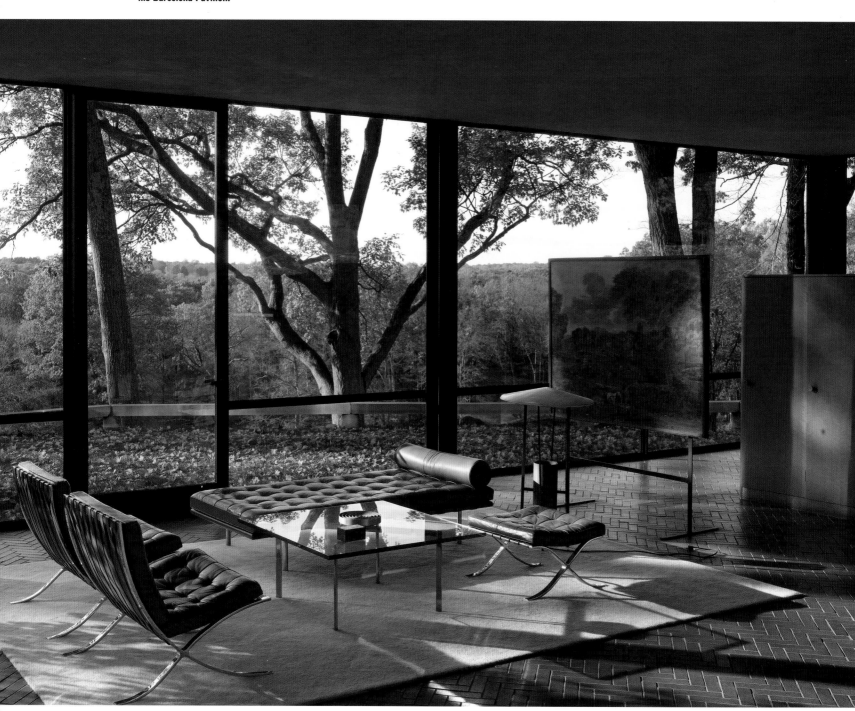

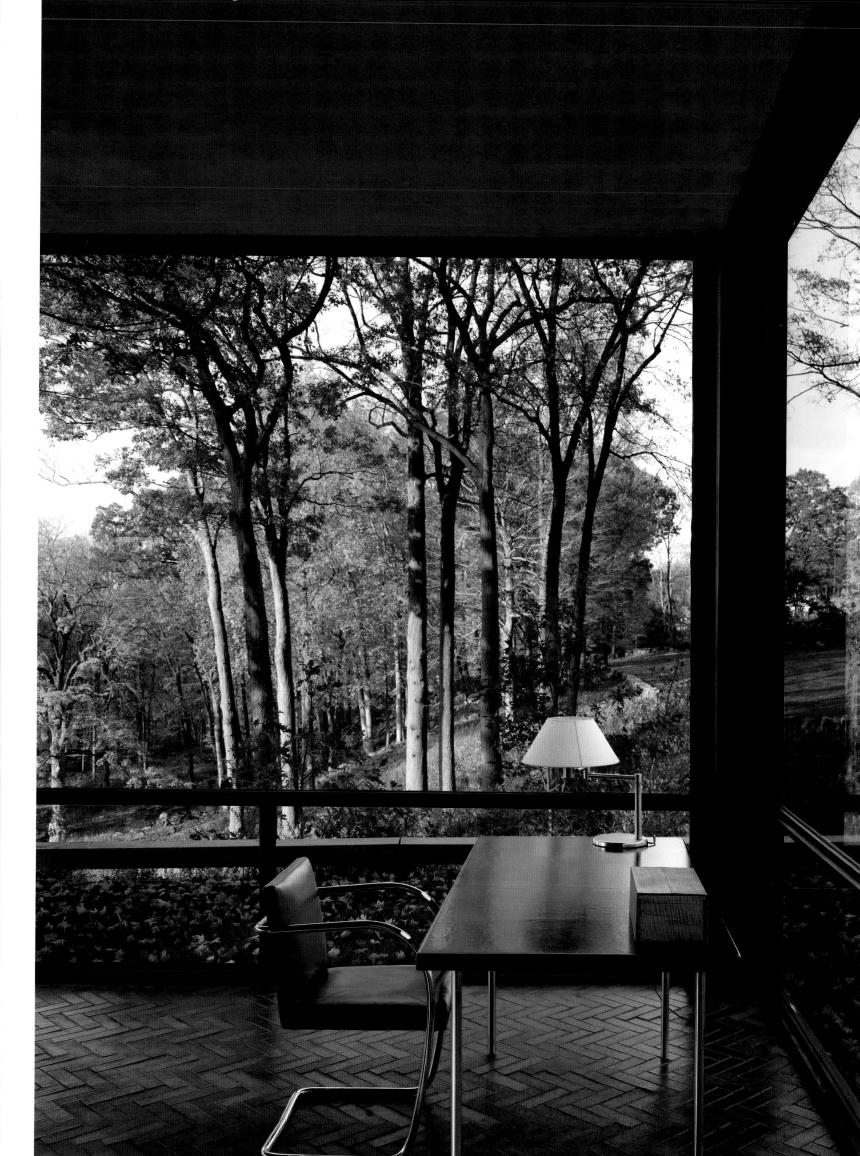

Notre-Dame du Haut

RONCHAMP FRANCE

When Le Corbusier returned to active practice in Paris at the end of the Second World War he was in his late fifties and had not built for over a decade. In this period he became increasingly concerned with buildings that would reflect the full range of his ideas and principles. The great Utopian vision of the 1920s and 30s, of a society transformed by modernism, was overshadowed by his desire to find a fraternity with nature. The result was a series of religious buildings that stand in stark juxtaposition with Corbusier's earlier principles of uniformity and mass-production.

The finest example of this change of heart is Corbusier's pilgrimage chapel on a magnificent hilltop site near Besançon, eastern France, which was planned and built between 1950 and 1954. He worked on the design process for over three years and accommodated a huge array of sources including Istrian huts, aeroplane wing sections and a crab's shell. The result was a structure with a huge curved concrete roof supported by convex and concave rubble walls punctuated to the south by a huge array of different-sized openings. The building's plan is ordered by light cowls (or scoops) inspired by Hadrian's Villa at Tivoli and numbering three to reflect the Trinity. These face in different directions and enclose side chapels off the nave. The rest of the interior is hollowed out. The weighty roof runs at an angle and meets the south wall leaving a slight gap so that what seems monumentally heavy outside appears to be a thin surface inside. The figure of the Virgin Mary sits in the eastern window within glass so that she can be seen from both inside and outside. On the outside there is also an altar and pulpit to accommodate large congregations on important occasions.

The building had a mixed critical reception, being instantly popular with the general public but enormously unpopular with fellow advocates of the Modern Movement. To be working for so reactionary an organization as the Catholic Church was deemed bad enough, but to produce such a 'Baroque' structure of curves and subtle ambiguities was completely beyond comprehension. In spite of being built with thick rubble walls, however, Ronchamp in some ways holds its own by Modernist criteria: the roof, for example, involved sophisticated structural engineering inspired by the design of concrete dams, while doubling as a rainwater collector, and inside the acoustics are excellent. But today Ronchamp can be seen clearly as Corbusier's greatest contribution to architecture precisely because it is not tainted by the dogmatism that led to the uniformity and inhumanity of so many social housing developments and office buildings. It triumphs because it represents Corbusier the artist, rather than Corbusier the social-planner.

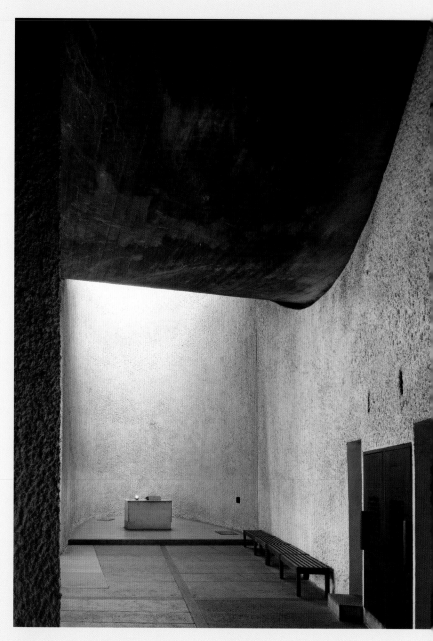

ABOVE
View from the northern to the south-western chapel, lit by the tallest light cowl. The entrance to two confessionals can be seen on the right.

OPPOSITE
The great overhanging roof was inspired by the shell of a crab and built with concrete technology used in the design of dams.

PAGES 300-301
A gap between the roof and walls of the interior gives an impression of great lightness. The 'windows' of the south wall are of varying sizes and depths, and are filled with coloured glass.

PAGES 302-303
Outside the eastern wall are two pulpits and an altar allowing for the saying of Mass to thousands at outdoor services.

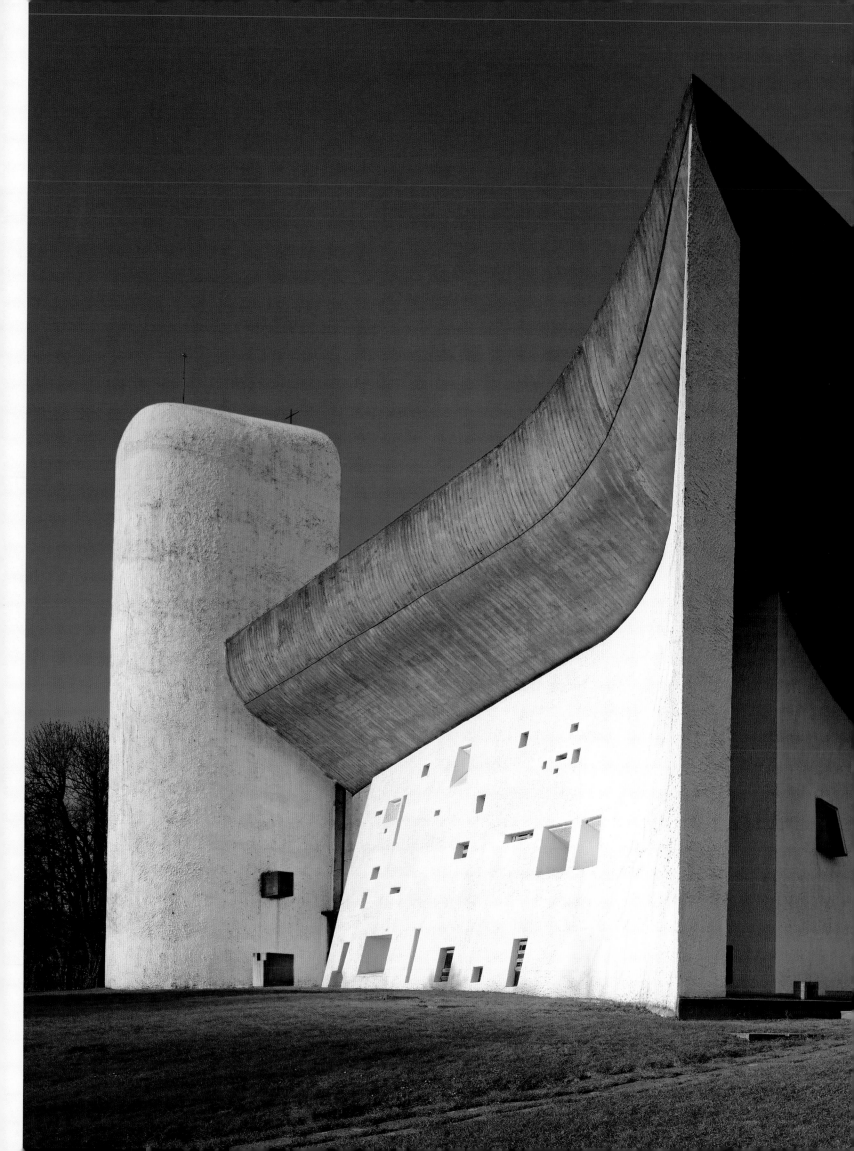

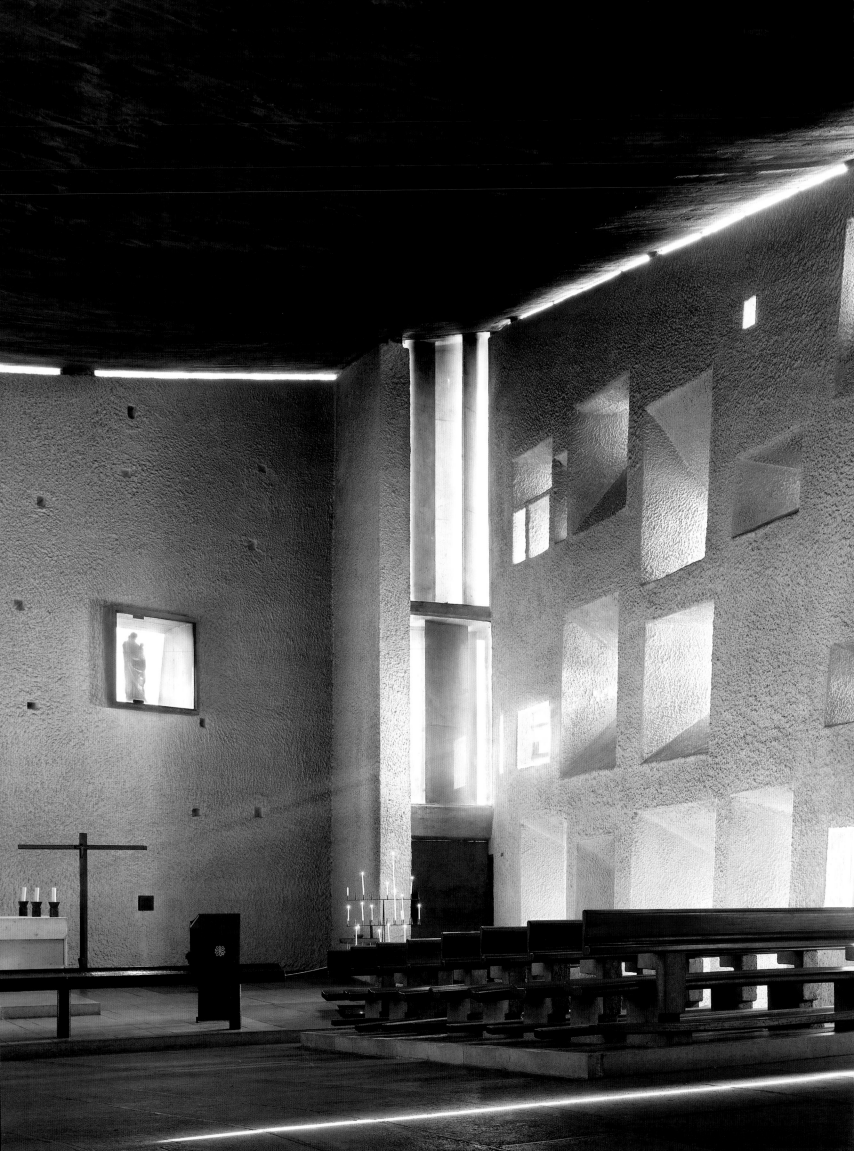

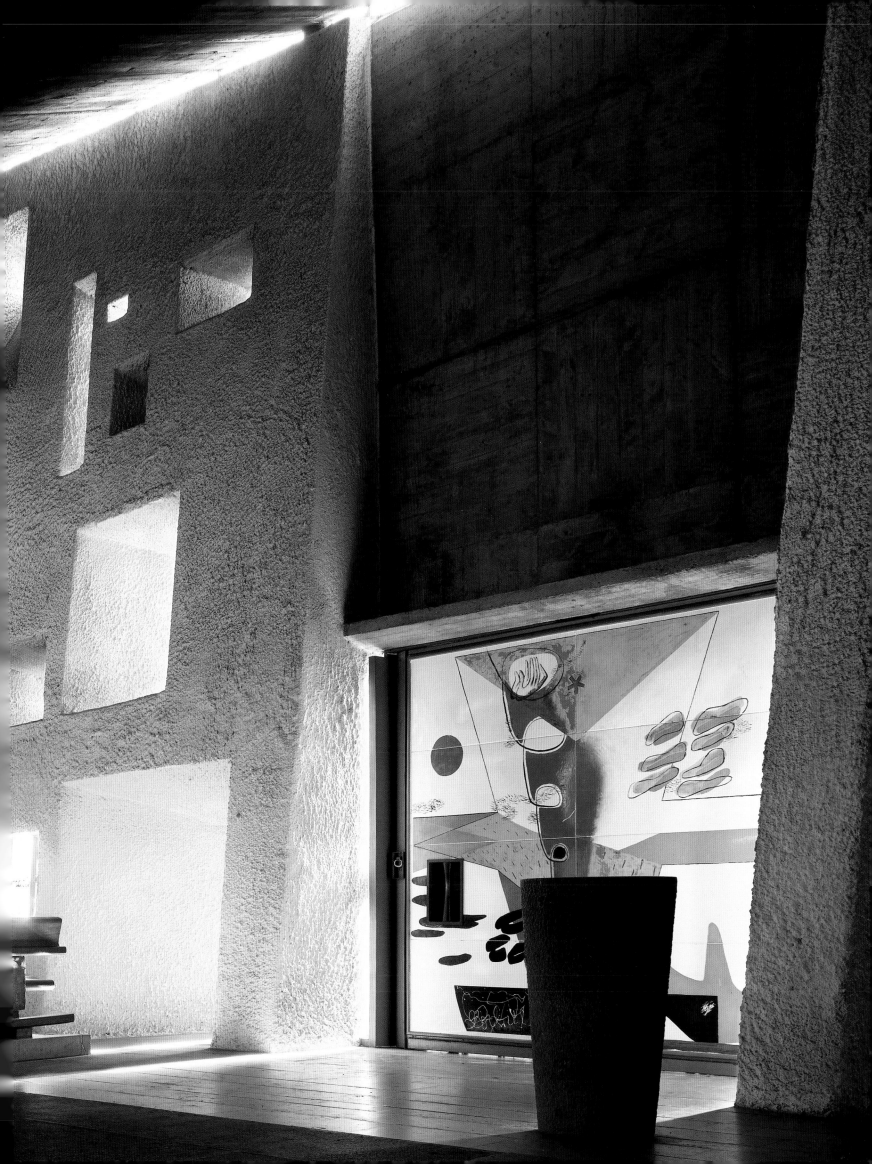

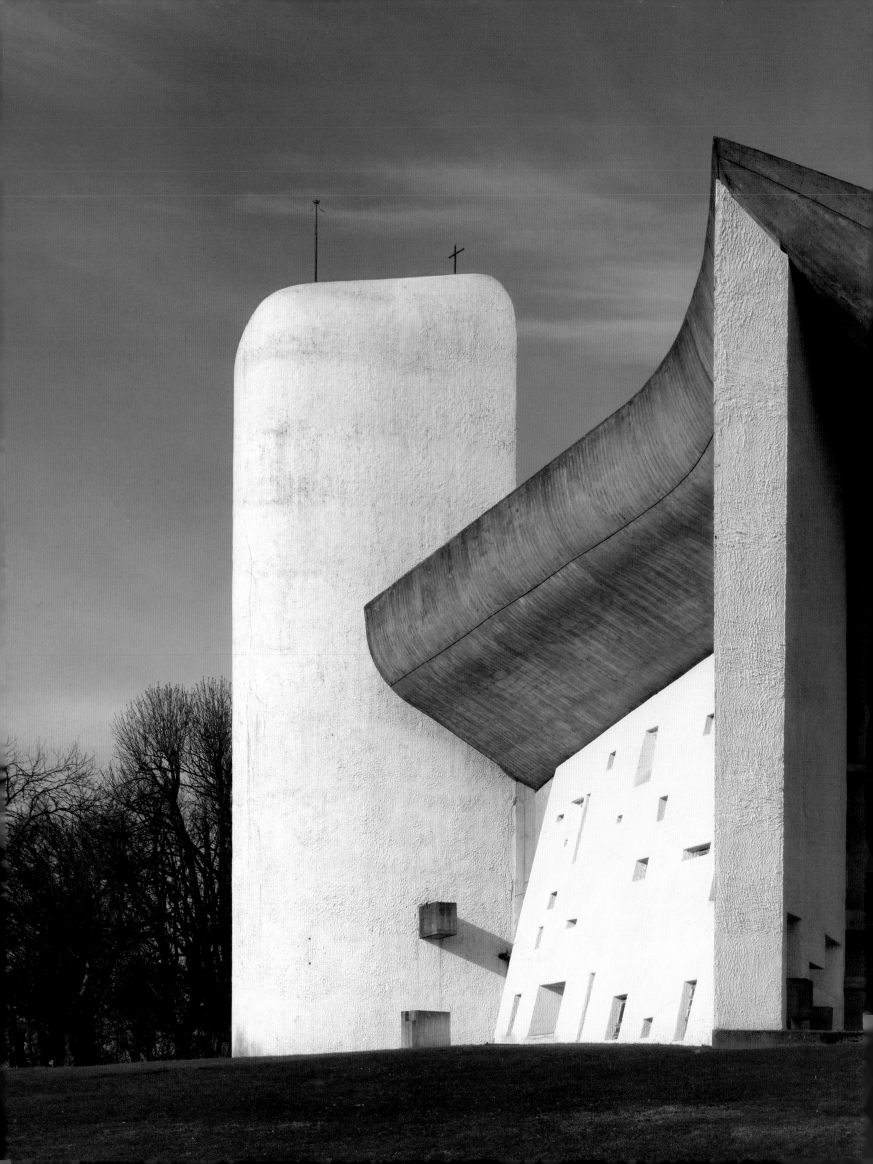

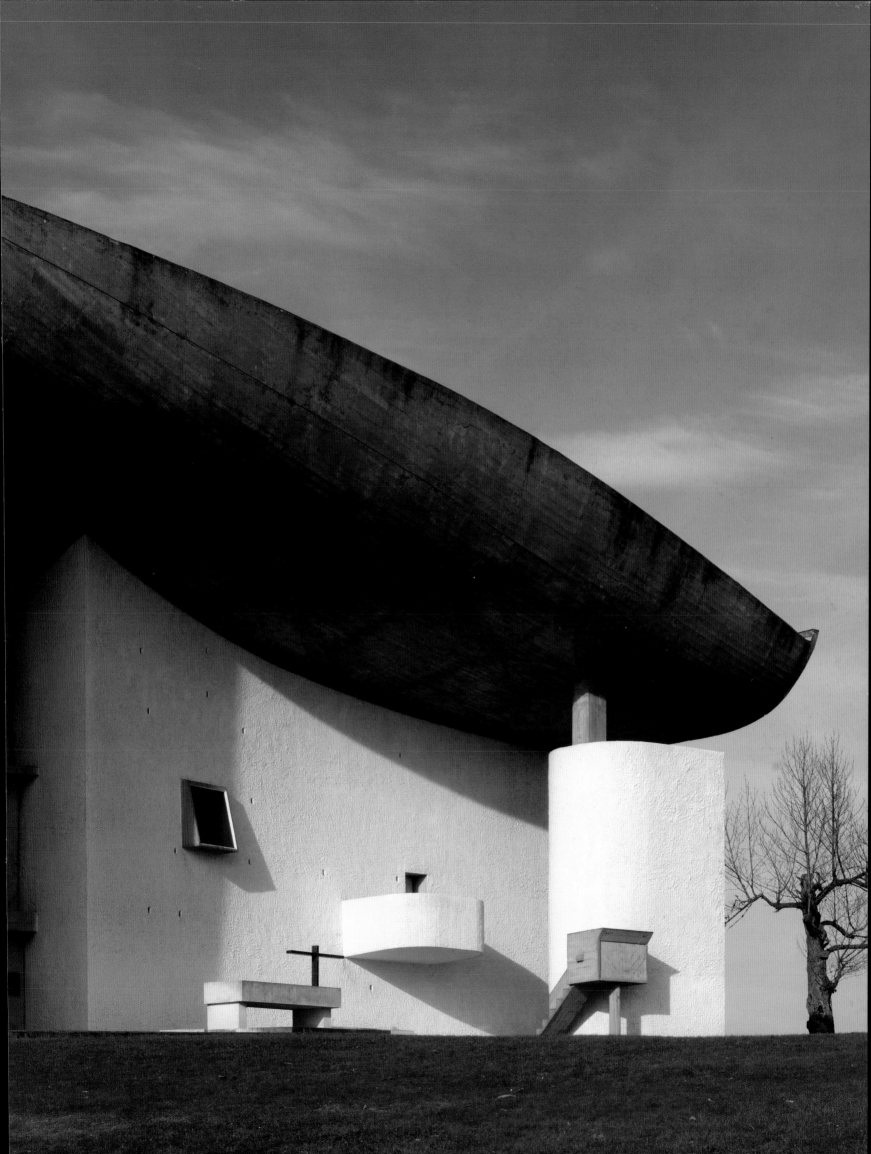

Seagram Building

NEW YORK USA

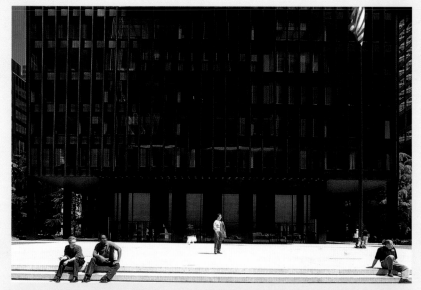

To mark their centenary in 1957, the Joseph E. Seagram and Sons Corporation decided to build an office building of their own. They chose Mies van der Rohe as their architect, and a site between 52nd and 53rd streets in New York. This skyscraper, more than any other, would determine what form all other skyscrapers should take.

Early skyscrapers in New York often evoked in a pyramidal shape, since the city's zoning laws forbade them to rise direct from the sidewalk without being cut back at certain points. The alternative was the placement of the tower upon a wider plinth. Mies rejected both solutions and designed a lofty rectangular tower set 27 metres (90 feet) back from the street, creating a unique block-wide city plaza. Mies argued that the greater architectural quality of the spaces on offer would offset the economic cost of lost floor space. At the time there was no comparable urban open space in the grid of midtown Manhattan, with the sole exception of the Rockefeller Center mall.

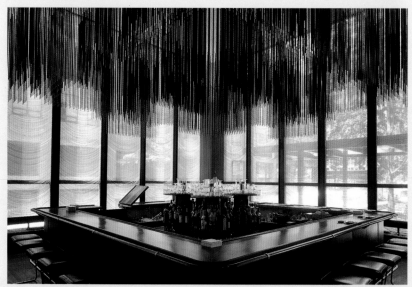

Directly opposite the site was McKim, Mead and White's stately Racquet and Tennis Club, built in 1918. By placing the plaza between the two buildings, Mies also created a dialogue between them – one four-storey and solid stone, the other 39 storeys and glass. Each structure was symmetrical and they shared a common axis. The decision enhanced the grandeur of both.

The tower rose 157 metres (516 feet), its verticality emphasized by the bold way it left the horizontal surface of the plaza. Famously Mies was forced to encase his steel structure in concrete for fire protection and used decorative I-beams to highlight the steel skeleton underneath. These beams give the façade greater relief and vertical emphasis and help overpower the horizontality of the spandrels.

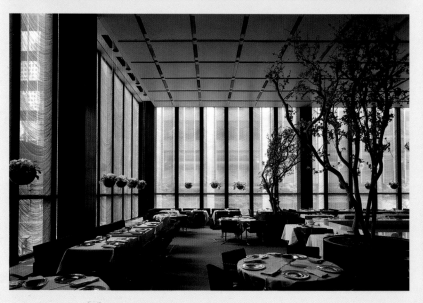

At the time of its completion in 1958, the Seagram Building was the most expensive skyscraper per square foot of floor space ever constructed in Manhattan. It was also the most admired. Mies was immediately bombarded with requests for similar buildings and other architects copied the Seagram. As a result it became the visual ideal for corporate America, in the process losing much of its shock. Before the Seagram a skyscraper was built as high as economics and planning allowed and then given an identity by sticking a recognizable 'hat' on it – for example, the Empire State Building. But Mies conceived of this building as a complete sculptural unit – proportioned, controlled, perfect. It was the first skyscraper as modern sculpture, an object that utilized its size for aesthetic effect.

OPPOSITE TOP

The front of the Seagram Building. Its relationship with the plaza is thought to have been inspired by Schinkel's Altes Museum in Berlin (see p. 177). The plaza is lined with steps that meet the street and contains two symmetrical pools and a single flagpole – the only asymmetrical detail in the whole ensemble.

OPPOSITE MIDDLE

The bar in the Four Seasons restaurant within the Seagram Building. Philip Johnson, who assisted Mies on the Seagram, designed the interior.

OPPOSITE BELOW

The Pool Room in the Four Seasons was designed by Philip Johnson. The metal draperies are the work of Marie Nichols. The series of paintings commissioned from Mark Rothko for the restaurant are now in the Tate Gallery, London.

RIGHT

The tower was made of expensive materials such as rust-coloured bronze, amber-grey glass, travertine and polished green marble and has come to look even more expensive as it has grown older.

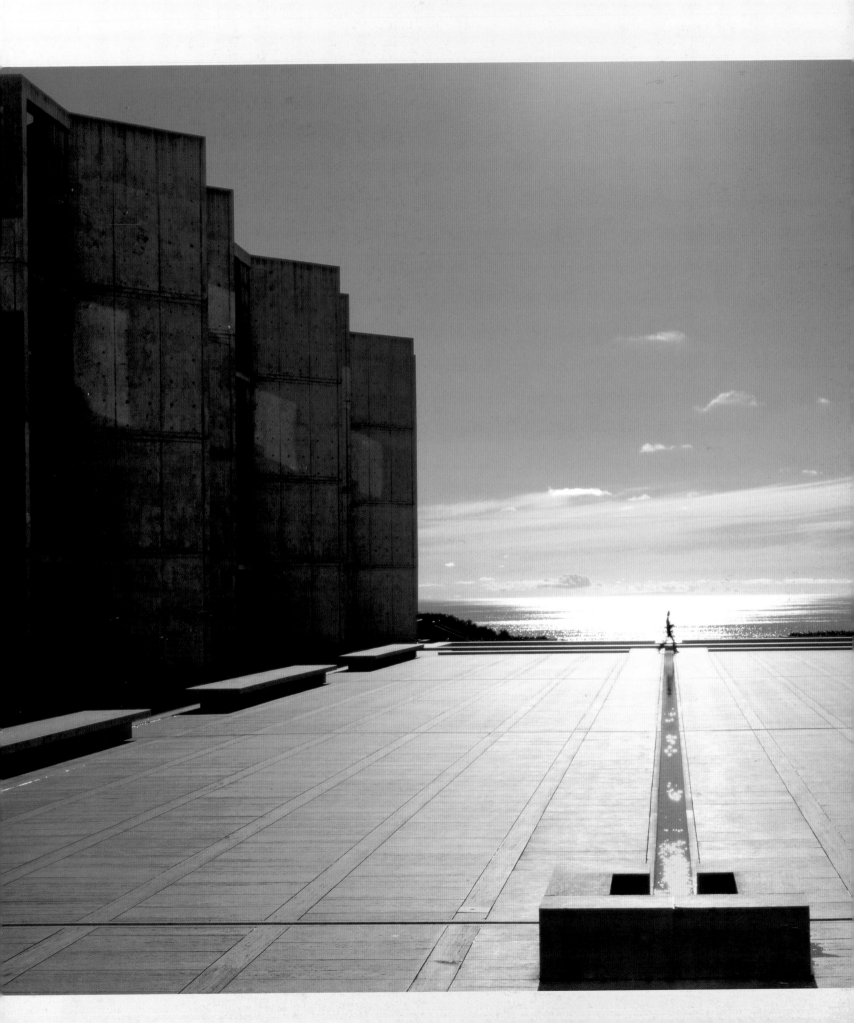

To ensure a smooth concrete
finish plywood forms were coated
with polyurethane.

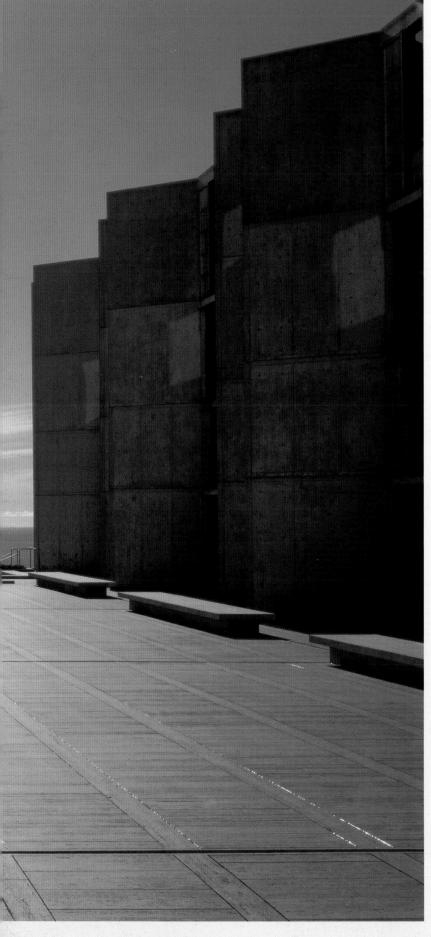

Salk Institute

L A J O L L A U S A

The Salk Institute for Biological Studies occupies a hillside site overlooking the Pacific Ocean at La Jolla, San Diego, California. It was the brainchild of Dr Jonas Salk, the inventor of the polio vaccine who, in 1959, commissioned architect Louis Kahn to design a new institution for medical research. Both Salk and Kahn were inspired by the beauty of monastic buildings, specifically the monastery of San Francesco in Assisi. At La Jolla, Kahn consciously sought to evoke a quasi-monastic character but using an abstract Modernist architectural language. The result is a complex of enormous monumentality, containing arguably the world's most powerful Modernist space.

The Salk Institute is planned around two rectangular laboratory blocks that lie perpendicular to the ocean, each containing three floors of open-plan laboratories. Between them lies a central court flanked by two rows of five four-storey towers. In each tower only two of the four floors contains contain rooms - studies for the scientists. The other two are left open to serve as covered 'porticos' to the labs, allowing views both through and between the towers into the court. A lightwell between the towers and the labs lights the lower storey. These thirty-six studies, detached from the communal laboratories, take on the character of monastic cells. Each successive eastwards study was set out in an exaggerated perspective to allow it to see past its neighbour, framing a view out over the ocean.

The complex was built in concrete of an astonishing quality. In order to avoid the usual cold grey colour, Kahn mixed in a small amount of pozzolana to produce a warmer tone, a technique that dates back to Ancient Rome. Every piece of formwork was designed and drawn, rather than being left to the contractor. Contrasting with the concrete were panels of teak that covered the office walls and provide pockets of visual warmth within the concrete skeleton.

The central court was always intended to be a garden space, with its central channel of water inspired by Islamic gardens such as those of the Alhambra or in Mughal India. However, Kahn invited the celebrated Mexican architect Luis Barragán to visit the site in February 1966. Kahn recalled later: 'He turned to us and said, "I would not put a single tree in this area. I would make a plaza...if you make a plaza, you will gain another façade - a façade to the sky."' Remarkably, this empty travertine plaza created a defining symbol for the Salk Institute's elliptical function as a repository for the intangible - imagination and endeavour.

BELOW
The warm-hued concrete was a result of Kahn's research into the 'pozzolanic' concrete used by the Romans. In this setting, the material is at once hard wearing, a thermal insulator and provides plentiful shade from the Californian sun.

OPPOSITE
Originally Kahn designed the institute to have three groups of buildings but only the central laboratories were ever built and these in a form that had changed considerably during a protracted design process.

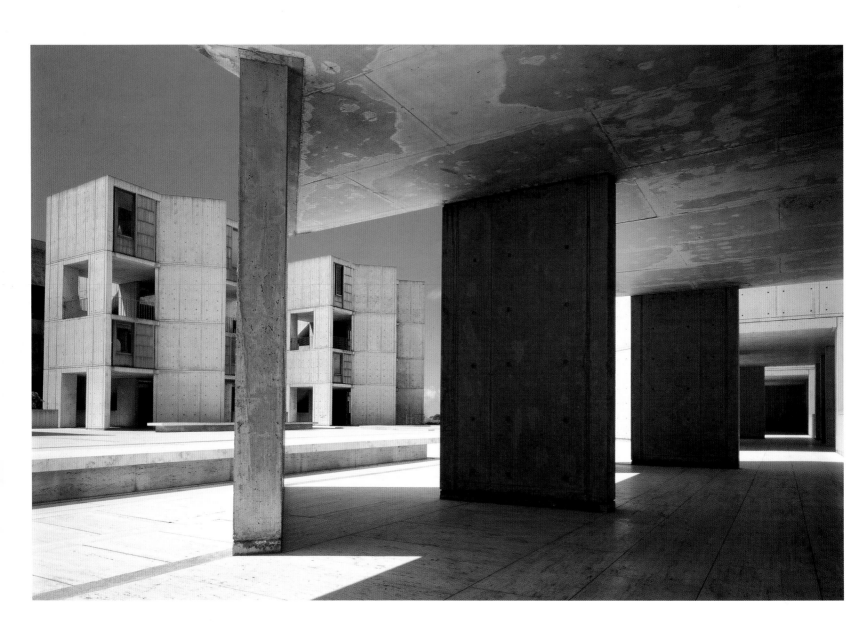

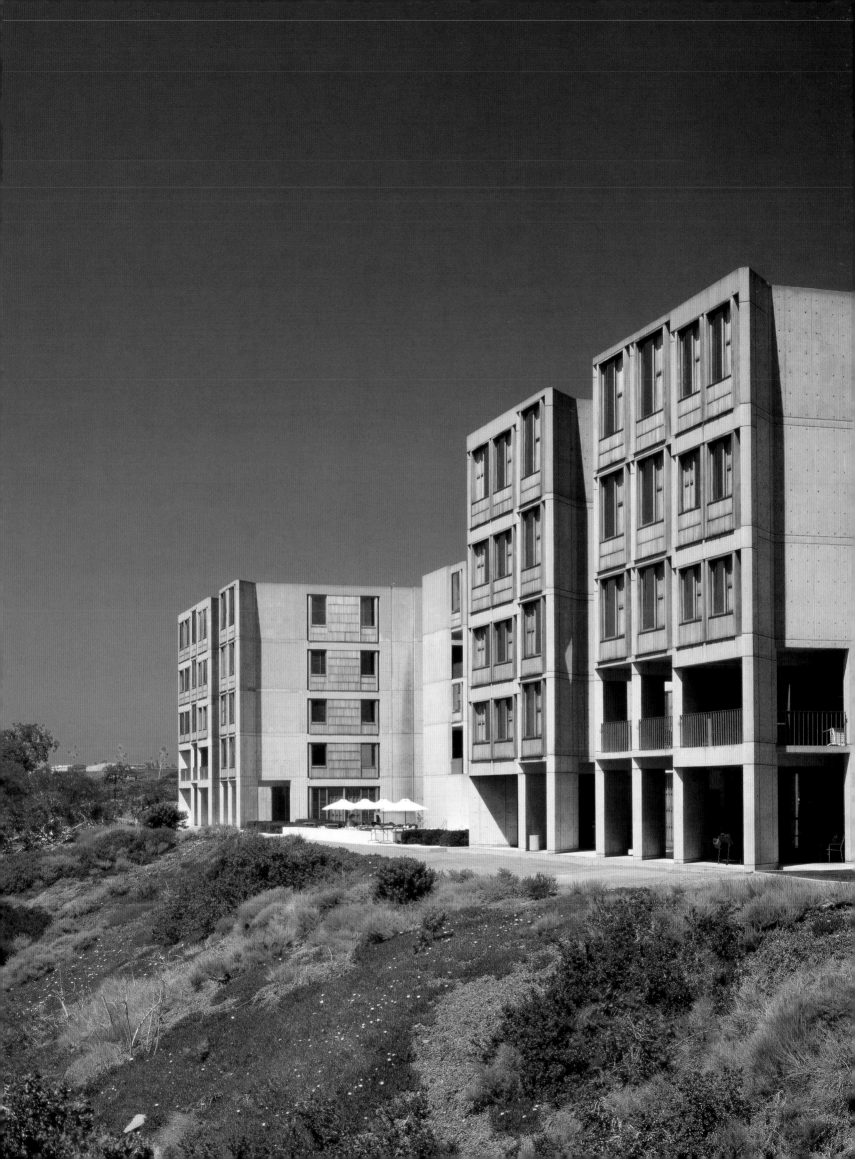

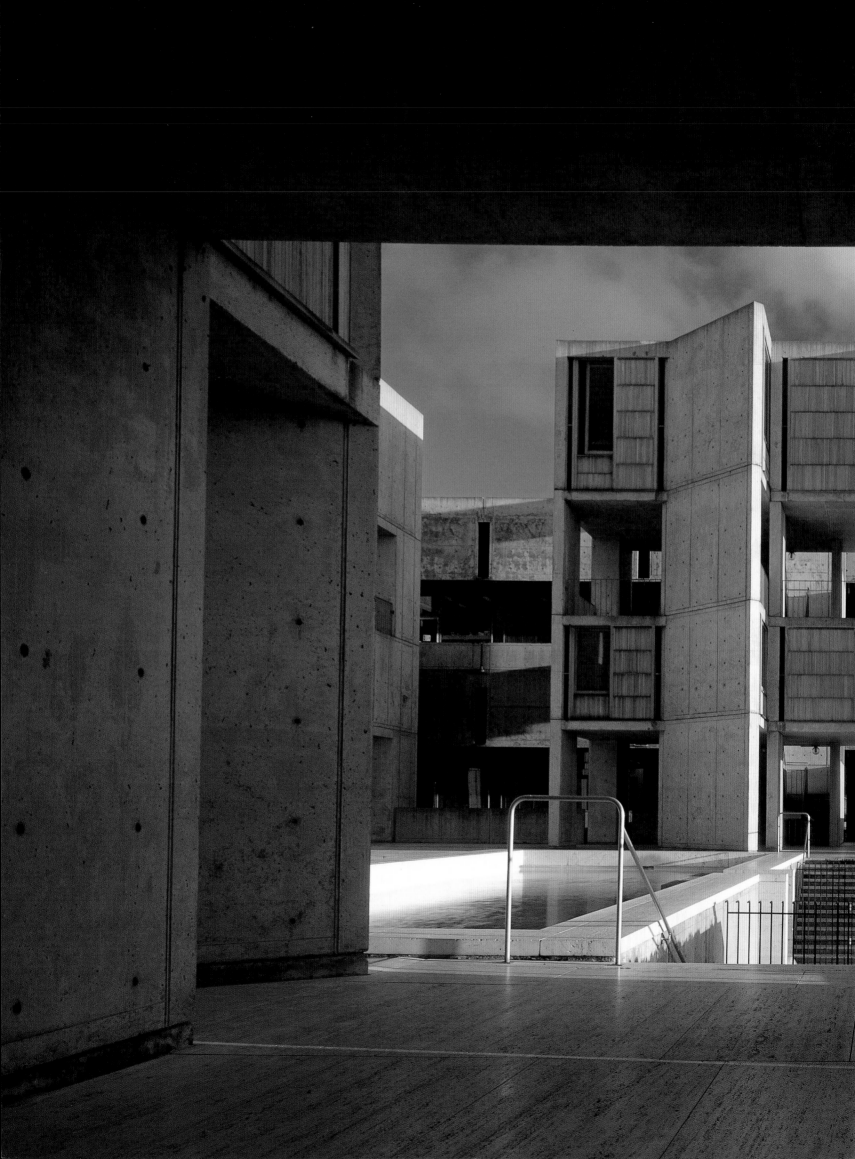

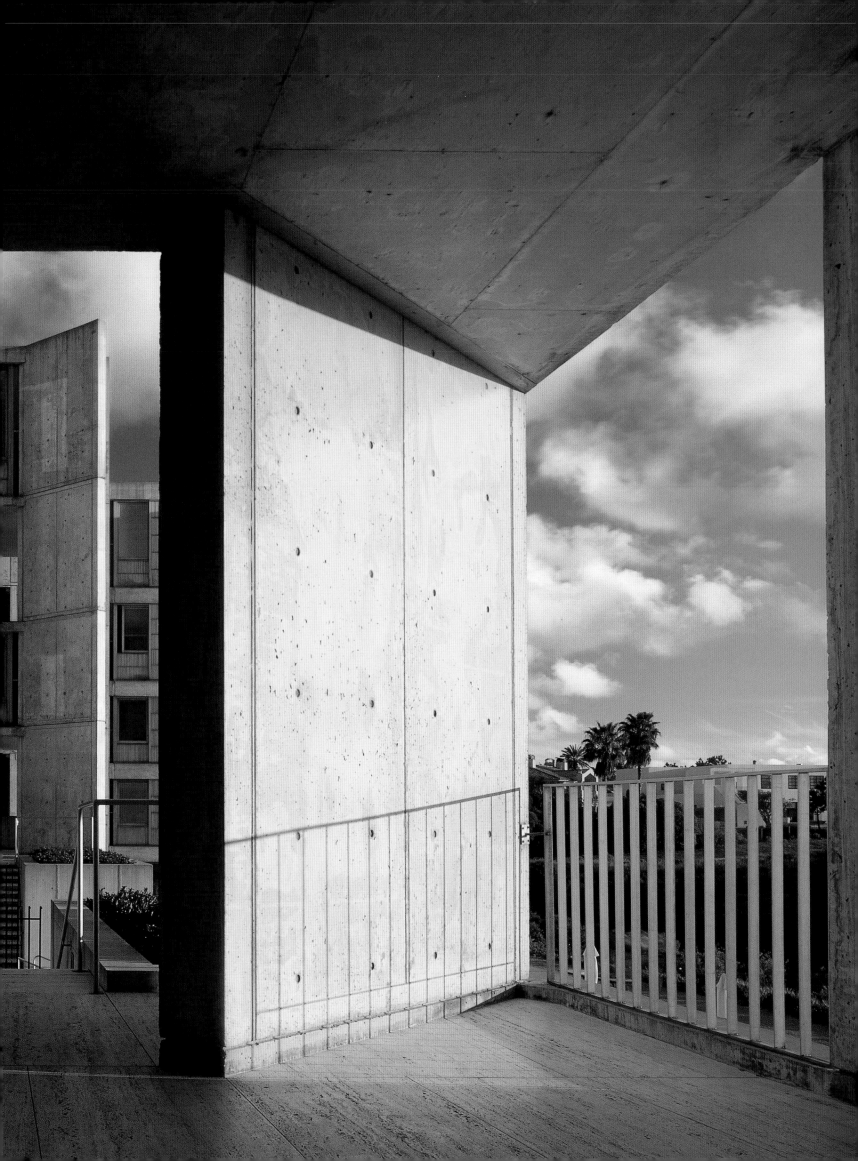

Guggenheim Museum

BILBAO SPAIN

The Guggenheim Museum in Bilbao marked the first overseas sale of the Guggenheim franchise, in which the authorities of this prosperous, if unglamorous, northern Spanish city united with the famous brand to build an offshoot of the museum hundreds of miles from New York. The role of the building was to sell this idea to tourists internationally, to put Bilbao on the cultural map.

The architect chosen by the Guggenheim was Frank Gehry. He looked at the site, which was bounded by the city, the harbour and a road bridge, and then overlaid a relatively orthodox stone-clad building with a series of wave-like titanium sculptural shapes to create something that at the time looked like no other building on earth. In fact, the titanium sheets themselves are only half a millimetre thick, and while much has been made of Gehry's use of the CATIA computer program that had also been used to design the Boeing 777, the attractive curves were to a large extent shaped intuitively by hand.

The museum is entered from the south and visitors descend to arrive in the atrium, which is some 50 metres (164 feet) high – one-and-a-half times as tall as the spiral of Frank Lloyd Wright's original Guggenheim. The glass walls of the atrium look onto the river below, as well as the surrounding mountains. On the other three sides of the atrium, which is the heart of the museum, visitors have access to three floors of galleries. The south wing contains the permanent collection, which is housed in orthogonal galleries, clad in limestone. To the west lies what Gehry called 'the boat', a 130-metre (427-foot) long space that runs right under the road bridge. This has been designed to accommodate large-scale artworks, and has a specially prepared floor that can take heavy loads. Opposite, the smaller east gallery contains display spaces and public facilities overlooking the harbour.

As it has turned out the principal draw of the Guggenheim in Bilbao has been not the collection but the building itself. The contrast between the industrial city and the glistening titanium shapes is incredibly striking. Consequently it has been widely referred to as an example of 'destination architecture' – an eye-catching building that plays a role in the redevelopment or regeneration of a region or city by encouraging tourism. In the case of the Guggenheim in Bilbao, the experiment has worked: the building cost $100 million, but in its first year alone tourist revenues in the city had increased by $400 million. This suggests that people are still prepared to travel great distances to see a building – perhaps not unlike the pilgrims who visited the great monuments of Santiago de Compostela, Chartres or Angkor Wat, albeit for profoundly different reasons. On the other hand it has encouraged architecture to place enormous emphasis on visual novelty, and certainly the Guggenheim in Bilbao, more than any other contemporary building, has re-established the idea of a building whose inherent form is an artistic signature – this is unmistakably the work of Frank Gehry.

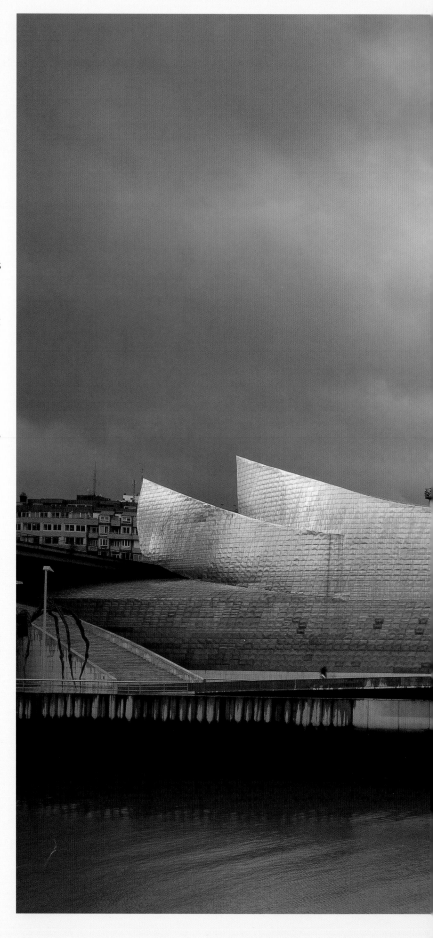

**The Guggenheim seen from
the north across the river.**

PAGE 314

**The eastern façade seen from the
bridge. The Guggenheim's titanium
skin ensured its iconic status.**

PAGE 315

**The street-level entrance. From
here stairs take visitors down to
the river-level atrium.**

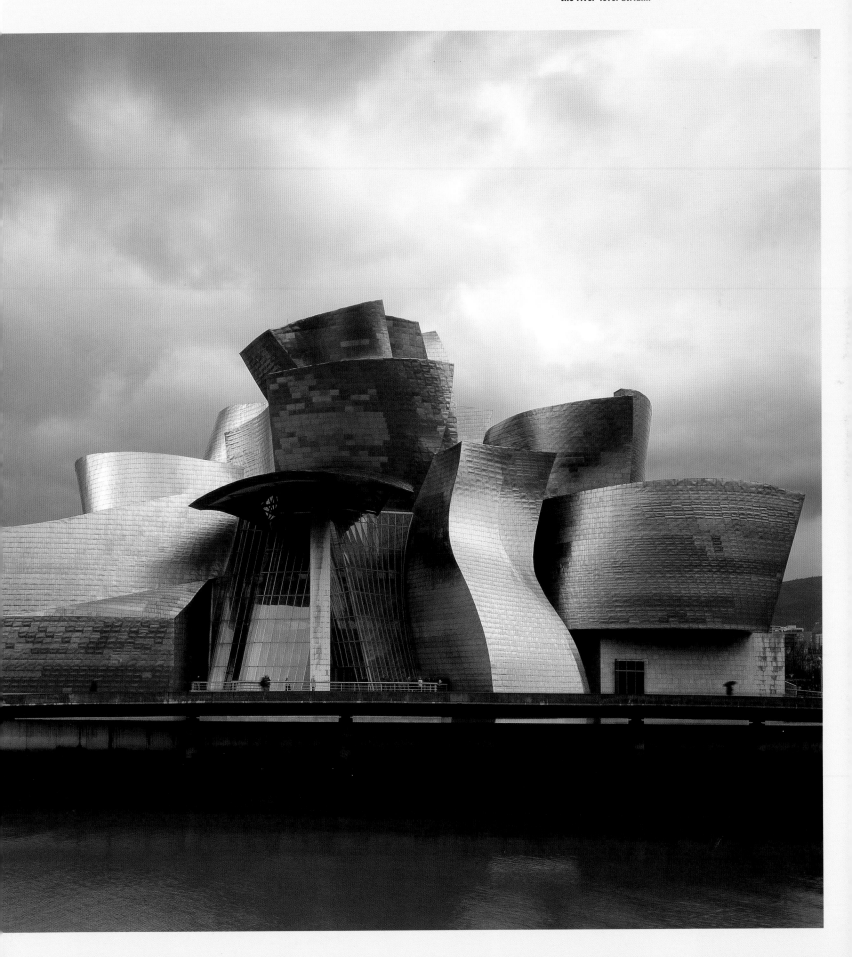

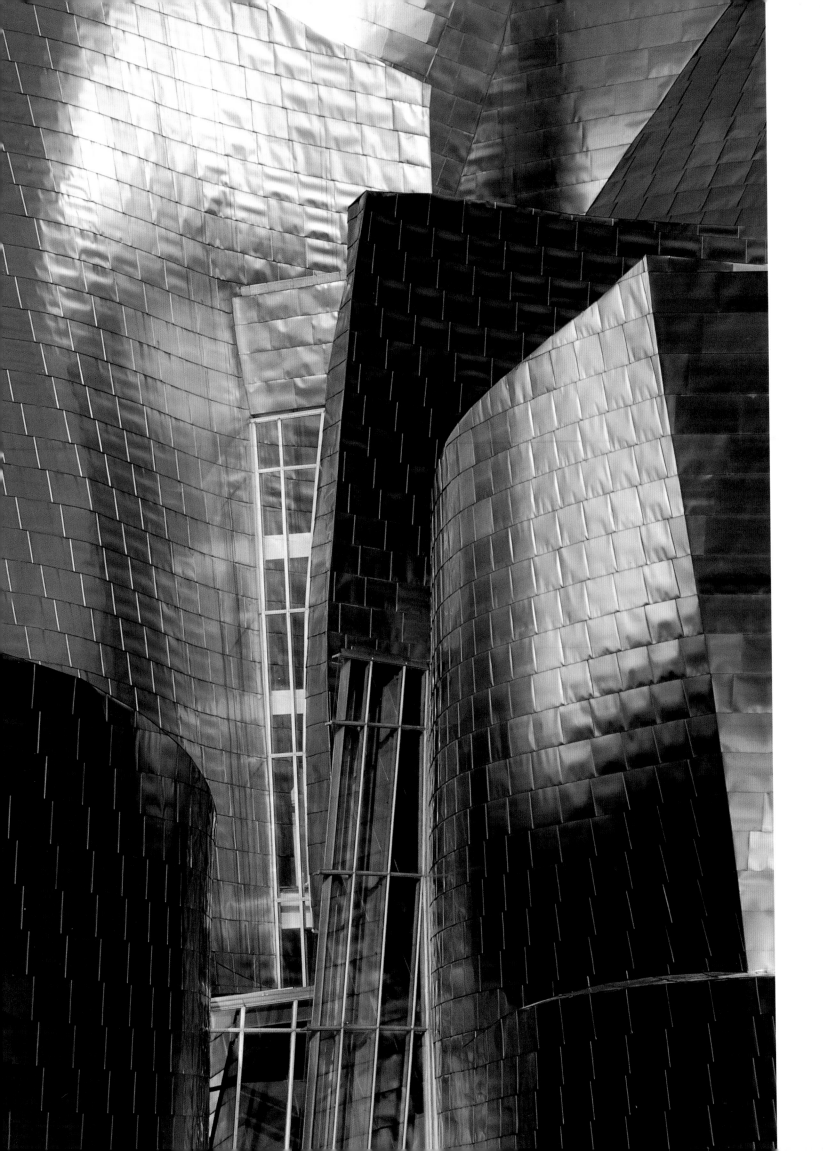

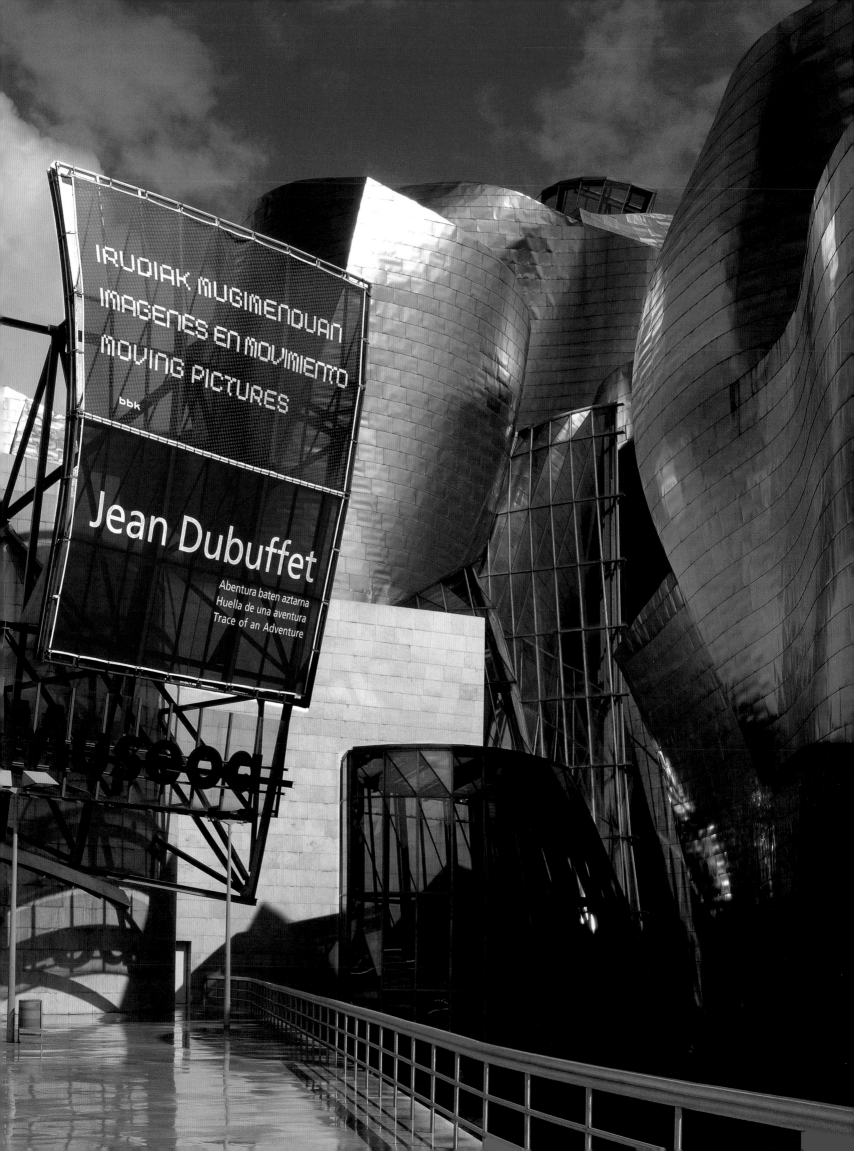

IRUDIAK MUGIMENDUAN
IMAGENES EN MOVIMIENTO
MOVING PICTURES

bbk

Jean Dubuffet

Abentura baten aztarna
Huella de una aventura
Trace of an Adventure

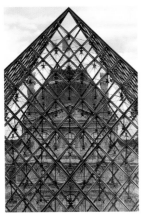
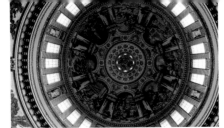
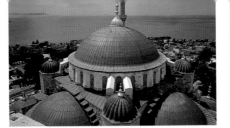

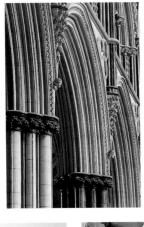
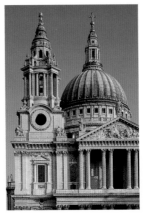

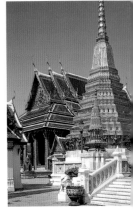

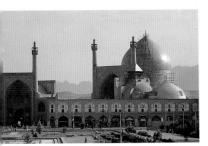
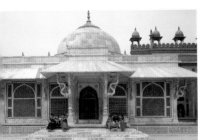
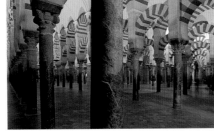
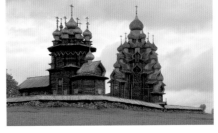
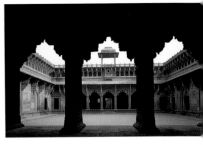

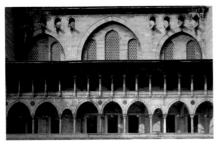
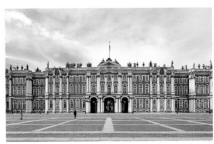
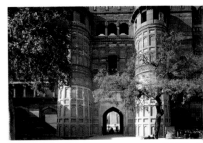

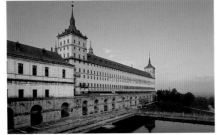

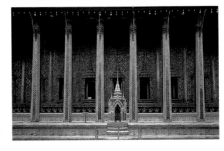
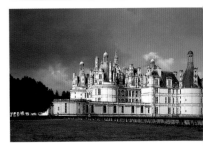

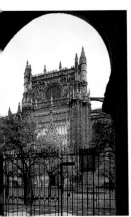
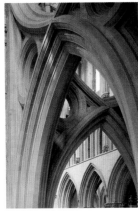
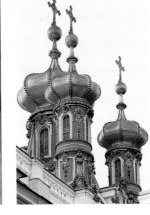

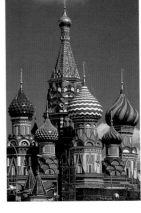

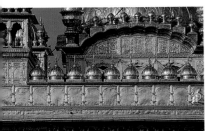
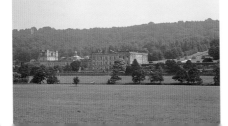

Acknowledgments

I owe a great debt of gratitude to many organizations and individuals all over the world. I am particularly grateful to the representatives of all the buildings included in this volume. Particular thanks are owed to: The Archaeological Survey of India, The Mayor and City of Istanbul, Ely Cathedral, King's College, Cambridge, The Philip Johnson Glass House, The Salk Institute and The Golden Temple.

Also particular thanks are due to the following individuals: Marcus Bleasdale and K. B. Nøsterud, Robert Bradford, Lorna and Andrew Camden, James Campbell, Pamela Drukerman and Simon Kuper, Ophelia Field and Paul Laikin, Cecily Hillsdale and Jonathan Sachs, Charles Lewis, Karoki Lewis, Julie and Philip Lewin, Kathy Long, Teresa and Adrian Richardson. As ever, thanks to Colette.

Glossary

This is a glossary of architectural terms relating to forms, construction and distinct elements of buildings; it does not cover styles or movements.

adobe Construction using bricks made of unfired earth.

aisle A longitudinal division of a church, running alongside the nave.

ambulatory A passageway at the east end of a church behind the altar.

apse The semicircular termination of a building or part of a building, often at the east end of a church.

arch A masonry construction spanning an opening. Arches can be pointed (as in Gothic and some Islamic architecture), or round (as in Classical or Romanesque architecture).

ashlar Finely cut stone.

baldacchino A permanent canopy over the altar of a church.

baptistery Part of a church, or less often a separate building, used for the ceremony of baptism.

bays Repeating units, defined by arches and piers or by windows.

bracket A horizontal member projecting from a vertical surface.

buttress Buttresses support walls, and counter the outward thrust of vaults; they typically take the form of large piers of external masonry. A flying buttress is separated from the wall by an arch.

campanile The Italian name for a bell tower.

candi Indonesian temple – literally a sacred compound that contains one or more shrines.

capital The upper part of a Classical column – plain (Doric), volute (Ionic) or foliated (Corinthian or Gothic).

chajja A roofed arcade found in mosques.

chancel The east end of a church containing the altar.

charbagh A garden plan particular to Mughal architecture that splits the garden into four equal sections using two crossing water courses.

choir Used synonymously with chancel, since it housed the choral singers. The area in a church that extends eastwards from the crossing; traditionally out of bounds to the lay congregation.

Churrigueresque A highly elaborate style that developed in Spain in the 18th century.

Classical architecture The architecture of the Greeks and, more typically, Romans, that relies on columns (as expressed through the orders) and round-headed arches. After the fall of the Roman Empire, Classical architecture was not revived until the 15th century.

clearstory The upper section of an elevation, with windows letting in light.

column An upright pillar with a supporting function and three distinct elements: a base, a shaft and a capital, which is often decorated.

colonnette A small, decorative column with no supporting function.

corbel A stone member that projects out of a wall in order to support a roof member, vault or shaft .

Corinthian *see* orders

crossing The area where the nave, choir and transepts meet at the centre of a church. Often covered with a tower or dome.

cupola A small dome, sometimes on top of a larger one.

dome A hemispherical roof.

drum A circular wall that supports a dome.

Doric *see* orders

entablature The upper part of a Classical elevation, usually above the columns

(and supported by them). It can be divided into an architrave, a frieze (often decorated with sculpture) and a cornice.

flying buttress *see* buttress

formwork A mould, typically made from wood, into which concrete is poured to give the desired shape, removed once the concrete has set.

gable The triangular end of a roof, or the same shape on its own.

gallery A covered passageway open on one or both sides. It can also take the form of a balcony, typically in churches or mosques, running along the edges of the building.

garbhagriha Literally 'womb chamber' – a centralized chamber enclosing a figure of a deity, found in Indian architecture.

gopura A formal entrance surmounted by a tower or towers, found in Buddhist architecture.

Gothic A style characteristic of European architecture between c. 1130 and the mid-16th century. Its defining features are pointed arches, rib vaults and flying buttresses.

gu A cave-like central chamber found in Burmese architecture.

gurdwara A Sikh sanctuary.

Ionic *see* orders

iwan A term with various meanings. In the context of this book it refers to a common feature in Islamic architecture – a tall arched wall niche that provides an architectural focus often enclosing a central entranceway.

jagati A platform found in Indian temple architecture

lantern A structure sitting on top of a dome or similar structure that allows light to enter.

mihrab A construction, normally in the form of a

niche, found in mosques that indicates the *qibla* or direction of prayer.

minaret A tall structure attached to a mosque and used for calling to prayer.

minbar A pulpit-like structure found in mosques and used for speaking to the congregation.

muqarnas A honeycomb or stalactite-like decoration found in Islamic architecture.

nave The main space in a church, extending to the west of the crossing or chancel. Often flanked by aisles.

niche A recess in a wall, often used to display sculpture.

orders The four main Classical orders are Doric, Ionic, Corinthian and Composite.

pavilion A light structure, often open, that offers shelter.

pedestal A base to support a column or a statue.

pediment A triangular gable, with a low pitch, found on Classical façades.

pendentive A curving triangular surface that reconciles the circle of a dome with a square plan.

pier A solid masonry, structural, supporting element, often with a square plan.

pietra dura From the Italian for 'hard stone'; a decorative, mosaic technique using semi-precious stones.

pilaster A flattened column applied to a wall. Its function is decorative rather than structural.

portico A structure with a roof supported by columns, often attached to a façade.

portal A formal or highly decorated doorway, often with sculpture.

presbytery A part of a church reserved for use by the clergy. Same as chancel or choir.

retrochoir An area behind the choir in a church.

ribs A structural element in vaulting, particularly in Gothic architecture.

rose window A large, circular window with tracery found in Gothic churches.

sikhara Spire or finial found in Burmese architecture.

spandrel A near-triangular shape formed between an arch and a bounding rectangle.

squinch An arch placed at the corners of a square plan to support a dome.

stupa A spire-type construction containing a relic, found in Buddhist architecture.

tracery Decorative stone pattern filling a window in Gothic architecture.

transepts Arms of a church, opening from the crossing at right angles to the nave and choir.

tribune A raised gallery.

triforium A horizontal level, often inaccessible (in contrast with a gallery), between the lower arcade and clearstorey built into the thickness of the wall of a Romanesque or Gothic church.

trumeau A post dividing a doorway.

tympanum The area between the lintel and the arch of a doorway; in Romanesque and Gothic churches it is often decorated in with sculpture.

vault A stone ceiling. A barrel vault is a continuous semi-circle. The intersection of two barrel vaults forms a groin vault. In Gothic architecture the groins are defined and supported by ribs, with either two ribs per bay (quadripartite vault) or three ribs per two bays (sexpartite vault). Later Gothic architecture saw a profusion of decorative ribs (liernes), and the introduction of fan vaults, which use curving ribs to form conical shapes. Islamic architecture has used *muqarnas* vaults.

Index